9

A City Upon a Hill

A City Upon a Hill

How Sermons Changed the
Course of American History

Larry Witham

HarperOne
A Division of HarperCollins*Publishers*

HarperOne

HarperCollins books may be purchased for educational, business, or sales promotional
use. For information please write: Special Markets Department, HarperCollins
Publishers, 10 East 53rd Street, New York, NY 10022.

HarperCollins Web site: http://www.harpercollins.com

HarperCollins®, 📕®, and HarperOne™
are trademarks of HarperCollins Publishers.

FIRST EDITION

Library of Congress Cataloging-in-Publication Data is available.

ISBN: 978–0–06–085427–0

07 08 09 10 11 RRD(H) 10 9 8 7 6 5 4 3 2 1

Contents

III

Modern Period

(1900–)

Acknowledgments and
Literary Note

Every time Americans think we have confronted something "new," plummeted to a nadir, or reached a national apex, we should read our own four hundred years of history. That has been my pleasure in this project, something made possible by countless careful scholars and archivists. Thanks to them, sermons from America's beginnings to the present are easy enough to find. On this front as well, I am indebted to staff at the Library of Congress and to the University of Maryland, Catholic University of America, American University, and Wesley Theological Seminary libraries. Many others were my helpful guides on research visits to Massachusetts, New York, Ohio, Kentucky, Georgia, and South Carolina.

In recent years, a number of talented scholars have reassessed all of American religious history. They have proffered new theories and questioned old ones. I have adopted the historical arguments that seemed persuasive to me, and the sources will be evident by the notes and a bibliography. I would like to thank historian Edwin Gaustad for reading the manuscript. As ever, the work could not go forward without the able help of my editor at HarperSanFrancisco, Eric Brandt, and my agent, Giles Anderson.

As will be seen, sermons from our colonial period used old-style English, which I have generally kept intact. Furthermore, the sermon is a spoken event and always loses something when it is reduced to print or quoted piecemeal. Some historical sermons are at best careful recollections or reconstructions. Probably the greater obstacle to treating this topic, however, is reflected in *Webster's* very definition of a sermon: "any serious talk on behavior, responsibility, etc., esp. a long, tedious one." In my narrative, I have tried to alleviate those negatives, beginning with an amusing old style in the section openings, reminiscent of Voltaire's *Candide,* where chapters open with teasers such as "How Candide met his former philosophy teacher, Dr. Pangloss, and what ensued." I hope I have shown that a sermon history can be short and lively, if inescapably moralistic.

Timelines

Historical Events		Sermon Events
1607	The Virginia Company founds Jamestown.	
1619	First General Assembly in America at Jamestown and arrival of first African slaves.	
1630–40	The Great Migration to Massachusetts Bay Colony.	Massachusetts Bay Colony governor John Winthrop in 1630 preaches "A Model of Christian Charity," a blueprint for Puritan society and a lasting "city upon a hill" symbol in American rhetoric. John Cotton preaches the first "election-day sermon" at the Boston meeting house in May 1634, a precedent for the nation's inaugural speeches by presidents.
1636	Connecticut and Rhode Island founded.	Anne Hutchinson's preaching on radical grace in 1636 prompts Massachusetts to restrict "Hutchinsonian" immigration and deport her to Rhode Island.
1642–60	English Civil War, Puritan rule, and Restoration of the monarchy.	During New England's 1662 drought, Michael Wigglesworth's *God's Controversy with New England* begins a "jeremiad" tradition in American oratory. Leading Bostonian Increase Mather preaches "The Day of Trouble Is Near" in 1674, helping to interpret America's first great devastation, "King Philip's War" between settlers and Indians.

Historical Events	Sermon Events
1675–76 "King Philip's War" between Indians and New England settlers.	
1692 Salem witch trials.	Cotton Mather preaches "The Wonders of the Invisible World" amid the 1692 Salem witch hysteria, a period that sobers America about unfounded "witch hunts."
1732 Georgia established as thirteenth colony.	
1740 Naturalized residents of one colony allowed citizenship in other twelve.	The Great Awakening divides American denominations, driven by such sermons as Presbyterian Gilbert Tennent's "Dangers of an Unconverted Ministry" on March 8, 1740, in Maryland.

Jonathan Edwards revives a flagging Calvinism with his July 8, 1741, sermon, "Sinners in the Hands of an Angry God," at Enfield, Connecticut.

To combat religious emotionalism, Boston Congregationalist Charles Chauncy preaches a rational Enlightenment faith in his July 1742 sermon, "Enthusiasm Described and Cautioned Against." |
1747 Ohio Company organizes to settle western lands.	Boston's Jonathan Mayhew gives colonials an inkling of rebellion against British royalty in his February 1750 sermon, "Unlimited Submission," later called a catechism of the Revolution.
1754–63 "French and Indian Wars" in North America.	
1765 The Stamp Act tax by Parliament.	

Historical Events		Sermon Events
1775	Battles of Lexington and Concord.	From London, Methodism founder John Wesley sends his mid-1775 "Calm Address to Our American Colonies," urging obedience to British taxation and rule.
1776	Declaration of Independence.	John Witherspoon, president of Princeton College, in May 1776 justifies war in his widely printed sermon "Dominion of Providence over the Passions of Men," and signs the Declaration of Independence.
1789	First U.S. Congress.	The Jewish voice in America becomes public on November 26, 1790, when Gershom Mendes Seixas preaches a "Thanksgiving Sermon" at Shearith Israel Congregation, New York City.
1796	Washington's "Farewell Address."	Yale College president Timothy Dwight preaches against European atheism and conspiracy in his July 4, 1798, sermon, "The Duty of Americans," which espouses keeping the Sabbath.
1800	Jefferson elected president to new Washington, D.C., capital.	
1803	Louisiana Purchase and Lewis and Clark expedition.	In Connecticut, Lyman Beecher's antidueling sermon in 1804 and sermons on temperance in 1826 spur America's "reform" movements.
1812	War of 1812 with Britain.	William Ellery Channing delivers his "Unitarian Christianity" in Boston in May 1819, the start of America's religious liberalism.
1821	Americans receive first Texas land from Mexico.	Bishop John England delivers his "Sermon to Congress" on January 8, 1826, a first for a Roman Catholic prelate and a declaration of Catholic political loyalty.

Historical Events	Sermon Events
1828 President Andrew Jackson elected as head of new Democratic party.	Evangelist Charles Finney in 1828 preaches "Sinners Bound to Change Their Own Hearts," rejecting Calvinism in favor of a freewill salvation suited to Jacksonian democracy. For eight days in Cincinnati in April 1829, utopian socialist Robert Owen and Bible evangelist Alexander Campbell debate the "American system" in the greatest of the frontier's many sermon contests.
1830 The "common school" movement begins in America.	Slave preacher Nat Turner addresses a Virginia revival in the summer of 1831, then returns home to lead a failed slave revolt on August 21, galvanizing the South to defend slavery.
1832 Whig party formed to oppose Democrats.	
1838 Federal troops force Cherokees from Georgia land in "Trail of Tears" saga.	At Harvard on July 15, 1838, Ralph Waldo Emerson delivers his "Divinity School Address," starting the Transcendentalist movement, which influences American literature and fuels abolition. Methodist church leaders, meeting in New York City in May 1844, split over slavery North-South, and their oratory persuades southern politicians that secession could be amicable.
1846 Beginning of Mexican War.	In Seneca Falls, New York, Quaker preacher Lucretia Mott delivers the July 19, 1848, opening address for the first women's rights convention, which issued a "Declaration of Sentiments."

Historical Events	Sermon Events
1849 California Gold Rush.	Theodore Parker's "Mexican War" sermon in Boston on February 4, 1849, rejects White House charges of treason for opposing the war, a turning point in antiwar and antislavery oratory.
1850 Fugitive Slave Act requires return of slaves.	In Charleston, South Carolina, on May 26, 1850, theologian James Thornwell preaches "The Rights and Duties of Masters," giving the South a manifesto to justify its way of life.
1854 Republican party forms on collapse of Whigs.	Phoebe Palmer, the founder of the "holiness" movement, collects her talks on female leadership in an 1859 book, *Tongue of Fire on the Daughters of the Lord*. After Abraham Lincoln's election in 1860, secessionist Benjamin Morgan Palmer of New Orleans preaches his November 29 "Thanksgiving Sermon," published widely and calling for a Confederacy.
1861 Fort Sumter surrender starts Civil War.	In Savannah, Georgia, on July 28, 1861, Episcopal bishop Stephen Elliot preaches "God's Presence with Our Army at Manassas," seeing God in the Confederate victory at the Battle of Bull Run in Virginia.
1862 High tide of Confederate army victories.	Black church bishop Daniel A. Payne preaches "Welcome to the Ransomed" on April 13, 1862, a message on morals and education to slaves emancipated in the District of Columbia. After Union defeats, James D. Liggett of Leavenworth, Kansas, says in a September 7, 1862, sermon, "Our National Reverses," that God will bless only a fight against slavery.

Historical Events	Sermon Events
1863 Lincoln issues Emancipation Proclamation.	
1865 Lee surrenders at Appomattox and Lincoln assassinated.	Brooklyn preacher Henry Ward Beecher's "Address at the Fort Sumter Flag-Raising" on April 14, 1865, blames the war on the southern aristocracy, not the ordinary man.
1867–87 Heyday of the American cowboy.	In November 1872, Quaker activist Susan Anthony is arrested for voting in Rochester, New York, and before her June 1873 trial travels to preach a "Constitutional Argument" for suffrage. Beginning in the late 1870s, Philadelphia Baptist Russell Conwell delivers his "Acres of Diamonds" on the Chautauqua circuit, a gospel of wealth that became the most-given sermon in U.S. history.
1876 U.S. Centennial and end of "Reconstruction" in South.	Temperance preacher Frances Willard takes her "Home Protection" sermon on the road in 1876, persuading Christian women to back the female ballot. On becoming archbishop of Baltimore, James Gibbons delivers his "Man Born to Work" sermon in 1878 as the city's Knights of Labor organize and he seeks Vatican support for labor unions.
1880 Andrew Carnegie monopolizes the American steel industry.	Henry Ward Beecher delivers his eight "Sermons on Evolution" from May 31 to July 5, 1885, carried in newspapers and offering a Protestant truce between the Bible and Darwinism.
1886 Leading Georgia newspaper editor declares rise of "the New South."	On October 8, 1893, outside the Columbian Exposition in Chicago, Dwight Moody preaches his "Fire Sermon," giving modern urban evangelism its rationale for immediate conversions.

Historical Events	Sermon Events
	Baptist theologian Walter Rauschenbusch's "The Church and Money Power," delivered in Augusta, Georgia, gives a Social Gospel critique of capitalism amid the stock market Panic of 1893.
1896 Supreme Court upholds the segregation doctrine of "separate but equal."	
1898 Spanish-American War.	John R. Mott preaches "The Obligation of This Generation to Evangelize the World" to a Carnegie Hall missions convention on April 28, 1900, a time of American imperialism.
1901 Theodore Roosevelt becomes president.	
1912 Woodrow Wilson elected president.	
1915 Sinking of the *Lusitania*.	
1917 United States enters First World War.	For a decade before Prohibition in 1919, evangelist Billy Sunday tours America with his famous "booze sermon," helping Prohibition forces win dry states.

Episcopalian Randolph McKim's "America Summoned to Holy War" delivered in Washington, D.C., during Easter 1917 makes entry into the First World War a crusade, starting a reliance of U.S. sermons on government propaganda.

Fundamentalist leader William B. Riley preaches "The Great Divide" sermon in Philadelphia on May 25, 1919, launching a combative conservative religious movement. |
| 1920 Nineteenth Amendment gives women the vote. | |

Historical Events	Sermon Events
1922 America's first radio station broadcasts.	Liberal Protestants rally around Harry Emerson Fosdick's May 21, 1922, sermon, "Shall the Fundamentalists Win?," keeping control of denominations and creating "mainline" Protestantism.
1925 Calvin Coolidge inaugurated president.	Nationwide radio carries William Jennings Bryan's defense of the Bible at the Scopes "Monkey Trial" on July 20, 1925, at Dayton, Tennessee, a cultural setback for Bible conservatives.
	In 1926 during the failed "Battle of Detroit" to unionize Ford Motor Company, pastor Reinhold Niebuhr gains a national reputation preaching against Henry Ford's profiteering.
1927 Charles Lindbergh flies solo across the Atlantic.	
1929 "Black Thursday" stock market crash starts Great Depression.	Pentecostal Aimee Semple McPherson preaches her autobiographical rags-to-riches "Milkpail to Pulpit" at Angelus Temple in Los Angeles during the Great Depression, which begins in 1929.
1932 Roosevelt elected president.	Detroit's Catholic "radio priest" Charles Coughlin in 1932 begins his "Christianity and Americanism" sermons, soon attacking President Roosevelt and inventing the radio demagogue.
1939 War breaks out in Europe.	In New York City, Reinhold Niebuhr's "Beyond Tragedy" sermons advance a pessimistic doctrine of social sin, justifying the morality of power and force as war begins in Europe in 1939.
1941 Japan attacks Pearl Harbor and United States enters war.	

Historical Events	Sermon Events
1945 Atom bomb dropped on Hiroshima, ending war.	Oral Roberts launches the modern faith-healing movement, soon to change broadcast media and politics, with his 1947 sermon in Enid, Oklahoma, "If You Need Healing."
1948 Harry Truman reelected president.	Billy Graham rises to national fame on his summer 1949 Los Angeles crusade sermons warning of "judgment day" as the Cold War heightens with news of a Soviet nuclear test.
1950 Korean War and rise of Senator Joseph McCarthy.	Catholic bishop Fulton J. Sheen's TV show, named after his 1951 sermon "Life Is Worth Living," preaches anticommunism, wins an Emmy Award, and becomes history's most popular televised religious show.
1952 Eisenhower elected president.	The "positive thinking" preaching of Norman Vincent Peale leads to a 1952–55 bestselling book, creating a new ethic of success and "church growth" in conventional churches.
1954 Television reaches half of American homes.	Martin Luther King Jr. leads the civil rights movement after his December 5, 1955, "Sermon at Holt Street Baptist Church" starts a successful Montgomery, Alabama, bus boycott.
1957 Federal troops desegregate Little Rock High School.	
1960 Kennedy elected president.	
1961 Rise of the Berlin Wall.	The Supreme Court's 1962–63 rulings against organized prayer and Bible reading in public schools divides American pulpits, as school prayer becomes a sermon topic and a political cause. Martin Luther King Jr.'s "I Have a Dream" speech at the August 28, 1963, march on Washington, D.C., introduces black oratory to America by way of television, an important cultural shift.

Timelines

Historical Events	Sermon Events
1964 Gulf of Tonkin incident begins U.S. entry into Vietnam conflict.	
1965 Voting Rights Act for blacks.	In Lynchburg, Virginia, in 1965 Baptist minister Jerry Falwell preaches "Ministers and Marches," in which he says that clergy should not agitate in politics but focus on saving souls.

At Yale University in 1967 William Sloane Coffin delivers a November 5 "Reformation Day" antidraft sermon, giving religious impetus to a student antiwar movement. |
1969 Apollo 11 moon landing.	Jesuit priest Daniel Berrigan flees the FBI in 1970 after illegal anti–Vietnam war protests and delivers an "underground sermon" August 2 at Germantown, Pennsylvania, before his capture.
1974 Richard Nixon resigns presidency.	
1980 Ronald Reagan elected president.	On August 21, 1980, evangelist James Robison preaches to 2,500 pastors in Dallas and privately advises candidate Ronald Reagan to tell them, "I know you can't endorse me, but . . . I endorse you."
1991–92 First Gulf War.	The Oklahoma City bombing on April 19, 1995, and attacks of September 11, 2001, turn Billy Graham, "America's Pastor," to interpreting terrorism for the nation: he preaches that evil is a mystery, God is sovereign, and America needs revival.
2003 War in Iraq.	

Of Words and Nations

THE PURITAN FOUNDER JOHN WINTHROP PREACHED ABOUT "A city upon a hill," Abraham Lincoln's two greatest speeches have been called "sermons on the mount," and Martin Luther King's "I Have a Dream" oration is nothing if not a sermon. It is not hard to feel that the sermon has changed the course of American history. This book aims to put flesh and bone on that intuition.

The sermon, a stream of words transporting ideas, has woven itself into four hundred years of national life. Words are just that, but even the nebulous power of rehetoric sets entire societies on their courses. Words can rally sentiments and peoples and alter the course of events. Some would say that America is a material thing, while others might define it as an idea or an experiment. Whichever description is truest, religious oratory has played a significant role in making America what it is today.

The sermon has been best known across the American generations as an event that takes place inside the sanctuary. These have been the "saving sermons" of so many Sabbath worship services, and in Christian parlance they hinge on the art of "homiletics," or preaching a divine word from a sacred scripture. But the sermon also has left the sanctuary and shown its impact on public life. As early as 1749, Benjamin Franklin spoke of the necessity and usefulness of colonial America's "publick religion," a general atmosphere contributed to by all the American sects. More recently, this public faith has

been called a "civil religion," seen in presidential inaugurals in particular, or identified as a "civil piety," which is a religious rhetoric shared by church and state along the borderland that separates them as two kinds of powers.[1]

Either way, the sermon has contributed significantly to this general religious personality—oftentimes nebulous and atmospheric—of American culture. If the countless saving sermons make up a foundation, much as millions of tiny animalcules create an ocean reef, the public and historical sermons have erected the temple of civil religion. The nation's historical sermons have come at the great turning points in American history. They have been central participants in the nation's great moral debates, and they will be the focus of this book.

The sermon has found its quarry in the Bible, and that explains much about America's founding assumptions. Three biblical themes, though present in the ancient classical world and in the Enlightenment, were fundamental to how America interpreted its existence under God. The first of these is America as a chosen people, a "new Israel" on an "errand in the wilderness." As this story will show, such religious beliefs eventually took on a secular character, as when Providence becomes a "manifest destiny" or "national interest." Religious rhetoric gave America two other biblical themes: liberty and order. They have become important secular values, but much of their rhetorical power comes from the American sermon's use of scripture. In the Hebrew Bible, Jehovah liberates the Israelites. In the New Testament, Jesus gives "liberty" in the spirit. But the Bible also demands order and sometimes the suppression of freedom for the sake of discipline or harmony. Thanks to the sermon, Americans have used countless biblical texts to claim their utter liberty on the one hand, and to demand conformity on the other.

The American sermon has also been shaped by its audiences, which have changed, migrated, and shifted over four centuries. In American history the primary audience has been Protestant, so that is the predominant story in these pages. Catholic and Jewish sermons also have played a role, and in that order of importance. Social and economic class have defined the American audiences as well. Some are highbrow in tastes, and others lowbrow. Every racial, geographic, and ethnic group has shown its preferences when it comes to the content and delivery of the sermon.

Finally, the story of the American sermon is one of great public speaking. With roots in the biblical and classic worlds, the English-language sermon found an unprecedented laboratory for experiments in America. It experimented in fields, colleges, frontier towns, and great urban pulpits. The original Puritan sermon sought to turn a text into a doctrine, argument,

and application. But in time the American sermon took on a wide variety of goals, and for each one a new oratorical style was burnished.

The sermon turned America into a land of many rhetorical accents. The net effect, though—as Franklin suggested in his "publick religion"—was a national quest to be a chosen people, balancing liberty and order, and honoring God and scripture. The main change since Franklin's day has been the relationship of church and state in this quest. At first, church and state were generally united, and that lasted in some states for a short while after the American Revolution. Down to the present, church and state inexorably have parted ways. Modern technology has given the sermon its widest and swiftest reach in American history. But like never before, it has lost much of its role in secular society and can seem sequestered in the sanctuary.

Still, the sermon resonates, as the following pages will show. Religious oratory continues to participate in great public events, negotiating the delicate boundary between religion and government, faith and culture. This book will conclude with a brief reflection on four themes of that borderland, ideas contained deep within four centuries of American sermons and now important parts of the national psyche: the ideas of chosenness, comfort, challenge, and the battle between good and evil.

There are many ways to think about America: a Puritan project, a constitutional model, a marketplace, or the refuge of immigrants. To the extent that America is an idea, and owes its shape to generations of religious rhetoric, the heritage of the sermon tells that national story like no other chronicle.

I

The Colonial Period

(1607–1800)

How the ancient world, through England, gave America the sermon, so that it could be a "city upon a hill" and a new Israel with a covenant. How the Bible and sermon styles crossed the Atlantic, dissenters arose, and America had prophets that spoke like Jeremiah. How settlers warred with Indians, feared witches, and pleaded to Providence. How rational faith vied with "heart" religion, and great pulpits preached "horrors." How churches organized society and a theatrical preacher, George Whitefield, was famous before George Washington. How Puritan sin gave way to Benjamin Franklin's "do-goodism," and how Calvinists battled Arminians over grace and free will. How "liberty" in Christ became liberty from England, belief in foreign

conspiracies arose, and Antichrists were espied abroad. How sermons created mobs and rebellion divided pulpits, and how patriots put God on their side. How the Enlightenment and the Bible briefly united, and Jews and Catholics got their voice. How the Constitution left out "slavery" and "God" but designed a system of liberty and order. How Federalists and Democrats were born. How "infidels" threatened a new Israel and Jefferson's election was a second revolution.

CHAPTER ONE

Robert Hunt's Library

The Sermon Comes to America

R OBERT HUNT LOOKED OVER THE BOW OF THE CREAKING *Susan Constant*. The masts and ropes crackled as its sails caught a wind up the wide James River in a land called Virginia. Hunt had survived sea-sickness and scurvy on the open ocean in the great oaken ship, typical of its kind in 1607, and now he relished the bright spring morning, which revealed a landscape of dogwoods and redbuds in bloom.

At age thirty-eight, Hunt had left a wife, children, and country church in England to make the Atlantic crossing. Soon after landing, he became the first Anglican minister to give a sermon in Jamestown, England's only permanent outpost on American shores. He had his health, his faith, and his library of religious books intact. The tribulations were finally over, or so it seemed. The *Susan Constant* and two other ships dropped anchor by a wooded prominence, easy to defend on all sides. Now the task of the roughly one hundred men and boys, a quarrelsome group already, was to colonize these woods and waterways for God and for King James I. They were there to bring wealth to the nation and convert the Indians to Christianity.

Hunt's first mission was to establish an English pattern of church worship. He began the day they landed by conducting a service under a sail strung in

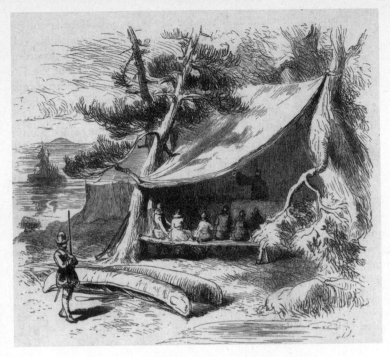

The first preaching at Jamestown took place under
a sail strung in the treetops.

the treetops. His pulpit was a pole lashed between two trees, and on this he
laid his *Book of Common Prayer,* which prescribed two sermons on Sunday
and prayers twice a day. That first sermon is lost to history, but it is likely that
Hunt, trained at university, had Puritan leanings in the Church of England
and may have preached in their simpler style.

The short spring and humid summer gave way to winter, and then came
the first cycles of disease and starvation. Eight months after the landing, a fire
destroyed the settlement. In the ashes lay Hunt's library, the first American
repository of resources—Hebrew, Greek, Roman, and Christian—that pro-
duced the sermon. In fire and ash, Hunt's library christened the New World
soil. Only a third of the original settlers survived the first year. Hunt was dead
before he could begin his second year of preaching in the Virginia wilder-
ness. "Our good pastor," as Captain John Smith called him, dissolved into the
marshy riverbanks along with his library.

Jamestown holds a pride of place in America's founding. But like other
early settlements, it was a transient affair. The English cultures that shaped

colonial America were still to come. Before then, the Roman Catholic empires of Spain, France, and Portugal also sought a foothold in America. The late sixteenth century, thanks to the Protestant and Catholic reformations, was a golden age of preaching. It was expressed in men like Hunt, but also in the Catholic friars who pioneered New Mexico and Quebec.

By the time Hunt died, a wagon train of Spanish soldiers, colonists, and Franciscan friars had trudged north into the uncharted domain called New Mexico. They named their destination Santa Fe, where two rivers met in a high plateau ringed by mountains. Most of the friars were callow but rugged young men. The Catholic reformation had decreed that they learn to preach, attend seminary if possible, and carry new handbooks with sample sermons.

The French empire landed elsewhere, at a sharp turn in the frigid St. Lawrence River, and from the fort city of Quebec the royal mandate to "increase" Catholic dominions began. In those early days both Huguenot, or French Protestant, and Catholic ministers arrived, but only Catholicism had a mission. Quebec became the springboard for Franciscans and Jesuits to carry the faith along the Great Lakes to the Mississippi River and down to the delta, to be called New Orleans.

European politics dictated the pattern of settlement as well as what kinds of sermons sank roots in America. Once England had defeated the Spanish Armada, for example, it was free to attempt commercial ventures such as Jamestown. As part of the spoils of the war between England and the Netherlands, the Dutch settlement of New Amsterdam became New York. This opened the way for a century of warfare between England and France, the outcome of which gave the American colonies their boundaries. Through it all, the English sermon prevailed under English dominance.

All the New World empires were Christian, however, and the library of Robert Hunt reflected that basic heritage. Having studied Hebrew, Greek, and Latin, Hunt was exposed to all the ancient works on preaching. He saw that the Old Testament orators, more prophets than preachers, nevertheless remarked on how "pleasant speech increases persuasiveness" (Proverbs 16:21). When Moses shrank back because he stammered, the Lord assured him, "I will be with your mouth and teach you what you shall speak" (Exodus 4:12). The New Testament preacher also believed that divine inspiration would come. "Say whatever is given you in that hour, for it is not you who speak but the Holy Spirit," Jesus told his disciples (Mark 13:11).

Early Christianity, moreover, borrowed heavily from the rhetorical tools of the Greco-Roman world, finally illustrated by the life of St. Augustine, who was not the only pagan professor of Latin rhetoric to convert to Christianity.

Hunt's library may have contained Augustine's fifth-century work *On Christian Learning,* a synthesis of Christian preaching and classical oratory. The ancients had developed rhetoric to persuade in courts and legislatures and at ceremonies. It was an art for Everyman. But the philosophers, from Plato (in *Gorgias* and *Phaedrus*) to Aristotle (in *Rhetoric*), explained why rhetoric worked. The Roman statesman Cicero summed it up best in *On Invention* and *On the Orator,* works that Christians imitated for centuries.[1]

Cicero said the duty of the orator was to prove, delight, and stir, depending on the circumstances. Plain speaking could prove. A middle style pleased the ears. But grand oratory was necessary to fire audience passions. As Hunt would learn, Cicero provided a checklist for speaker preparation. Once the speaker "invents" a topic, he must arrange it, pick an oratorical style, memorize the material, and then commence delivery. The "arrangement," or *dispositio,* of a sermon was key and fueled centuries of Christian debate. Again, Cicero's common sense shone through. The ideal arrangement was an attention-getting opening, narration of the topic, proof of its argument, and an epilogue to summarize and stir the audience.

Cicero's canon was handed down. In the first century, when the Christian gospels were written, the Roman rhetor Quintilian distilled Cicero into *The Education of the Orator* and Augustine in turn applied Quintilian to Christian rhetoric a few centuries later. Now the "inventions" were Bible texts and Christian doctrines, from sin and faith to divine love and the Trinity. In thousands of sermons, Augustine interpreted Bible texts as "signs"—symbols and allegories about spiritual truths. "My own sermon nearly always displeases me," he said. Nevertheless, generations of preachers studied him, and no doubt Robert Hunt did as well.

Long before Hunt made his American landfall, the English church had gathered up all the existing wisdom of preaching, worship, and ritual in the *Book of Common Prayer* (1549). Many of the pioneer clergy, however, had come under the influence of "puritanism," a movement to simplify worship and purify governance in English Protestantism. In addition to the *Book of Common Prayer,* Hunt may have carried to America the compact, Puritan-approved Geneva Bible (1560), the first to have numbered verses.

He also had two styles of preaching to choose from. One was more ornate, echoing the prayer book. The other was the "plain style," a Puritan creation, put down in *The Arte of Prophesying.* That theological work, written by William Perkins, a leading English Puritan, laid out the four-part plan for a true sermon.

1. To read the Text distinctly out of the canonicall Scripture;

2. To give the sense and understanding of it being read by the Scripture itself;

3. To collect a few and profitable points of doctrine out of the naturall sense;

4. To applie (if he have the gift) the doctrine rightly collected to the manners of men in a simple and plain speech.[2]

This format would influence American rhetoric for a century or more. The title of Perkins's work, in fact, prophesied the perennial debate in American religious oratory: was the sermon an "arte," as in formal rhetoric, or a "prophesying," in which the speaker claims an ecstatic connection to God?

For Perkins and his legacy, which has been called Puritan scholasticism, the "plain-style" preacher assumed that the Bible texts revealed themselves plainly, literally, and factually. Therefore, the preacher's role simply was to give the text, explain its clear doctrine, and provide an "application" for life. The plain sermon was an extremely logical affair, famous for its divisions and subdivisions. It was perhaps Europe's most extreme version of the Reformation slogan, *sola scriptura,* or scripture alone.

In the end, Jamestown failed as a commercial venture. While it lasted, clergy came and went. Church attendance was required, and slackers were punished. The mission to Christianize the Indians was made a selling point to investors in London. The settlement was a "new Jerusalem," despite its population of roughneck men and boys. To the colony's credit, in 1619 it convened the first legislative General Assembly in America. Still, neither investors nor the crown was impressed. So in 1624 the London Company was dissolved, and the burial grounds of Hunt and his library became a royal backwater for the next two decades.

Jamestown had been named for King James I, who came to the throne from Scotland after the death in 1603 of his distant relative, Queen Elizabeth. Thanks to James, faraway New England would also be colonized, but with far greater permanence than the early exploits in Virginia.

In Scotland, James had been reared amid the harsh Protestant Reformation driven by Calvinists, followers of the French theologian John Calvin who chose a "presbyterian"—rule by ordained men—form of government. James did not like fanatical Calvinism. Like Elizabeth, he sought a *via media,* or middle way, for English Christianity after it broke with the Church of

King James I, who met the Indian princess Pocahontas, shaped
American oratory with his new Bible and colonial exploits.

Rome. Though a Protestant king, James did not like the purifying "separat-
ists" who opposed his court, state, and church. A separatist was an extreme
Puritan. He was a stubborn Englishman who would not declare loyalty to
the Church of England, which a moderate Puritan certainly would. The
separatists made a point of denouncing the remnants of popery still seen in
English Christianity.

For American history, a cell of separatists on the Scrooby estate in east
England became significant. To escape prison or worse, these self-named
"pilgrims" fled for tolerant Holland, and then came back, hoping to book an
oceangoing passage to Virginia. Their contract ship headed for just north of
the Hudson River, but the ill-guided voyage hit land at Cape Cod in 1620.
Like Jamestown, the Plymouth Colony has a storied pride of place in Ameri-
can beginnings. They did indeed set foot on a shoreline "rock," giving the
Pilgrims at Plymouth Rock to history.

But for the cultural formation of America, and the transfer of the sermon,
the substantial vehicle was a later event—the "Great Migration" to found
Massachusetts Bay Colony in 1630. By then, the court of King James had
two relatively new things to offer the New World plantations. One was the
"witty" sermon, and the other the King James Bible. Both of them, in dif-

ferent degrees, washed up on American shores, as if part of Shakespeare's contemporaneous play about a foundering plantation voyage, *The Tempest.*

When James needed to suppress the separatists, he turned to the leading men of his church, one of whom was Lancelot Andrewes, a biblical scholar. An arm of the royal state, Andrewes also was the greatest preacher and linguist of his day. His sermon style came to be called metaphysical, for its rich play on language. He dissected words, rhymed them, and built entire sermons on a syllable. The poet John Donne, a preacher as well, brought the metaphysical style to high polish. It was the *sermon du jour* in the court of James I, and in some degree was carried to colonial outposts, especially those where a royal governor liked pomp, velvets, processions, and rituals at worship. The style may have cropped up in Virginia, but probably not in New England.

One Christmas season at James's court, Andrewes displayed the verve of this witty oratory. He preached on the birth of Jesus.

> For if this Child be "Immanuel, God with us," then without this Child, this Immanuel, we be without God. "Without Him in this world," (Eph. ii. 12), saith the Apostle; and if without Him in this, without Him in the next; and if without Him there—if it be not Immanu-el, it will be Immanu-hell; and that and no other place will fall, I fear me, to our share. Without Him, this we are. What with Him? Why, if we have Him, and God by Him, we need no more; Immanu-el and Immanu-all.[3]

Such clever wordplay grated on Puritan ears, and if Latin were quoted, it brought Puritan blood to a higher boil still. By being opposites, however, the metaphysical and plain styles created a fertile tension for English oratory. A middle path would be found, but that was well after James began to set the Bible's English into new lexical channels. When he rode down from Scotland in 1603, Puritans had appealed to the red-haired and theology-minded James for a new Bible. Although James was not for Calvinist stringency, he did want to shape a Christian scripture that supported national unity and the divine right of his throne. He set Andrewes to the task. Between 1604 and 1611, the great linguist and his scholars produced the Authorized Version of the Old and New Testaments. The translation was not metaphysical. But it was majestic, beautiful, and even witty in wordplay.

Foremost, the Authorized Version supported kinghood and nationhood. The Geneva Bible used the word *tyrant,* but the King James Bible put that aside for *king* and *ruler.* The older Latin Bibles, struggling to find an

equivalent for Hebrew and Greek concepts of tribes, peoples, and empires, came up with the term *natio* one hundred times. The term *nation,* in a five-fold increase, had 454 uses in the King James Bible.[4]

During the civil wars after James's death, Puritan armies carried the Geneva Bible and royalists, or Cavaliers, the Authorized Version. In America, English Protestants would not come to blows over Bibles. But after two generations, when America sought to be a biblical "nation" on the model of Israel, the sermon drew upon the King James Bible as the favorite source of scripture. New England became the most literate region in the world. Its citizens believed that God had spoken in the cadence of Lancelot Andrewes and his team of Shakespearean-era editors.

For the English sermon styles to spread, they needed an English audience. The Spanish, French, and Dutch cultures had tried to make North America in their images, theologically and linguistically. Although some remnants remained, it was English culture that overwhelmingly claimed American soil, creating the audience for the early sermon. That audience was formed by four great cultural migrations from England.[5]

The "Great Migration" to Massachusetts Bay Colony was the first, lasting for a decade until 1640, when the English Civil War ended Puritan motivations to cross the Atlantic. The Puritans stayed in England to oust the king and create a Protestant commonwealth. Under Oliver Cromwell, they took control of England for a decade.

During the war, the Puritan Parliament not only beheaded the Catholic-leaning Charles I, son of James, but also his archbishop, William Laud. A chief political adviser, and a persecutor of Puritans, Laud was also a great preacher. He too had adopted metaphysical oratory with great relish, as finally illustrated in 1645, when he preached his own execution sermon on the creaking wooden scaffolding. In metaphysical style, he played on the word *red*. There was first the Red Sea crossed by Moses, and then the red communion wine of the church. After his sermon, mainly a political protest of innocence, it was his own red blood that spilled from his severed neck.

> That this Cup of red Wine might pass away from me, but since it is not that my will may, his will be done; and I shall most willingly drink of this cup as deep as he pleases, and enter into this Sea, aye and pass through it.[6]

Now that the Great Migration of Puritans to New England had basically dried up, the tables had turned, and the supporters of King Charles I and

Archbishop Laud needed a refuge. These royalists and Cavaliers began to beat a path out of southern England, their stronghold, to the Chesapeake Bay region, especially Virginia. The royalist William Berkeley, for nearly half a century the royal governor of Virginia, offered them a haven. By Berkeley's efforts, an entire royalist English class was transported to America. They transplanted an entire new society, far beyond Jamestown's ragged precedents. This included "high church" Anglican culture and a stratified social order, with manorial lords at the top and serfs at the bottom. Its plantation system stayed in place for generations. When the white indentured servants moved on, African slaves replaced them, and the Christian order continued unabated. It was a *via media* of wealth, manly honor, good taste, and official religion—an important audience for one type of sermon in America.

A different English culture planted itself around the Delaware River, scene of the middle colonies and their hub city, Philadelphia. In about 1675, the Quakers began to leave the British midlands for America. An enthusiast sect, the Quakers were thrown in prison in England for "quaking." Following the teachings of George Fox, they insisted that God spoke to each man and woman by an "inner light." Opposed by both Puritans and Cavaliers, they ended up having a chapter in the era's *Book of Martyrs*. Fox preached in tolerant Maryland in 1671, and soon his frugal, egalitarian, and industrious followers began to arrive up the Delaware River. Under the "holy experiment" of Quaker gentleman William Penn in Pennsylvania, Quakers carved out a region of tolerance, bringing European sects and their sermon styles to America in droves.

In 1717 the Quakers began to see a new kind of immigrant walking the streets of Philadelphia. The men were hard and tall, their features sharp and gaunt, while the women were shockingly loose. The largest migration of all was about to begin, and it was made up of the English, Irish, and Scots who lived around the north British borderlands. Hard by the Irish Sea, it was a land of rugged terrain, constant wars, and glorious warlords upholding their honor and customs. Over the next half century, a quarter million of them poured into the middle colonies, moved to the back country along the Appalachian Mountains, and then spread south and west. They created the core western populations of New Jersey, Pennsylvania, Maryland, Virginia, and the Carolinas, and a new audience for the sermon.

By sect, they were mostly Presbyterian, but also Anglican, nonconformist, and even Catholic. Either way, theirs was a militant Christianity that suited their homeland culture. They liked charismatic leaders with military prowess. They preferred long-winded, exuberant preachers, and they brought to

America outdoor religious festivals, the "big meetings," "feasts of fat things," and "love feasts" that were both bawdy and religious. They would create a future American audience called the camp meeting.

Of the four migrations—Puritan, Cavalier, Quaker, and borderland—New England put the strongest stamp on the early American mind. It created the fabled Yankee, the honest, independent merchant. And New England also gave America one of its lasting theological concepts, the idea of the covenant. It was an idea that ran through both the Pilgrim flight in 1620 and the Great Migration a decade later. These two Puritan journeys, one covert and separatist, the other quite open and dominantly commercial, began with the idea of a covenant with God and among a band of people. They struggled to understand what it meant. They thrashed it out in sermon after sermon. In time, the covenant was ingrained in American thinking, almost as if burned into all future heredity of the nation.

It began with the 101 Pilgrim separatists whose single ship arrived in the winter of 1620 and anchored for months beyond the shallow Plymouth Bay. Besides weather, the Pilgrims faced another practical problem: their navigation had gone wrong. They were not at the Hudson River but had been blown north to Cape Cod. With their English charter null and void, they needed to write up a new form of government.

Under such duress, William Bradford, the governor of the Pilgrim group, gathered his band to write a covenanting document, the Mayflower Compact. It was signed November 11, 1620, and it said they would "in the presence of God and one of another, Covenant and Combine ourselves together in a civil Body Politick." When the scouting party finally found a hillside spring, the surviving Pilgrims went ashore, carrying their covenant and small Geneva Bibles with them.

If Robert Hunt's library had brought to America the heritage of the sermon, the tenuous Puritan foothold carried over the covenant, a political and theological idea that now would be tested on rocky New England soil.

The Three Covenants

Preaching on Order and Liberty

T EN SHIPS WITH A THOUSAND PURITANS LEFT SOUTHAMPTON, England, in April of 1630. Four of them departed first, a kind of spearhead across the Atlantic to New England. Of these, the *Arbella* was the flagship, and its spiritual and political leader was a Puritan lawyer named John Winthrop.

Winthrop's departure for Massachusetts Bay was bittersweet. Like many other Puritans, he was a man of means with a lovely estate. But once again, in 1629, Charles I had abolished Parliament. A true Puritan reform in England now seemed impossible, and Winthrop and his London friends faced a difficult choice. Should they stay in England, keeping their wealth but losing their religious freedoms? Or should they leave for America, waiting for a better day? They finally joined in buying an old charter for settlement north of Virginia. Along with the investors, they renamed the exploit the Massachusetts Bay Company.

In a stroke of luck, royal approval came a week before Parliament's closure, and the king's bureaucracy bungled as well. It did not designate where the company "governors" would meet. Based on this loophole, the Massachusetts company governed itself from Boston for the next fifty-five years, avoiding

royal meddling. In contrast, the Virginia Company had not been so lucky. It was shut down in 1624 and operated under royal military control for the next 150 years.

A few days before Winthrop's flagship set sail, the bands of Puritans—families and artisans all—declared loyalty to the Church of England, "our deare Mother." They were not acrimonious separatists, but saddened expatriates. They parted with "teares in our eyes." John Cotton, a leading Puritan theologian, traveled to Southampton to preach on why the Bible justified such a drastic departure. Winthrop also gave a sermon, but it is not clear when and where, for in all the voluminous records, no one mentioned it. Today, "A Model of Christian Charity" is known by only one surviving copy, written in a hand that is not Winthrop's.[1]

Winthrop's sermon, however, has dilated into a manifesto of America's founding. He could have delivered it before, during, or after the *Arbella* voyage, but popular imagery likes to see him straddling the great, swaying *Arbella* deck, speaking into the ocean spray. His painted portrait, showing an oval-faced man with brown eyes and black hair, impresses us today as much as his speech on charity. At the time, however, his sermon was not worth remembering. It was the ordinary thing preached among Puritans. Winthrop had simply turned a tried-and-true Puritan message into marching orders for the

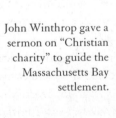

John Winthrop gave a sermon on "Christian charity" to guide the Massachusetts Bay settlement.

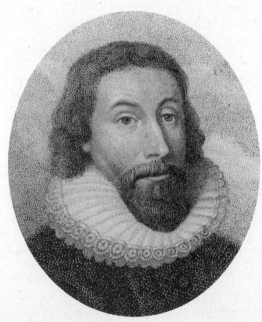

Massachusetts settlement, ever mindful of the political implications of their project. If this group of one thousand lived a Puritan life, based on a "due forme of government both civil and ecclesiasticall," their example might fly back to troubled Puritan England.[2]

> For wee must Consider that wee shall be as a Citty upon a Hill, the eies of all people are upon us; soe that if wee shall deale falsely with our god In this worke wee have undertaken and soe cause him to withdrawe his present help from us, wee shall be made a story and a by-word through the world, wee shall open the mouthes of enemies to speake evill of the wayes of god and all professours for Gods sake.

Winthrop knew that both friends and critics in England would be watching the Bay Colony. If it succeeded, it might be an inspiration to sullen Puritans back in England. They might renew their efforts at reform, and if that began to succeed again, Winthrop and his following could return to England's green pastures. Whatever the future held, Winthrop wanted his sermon of the moment to portray the ideal Puritan life. It was a way of life that worked under a "special overruling providence" and had "entered into Covenant with him for this work." They were like Israel, for God would "dwell among us, as his owne people." And so it was to be in Massachusetts.

Otherwise, the sermon urged contentment with social rank. The settlers were rich and poor, masters and servants, learned and ignorant. But they would work together in "Christian charity," which meant love, not almsgiving. They would be ruled by "common consent" and guided by "two rules," justice and mercy, one found in God's laws of nature and the other in grace. The colony would observe the Ten Commandments and their elaboration. By succeeding, the settlers and their posterity would be free "to serve the Lord and worke out our Salvacion under the power and purity of his holy Ordinances."

This was the "social covenant" that shaped New England. It was standard Puritan political belief, and it began to be applied on the morning of June 12, 1630, when the first four ships set anchor off Salem. Once inside Massachusetts Bay, the ships docked on its northern shore, now Charlestown, but soon crossed over to today's Boston. The *Arbella* anchored at a spot now occupied by Faneuil Hall, for Boston became a city of landfills. The nearest high ground became the Puritan graveyard, and in that hilltop cemetery, later the site of King's Chapel, the remains of Winthrop still rest.

As Winthrop knew well, there was more to the covenant than just its social aspect. But it would take a theologian to explain that to the ten thousand

Puritans who came over in the next decade. Fortunately, the great theologian John Cotton was on his way to America. He could teach not just the covenant but its three interlocking parts. It was the deepest theology of the Puritan sermon. The "tripartite Covenant," as Cotton would preach, included the covenants of grace, church, and civil rule. Before long, such preaching opened a fault line in New England's "city upon a hill," for the Puritans struggled over whether "grace" or "works" was the key to a godly society.

In England, there were few people so well educated as Cotton, a don at Cambridge. As a Church of England minister, Cotton was famed for his metaphysical, or "witty," sermons. Then he had a conversion. One day he preached in the plain style, signaling where he stood: he was a Puritan. A small scandal ensued, so Cotton left for the east coast, moving to Boston in Lincolnshire. There he served a Puritan congregation at St. Botolph's parish for twenty years, reverting all he did to Puritan canons—no ritual or vestments, and the four-part plain-style sermon straight out of *The Arte of Prophesying*.

Fortunately, Cotton had a lenient bishop who let him be. But in about 1632, as the High Commission in London began to investigate errant clergy, Cotton started making plans to leave for America. He was not the only famous preacher on the run, for the Cambridge-trained Thomas Hooker, just back from exile in Holland, was also trying to escape the royal police. Together, Cotton and Hooker donned disguises and headed south, catching the ship *Griffin* for Massachusetts. It was July 1633.

Their stories became a road map for early America. The famous Cotton was tapped as teaching minister at First Church in Boston, and many of his Lincolnshire acolytes followed him across the Atlantic. Hooker was called to be minister of a new church erected across the river at a "Newtowne," now called Cambridge. Cotton was forty-nine and Hooker forty-seven. After a few years of preaching on separate sides of the bay, the two men began to take the American colonies in two different directions.

Under Cotton's sway, American settlers were treated to a strict Calvinist doctrine of election, which was the very kernel of covenant theology. Election, which suited a sovereign God, was not always a happy doctrine to swallow, but there it was in the New Testament: "He hath chosen us in him before the foundation of the world" (Ephesians 1:4). Over time, as American theology sought a benign and democratic God, the doctrine of election came under heavy assault. But in their day, the Puritans coped with a stern Jehovah. Election offered a buffering hope. Election began with a covenantal relationship within the Godhead itself. There, the Father and Son made a covenant to elect some human beings for heaven and others for damnation.

It was eternal and irrevocable. Those predestined for heaven received a "covenant of grace," the heart of the matter. Based on this core group, two more covenants emanated, those of church and society.

In Puritan theology, church membership was restricted to the elect, who knew their election by an experience of grace. They became "visible saints," and were under the "church covenant." But everyone came under the next covenant, the "social covenant." By agreement with God, every citizen lived under social laws found in the Bible. It was an organic order of three circles: the elect at the center, the church around them, and society around the church. Ideally, the elect would be the governors, adopting godly laws for society. God took the social covenant seriously. If society sinned, judgment fell on the whole. Faced with such calamity, all of society had to repent.

Leaning over their Bibles, and in excruciating detail, the great Puritan theologians discovered all of this. They used scholastic categories and logic and, by discerning God's logic, found the rich order of grace, church, and society. Understanding the covenant was never easy, even for skilled theologians. It was shrouded in mystery and difficulty, beginning with deciding who had "grace." That is what ordinary believers struggled to know. It was the deepest kind of discernment, and it burned an introspective hole into the American mind. What was more, living up to the church and social covenants was hardly easy. Still, preachers such as Cotton explained these divine truths every Sunday. In 1636, after three years in Massachusetts, he was on his way to the Salem meetinghouse to do so again.[3]

Using a text from Jeremiah, Cotton wanted to show that God's covenant was everlasting. In plain style, he first laid out the exact doctrine: *"That the Church-Covenant . . . was a Perpetual Covenant."* If the Salem meetinghouse was like all others, it was an all-purpose affair, built of sturdy logs. The high pulpit was at the front, a wall-like box ascended by a side stair. Cotton, who was gaunt with large eyes, wore no beard and let his hair fall to his shoulders. At this moment of preaching, he might have leaned over the pulpit, his black robe swishing. "The Covenant of Grace doth make a People, a joyned People with God, and therefore a Church of God," he said. "And therefore you shall find that when the Lord Establishes Israel for a Church unto Himself, He maketh this Covenant."

In Cotton's theology, election was entirely "passive." God gave it with no human effort involved. A person could do nothing to obtain it, he preached. But once God delivers the gracious proof of election to a person, the deity will never change his mind, "will never repent" of giving it. As a corollary, Cotton always preached against trying to grab for grace. It could not be obtained by

good behavior or pious words, for that was a useless "Covenant of Works," he told the Salem congregation. "If you come to Christ by virtue of any thing which is in you, it is but a legal work."

The Cotton sermon, like so many others, ranged over the tripartive covenant. But the plain style, in its hyperrationality, also allowed for skeptical questions. Cotton asked them as part of the sermon, "*Qest. But how shall I know whether I have built upon an Everlasting Covenant, or not?*" This was the question on every listener's mind. Cotton said a person knows his eternal destiny in two steps. First, God *allows* him to feel remorse at sin, and then *gives* him a spirit of grace. It was entirely God's doing, both the depths of unmitigated guilt, and the moment of euphoric liberation.

> If the Lord do thus draw you by his Everlasting Arm, He will put a
> Spirit into you, that will cause you to wait [guilt] for Christ, and to
> wait for Him until He doth shew Mercy upon you; and if you may but
> find Mercy [euphoria] at the last, you will be quiet and content with it.

Nearly everyone in early New England, it is told, struggled with anguished introspection over election and damnation. A few went crazy waiting to receive a sign of grace. This Salem sermon contained not only the three covenants, but a description of a human psychology and experience that would run through American culture: guilt and euphoric liberation. Cotton inculcated America with a doctrine of experiential conversion, an idea hardly known in Reformation Europe, where baptism was quite enough.

During the decade-long Great Migration, Cotton was one of ninety Puritan ministers who made the Atlantic crossing. They all preached in the same plain meetinghouses, of which 220 were built in the 1600s. In the next century, nearly ten times that many went up. By the American Revolution, New England had more clergy per population than anywhere else, and these five generations of clergy delivered at least five million sermons. A churchgoer listened to seven thousand sermons in a lifetime.[4] They averaged two hours, though Cotton did some in thirty minutes. Perplexed farmers and merchants grappled with the covenant, and independent minds winked at these Calvinist complexities. But they all went along.

Most preaching came on Sundays, but another tradition developed as well: the sermon as a weekday lecture or oration for a public event. The Puritans had no holy days, such as Christmas. So the public sermon was delivered on fast, humiliation, and thanksgiving days, called by clergy and magistrates at any level. Everyone ceased work and headed to the meetinghouse. Public sermons made up a tenth of New England's total, and were commonly

printed. Published sermons outnumbered almanacs, newspapers, and political pamphlets by four to one. New England was the most literate society in the world. Most important, the public sermon—soon to enter the precincts of politics and war—shaped American public oratory.

Wherever Puritan theology was preached, it raised questions about a person's experience of grace. That was Cotton's favorite topic. But he soon realized that such a personal experience also could kindle political dissent. New England was still a tiny place. A single word of dissent in this world of the meetinghouse and sermon could shake all of Massachusetts. The shaking began with two new arrivals, Roger Williams and Anne Hutchinson, both enamored of the doctrine of grace.

The path beaten to New England by Cotton and Hooker had opened the way for others, including those equally interested in theology. Williams, the eventual founder of Rhode Island, was a young Cambridge-trained clergyman. Hutchinson, perhaps America's first female preacher, was a minister's daughter and member of Cotton's Lincolnshire congregation. Williams arrived in Boston in 1631, Hutchinson in 1634. Soon after, a preaching war over the covenants began, drawing such religious and political leaders as Cotton, Hooker, and Governor Winthrop into the widening fray of New England's first great rows over liberty and order.

From his student days at Cambridge, Williams knew how to argue. In the scholastic hairsplitting of Puritan theology, he had come out a purist and separatist, much like the Pilgrims who had fled to Plymouth. But when he arrived in nonseparatist Boston with his wife, Mary, on February 5, 1631, what church would not want the charismatic twenty-eight-year-old as minister? It was a difficult year in Massachusetts, hit by a harsh winter, and the Williamses had arrived on the emergency provisions ship *Lyon*.

Winthrop's job, however, was to keep order, and after an interview with Williams, he had his doubts about the young separatist. For Williams's part, he felt Winthrop was a compromiser on church affairs. Williams was quite ready to criticize civil officials for telling churches what to do and individuals what to believe. In effect, he had set the individual conscience, throne of the covenant of grace, on a collision course with the social covenant ruled by government. Winthrop was a Puritan, but one who had pledged loyalty to the Church of England. He performed a wise but delicate balancing act with England, and Williams seemed ready to upset that, stirring up London murmurs of treason in New England. Williams was not welcomed in Boston. So he and his wife crossed the bay to Salem, whose church was pressured by the General Court to send Williams on his way.

The hapless preacher went south to Plymouth, where he was called as a teacher in August 1631, and where "I spake on the Lord's day and week days, and wrought hard at the hoe for my bread."[5] Soon enough, Plymouth's Governor William Bradford found "strange opinions" in Williams's teachings, which emphasized the individual conscience, or "soul liberty," with all its dangerous political implications. His preaching split the Plymouth church, so Williams was sent packing, fortunately with mastery of some Indian dialect and warm relations with the tribes.

Back in Salem in the fall of 1633, Williams stirred a final showdown with the Standing Order. His preaching inspired the Salem magistrate to tear the Anglican cross off the militia flag. When Boston condemned this act, Williams's church learned the art of defiance, including letter-writing campaigns to outlying churches. Most of all, Boston was worried that London might crack down on treasonous rumblings in New England. Not only had Williams challenged the right of the civil government to enforce the first four of the Ten Commandments, which upheld one true God, opposed graven images, forbade the use of God's name in vain, and required Sabbath worship, he had declared that Europe was not Christian and that the king was probably the Antichrist. He said the crown had no right to steal Indian land, which some Puritan theologians felt was given to them by a special Providence, including the mystery of mass disease.

The Salem church finally elected Williams as minister in the summer of 1635. So the General Court, meeting in Boston, summoned him for a hearing on "erroneous and very dangerous" teachings. To Williams's argument, Cotton gave the official reply (*A Reply to Mr. Williams's Examination*), and then the court threatened to withhold a land grant to the Salem church if Williams was not dismissed. As the two sides hardened, the crown in England suspected disoloyalty among the colonists, so it required loyalty oaths from new immigrants.

In October 1635, the General Court demanded that Williams recant. He traveled to Boston for a verbal "dispute" with Hooker, who "could not reduce him from any of his errors."[6] So the court decreed Williams's banishment "out of this jurisdiction within six weeks." Back in Salem, Williams could no longer swing the church to his side. He agreed not to exhort, but he still talked. The court took this as rebellious advocacy. Before soldiers arrived, however, Williams had fled. He headed south to his friends the Indians, trudging through the snow until he reached Narragansett Bay. He bought a piece of land from the Indians, and he eventually called his settlement Providence.

Williams had been long gone, therefore, when Cotton traveled to Salem in 1636 to deliver the aforementioned sermon on the covenant of grace. But the argument with Williams was hardly over. In that same year, Cotton apparently wrote to Williams, defending the government's role in enforcing religion. The letter had historical consequences. When Williams traveled to England in 1643 to request a charter for Rhode Island, he used Cotton's letter as whipping boy for a manifesto on religious liberty, *The Bloudy Tenet of Persecution for Cause of Conscience*. Williams's oratory has not survived in print, but *Bloudy Tenet*—a rambling book dashed off in a few months, featuring Cotton's letter and a long dialogue between "Peace" and "Truth"—surely reflects his preaching. Williams opened with twelve points, which included the assertion that political regimes are

> not judges, governors, or defenders of the spiritual, or Christian, state
> and worship. [I]t is the will and command of God that, since the coming of his Son the Lord Jesus, a permission of the most paganish, Jewish, Turkish, or anti-Christian consciences and worships be granted
> to all men in all nations and countries, and they are only to be fought
> against with that sword which is only, in soul matters, able to conquer,
> to wit, the sword of God's Spirit, the word of God.[7]

Contrary to so many Puritan theologians, Williams viewed Israel as a "Spiritual Nation," not a civic kingdom, and so "God requires not a uniformity of religion." A Christian magistrate was no better or worse than a pagan magistrate. Merit depended on "serving for the good of the whole." His soul liberty set the stage for America's anti-institutional religion, and brooking no group conformity, his ideas slid rapidly to the left. His separatism was so great that he shared Christian communion only with his wife, and finally only himself. The individual conscience became ultimate. Thus, this orthodox Puritan became the stalking horse of freethinking in America, and his colony of Rhode Island the first haven of heretics, freethinkers, liberals, and skeptics.

In 1634, when Williams was back in Salem after his sojourn among the Plymouth farmers and Indians, a ship arrived in Boston carrying one of John Cotton's greatest admirers, Anne Hutchinson. She and her husband, William, had been members of St. Botolph's before leaving degenerate England for the true spiritual life in Massachusetts. All went well for the next two years. But soon after Williams had been cast out, Hutchinson was rumored to be the purveyor of a new chaos in New England.

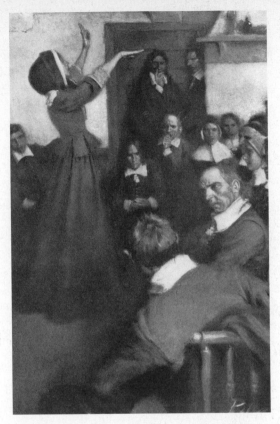

Anne Hutchinson preached a radical doctrine
of grace in her Boston home.

Her husband prospered as a merchant, and she became prominent as a midwife, and privately even a healer. They both were pillars of the Boston church. Hutchinson happened to be sister-in-law of the Puritan clergyman John Wheelwright, so he also made his way across the Atlantic. For a lifetime, Hutchinson's environs had sharpened her theological wits. By the spring of 1636, she was holding spiritual meetings in her home, first for women friends, and finally for husbands who tagged along. The gatherings would often draw sixty or eighty people, nearly the entire town, and the mixed company became quite the talk. Finally, the clergy caught wind of mild heresy. The battle between the first woman preacher in America and the Standing Order had begun.

As John Cotton had explicated in so many sermons, the great fault line in Puritan thought was between grace and works. Hutchinson admired

Cotton's stand for grace alone, or as he put it, God's power to "put a Spirit into you." As will be seen, the contrary view would be called *preparationism*, which suggested human effort as preparation to help God in the final act of grace. To Cotton this was wrong doctrine, and Hutchinson's brother-in-law, the Reverend Mr. Wheelwright, could not agree more. Indeed, when Wheelwright arrived in Massachusetts in October 1636, several months after Anne began her home meetings, he became a firebrand preacher of grace.

The Boston church was quite taken by the doctrine of grace. Its lay members wanted to call Wheelwright as an additional minister. The clergy and magistrates, having calmed the waters with Hutchinson by quiet discussion, now had Wheelwright, a loose cannon making a public scene. The church was dividing over radical grace, which was criticized as "antinomian"—a rejection of human law and order, especially as set by clergy and magistrates. To quell the tempest, one minister preached against division. Then, quite innocently, Cotton invited Wheelwright to preach on a fast day, igniting a new powder keg. Wheelwright declared that it was usually people without grace—papists, Pharisees, and pagans—who fasted. Such advocates of "works," he said with biblical relish, were subject to axing at the roots, slaying by the sword, or burning up like chaff.

> We must all of us prepare for battell and come out against enimyes of the Lord, and if we do not strive, those under a covenant of works will prevaile. . . . Brethren, those under a covenant of works, [the] more holy they are, the greater enimyes they are to Christ, Paul acknowledgeth as much in Galations [1] he saith he was zealous according to the Law and the more he went in a legall way, the more he persecuted the wayes of grace. . . . It maketh no matter how seemingly holy men be, according to the Law; if they do not know the worke of grace and ways of God, they are such as trust to their own righteousness, they shall dye sayth the Lord.[8]

Boston was thrown into a frenzy. The sermon put the religious legalists on the defensive and "stirred up the people against them with much bitterness and vehemency," as Winthrop recounts. Indeed, the grace partisans began storming Sunday meetinghouses to disrupt "works" sermons. They openly questioned clergy. Winthrop and the court acted quickly. They charged Wheelwright with sedition and ended immigration of "Hutchinsonians" into the colony, probably the first immigration restrictions in America. The court banned Anne Hutchinson's meetings. Then it stacked a judicial election to consolidate its members. But the crucial event still was to come. The

magistrates called a closed conference of the clergy and Hutchinson, at which Cotton was present. Behind closed doors, she made the fatal mistake of contrasting her favorite, Cotton, to other clergy: he "preaches the covenant of grace and you the covenant of works."[9] The insult had lasting consequences.

Only Cotton's stature protected Hutchinson over the next year, but suspicions deepened. The political order was being disrupted. So in November 1637 the court summoned her for a two-day inquiry. Throughout, it was hard to trip up a woman of such theological training. She handled the questions with agility: did she wrongly preach to men, did her meetings breed disorder, did she break the Fifth Commandment by dishonoring rulers, and did she promote faction? To charge Hutchinson with criticizing clergy, however, someone had to break confidence and give evidence from the confidential meeting that she and Cotton had attended. In desperation, all the ministers did.

Cotton defended Hutchinson, first by confessing his embarrassment at being compared favorably to his fellow clergy. What she had said in the meeting, he explained, was not "so ill taken" at the time as now, when public controversy had riled emotions. Unfortunately, Hutchinson felt emboldened by Cotton's defense. Her next words surprised even him. She testified that in her conversion experience in England, the "spirit" of God had led her to find a true minister, and indeed the truth itself. The court inquisitors were enthralled, especially court secretary Increase Nowell and the Deputy Governor, Thomas Dudley.

Nowell: How do you know that that was the spirit?

Hutchinson: How did Abraham know that it was God that bid him offer his son, being a breach of the sixth commandment?

Dudley: By an immediate voice.

Hutchinson: So to me by an immediate revelation.

Dudley: How! an immediate revelation.

Hutchinson: By the voice of his own spirit to my soul.[10]

It was a shock to all. Hutchinson had testified to having a new revelation. The court had its damning evidence. As Winthrop later recalled, "her own speeches have been ground enough for us to proceed upon." He acknowledged the "danger of her course among us." Cotton tried to find a way out. He said that there are two kinds of revelation, one miraculous and the other

a general providential revelation, a gift of many good Christians. Hutchinson claimed no more than that. But her accusers did not let go. By her revelation, they declared, she had put herself above not only the clergy and doctrine, but above the Bible itself. Mercifully, Cotton was not required to denounce Hutchinson, but he melted back. She was convicted and banished. Since it was November, she was given until spring.

To beat the winter, William Hutchinson, the children, and much of the dissenting Boston church moved to Providence. Anne came later, for she still faced a church trial. It was a time for clarity, so the clergy drafted a list of one hundred heresies abroad in New England. She was tried at a much-thinned Boston church at which Cotton admonished her for proclaiming false doctrines. She not only had claimed union with Christ but had questioned immortality and the bodily resurrection. She had "made a Lye" and so was excommunicated. Banished from the church and social covenants, she still had her claim to grace. She joined her husband William, who died two years later, then took her seven youngest children to the wilderness of Long Island, where she and all but one child were killed in Indian uprisings. In all, six of her fourteen children survived her, and the Hutchinson name lived on, as would be seen.

Throughout the turmoil of Roger Williams and Anne Hutchinson, the General Court had held the three covenants together, enforced by the civil authorities. But after this period, the grip on dissent in New England was never the same. Even the outlying towns were jealous of the political hegemony of Winthrop after only four years. In 1634, during the Williams episodes, Winthrop had been ousted as governor by vote of a new alignment of deputies, although he was back in office by the time of the Hutchinson trial. In these electoral events, the sermon began to play a new role.

Winthrop was challenged in the 1634 election because he was a moderate and some of his orthodox peers wanted tighter control on church and state in New England. In the shifting loyalties, Winthrop had supporters, but none was stronger than the preacher Cotton. That may be why, before the 1634 election at the General Court in the Boston meetinghouse, Cotton gave a sermon. It was the first "election-day sermon" in New England and set a powerful precedent in America. Cotton probably tried to swing the vote to Winthrop, to no avail. Winthrop was voted out of office, but the election sermon endured.

Elections came every May, and from this time forward, a designated minister preached before the vote. The sermon was delivered in the presence of New England's ruling order: the oligarchic magistrates, the democratic

deputies, and the theocratic ministers. Every one of New England's great founding Puritan clergy gave this sermon at least once between 1634 and 1669. It became the centerpiece of an increasingly elaborate festival day, and turned out to be the earliest form of that great American pageant, the presidential inaugural.

The Sunday sermon, which emphasized salvation by grace and the church, remained the predominant means to deliver a message in New England's colonial period. But the election sermon shaped the American social covenant like nothing else. It created the soul of American "civil religion." The civic sermons multiplied, being given for elections, fast days, executions, funerals, ordinations, and as weekday lectures. By the time of the American Revolution, these "occasional sermons" easily matched Sunday preaching as shapers of public attitudes.

Thomas Hooker, the minister in Cambridge, across the river from Boston, had done his public duty in this respect. He gave his election-day sermon, and he disputed Roger Williams face-to-face at the General Court. But Hooker was not around for the Hutchinson controversy, for he too had differences with the Standing Order. The church in Cambridge had grown restless. Its members wanted more and better land. They were thinking about new and better forms of church and civil government. As even chroniclers of the period recognized, Massachusetts had grown too small for such large Puritan figures: "Two such eminent stars, such as were Mr. Cotton and Mr. Hooker, both of the first magnitude, though of differing influence, could not well continue in one and the same orb."[11]

So in 1636 the Cambridge party—church and town combined—set out on the Old Bay Path, cutting through the south Massachusetts wilderness on foot to reach the Connecticut River. By establishing a settlement to be called Hartford, they founded the Connecticut colony. Hooker's theological teachings and political attitudes spread up and down the Connecticut River Valley. In time, the ministers of the valley created a different religious culture from the Boston of Winthrop and Cotton, and even a revolution in the American mind.

The differences between Cotton and Hooker could be seen in their sermon styles, and in what they hoped to achieve under the classic Puritan format of preaching. Cotton brought the Perkins style to an apogee. He stayed with Bible texts, expanding and subdividing, but he also drew a number of broad applications, from the soul and home life to English foreign policy. His style was dry and abstract, but authoritative. The *Arte of Prophesying* said that a proper sermon "had the efficacy of the holy Ghost adjoyned with it."

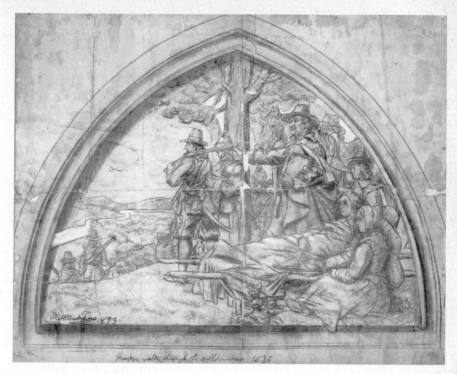

Thomas Hooker trekked through the wilderness to found Connecticut
and employ a new kind of religious persuasion.

In Cotton's emphasis on the covenant of grace, God could save a person by complete and sudden surprise. The sermon was a bridge for God's action.

Hooker, while giving lip service to *Arte,* took a new direction, a departure from Puritan preaching with long-term implications. Since his student days, Hooker had believed in "preparation," or that a sinful person must work at becoming contrite and humble. Then God could work. Hooker believed the sermon helped evoke that contrition. He started with a Bible text, but his sermon topics were guided by his theological and psychological scheme of preparation: contrition, humiliation, vocation, implantation, exaltation, and possession by Christ. Hooker viewed the sermon as an instrument to "prepare" people. To persuade, he used vivid imagery and figures of speech. He preached "a word of terrour"—indeed, galloping images of dark and sinful horror—so listeners knew the trouble they were in. But he always returned to a single theme, "the soul's preparation for Christ."

The house must be aired and fitted before it comes to be inhabited, swept by brokenness and emptiness of spirit, before the Lord will come to set up his abode in it. . . . As we say of grounds before we cast seed; there is two things to be attended there, it must be fit ground, and a fat ground; the ground is fit when the weeds and green sward are plowed up, and the soil there, and made mold. And this is done in contrition and humiliation; then it must be a fat ground, the soil must have a heart. We say the ground is plowed well, and lies well, but it's worn out, it's out of heart. Now faith fats the soil, furnisheth the soul with ability to fatten upon Christ, and so to receive the seed of his word, and the graces of sanctification, and thence it produceth good fruit in obedience.[12]

In the Hutchinson case, such "preparation" and soil-tilling to earn God's blessing was partly at issue. Like Cotton, she believed in surprise grace. Hooker, and perhaps the Standing Order, believed that people had to start feeling and living in more godly ways before God could act. In this, Hooker was a prophet of the evangelical sermon, an oratorical pounding on the conscience of listeners until they repented. He was thus the American father of hellfire preaching. Not by accident, the Connecticut River Valley became hellfire's most prominent pulpit.

In the process of their wilderness migration, Hooker and his church also endorsed a more open membership, since people should be supported in their "preparation," which might take months or years. Hooker was skeptical of preaching that portrayed a self-satisfied saint, self-assured of grace, as perhaps Cotton had preached. For Hooker, knowing exactly who was saved was an enormous mystery. Although he felt most people were eternally damned, he wanted to motivate piety and effort, namely preparation, among a wide swath of citizens.

As ever, this doctrine had major political implications. Hooker argued with Winthrop's contention that a small representative government was more trustworthy than the masses. In his 1638 election-day sermon, Hooker preached that "the choice of public magistrates belongs unto the people by God's own allowance." Authority came by "free consent of the people." The next year, Connecticut adopted the Fundamental Orders, which instituted wider suffrage than in Massachusetts, though it still was more a theocracy than a democracy. Hooker, seeing the English settlements surrounded by foreign empires, also proposed the New England Confederation in 1643.

By these actions, Connecticut produced two new mind-sets. One allowed the evangelical "awakenings" of the next century to burn their paths of religious enthusiasm up and down the river valley. The other prompted a confederation of English colonies. At the same time, however, the colonists felt more alienated from their British homeland. The Puritans in America, by becoming more orthodox, were at odds with the liberalizing Puritans back in England. After a civil war, regicide, a failed commonwealth, and the return of a king—all between 1640 and 1660—the English brethren had embraced tolerance. To the English, the colonial Puritans now looked like fanatics, bent on a "perfectionism" that knew the elect and ostracized the damned.

In turn, New England was dizzied by the events back home. Migration from England had ended after 1640. The migration service industry collapsed, and New England had to find a new way to do business. It became more orthodox, but also more commercial. The first hints of nationalism beat in colonial hearts. In 1648 the General Court summoned the clergy to clarify New England's way forward. The synod of ministers produced the Cambridge Platform, which espoused the "congregational way." For now, this was the model, the "city upon a hill." It was a defensive model, moreover. In England, the dread presbyterian system, or rule by clergy synods, had gained hold. It was creeping into the colonies and to fateful ends. Eventually, the presbyterian system was adopted in Connecticut.

With this, New England had its first "party system." One espoused congregational autonomy, the other rule by a clergy guild. The difference filled not a few sermons, which advocated these rival spirits much as if they were political platforms. Whatever the sermon, the language had become common. It was the cadence of the King James Bible. New Englanders read it at home and heard it three times a week, if not more, from the pulpit. The Scripture and the sermon now had equal divinity, and the idea of God and his nation was drunk deeply by everyone.

The America of the first Europeans had been born in a golden age of preaching, both Protestant and Catholic, and in several tongues: English, French, Spanish, and Dutch. In the English colonies, the clergy gained their authority by speaking the Bible. They became mediators between ordinary people, with lives of drudgery and hope, and a world of supernatural wonders and divine things. To secure that rank, the Puritan preachers did not adopt the images of their own surroundings: rocky soil, codfish, or the hedgerows so common in England. They spoke of vineyards, as if living in biblical lands.[13]

In John Cotton's sermons, for example, a favorite topic was comparing the covenants of the Old Testament and the New Testament. The older was a foretaste, but the new was superior. Still, the Old Testament prophet was never obsolete, according to the Christian preacher. Nothing had supplanted him, especially in how God dealt with nations and peoples. The prophet of note in America was Jeremiah, and that was why a peculiar kind of sermon—known as the jeremiad—gained powerful currency. The jeremiad's power was proportionate to the scale of a calamity in New England, so it was an Indian war—coincident with an ominous lunar eclipse in 1675—that brought the American jeremiad into full bloom.

Jeremiah in America

Times of Troubles and Revivals

FOR A LONG EERIE MOMENT, THE EARTH'S SHADOW PASSED OVER the bright face of the moon, seeming to blot it out of existence. In New England, both the Puritans and the Indians witnessed the same nighttime event of June 26, 1675. It struck awe in their hearts. To the minds of both, the lunar eclipse was a cosmic sign, especially at such a troubling time.

Two days earlier, Indians and settlers had skirmished over land boundaries at the edge of Plymouth Colony. It was the start of the fourteen-month "King Philip's War," named for the Wampanoag chief Metacom, or "Philip," who led the Indian forces. The border clashes, and now the natural "wonder," confirmed for the guilt-prone Puritans of New England that God was angry at their sins. Just the year before, the clergy had begun to warn about a "time of troubles" ahead, for as some Puritans would say, God had a "controversy" with New England.

The Indians also worried. English settlers had encroached on their lands. When the shamans saw the eclipse, they drew on a different tradition and concluded that such an omen presaged war. A few days earlier, Chief Metacom and a small band had looted and burned settler homes while the settlers were at church. Then it escalated. As the Puritans armed and declared a fast day

to elicit God's mercy, the Indians attacked again, killing nine and wounding others. The war might have been averted, but then came the eclipse. To many Indians, this meant total war.

The English colonists believed they had tried to Christianize the natives. The Massachusetts symbol was an Indian with arms outstretched saying, "Come over and help us." Puritan preachers learned the Algonquin tongue, "praying Indians" formed special settlements, and the first printed Bible in North America was in an Indian language. Yet the European desire for land put settlers in conflict not only with Indians but among themselves. At this turning point in American history, the moral debate was over the colonists'

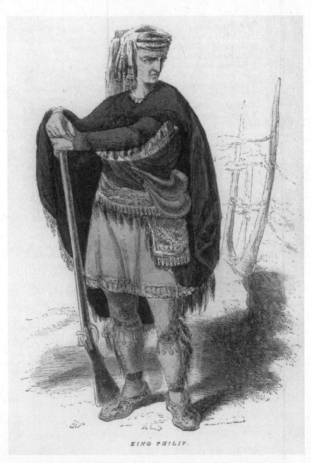

KING PHILIP.

Chief Metacom, or "King Philip," led an Indian revolt that
provoked early "jeremiad" and military sermons.

response to the Indians, and the cause of the calamity. As ever, the sermons offered prods and clues.

With King Philip's War, New England experienced death and destruction not equaled by past calamities, such as Indian deaths by disease or Puritan loss by exposure. The war reduced the Indian population from being a quarter of all inhabitants of New England to just a tenth. It killed one in sixteen settlers and set back economic growth and frontier settlement a generation. The Puritans had long heard in sermons that God both blesses and judges. Now, the "jeremiad" sermon gained new power. The war also produced New England's first military sermons.

The language of the New England jeremiad began building up thirteen years before King Philip's War, and it began in the fruitful mind of Michael Wigglesworth, a struggling minister at Malden, a little north of Boston. As a Harvard student of medicine, Wigglesworth had a conversion experience and turned to ministry, taking his place in the second generation of Puritan clergy. He gave a student speech on "eloquence" at Harvard, citing Cicero rather than the Bible or Puritan fathers, but once at Malden, his verbal eloquence failed him. Owing to lifelong maladies, including illness of the throat, Wigglesworth had to give up oratory. He fell back on narrative poetry. In 1662 he published a popular children's-quality verse, *The Day of Doom,* a rhyming work of prose describing Judgment Day. It became America's first bestseller, unsurpassed for a century until Benjamin Franklin's *The Way to Wealth* set a new record.

As one contemporary said of Wigglesworth's reader appeal, "A Verse may find him who a Sermon flies." By 1662 a great drought had descended on New England, and Wigglesworth, barely holding on to his pulpit ministry, began another work, one that set down New England's first explicit jeremiad. The verse, made up of sixty-three stanzas, was titled "God's Controversy with New England."[1] Although never published, the verse may have been recited or read. It certainly caught a new Puritan mood. Wigglesworth had extended the covenantal judgment to the entire society. "God's Controversy" finds Wigglesworth, age thirty-one, hearing God's voice amid stormy skies and quaking wilderness:

Is this the people blest with bounteous store,
By land and sea full richly clad and fed,
Whom plenty's self stands waiting still before,
And powreth out their cups well tempered?
For whose dear sake an howling wilderness

I lately turned into a fruitful paradeis? . . .

If these be they, how is it that I find
Instead of holyness, Carnality,
Instead of heavenly frames, an Earthly mind,
For burning zeal, luke-warm indifferency,
For flaming Love, key-cold Dead-heartedness,
For temperance (in meat, and drink, and cloaths), excess? . . .

For think not, O backsliders, in your heart,
That I shall still your evil manners bear:
Your sinns me press as sheaves do load a cart;
And therefore I will plague you for this gear.
Except you seriously, and soon, repent,
Ile not delay your pain and heavy punishment. . . .

But there was always hope under the covenant, as Wigglesworth revealed in his own closing voice:

Ah dear New England! dearest land to me:
Which unto God hast hitherto been dear,
And mayst be still more dear than formerlie,
If to his voice thou wilt incline thine ear.

The dour spirit of Wigglesworth rapidly expanded, and the jeremiad became central to May election-day sermons. In 1667 New England citizens heard "Nehemiah on the Wall in Troublesome Times," a sermon urging civil rulers to reestablish true religion. Three years later came "A Brief Recognition of New-England's Errand into the Wilderness," which offered the first public list of society's sins. Chief among them was materialism, robustly on display in land speculation, pursuit of rank, and flashy dress. Said one distraught preacher, "[T]his is never to be forgotten, that *New-England is originally a plantation of Religion, not a plantation of Trade.*"[2] A judgment seemed imminent. During a fast day in 1674, a prescient Increase Mather, Boston's leading minister, preached on "The Day of Trouble Is Near." He predicted that "dismal and calamitous days" were ahead. But even a brooding Mather could not foresee the traumatic costs of King Philip's War.

As illustrated by the Indian war, the jeremiad both hurt and helped Puritan fortunes. In the negative column, Puritans overlooked practical solutions by seeing blight as God's judgment. They might have sought out the real Indian grievances. But they viewed the Indians, like crop failures, as

instruments of God's justice. So Plymouth Colony called a fast day, as did Massachusetts and Connecticut. The General Court declared that God had commissioned the Indians to attack, "speaking aloud to us to search and try our wayes, and turne againe unto the Lord."[3] So the government enacted reforms, cracking down on cursing, long hair on men, misbehaving children, and frivolous apparel.

In the positive column, the jeremiad gave New England sermons and literature an overarching logic. It explained why good and bad happened. Early on, Edward Bulkeley preached that the settlers' military defeats were an object lesson, a "ground of *humbling and abasing our selves,* in the Consideration of our great neglect of serious observation of God's favours towards us."[4] The war, in fact, brought a religious revival. The jeremiad also gave America its earliest distinctive literature. After King Philip was killed in August 1676, and his severed head stuck on a pike in Plymouth, ministers poured out their Jeremiah-like interpretations through the printing presses.

The leading work in this genre was Increase Mather's *A Brief History of the Warr with the Indians in New-England.* The Mather dynasty began at Massachusetts's founding with Richard, a first-generation Puritan. It was extended by his son, Increase, and grandson, Cotton. As eyewitness to the war, Increase wrote his *Brief History* to show that God worked at every turn. Settlers lost the swamp fight in July, for example, because "God saw we were not yet fit for Deliverance, nor could Health be restored unto us except a great deal more Blood be first taken from us." The next spring, however, after Boston's great day of humiliation, God mandated a "turn of Providence towards us in this Colony, and against the Enemy in a wonderful manner."

In the psychology of the jeremiad, a calamity of some kind always was required. By judgment, God promised better days. He proved his interest in New England, Increase preached after the war. "The Lord then sheweth, that his design, in bringing this Calamity on us, is not to destroy us, but to humble us, and reform us, and to do us good in the latter time."[5]

Increase's son, Cotton, exceeded even the father in this interpretation of the past. During the 1690s, Cotton Mather wrote America's first history, *Magnalia Christi Americana* (1702). Filled with facts and color, *Magnalia* was a sustained jeremiad. It engaged in ancestor worship, since the original Puritan standard was so high. When Americans emulated their forebears, the *Magnalia* showed, blessings increased. But when they detoured, judgment was sure. In the *Magnalia,* the pattern explained eighty years of American experience perfectly.

Once the Indians were pacified, the sermons of New England returned to fires, shipwrecks, witches, and epidemics as signs of God's warning. The

jeremiad created the first American myths and the country's first national biography. But the Indian War also gave New England sermons their first militarism. For one thing, such sermons helped recruit militia. Their tone was quite the opposite of the jeremiad, with its appeal for *"humbling and abasing our selves."* The military sermon, which liked to quote Exodus—"The Lord is a Man of War"—steeled American hearts with self-righteousness.

Before King Philip's War, Puritan sermons had spiritualized Old Testament warriors at militia elections, parades, and musters. Once New England was embroiled in physical battle, however, the sermon used Old Testament figures as military exemplars. North of Boston, John Richardson preached that believers should imitate King David, who taught "the Children of Judah the use of the Bow," and get their own muskets, powder, and battle training.[6]

> While the Church hath her Enemies in the world, men ought to be in readiness, not only to Pray with their hearts and tongues, but to fight with their hands for the *Peace of Jerusalem*. . . . You are now as it were in *Garrison,* but you may very quickly be in the Field, not in a naked field, but in a field of Warr, yea perhaps in Aceidema, a field of blood.

For army chaplain Samuel Nowell, the Puritan soldiers, in taking Indian lands, had "as fair a title as any ever had since Israel's title of Canaan." Like Bible figures, Americans revealed "the heart of Lions."[7]

The Indian wars of the 1670s, which touched Virginia and the middle colonies as well as New England, brought a semblance of unity to colony culture. A greater unifying flood tide still was to come, and that was English culture itself. Between 1680 and 1760, the colonies were Anglicized. Maryland came under the crown in 1691, New England was reorganized under a royal governor the next year, and other colonies fell like dominoes. English immigration, trade, military cooperation, and exchanges of literature all increased. All of this had an impact on the sermon, and the audience it addressed. The old Puritan styles now dealt with Enlightenment influences, which included the new sciences, a simpler oratory, and tolerance.

After decades of religious turmoil, the English Parliament deposed the last of the Catholic-leaning kings, and to the English throne summoned William and Mary of Holland, the next relatives in line. Completed in 1689, the political transition was called the Glorious Revolution for its lack of bloodshed. Parliament gained equal footing with the king, and the nation adopted religious tolerance under a state Anglican church. In this mercurial decade, moreover, the face of British politics changed, for the Tory and Whig parties took shape. Although the two parties had shifting interests, the former began

in support of the divine right of the king, the latter in support of a constitutional monarchy. Tories became royalists, demanding uniformity, whereas Whigs were reformists, speaking for rural interests but also for liberal aristocrats and merchants. The rows between Tories and Whigs soon hit American shores, with the Whigs, in the American Revolution, winning the day.

Before that occurred, however, Tories sent to America their triumphalist spirit in Anglican missions. The Church of England legally established itself in Virginia, Maryland, and the Carolinas. King's Chapel, the first Anglican congregation in Boston, brought shudders to Yankees when it opened in 1686. The Society for the Propagation of the Gospel, based in London, bolstered clergy, literature, and new parishes in the colonies, especially those in the South. Virginia, for example, underwent a forty-year Anglican renewal, establishing America's first "commissary," or bishop's delegate, and opening the clergy-led College of William and Mary. Right up to the American Revolution, nonconformists feared that an Anglican bishop would arrive by ship any day.

The middle colonies were populated by a variety of European sects. As these Quaker, Baptist, Presbyterian, and Lutheran settlers congregated around Philadelphia, they formed the first denominational bodies, setting down rules and regulating clergy. The middle colonies would finally eclipse New England as the arena of religious diversity, and their sermons took on the babble of many tongues, though clergy were never as plentiful as in New England. By this hour, all of America was cloaked in the attire of organized religion. It had state churches, denominations, public ceremonies, urban steeples, and clergy guilds.

In Europe, this was the age of a new "heart religion," also called Pietism, which inspired pious communities from the Rhine Valley to England. With roots in the Reformation, Pietism arose in reaction to an age of reason, typified by deism in theology, John Locke in philosophy, and Isaac Newton in science. In Locke and Newton's wake came the new "rational" preaching, which made its way to America as well. Men of wealth in the colonies could never enter the British ruling class, but they could imbibe culture and become "gentlemen." Even Puritan New England—shaken by the Salem witch trial hysteria in 1692—welcomed every civilizing effect. The man to proffer it was John Tillotson, the new archbishop of Canterbury.

A few days after William and Mary took the throne, completing the "Glorious Revolution," Tillotson mounted the court pulpit to preach. It was 1689 and Tillotson was nearly sixty years old. He had been born in a Puritan family and studied at Cambridge. A broad-minded soul in a time of sectarianism,

he married the niece of Oliver Cromwell, worked with the Presbyterians, and was ordained in the Church of England. His preaching around London had cultivated his fame. The new husband and wife monarchs liked what they saw. They made Tillotson archbishop immediately.

Tillotson had taken a middle path between dry deism and harsh Calvinism, a liberal tack called latitudinarian. Faith and morals were founded in supernatural revelation, he preached. But all other subjects were amenable to reason. At this time, moreover, clergy were central to improving the British arts and sciences. Tillotson and a clerical in-law helped improve the clarity of the scientific language of the Royal Society, of which both were members.

Both a clarity of voice and moderation in doctrine shaped the Tillotson style, which, in turn, shaped Anglicanism. His sermons were like well-organized essays. He touched on morals and manners, but to a lesser degree on doctrine. He would preach on friendship or, as in the sermon "Against Evil Speaking," on gossip.[8]

> Another cause of evil-speaking is impertinence and curiosity, an itch of talking and meddling in affairs of other men which do not concern us. Some persons love to mingle themselves in all business, and are loath to seem ignorant of so important a piece of news as the faults and follies of men, or any bad thing that is talked of in good company. . . . [But] consider how cheap a kindness it is to speak well— at least, not to speak ill of any.

For the gentlemen's class, this type of sermon was like a calm and reasonable conversation. Every sentence counted. He avoided dramatic or poetic flourish. English oratory had turned back to Greek and Roman models, and was thus termed "neoclassical." This kind of sermon knew its audience, which often was smug and content. By logic and persuasion it offered moral wisdom and doctrinal order, not a concluding plea to sinners.

So refreshing was this, like a stream cutting through metaphysical and Puritan thickets, that Tillotson's published homilies gained a massive audience in the colonies. American clergy imitated his style. It was based on a pat structure and used themes rather than Bible verses. The Tillotson lexicon infiltrated American religious culture, so that colonial sermons now spoke of "delight" in God, a deity who was "Governor of the Universe." The phraseology well suited political oratory in the future.

In New England, Tillotson had his rough Puritan parallel in Cotton Mather, a kind of eccentric genius and also a member of the Royal Society. Mather had the largest personal library in the colonies, wrote nearly four

hundred works, and brought modern science to New England in his *Christian Philosopher* (1721).

Still, Cotton Mather was a Calvinist Puritan, full of rational and supernatural contradictions. When reports of witches tormenting children in Salem erupted in early 1692, both Increase and Cotton Mather (father and son) decried rampant witchcraft. The purported witches, mostly elderly people and one stubborn clergyman, were accused of using "specters," or invisible demons, to attack others. The witch trials' reliance on "spectral evidence," as told by children, became such a sham that the Mathers finally demanded a halt. The trials ended, but not before twenty people had been executed, and Cotton Mather preached his famous sermon to a public "extraordinarily alarum'd" by witches.[9]

> Each of them have the *Spectres,* or Devils, Commission'd by them, and Representing them, to be the Engines of their Malice. By these wicked *Spectres,* they Seize poor people about the Country, with Various bloody *Torments;* and of those Evidently Preternatural Torments there are some have Dy'd. They have bewitched some, even so far as to make them *Self-Destroyers:* and others are in many Towns here and there Languishing under their *Evil Hands.* The People thus Afflicted, are miserably Scratched and Bitten, so that the Marks are most *Visible*

Cotton Mather, who wrote the first American history, endorsed a diversity of sermon styles.

to all the World, but the causes utterly Invisible; and the same *Invisible* Furies, do most Visibly stick *Pins* into Bodies of the Afflicted, and *Scald* them, & hideously Distort, and Disjoint all their members, . . . Yea, they sometimes drag the poor People out of their Chambers, and Carry them over *Trees* and *Hills,* for diverse Miles together. A large part of the Persons tortured by these Diabolical *Spectres,* are horribly Tempted by them, sometime, with fair Promise, and sometimes with hard Threatenings, but alwayes with felt Miseries, to sign the *Devils Laws,* in a Spectral *Book* laid before them.

The witch hysteria was history's blot on Cotton Mather, erased somewhat by his confession of regret. By his orthodoxy, however, Mather remained a crucial figure in the Puritan shift from a superstitious to a modern New England. He promoted that shift first of all by liberalizing the content and aim of Puritan rhetoric. After writing the *Magnalia,* with its jeremiad logic, Mather backed away from the narrow message of sin-judgment-renewal-blessing. He preached the benefits of a general piety and charity, which became a hallmark of modern Protestantism. Mather did not renounce the truth of election and the interlocking covenants. He only conceded that this was indeed a mystery, and the better part of wisdom was to tolerate good-hearted people, whatever their sect.

Mather's shift was obvious to Puritan scoffers, and particularly to sixteen-year-old Benjamin Franklin, who in 1722 was about to launch a career as a Boston newspaper columnist. Taking on the persona of a feisty widow named "Silence DoGood," Franklin satirized Mather-the-scold in a series of fictional letters written to the *New-England Courant,* deceiving even his own brother, who owned the paper. The *DoGood Papers,* as they are called today, mocked Mather's moralistic tract, *Bonifacus* (1710), better known as "Essays to Do Good." In one letter, Mrs. DoGood, a rural and prudish type, made fun of the temples of learning at Harvard, where dull but privileged merchants' sons copied Tillotson. In another of the fourteen letters, Mrs. DoGood attacked theocracy (when brother James Franklin had been briefly jailed for criticizing authorities in the newspaper). She asked "whether a commonwealth suffers more by hypocritical pretenders to religion, or by the openly profane?"[10]

In a few more decades, however, a chastened Franklin would praise *Bonifacus* for guiding his own morals, and as a wealthy celebrity in Philadelphia, the deistic Franklin would have sermons preached in his honor as he helped raise money to build more churches. In both Franklin and Mather, America shifted from sectarian strife to a benign religion in general, and in fact an ap-

preciation of "hypocrisy," for it kept standards for the greater good. Franklin left this legacy when in 1749 he advertised in a Philadelphia newspaper his scheme for a college, eventually to be the University of Pennsylvania. In his survey of instruction, which included study of Tillotson, Franklin said:

> History will also afford frequent opportunities of showing the neces-
> sity of *public religion,* from its usefulness to the public; the advantage
> of religious character among private persons; the mischiefs of supersti-
> tion, &c. and the excellency of the Christian religion above all others
> ancient or modern.[11]

In this "public religion," America gained its first inkling of a nonsectarian faith, later to be called the civil religion of the United States. It was do-goodism writ large, and it arose in some part thanks to Mather. Do-goodism replaced the anxious guilt of Puritanism. Most important, it allowed for "hypocrisy." It allowed that people might not practice what they preached, though the preaching still was a social good. At the least, Mather agreed, hypocrites give God the "outward man" by endorsing a good social order. Mather's embrace of hypocrisy helped calm worries in England, which still viewed American Puritans as overzealous perfectionists.

Do-goodism also underwrote making money. The first-generation Puritans had preached, and legislated, on the price of goods and the godly rates of interest and profit. One was not to swindle one's neighbor or "grind the faces" of the poor, the sermons said. That had been swept away by financial factions. For this commercial epoch, do-goodism was a better sermon topic. If people could not always have personal honesty and moral virtue, they could at least have charity. Do-goodism showed Protestants the way forward in America. The old Puritan asceticism still had its place. But when American wealth essentially was built on rum, tobacco, slaves, and smuggling, the secular workings of the economy were best kept free of too much moral angst.

In addition to allowing for hypocrisy, Mather's second contribution to New England's step into modernity was to declare a moratorium on Puritan style. He said, Let every style bloom. Mather knew the popularity of the Tillotson sermons. In fact, young "blades" had criticized his own flowery verbiage. So in his final handbook for divinity students, *Manductio ad Ministerium,* Mather declared a truce. There was a great "deal of ado about style," he said.

> Since every man will have his own style, I would pray that we may
> learn to treat one another with mutual civilities and condescensions

and handsomely indulge one another in this as gentlemen do in other matters. I wonder what ails people that they cannot let Cicero write in the style of Cicero and Seneca write in the (much other) style of Seneca, and own that both may please in their several ways.[12]

The new tolerance suited urban America's new prosperity, for business boomed when sects were at peace. On the other hand, prosperity also made the churches sleepy, and this was hard to ignore. Reason was fine, but it quenched the fire. That was what advocates of the "heart religion" in Europe had been saying, from Quakers railing at staid state churches to decent Anglicans such as John Wesley and George Whitefield, who had Pietist conversions in the 1730s and descended into undignified "field preaching." Earlier still, in the Rhineland, Pietists had formed orphanages, gathered in communities called *collegia pietatis,* held "convential" prayer meetings of ordinary folks, and taken over theology chairs at the university.

All this ferment was bound for America, where it started a religious tremor called, with calculated hyperbole, the First Great Awakening. The religious commotion increased a colonial sense of collective identity. Although the term *America* had been around, now it was increasingly used to talk about a single religious people. According to jeremiad logic, however, a judgment must come before social and religious renewal. A 1727 earthquake in New England offered such a sign.

New England does not fall along the continental fault line, but tremors have been reported since the 1500s and possibly reflect ancient rifts. For the Puritans, the occasional tremor was a local affair and might inspire a sermon on its lessons, especially as a natural "wonder" from God. This did not prepare New England for the late night of October 29, 1727, however, when it seemed a final reckoning had come. Great houses shook, chimneys fell, and people huddled in the streets during nine days of aftershocks.

A foreboding mood descended on the pulpits. The very morning before the earthquake, in fact, Nathaniel Gookin of Hampton had preached, "[T]here may be a *particular Warning* design'd by God of some Day of Trouble near, Perhaps to *me,* Perhaps to *you,* Perhaps to *all of us.*"[13] The earthquake came that night. Fast days and sermons calling for repentance and revival took the field, but then faded as always. The earthquake, however, remained a point of testimony in the writings of a whole new era, called the Great Awakening. It first bubbled forth not in a great city but in a relative backwater, the Raritan River Valley.

The settlement of America had taken place along its great bays and water-ways: Cape Cod, the Chesapeake Bay and the Hudson, Connecticut, and James River valleys. The more obscure Raritan River cut a snaking course through the New Jersey mountains, meeting the Atlantic just south of Manhattan's harbor. It was Dutch territory, even after the English had conquered the coast. By 1720 the Dutch churches there were aching for clergy, and by a medley of errors, the German-born preacher Theodore Frelinghuysen landed in New York in January 1720 to supply their need.

Frelinghuysen, part of the Pietist ferment in Europe, began his American career by giving a fiery sermon in New York City. His theme was that the ecclesiastical superiors and their formality had killed the churches. Amid a roar of protest, Frelinghuysen then fled to the Raritan, where he took charge of four churches. He preached that God hated ritual, and he stirred sleepy congregations with stories of eternal damnation and traumatic, tearful conversion. Frelinghuysen brought converts and rallied the support of local clergy. In New York, the Dutch ecclesiastics accused him of Quakerism and demanded that Holland intervene, but to no effect.

By 1726, Frelinghuysen had his picturesque valley astir with a Pietist revival. It mirrored all the best of Europe: fiery preaching, lay preaching, prayer gatherings, eschewing of rituals. Pietism in Europe had three varieties, two of which emphasized renewal around creeds or ritual traditions. Frelinghuysen took the third approach, which was to emphasize nonsectarian cooperation, at least among Reformed groups. Thus, when a young Presbyterian preacher arrived in New Brunswick, the main city of the Raritan Valley, Frelinghuysen already was reaching out to English Presbyterians.

The young preacher was Gilbert Tennent, part of an increasingly important Scotch-Irish dynasty in America's religious history. William Tennent, his father, was an Irish-born Anglican minister who had converted to Presbyterianism. Unhappy with its stubborn formality, he opened his own theology school, derided as the "log college," in the hilly woods of Pennsylvania. There he trained his four sons as evangelical ministers. The idea of "log colleges" spread with the frontier. This was the start of the New Light versus Old Light battle among Presbyterians, a new-guard–old-guard struggle repeated many times in American evangelical religion. Gilbert Tennent, straight from graduation, was a New Light who came into the scorching glow of Frelinghuysen. He could not resist. They shared pulpits. The Pietists cheered Gilbert on.

The Raritan Valley was an early glimmer of later revivals, gaining it an historical pride of place. A few hundred miles to the north, however, the

Connecticut River Valley had cultivated this new kind of agitation for nearly a century. In Hartford, Thomas Hooker had advocated open membership and a "word of terrour" in his preaching, "preparing" the soul for conversion. In his footsteps, a Congregationalist minister named Solomon Stoddard continued that legacy, but far up the Connecticut River in the wilderness of Massachusetts, in a town called Northampton.

A Yale graduate, Stoddard took the Northampton pulpit about the time of King Philip's War. After fifty years there, he was known as the "pope" of the river valley. From the start, Stoddard had mounted a debate with the Boston clergy on election. In 1707 he preached a sermon that rattled the region. He declared open membership based on baptism and communion. The two sacraments were not simply to assure the mysterious elect; they were "converting ordinances" for everyone. "There is no bar in any man's way," he wrote elsewhere about the Lord's Supper.[14] Like Frelinghuysen, Stoddard had found a formula for success. He opened the church to all, and he preached, with great and vivid oratory, the terrors of hell. Not surprisingly, between 1679 and 1718 Northampton's church reported five "harvests" of converts.

Frelinghuysen, Tennent, and Stoddard were important stalking horses in the Great Awakening. But only in the 1730s did the awakening's two herculean figures come on the scene. They were the Anglican evangelist George Whitefield, who made seven tours of America over thirty years, and Jonathan Edwards, the inheritor of Stoddard's pulpit in Northampton. Whitefield came by way of Oxford University, where he had his Pietist conversion attending John Wesley's "holy clubs." Edwards came by way of Yale, and was apprentice to Stoddard until the old man died in 1729. Whitefield always was on the road. His clashes with bishops in England, reported on front pages, brought news of the ferment to America. Edwards hardly traveled at all, but his writings alerted England to revivals in America.

In describing God, Edwards had sided with Stoddard over Cotton Mather, who preached a reasonable, benevolent, and predictable deity. In Northampton, God was jealous, arbitrary, vindictive, and absolute. But once free of Stoddard's shadow, Edwards could say what he really believed: open membership had made the church lax. Northampton's profligate youth proved the point. They were in church twice on Sunday, but Sunday night read tawdry literature. So Edwards rounded them up in small discussion groups. He preached guilt, damnation, and salvation, and by 1734 began to see an effect. After a series of sermons, three hundred converts came forward over six months. "The town seemed to be full of the presence of God," Edwards reported.[15]

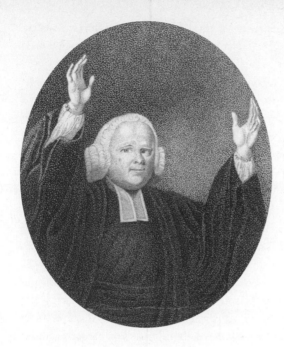

The theatrical George Whitefield's thirty years of traveling evangelism made him America's first celebrity.

Although this did not last—for "the Spirit of God was gradually withdrawing from us"—similar revivals had erupted in thirty two congregations along the Connecticut River. Edwards believed it was providential, even the end of the world, namely the millennium. He wrote his report, first brief and widely dispersed, and then longer. Known overall as *A Faithful Narrative of the Surprising Work of God,* it was published in England in 1737. Wesley read it, and Whitefield could hardly wait to hit American shores.

John Wesley, who struggled through two years as missionary rector of an Anglican parish in Savannah, Georgia, had learned about "field preaching" from a Welsh revivalist. Wesley taught it to Whitefield. He also invited Whitefield to take his place in Savannah in 1739. Whitefield had one quality that nobody else had: he was trained in the English theater, though he denounced it as satanic, and rivaled it on the open streets of London. He put field preaching and the theater together, and no greater orator—combining drama, voice projection, facial contortions, and bodily mannerisms—had preached in America. Whitefield became the first colonial celebrity.

Thanks to the Tennent family in the middle colonies, Whitefield got a roaring start. The "log college" people were Whitefield's first allies. Arriving in Philadelphia in October 1739, Whitefield told patriarch William Tennent

that they were up against "the priests of Baal" in America. Then in New Brunswick, Gilbert Tennent offered to lead the English evangelist on a tour of New Jersey and New York.

Whitefield brought extemporaneous preaching to the colonies, speaking without notes. He adopted the Tillotson topical style, but opened with a short Bible verse, used a fetching introduction, and ended with a dramatic, even theatrical, call for conversion. His daily theme was "the new birth." But Whitefield also learned a few things in America. His own style picked up a new "roughness," which was the preaching of terrors he learned from Gilbert Tennent. "I never before heard such a searching sermon," he said of one of Tennent's efforts. "He had learned experimentally [by experience] to dissect the heart of a natural man. Hypocrites must either soon be converted or enraged at his preaching. He is a son of thunder, and does not fear the faces of men."[16]

The newspapers gibed at Tennent as a soothsayer practicing a "cunning Art," a "Holy Necromancer." Three of the Tennent brothers—Gilbert, John, and William Jr.—testified to visions and miracles in their ministries. Gilbert nearly died from illness, and in a widely published letter said he was "raised up to health" much as Lazarus was raised from the dead. John was known for "*Weeping,* and *moaning*" over Bible study, and a dream sent a witness to save William Jr. from a court conviction. Later, when William Jr. was "laid out on a board" as dead, he came back to life in three days, nurtured to health by Gilbert. Poor William also awoke one night to find that the toes on one foot were missing, a demonic miracle to be sure.[17]

No one doubted Gilbert Tennent's power as a speaker, but some decried it as blurry incantation, delivered in "the extemporaneous way, with much Noise and little Connection." He was accused of employing a "Dialect as hath no Precedent in the Word of God," working "on the Passions of weak Minds as to cause them to cry out in a dismal Manner, and fall down in Convulsion like Fits."[18] Nevertheless, Tennent had plenty of admirers, and while the sound and fury of his sermons cannot be captured, his otherworldly imagery remains:

> O unhappy sinners! It would not be hard to persuade you, I suppose, to be induc'd to accept of Riches worth Millions of Worlds? Sirs, here, in the blessed Gospel, is the glorious *Pearl* of Price, the inestimable *Jewels* of the Covenant, try'd *Gold,* more pure and noble than that of *Ophir, Peru,* and *Mexico;* and white *Raiment,* to enrich and adorn you; and will ye not accept them on the reasonable Terms they are offered?

O cruel Murder! O vile Ingratitude! O detestable Madness! Be aston-
ished and horribly afraid ye Heavens and Earth at this!

While the urban Englishman Whitefield avoided the sphere of miracles
and visions inhabited by the woodsy Tennent clan, he and Gilbert agreed
that American clergy needed rebirth. So they preached a new kind of jer-
emiad. They blamed unconverted clergy for God's wrath, and their luke-
warm pulpits for dragging people into hell. Well versed in such vituperation,
Whitefield gave it in ample servings. He relished the newspaper publicity
and enormous crowds it brought. Tennent took it more personally. He was
enraged at the "carnal Ministers" in New York—Anglican, Dutch, and Pres-
byterian—who barred Whitefield from their pulpits.

Back in New Brunswick, Tennent decided to come out fighting. In 1740
a church in Nottingham, located amid the rolling hills, woods, and farms of
Maryland, was seeking a new minister. New and Old Light Presbyterians
vied for the post. So on March 8, Tennent rode into town to preach as a New
Light partisan. By now, he had taken on all the trappings of a charismatic
preacher. He dispensed with the traditional white wig and let his long hair
down. He wrapped himself in a great coat and tied it with a belt, as if it were
the girdle of John the Baptist. And at Nottingham he preached with John-
like urgency on "The Dangers of an Unconverted Ministry."[19] The sermon
became Tennent's claim to fame—and infamy, especially for calling fellow
clergy not just "natural Men," versus spiritual, but "hypocritical Varlets,"
who sedated entire congregations.

> They comfort People, before they convince them; sow before they
> plow; are busy in raising a Fabrick, before they lay a Foundation.
> These fooling Builders do but strengthen Men's carnal Security, by
> their soft, selfish, cowardly Discourses. They have not the Courage,
> or Honesty, to thrust the Nail of Terror into sleeping Souls. . . . Poor
> Christians are stunted and starv'd, who are put to feed on such bare
> Pastures, and such dry Nurses. . . . O! it is ready to break their very
> Hearts with Grief, to see how lukewarm those Pharisee-Teachers are
> in their publick Discourses, while Sinners are sinking into Damna-
> tion, in Multitudes!

Many of the New Lights, cringing at his rhetoric, sincerely felt unquali-
fied to judge the souls of fellow ministers. Tennent, however, jettisoned such
mystery. He measured clergy by their prayers, preaching, and lives. He said
more was better: more emotion and gesture, more claims of special gifts, and

more stomach for preaching unspeakable terrors. The larger issue, pushed into sunlight by the sermons of the Awakening, was whether purity was more important than unity, revival more important than peace. Tennent chose the first, at least in the short run.

That winter, Tennent retraced Whitefield's recent footsteps in New England. Whitefield had gained renown there, drawing thousands to Boston Common. By the time Tennent arrived, his own diatribe against dead clergy had been published and well circulated. Still, his own tour of New England was a high point in his preaching career. In December, Tennent set off by horse and foot through snow and ice. He hit Boston, then an outlying circuit, and returned to New Brunswick weary and victorious, but without a voice.

In Boston, many New Lights said he preached even better than Whitefield. His foes, typically rationalist Anglicans and Congregationalists, were equally articulate. They said Tennent was a "monster" who preached "with a Spirit more bitter and uncharitable than you can easily imagine." He told people they were "damn'd! damn'd! damn'd! damn'd!" What was Tennent's response? Such New Englanders were bloated with pride, and their Puritan forebears would be ashamed.

Tennent had to face the fallout, nevertheless. Clergy were at each other's throats. In mid-1741 Tennent's own Presbyterian Synod split in two. But the excesses of the Awakening finally came home to him one quiet day in December 1741 when the famed Pietist Count Nicholas Zinzendorf, leader of the German Moravians, arrived in America and passed through New Brunswick. Despite language difficulties, the two men met and talked. They came away with distinctly negative impressions. It was the start of what Tennent called "the Trials I have had of the *Moravians*."

In Germany, Zinzendorf had led a Pietist community at his manor in Berthelsdorf, a *collegia pietatis*. The Moravians, who had inspired Wesley in London, in America had helped Whitefield found an orphanage in Georgia and had helped erect the "New Building" for Whitefield's preaching in Philadelphia. Yet Tennent was shocked by Zinzendorf's spiritualist theology, which drew only upon New Testament love and divine union. He preached no hellfire. Empathy with Christ's suffering on the cross was quite enough. Tennent realized he was face-to-face with a pure "enthusiast," a preacher of salvation for everyone.

Chastened, Tennent saw his own enthusiasm in new eyes. Zinzendorf had "given me a clear view of the Danger of every Thing which tends to ENTHUSIASM and DIVISION in the Church."[20] The tables had turned on Tennent. He returned to wearing a suit and wig and, beginning in 1744,

gave measured sermons from his pulpit at the respectable Second Presbyterian Church in the heart of Philadelphia. His critics celebrated his hypocrisy, the great enthusiast condemning the enthusiasts. One vengeful tract read, *Gilbert Against Tennent*. In reply, Tennent said he always had been consistent. His tract read, *Gilbert Tennent Harmonious*.

The American revivals seemed to peak collectively in 1741. After that, a battle of interpretation was waged. Were they authentic religion, or emotional hysteria? This interpretive task became the legacy of Jonathan Edwards, still ensconced at Northampton, a veritable wilderness outpost in western Massachusetts.

In their first 120 years, the American colonies had absorbed, adapted, and expressed a range of sermon styles. Now, Edwards produced the first original American theology. Essentially, he took the science and psychology of Locke and Newton, joined it with Calvinism, Bible exegesis, and Platonic mysticism, and proposed an in-depth look at the experience of conversion. The core theme was the "superlative excellency" of God's absolute being. As a Calvinist, though, Edwards said that God imparted this grace only to the elect, a supernatural light "immediately imparted to the soul by God." The purpose of preaching was to find these souls, a wheat in the chaff to whom God would give an ecstatic revelation, an experience far exceeding the natural pleasures of love, beauty, or conscience.

Edwards explicated this fully in his sermon "A Divine and Supernatural Light," which gave his narrow electionist theology a glowing warmth, holding out what was in store for the converted.[21] This idea of God's sweetness, pleasure, and "excellency" endured even after many of Edwards's future disciples dropped election: superlative excellency was an experience offered to all. In his lifetime, however, Edwards did not budge, as his hundreds of surviving sermons attest. Yet his description of religious ecstasy, a grasping beyond "natural" faculties, was to speak to an enduring side of the American quest for what Edwards called "the things of religion."

> There is a divine and superlative glory in these things; an excellency that is of a vastly higher kind, and more sublime nature, than in other things; a glory greatly distinguishing them from all that is earthly and temporal. He that is spiritually enlightened truly apprehends and sees it, or has a sense of it. He don't merely rationally believe that God is glorious, but he has a sense of the gloriousness of God in his heart. There is not only a rational belief that God is holy; there is a sense of the loveliness of God's holiness. There is not only a speculative

judging that God is gracious, but a sense how amiable God is upon that account; or a sense of the beauty of this divine attribute.

As a Puritan, Edwards was part of the debate on which faculty of the human being God spoke to: reason, emotion, or the will. Traditional Puritans said reason, which was least corrupted by sin. Reason was most able to comprehend Bible doctrines. Revivalists made emotion preeminent. Edwards tried to resolve the dichotomy by speaking of a unifying experience, the "affections." Yet, for all the divine loveliness in his theology, Edwards exceeded even Stoddard in preaching hell. And in delivery, he was the exact opposite of Whitefield. Edwards gripped his manuscript, read every sermon, used no gestures, and often gazed into oblivion. He usually stuck to the Puritan plain style, at one time using thirty subdivisions. But his descriptive words could rattle even "sermon proof" listeners, as he called them.

Such was probably the case in 1741, when he rode across the border to the Connecticut town of Enfield and there delivered his sermon "Sinners in the Hands of an Angry God."[22] For an age without mass media, descriptive oratory could arouse with the impact of a Hollywood film. This sermon held such potential imagery. For example: "The bow of God's wrath is bent, and the arrow made ready on the string, and justice bends the arrow at your heart, and strains the bow." And there was far more imagery to shudder at:

> Your wickedness makes you as it were heavy as lead, and to tend downwards with great weight and pressure towards hell; and if God should let you go, you would immediately sink and swiftly descend and plunge into the bottomless gulf, and your healthy constitution, and your own care and prudence, and best contrivance, and all your righteousness, would have no more influence to uphold you and keep you out of hell, than a spider's web would have to stop a falling rock. Were it not that so is the sovereign pleasure of God, the earth would not bear you one moment; for you are a burden to it; the creation groans with you; the creature is made subject to the bondage of your corruption. . . .

Next to Edwards's great sermonic prose and his original American theology, his other pillar of work was a defense of the Great Awakening. He said it had signs of true religion. Natural emotions often were mixed in, he explained, but there was proof of spiritual emotions as well, such as the fruits of holy living in their aftermath. The preaching of terrors, moreover, was an entirely legitimate way to help the elect find grace.

Edwards took his defense on the road and also committed it to print. Two months after preaching at Enfield, he traveled the valley south to Yale College. He was asked to give the commencement sermon on September 10, 1741, and he used the occasion to defend the revivals, preaching on "The Distinguishing Marks of a Work of the Spirit of God"—marks that included calmness, piety, and godly converts. The physical excesses were mere effects "on bodies of men," not proof of fraud. Edwards saved his harshest criticism, however, for opponents of revivalism. He was never invited to preach at Yale again.

The reason had something to do with a man named John Davenport, a graduate of Yale, but a man whom Connecticut ecclesiastics finally ruled had gone mad. As a revivalist preacher, Davenport mimicked Whitefield. His wild extravagance, as if a final peroration of the Great Awakening, capped the colonial enthusiasm. Preaching in a high voice, Davenport contorted his body, made wild sounds, and spoke gibberish. On storming Boston Common, he wore a cape and was preceded by a singing throng and an armor bearer. His followers burned books and wigs and believed his theology that revelation came at a moment of high emotion. Indeed, once grace had come, the person was sinless. As a technique, Davenport preached that an "afflatus"—anything from a sermon to a scripture or a dream—could trigger the moment of high emotion and saving grace.

Organized opposition to the Davenport phenomenon was inevitable. Tennent also had urged people to leave their churches, but Davenport's way of doing the same became too much to bear. In New England, the Congregationalist minister Charles Chauncy of First Church, or "Old Brick" Church, led the attack. He savored Tillotson sermons in an age of reason. As Edwards preached at Yale College that Sunday, Chauncy gave his own sermon favoring moderate evangelism, a "real and effectual renovation of heart and life." By July 1742, however, the Davenport fiasco allowed him to publicly confront Edwards's defense of enthusiasm.[23]

The counterpunch to Edwards came when Chauncy preached on "Enthusiasm Described and Cautioned Against." The sermon was published with an open letter to Davenport. The very meaning of the Awakening was at stake. Chauncy argued from the side of tradition and reason. The Awakening had produced "a kind of religious Phrenzy," he preached, a "genuine force of infinite evil" worse than the pope. Relying on their own feelings, the enthusiasts had "render'd the Bible a useless dead letter."

As a rationalist, Chauncy built upon the work of Locke, who said "enthusiasm" blurred the rational comprehension of God and morals. Enthusiasm was "founded neither on reason nor divine revelation, but rising from the

conceits of a warmed or overweening brain," Locke said. "Whereby in effect it takes away both reason and revelation, and substitutes in the room of them the ungrounded fancies of a man's own brain, and assumes them for a foundation both of opinion and conduct." This had been seen in London in the 1710s, Chauncy reminded his audience, when the so-called French prophets claimed to raise people from the dead. Now in America, such enthusiasm "made men fancy themselves to be prophets and apostles," and some claimed to be Christ or God himself.

The famous Chauncy–Edwards debate soon turned to print. In late March of 1743, the *Boston Weekly News-Letter* advertised a book expanding Edwards's Yale sermon. It was titled *Some Thoughts Concerning the Present Revival of Religion in New England.* It was Edwards's third treatise on the revivals, but the greatest was still to come. In response, Chauncy dashed off his own book, *Seasonable Thoughts on the State of Religion in New England.* For a few weeks, the rival books were advertised cheek by jowl in the same newspaper. Rather than rebut Edwards, Chauncy's book offered a catalogue of revivalism's "dangerous tendencies."

By 1746 the revivals were almost ancient history, though they had yet to break out in the South. By then Edwards had withdrawn from the public debates, but he wrote a final manuscript on psychology, published as *A Treatise Concerning Religious Affections.* In marvelous detail and eloquence, the book dissected human experience. It looked at human behavior. It paralleled physical and spiritual attributes, especially the two wills—natural and spiritual. "There is no true religion where there is not religious Affections," he summed up.[24] For many, *A Treatise* stands as America's greatest work on the psychology of religious experience.

Edwards grew in his Calvinist convictions. He preached more hell. He pressed his Northampton church to narrow membership. So in 1750 the church turned him out. Edwards rode into the wilderness to serve at a mission station to Indians, and continued writing. He produced a great biographical work on David Brainard, a sacrificial missionary to the Indians, and finally was invited to be president of Princeton, which once had been called Tennent's "log college." A year after Edwards arrived, he died of a smallpox inoculation.

The colonial era was coming to an end, and with it the world of "wonders" that surrounded eclipses, Indian wars, and earthquakes. Both the Enlightenment and heart religion had reached America in great abundance. In their sermons, the clergy had to decide which human "faculty" they were preaching to: reason, emotion, or, as Edwards offered, some kind of affections that

united them all. The Great Awakening disrupted the Puritan style of preaching. The subdivided sermon gave way to the essay. If preaching had been a work of art before, now it had to be an event, an oration with immediacy, judged by its ability to convert.

The Awakening also gave America two kinds of religious figures, typified by Whitefield and Tennent, both masters of evangelical preaching. Whitefield was the pioneer of celebrity. He had no local congregation, but moved from place to place asking, "What must I do to be saved?" He achieved this celebrity by a canny use of letters, news accounts, advertising, advance teams, strategic controversies, and dramatically staged events—in a word, the first mass-media campaign in America. Ben Franklin, who also excelled in mass media as a commercial printer, befriended Whitefield, and at one point they considered teaming up to "found a colony in Ohio." The second kind of religious figure, like the faith healers of more recent times, was typecast in the life of Gilbert Tennent. He was a local teacher of charisma and supernatural power, surrounded by stories of miracles, visions, and the raising of the dead. Tennent's preaching could be more incantation than rhetoric.

The so-called Great Awakening—whether viewed as isolated events or the first colonywide experience—was brief but intense. It hit the middle colonies and New England and then drifted south to Virginia. The Awakening seemed to defy the jeremiad's logic. Doctrinal orthodoxy declined, but religious organizations grew, even under the corrosive effect of migrations and pluralism. The Congregational, Anglican, and Quaker churches dominated eighteenth-century America. But new churches and sects formed everywhere, and sermonizing increased with the number of clergy and lay preachers. By the time of the American Revolution, Congregational clergy alone delivered more than two thousand sermons a week.

The Awakening helped create a religious infrastructure, a network that was in place when the American Revolution erupted. During the Awakening, churches formed "committees of correspondence," circulated letters, organized election tickets, voted in blocs on Indian affairs, and signed political petitions "as a Sabbath-Day's Exercise." Nonconformists formed a "confederacy" against a long-rumored Anglican bishop's arrival in America. Denominations operated on a "federal" system. A vitriolic religious vocabulary came into use, and when secularized, it fit the revolutionary decades to come. Between 1740 and 1776, preachers and pamphleteers made "liberty" and resistance to British taxation sound like a religious conversion.

The interest in politics marked a passing away of superstitions about eclipses, earthquakes, and certainly about witches in New England. Nature

was increasingly viewed as operating under regular laws. That was what Boston minister Jonathan Mayhew preached in the 1750s and 1760s. A new kind of American, Mayhew was a man of the Enlightenment. At his well-to-do West Church he sermonized on God as "the Author, Upholder, and Governor of the Universe." Mayhew was part of a noted Puritan family, and his Puritan life a bridge between Indian wars, the jeremiad, the Great Awakening, and the new Whig political ferment that opposed royalist England.

His father, Increase Mayhew, was a famed missionary to the Indians. He farmed at Martha's Vineyard and Cape Cod and ministered to a branch of the Narragansett tribe. Increase translated the Psalms and Book of John into Algonquin. Finally, he gave up trying to teach Indians about the arbitrary God of strict Calvinism. He entertained the mild "heresy" of Arminianism, which recognized human free will and choice. As Increase farmed and wrote, his son Jonathan entered Harvard. This was in 1740, just a few weeks before Whitefield stormed through Boston, preaching to crowds at Harvard Yard. Soon after came Tennent, and then the bizarre Davenport. Like many young men, Jonathan was converted and studied for the ministry.

In the long run, though, he eschewed both orthodoxy and emotionalism for the Enlightenment. Before long, Mayhew matched Chauncy as a New England pillar of rational religion. They adopted Whig concepts of religious and political liberty. Mayhew entered the pulpit of the new West Church in 1747, aged twenty-seven and full of new ideas. Sixteen years later, the last Indian war of that century ended when the British expelled the papacy-allied French from North America. The end of the French and Indian War became a moment of acute self-awareness in both the colonies and the British Parliament. Should not America, Parliament asked, be taxed to help pay off the war debt?

At West Church, Mayhew preached on such subjects. By 1765, some in his congregation were forming a secret society, the Sons of Liberty. They opposed taxation. Then one Sunday afternoon in August, Mayhew gave a homily that resounded in England. Across the Atlantic, it was called "one of the most seditious Sermons ever delivered."[25]

CHAPTER FOUR

Pulpits of Sedition

The Rhetoric of Revolution

WHEN JONATHAN MAYHEW PREACHED HIS "MOST SEDITIOUS" sermon on the hot afternoon of August 25, 1765, West Church still had the tallest steeple in Boston. It was a sixty-foot beacon. Once the American Revolution began, still a decade in the future, the British redcoats knocked the steeple down.

West Church stood near the rum distilleries on the waterfront in the new end of town. In summer, the harbor sent a cool breeze through its green-curtained windows. On August afternoons, congregants fanned themselves with hats and handkerchiefs. These days, they also used the small political pamphlets that seemed to be flooding Boston.

At age forty-five, Mayhew was the best-paid clergyman in town. His was an up-and-coming Congregational assembly, one joined by merchants, lawyers, shipbuilders, sea captains, artisans, and printers. They had built their clapboard sanctuary in the quieter end of Boston, a bustling port city of fifteen thousand. Each Sunday Mayhew mounted his pulpit, with its green velvet accents and white Doric columns, to look down on a cross section of the city's elite. On August 25, he knew what was on their minds. The congregation was home to some of the Loyal Nine, a clandestine group soon to call

itself the Sons of Liberty, set on ousting British governance and troops from the colonies. And there sat the publisher of the *Boston Gazette,* which had just opposed the Stamp Act issued by the British Parliament.

After eighteen years, the congregation knew Mayhew equally well. All the colonial clergy had given anti-Catholic sermons, peaking during the French and Indian War. But Mayhew preached against an Anglican bishop coming to America, still no more than a rumor. At the time, liberal Whigs in England were attacking royalist tendencies, especially the power of bishops in a corrupt royal court in London. This literature shaped the thinking of many colonial merchants, lawyers, and clergy, as colonists also watched Anglican missions grow around them. Mayhew played on all of these sentiments.

Everyone knew the particular sermon that had made Mayhew's reputation. In 1750 he had preached "A Discourse Concerning Unlimited Submission," later published to colonywide attention. In it, Mayhew attacked the "mysterious doctrine" that King Charles I, beheaded by the Puritans in 1649, was worthy of a saint's day in the Anglican calendar. "What of saintship in

The public called Jonathan Mayhew's sermons both "seditious" and a "catechism of the Revolution." His last published sermon marked the rescinding of the Stamp Act.

The Snare broken.

A

Thanksgiving-Discourse,

PREACHED

At the Desire of the West Church

IN

BOSTON, *N. E.* Friday *May* 23, 1766.

OCCASIONED BY THE

R E P E A L

OF THE

Stamp-Act.

BY

JONATHAN MAYHEW, D. D.

Pastor of said Church.

Brethren, ye have been called unto LIBERTY *: only use not* LIBERTY *for an occasion to the flesh, but by love serve one another.* Ap. PAUL.

B O S T O N

Printed and Sold by R. & S. DRAPER, in New-bury-Street ; EDES & GILL, in Queen-Street ; and T. & J. Fleet, in Cornhill. 1766.

overturning an excellent civil constitution?" Mayhew asked. "And what of martyrdom is there in a man's bringing an immature and violent death upon himself, by being wicked overmuch?"[1] In all, the sermon rejected "submission" to tyranny. John Adams, who read the sermon at Harvard, later called it the "catechism" for the American Revolution.

Mayhew's standing, Whiggish in politics and liberal in theology, did not bar him from honors such as delivering the 1754 election-day sermon in Massachusetts, with royal officials assembled. But now it was August of 1765, and the heat, the Stamp Act, and the mobs probably gave his preaching on the Bible and liberty a bit more edge. A few days earlier, the Sons of Liberty had put a Boston mob into action. In the past, merchants had smuggled goods past British tariffs. But the stamp tax required an open registration for domestic trade, available only at the local stamp office. One hot night, as Boston flickered with bonfires and drinking, the rebels' gangs destroyed the stamp office and hanged its officer in effigy. Then they veered north to smash windows at the home of Thomas Hutchinson, the lieutenant governor.

Naturally, the commotion still hung in Boston's warm and briny air when Mayhew began to preach a few days later, on August 25. His Bible text from Galatians offered some vivid images, hopeful words from Saint Paul saying that "they were even cut off which trouble you," and that "brethren, ye have been called unto liberty." As a rule, Mayhew, donned in black robe and wig, preached without gesture or drama. He followed the plain style and ended with an application. In his subdivisions that day, Mayhew gave his audience six meanings of liberty, with the greatest emphasis on "civil liberty." Nations differ in their degree of liberty, Mayhew preached. Liberty came by "common consent," and a country without liberty suffered not just tyranny, but enslavement.

> For the essence of slavery consists in being subjected to the arbitrary pleasure of others. . . . As, for example, a Mother-country & her Colonies. While she is free, it is supposeable that her colonies may be kept in a state of real slavery to her. For if they are to possess no property, nor to enjoy the fruits of their own labor, but by the mere precarious pleasure of the Mother, or a distant legislature, in which they neither are, nor can be represented; this is really slavery, not civil liberty.[2]

The Stamp Act naturally slipped into the sermon, more as an aside, but nobody could ignore the topic of the hour. As a spiritual leader, Mayhew made clear he was not espousing a "liberty of the flesh," that unruly and selfish discontent that the Bible condemned. "Let not us, my brethren, use

liberty for an occasion to the flesh, or use any method, for the defence of our rights & privileges, besides those which are honest & honorable." Although Mayhew preached about "restrictions & limitations," he added, "*let us do all in our power.*" In a month like August, someone might have taken Mayhew's words the wrong way.

On Monday night, the bonfires and drinkers were out again. The Sons of Liberty, still clandestine, thought strategically in their use of mobs. But that night, they apparently were not in control of the streets. Again, a rum-swilling crowd moved from the bonfires into the northern neighborhood, heading straight for Hutchinson's house. "The doors were immediately split to pieces with broad axes," Hutchinson recounted.[3] As he and his family fled, the mob poured in through every door and window.

By dawn the mob had "destroyed, carried away, or cast into the street, everything that was in the house" and had begun to chip away the brick itself. It stole money and silverware. Mayhew would have been left out of the affair, except that in jail one agitator tied his rampages to Mayhew's Sunday preaching. "He was excited to them by this sermon," said Hutchinson, based on his best information. "He thought he was doing God service."

Mayhew was horrified. He immediately wrote Hutchinson, giving an account of the sermon: "I had rather lose my right hand, than be an encourager of such outrages as were committed last night."[4] The two men shared the blue blood of New England. Hutchinson's ancestor was Anne Hutchinson, the heretic expelled from Boston in 1637. Mayhew's grandfather had been governor of Martha's Vineyard and patriarch of two generations of Indian missions there. In Boston, the Hutchinson clan had done so well in money and rank that some Sons of Liberty fought them in envy as much as from high principle. In any case, the rioter who heard Mayhew's sermon overlooked its caution.

Faced with the street trouble, the British rescinded the Stamp Act, but the conflict grew worse. Parliament dissolved the Massachusetts Assembly. To enforce new trade restrictions, it seized the ship of merchant John Hancock. Boston exploded in riots, and two British regiments arrived. Soon enough, a military ruler replaced Hutchinson, who had moved up from lieutenant governor to royal governor. Once the patriots exchanged gunfire with the British outside Boston—at Lexington and Concord in April and Bunker Hill in June of 1775—there was no return.

Mayhew did not live to see the armed revolt. His last great sermon, titled "The Snare Broken," came in 1766, the year the Stamp Act was rescinded. In it, he likened America to a bird that had broken free from the hunter's

trap—but a bird that must remain vigilant. Seven weeks later, after a long pastoral journey, Mayhew died of an illness. He was forty-six. Only two Boston clergy had deigned to attend his ordination in 1747, so heterodox was his reputation. His funeral procession, however, drew the largest clergy attendance in memory.

In addition to the strategic use of mobs, colonists excelled in pamphleteering. The small folded tract was the perfect vehicle for revolutionary writers. Most pamphlets were rapid responses to events of the day, from the Stamp Act to the September 1774 assembly of the first Continental Congress. Another type of pamphlet reported public addresses, including sermons.

John Wesley's attack on the American sermon "The Present Situation" was part of a pamphlet war among colonial pulpits.

A third popular kind was the vehicle for public argument, one pamphlet against another. It was this kind of pamphlet war that John Wesley, the Anglican missionary to America, would participate in from his ministry back in London. In response to some heated sermons in America, Wesley wrote "A Calm Address to Our American Colonies." It was the summer of 1775. A hundred thousand copies went into circulation. The bulk was shipped to America, but nervous Anglicans there, who worried about a patriot backlash, intercepted most of them.

Wesley had been chased out of Savannah, Georgia, for his moral zeal four decades earlier, and now he said the colonists whined too much. They brooked no sovereign at all. "Your rights are no more violated than mine, when we are both taxt by the supreme power: and your charters are no more mutilated by this, than is the charter of the city of London," he said. "Vainly do you complain of being 'made slaves.'"[5] For this, Wesley was called a Jesuit and royal terrorist.

As the Wesley pamphlets hit American ports, one of his royalist sympathizers, the Maryland cleric Jonathan Boucher, was also experiencing the colonial wrath. Most lay Anglicans in the south were patriots, leaving Anglican priests like Boucher in precarious circumstances. In Boston, Hutchinson had faced the mobocracy of city politics. Boucher, in the countryside, was about to experience the patriot vigilantes.

An Englishman, Boucher arrived in Virginia in 1759 as a tutor to the sons of a planter and, seeing the need, was ordained a minister in 1762. He was a friend of George Washington, owned a Virginia plantation, and ran a boys' boarding school. After the royal governor invited Boucher to the Annapolis parish that provided the Maryland Assembly with a chaplain, Boucher did that, and he helped manage the legislature. He wrote bills and the governor's speeches. And he made enemies, especially over the salaries of state-funded clergy and his sermon endorsing an Anglican bishop in America.

Boucher had the largest classical library in America. He was a typical figure in America's "golden age" of classics, which had experienced a revival
. ellectual elite, many of them architects of the American rebel-
. :ved the British system had a divine sanction.
. utside Annapolis, Queen Anne's, but on his first
. :s" locked the church doors. They seemed ready
. mes. The threat of violence escalated when he
. "-collection sermon for Boston. Now a marked
. preach, "with a pair of loaded pistols lying on the

Loyalist Jonathan Boucher
preached with pistols at
hand.

Boucher was a round, balding man with spectacles, but he was no push-
over. He once knocked down a blacksmith. When the showdown finally
came, it was a Thursday, decreed a fast day by the legislature. Boucher ar-
rived at Queen Anne's to preach, but a patriot curate was there first, ready
to deliver a Whig sermon, antiroyalist in sentiments. Then, two hundred
armed men filled the sanctuary. "With my sermon in one hand and a loaded
pistol in the other, like Nehemiah I prepared to ascend my pulpit," Boucher
said. Fearing for Boucher's life, a friend restrained him, but the hostile group
pressed in. So Boucher grabbed the ringleader by the collar and put a pistol to
his head. With hostage in tow, he shuffled to his horse and was off.

Boucher kept preaching as long as he could but finally left America in
September 1775. Even at that hour, the collective colonial mind had still not
rejected the king of England. Parliament was the villain. The Continen-
tal Congress denounced Parliament but appealed to the good sovereign. In
one of his last sermons, preached at Queen Anne's to rebut a patriot ser-
mon, Boucher gave the grounds for respecting royal governance. A wise
God would not have made human beings "capable of order and rule" just to
"turn them loose into the world under the guidance only of their own unruly
wills," Boucher preached.[7]

Hence it is that our church, in perfect conformity with the doctrine
here inculcated, in her explication of the fifth commandment, from
the obedience due to parents, wisely derives the congenial duty
of *honouring the king and all that are put in authority under him.*

Boucher never denied colonial grievances, but he was a man of order.
He believed in a natural hierarchy, much as the Founding Fathers did after
the American Revolution, for they too said that a "natural aristocracy" was
needed to keep the rabble in check. In his last months in America, Boucher
more freely castigated the aggressive and unlettered butchers and black-
smiths who, with pamphlets in hand, spouted Whig philosophy and Greek
republicanism. "In proportion as government is degraded, those who depress
it exalt themselves," he said of them. To the contrary, however, "Without
government, there can be no society; nor, without some relative inferiority
and superiority, can there be any government."[8]

When Boucher left for England in September 1775, he was a harbinger
of the sixty to eighty thousand loyalists who eventually fled the colonies as
well. A year before, an English revolutionist named Thomas Paine had ar-
rived in America. Paine thought the opposite of Boucher. Paine said society
was good and government bad. Working for a printer in Philadelphia, he
wrote *Common Sense*, and the sermonic pamphlet's publication in January
1776 broke the ice on the final delicate question: "But where says some is the
King of America? I'll tell you, Friend, he reigns above, and doth not make
havoc of mankind like the Royal Brute of Britain."[9] In July the Declaration
of Independence took a final step, renouncing not just Parliament but the
king himself.

When the warfare had begun, the colonists had a unique advantage. They
had the "black regiments" of clergy who preached rebellion. The contrast in
oratory was great. Mayhew sounded like he was preaching from John Locke's
political theory. In Virginia, however, a country lawyer named Patrick Henry
mimicked the backwoods revivalist preachers when he went to the Virginia
Assembly. With that kind of fiery emotion, he reportedly said, "Give me lib-
erty or give me death."

Most colonial preaching was evangelical. Most churchgoers, in turn, were
ordinary people who wanted assurance from the Bible. They were not city
elites curious about Locke. In addition to the Bible, most colonists understood
the idea of the "covenant," an agreement of consent. Probably three-fourths
of them were Calvinists. In wartime the old meetinghouses took on a new
allure as well. At the church, colonists heard war news and stored muskets,

powder, and ball, often under pulpits and floorboards. The churches were centers of recruitment as well.

The wartime preaching changed along with events. At first, sermons focused on the Bible's idea of liberty and the Calvinist covenant's insistence on "consent" of the people. Once the shooting commenced, and sons lay dead, sermons raised the stakes. They offered a glorious day to come. They no longer looked back at sainted "forefathers," but cast a vision forward to future saints, American inhabitants of a New Israel and Canaan. The millennium had dawned. America might become "the principal seat of that glorious kingdom, which Christ shall erect upon Earth in the latter days," preached Ebenezer Baldwin of Connecticut.[10] The Antichrist played a new role as well. No longer the pope, he was clearly King George III.

In town and country, the biblical preaching mixed with a popular interest in the ancient republics of Greece and Rome. This had been a staple of the more radical Whig literature, widely circulated in America. For now, biblical and pagan rhetoric combined. A leading Son of Liberty, Samuel Adams, described the revolution as a quest to build a "Christian Sparta." The Continental Congress forecast a pagan version of the biblical millennium, a "golden period, when liberty, with all the gentle arts of peace and humanity, shall establish her mild dominion."

Whether from the pulpit or town square, it was an era of oratory, and everything that was helpful—biblical and pagan—was thrown into the mix. Even Boucher, the classicist, credited the colonists with trying to speak their minds, on the street and in college courses. "Hence in no country were there so many orators, or so many smatterers."

For the most significant oratory, Philadelphia was the place to be after war was declared. It was the largest city and a natural hub for theorizing about a new republic. British armies focused on New York and the South. The roads to Philadelphia could be rocky or muddy, but upon arriving, delegates to the Continental Congress had the finest boarding rooms and the best foods, thanks to wealthy city patriots. Of the many who traveled to Philadelphia, none was such a sight as John Witherspoon, for he was the only clergyman to arrive as a delegate.

A stocky man of middle height, bushy eyebrows, strong nose, and large ears, Witherspoon had far less distance to travel than most: a mere fifty miles on horseback compared to three hundred from capitals such as Boston and Williamsburg, Virginia. As would become clear, he was the rhetorical equal of a political gathering that featured America's most fiery orators, most of them lawyers.

Witherspoon, not long from Scotland, was a Presbyterian minister and president of the College of New Jersey at Princeton. Since arriving in the colonies, he had avoided politics, and probably for the best. By the time of his death, he was America's most significant professor, educating one future president, a vice-president, and scores of cabinet members, senators, and judges, three of whom became Supreme Court justices.

In Scotland, Witherspoon had led the evangelical forces in their failed culture war with the secular Scottish Enlightenment. He had known a little prison time for engaging in those politics, and he was not eager to repeat the experience. But in May 1776 Witherspoon preached that he could no longer remain neutral, claiming that this was to be "the first time of my introducing any political subjects into the pulpit." From his church rostrum, he declared, "without hesitation, that the cause in which America is now in arms, is the cause of justice, of liberty, and of human nature."[11] What followed was "The Dominion of Providence over the Passions of Men," a ringing Calvinist justification for war, and proper behavior therein. When the sermon was printed in Britain, loyalist Scots decried such clerical agitation, and the "Presbyterian parson" became a topic of sly comment in Parliament.

As with sermons given for the next one hundred years, through the American Civil War, Witherspoon preached that God was in control. The sovereign Almighty used wrath and victory for his ends. This was the Dominion of Providence, and it was displayed in every event, large and small. The wrath that men delivered against each other revealed God's glory. It proved human depravity. All tyranny and war, he said, had the potential to humble souls and turn hearts to redemption.

> The most impetuous and disorderly passions of man, that are under
> no restraint from themselves, are yet perfectly subject to the dominion
> of Jehovah. They carry his commission, they obey his orders, they are
> limited and restrained by his authority, and they conspire with every-
> thing else in promoting his glory.

Witherspoon pointed to specific examples of wrath producing glory. Christ's death defeated evil. Persecution of early Christians ended in the triumph of the faith. Even Oliver Cromwell, trying to leave England on a ship, was turned back by foul weather and had to lead the Puritan armies. And so it was in America. God would work in so much mundane detail, and even in defeat. Meanwhile, Witherspoon urged soldiers to conversion before they met a British bullet, and families and civilians to retain their morality and

social order. From Europe he doubtless knew that war, like nothing else, plunged a society into immoral chaos.

A few weeks later, on other merits, Witherspoon was elected to the New Jersey delegation for the continuing Continental Congress, which soon convened in Philadelphia. At the State House there, delegates sat at thirteen green-cloth-covered tables, one for each of the colonies. They conferred on motions, stood for debate, and table by table cast votes. Witherspoon was in his chair dressed as a civilian. At one point, when Congress was locked in debate on whether political independence was the right step, Witherspoon had an opportunity rarely found in the pulpit. Standing, he said, "Sir, in my judgment the country is not only ripe for the measure but in danger of rotting for the want of it."

The war soon became more than an abstraction for the clergyman. At the end of 1776, the British invaded Princeton and burned down the college library, housing one of the best colonial collections, gathered for a lifetime by

The Dominion of Providence over the Passions of Men.

A

SERMON

PREACHED

AT PRINCETON,

On the 17th of May, 1776.

BEING

The GENERAL FAST appointed by the CONGRESS through the UNITED COLONIES.

TO WHICH IS ADDED,

An ADDRESS to the NATIVES of SCOTLAND residing in AMERICA.

By JOHN WITHERSPOON, D. D.

PRESIDENT OF THE COLLEGE OF NEW-JERSEY.

PHILADELPHIA:

PRINTED AND SOLD BY R. AITKEN, PRINTER AND BOOKSELLER, OPPOSITE THE LONDON COFFEE-HOUSE, FRONT-STREET.

M.DCC.LXXVI.

John Witherspoon, America's early tutor in eloquence, preached revolt in a published sermon (right) and signed the Declaration of Independence.

Witherspoon. His oldest son died as a colonial soldier at the battle of Germantown outside Philadelphia.

By the time Witherspoon had preached on the "Dominion of Providence," the American military sermon was well developed. It began with the Indian wars and was added to after Concord, Lexington, and Bunker Hill. In the broader picture, what Witherspoon brought to this period in American history was the formal study of eloquent speaking. Eloquence was much the rage in Scotland, and Witherspoon introduced his version to America. Scotland had pioneered the idea of the master professor standing before a large classroom. In Scotland, the doyen of eloquence was Hugh Blair, a Presbyterian cleric, but also the master of oratory and source of the famed *Lectures on Rhetoric and Belles Lettres.*

In Edinburgh during the 1760s, Blair gave the forty-seven courses regularly, and they were finally published in 1783 and circulated in America. At Princeton, in the early 1770s, Witherspoon gave his own *Lectures on Eloquence,* copied by students and later published as well. The two Edinburgh clerics had overlapped. They doubtless agreed on Blair's stance that oratory was a general power and Christian preaching a subspecies of that. Blair defined a sermon as "a serious persuasive Oration, delivered to a multitude, in order to make them better men."

Whatever their mutual influences, however, Blair liked fancier speech, and he instructed in the demonstrative use of gestures and voice, later called elocution. Witherspoon, though flowery by modern standards, preferred straight oratory, and this may have been his main influence on the Founding Fathers and scores of college-educated clergy. The story goes that a lady visited Witherspoon's home and commented on the lack of flowers in his garden. "No, nor in my discourses either," he replied.

At the Continental Congress, which lasted nine years and hosted 337 different delegates from the thirteen colonies, the talk had to be straightforward. Their documents, however, had to strike a balance, merging both the biblical and classical, or pagan, ideas of the age. The delegates came from states with established Protestant churches and citizens of simple Bible faiths. But they were practical men, inclined to avoid conflict over doctrines and prophecies. What worked best, as time would tell, was a simple evocation of God and providence. For a start, under the Articles of Confederation, Congress had very limited powers. It barely mustered the authority to prosecute a war. Evoking the Creator, therefore, amplified its authority.

It was now that the resonant phraseology of the great Tillotson, late archbishop of Canterbury, informed American legislative rhetoric. Deism also

portrayed God as governor, even as clock maker. But the Tillotson style was both a popular and a literary source, and must have crept into many founding minds. The Congress opened with a traditional ecclesiastical flourish. With no quibble, it chose an Anglican chaplain (later denounced for opposing independence). His first prayer drew upon Psalm 35, in which God protects his people. "It seemed as if Heaven had ordained that Psalm to be read," John Adams said. Another delegate complimented its canny use as a "masterly stroke of policy."[12]

Over the next several years, Congress paused for prayers and visited nearby churches for sermons, especially the splendid Christ Church, located between the State House and the city's best tavern and the largest building in the colonies. Over the years, Congress legislated on sin, repentance, humiliation, public worship, and even "true" religion. It declared colonywide days of fasting and thanksgiving, appointed chaplains to the army, and praised the "pious and laudable" work of printers who published Bibles, which were in short supply.

These actions played to popular appeal. Building a new social order, however, was going to be more complicated, even philosophically. The pagan and Christian currents in the Revolution did not always agree, and to these were added other British trends in Whig thought. In Adams's "Christian Sparta," for example, a "civic humanism" was supposed to motivate public-minded service and suppress greed. British liberalism, in contrast, offered the doctrine that private vice produced public virtue: self-interest, greed, and consumption fueled business like nothing else.

These contradictions, and the disappointments felt by idealist Founders, had to be worked out in the Constitution. Meanwhile, Congress adopted the language of God and providence, though it was winnowed away in time. The Declaration of Rights in July 1775 justified taking up arms under "the divine Author of our existence" and a "beneficent Creator," but the Declaration of Independence a year later only cited "nature's God" and a "supreme judge." To the consternation of clergy, the Constitution, adopted by Americans in 1791, contained no mention of God at all.

The Constitution was never part of the Revolution's vision. When Congress dissolved in 1783, the political drama returned to the states. The thirteen sovereignties had united against a common foe but now had their own prosperity to look after. It was the "critical period," according to historians, when political, economic, and religious self-interests pitted state against state. Many of the Founding Fathers had believed that only a "natural aristocracy" could guide the republic. In states, however, these architects of the revolution saw only the "despotism of democracy" and "spirit of locality."

The two overriding philosophies of America now were born, espoused by the Federalists and the Democrats, those who urged a federal government and those who stood for states' rights against all tyranny. Fortunately for the Federalists, individual states had no way to handle their war debts, regulate trade, and fend off foreign invaders. A movement for a federal system and central government had begun, and in 1787 a Constitutional Convention was called for Philadelphia.

The original idea was only to tinker with the Articles of Confederation. But greater minds had arrived with utopian plans in their pockets. There was a Virginia plan and a New Jersey plan, and by debate and compromise, the Constitution became a system that pitted one interest against another. None could tyrannize. It was state against national interest, individual rights against local prejudice. Courts, legislatures, and executives vied in theoretical repose. As one observer said, it was a system that would "run by itself." But for the same reason, it posited no deity and made no covenant. As one sad cleric would lament, "We formed our Constitution without any acknowledgment of God."[13]

At most, the Constitution barred religious tests for office and, with the later Bill of Rights, forbade an "establishment" of religion or obstruction of its "free exercise." For the time being, religious minorities had reason to celebrate. As ancient as they were, in fact, the Anglicans, Jews, and Catholics in the United States were just that, minorities. In sermons and in spirit, they celebrated their future in a new nation. In turn, America dropped its century-long fear of having a bishop of any kind, especially an Anglican bishop. The first man to hold that post was Bishop James Madison. He was a cousin of the Founding Father and now head of the newly organized Episcopal Church, a native Anglicanism. In 1795 Bishop Madison summed up his view of America during a fast day decreed by President Washington in his second term.

As in other sermons of the 1790s, the fact of the new nation was held in awe. But something else was noticed: a rise of disbelief at home and a French Revolution abroad. Bishop Madison attributed the American success to drawing on Christian and Whig principles from England, not the counterfeits on the Continent. His sermon, "Manifestations of the Beneficence of Divine Providence Towards America," argued exactly that point: providence had seemingly "thrown a veil over this portion of the globe" to be a place for the "regeneration of mankind."[14] America had undergone a "revolution unstained by fratricide." Still, scoffers had begun to exclude God from the founding, so Bishop Madison offered his contrary view of America:

She hath given to nations the first lesson by which their rights may be
preserved. . . . She hath established upon a rock, the empire of laws,
and not of men; if America, as a tender and affectionate daughter, is
ready, from her exuberant breasts, to afford the milk of regeneration
to her aged and oppressed relatives; [and] if these be effects worthy
of the divine interposition, then we will still cherish the fond idea,
we will cling to the full persuasion, that our God hath been, "our
strength, our refuge, and our fortress."

A lawyer, scientist, and surveyor as well as a priest, Bishop Madison was
in his eighteenth year as president of the College of William and Mary. His
message was not for the hoi polloi, the butchers and farmers alone, but for
the leading edge of American culture. He saw two things happening, and
foremost in his own church. He presided during one of the worst assaults on
Anglican property and prerogatives, and kept the helm as vengeful colonists
stripped the once-rich church of nearly everything. Still, Madison was a red-
blooded American. He urged the populace to keep its religion, now that it
had its political freedom. Public morality could not "trickle from the oozy
bed of political catechisms" but needed a "divine system." Must not virtue, he
asked, "gush, pure and in full stream, from the rock of our salvation?"

This led to Madison's second concern, which was the sophisticated skepti-
cism afoot in the land. He saw it every day as a college professor. The great
Founding Father Tom Paine had returned to England, was chased out again,
and landed in France, only to become a prisoner of the French Revolution-
ists. In the meantime, he had written the deistic—not exactly atheistic—*Age
of Reason,* and it was being widely read by curious Americans. It mainly
questioned as superstition many orthodox Christian doctrines.

For the small Jewish population, this doctrinal debate among Christians
was not an issue, though God and liberty certainly were. The first Jews to
arrive in New Amsterdam in 1654 were Sephardic, meaning Spanish and
Portuguese. The first known sermon occurred on a colonial fast day declared
by Puritan magistrates. Also, when the French were defeated in 1763, the
English-speaking *hazzan,* or prayer leader, of Shearith Israel Congregation
in New York preached a nationalistic homily like everyone else.

The *hazzan* who preached that day was Gershom Mendes Seixas, Ameri-
can Judaism's first public figure. During the Revolution, moreover, he orated
a "Prayer for Peace" that cited Washington, the "commander of the army."
And then came November 26, 1790, the first national Thanksgiving Day.

Thanks to Seixas, Jews had an auspicious voice. He preached from the Hebrew Bible, in which David made a "joyful noise unto the Lord." The Jews should do the same because the Constitution made them "equal partakers of every benefit that results from this good government." They were to support the government and be "living evidences of his divine power and unity," and "to live as Jews ought to do in brotherhood and amity, to seek peace and pursue it."[15]

The nation's Roman Catholics, having known just a brief stint of tolerance in early Maryland, felt almost as liberated as the Jews. The French crisis, moreover, gave them a special opportunity to unite with American purposes. It was a crisis to which the priest John Thayer, the "missioner" for Rome in Boston, paid close attention. By this time the Sulpicians, a French order, had fled to America and begun to establish Catholicism. Thayer was also the first of his kind, a Bostonian and former Congregational minister who had converted to Catholicism and traveled to France, the seat of Catholic learning, to train and be ordained. Returning to Boston, he founded the Catholic Congregation in 1788. He knew in great detail of America's conflict with France.

At first, much of America was on the side of the French. After all, the French had helped defeat the British army at Yorktown, ending the American Revolutionary War. But the French Revolution had gone terribly wrong. By 1793 the Great Terror had executed the king and queen. Then it turned on the Catholic church, not to mention a sympathetic Paine. He escaped France only by the intervention of some of his revolutionary allies from the glory days in Philadelphia.

Finally, in 1798, when the French Republic rebuffed American ambassadors (after trying to extract an enormous bribe), the two nations were on the brink of war. The American government had only one party at the time, to be known as the Federalists. But it was Federalist President John Adams who provided the justification for a permanent bifurcation of parties. First, he called George Washington out of retirement, tantamount to reorganizing an army for war. Then he decreed the Alien and Sedition Act, which made it a crime to criticize Federalist policy. In this, he sealed his fate. He came off as a tyrant, and in 1800 the anti-Federalists, to be called the Democrats, elected Thomas Jefferson. The factional split between New England and Jefferson's southern and western allies began to define the future of the United States.

Amid this political havoc, the Catholic priest John Thayer had his eyes on his own constituency, the six hundred Irish immigrants who made up his Boston congregation. Irish loyalty had been easy in the war against Britain but was not guaranteed in supporting the long-oppressive English royalty

against the French. Amid the French crisis, President Adams had declared May 9, 1798, a day of fasting and prayer. On that day, Thayer preached Catholic loyalty to the English alliance. It was not easy to bleach out the Irish hatred. He preached the evils of the French Revolution. It had killed three million citizens, he claimed, and shot, drowned, or guillotined thousands of priests and nuns.

> France appears to have been raised up by God for the chastisement of an impious world, [and] their object now clearly appears to be universal domination. . . . May we, then, never again hear from the mouth of any Irish Catholic, that he rejoices at every victory, and applauds every action, of the French, because they are the enemies of his English oppressors.[16]

Catholics should avoid not only people who fanned anti-British passions but also works such as Paine's *Rights of Man*. It was a licentious time, Thayer said, and duties rather than rights had to be emphasized. "A spirit of disobedience and revolt is strangely prevalent among children and servants. This is, at present, a very general complaint, and it is an abundant source of jacobinism in the state," namely in America itself.

Of all the religious groups in America, however, it was the New England clergy that struggled most with the new adjustments. Being the largest in number, and having more than a century of Puritan hegemony behind them, they faced the prospect of an infidel country and an infidel president. Theologically, the national government had not made a "covenant." The Constitution did not even mention God.

Still, the New England clergy were Federalist to a man. They felt good about a natural aristocracy and an America central to divine providence. They believed in a strong central government and, living in mercantile New England, a strong federal hand on trade, especially with the British, their own bloodline. They lauded Adams's fast day. But national traditions were changing. The election-day sermon, once universal, tended to fade as the presidential inaugural took over that spot. Washington's first inaugural address had the strong feeling of a sermon.

He delivered it on April 30, 1789, from the balcony of Federal Hall on Wall Street, New York City. Though Washington was a churchgoer, owning a pew, he was hardly an orthodox Christian. His voluminous papers included no mention of Christ, and as his inaugural revealed, he preferred "the Great Author of every public and private good," the "benign Parent of the Human Race," and similar divine honorifics:

It would be peculiarly improper to omit in this first official act my fervent supplications to that Almighty Being who rules over the universe, who presides in the councils of nations, and whose providential aids can supply every human defect, that His benediction may consecrate to the liberties and happiness of the people of the United States a Government instituted by themselves for these essential purposes. . . . No people can be bound to acknowledge and adore the Invisible Hand which conducts the affairs of men more than those of the United States.

By 1796, when Washington published his "Farewell Address" in Philadelphia and Boston newspapers, he, like the clergy, had come down to earth from divine providence, and argued the practical necessity of religion for social order. The address, written in consultation with three other Founding Fathers, articulated an enduring American argument:

Of all the dispositions and habits, which lead to political prosperity, Religion and Morality are indispensable supports. . . . A volume could not trace all their connexions with private and public felicity. Let it simply be asked, Where is the security for property, for reputation, for life, if the sense of religious obligation desert the oaths, which are the instruments of investigation in Courts of Justice? And let us with caution indulge the supposition, that morality can be maintained without religion. Whatever may be conceded to the influence of refined education on minds of peculiar structure, reason and experience both forbid us to expect, that national morality can prevail in exclusion of religious principle.

A decade before Washington's "farewell," Asa Burton of Vermont had driven home the same point in an election-day sermon: "Political virtue may serve as a support for a while, but it is not a *lasting* principle."[17] Here was the new focus of America's jeremiad, which remained at the center of American oratory and literature. From the 1780s onward, the jeremiad sermon sounded out on two things, the need for piety in the family, church, and school, but also a full-scale resistance to French atheism. In the Federalist version of this jeremiad, in fact, some of the Founding Fathers themselves were accused of being infidels, deists, skeptics, and even worse. Here was a drama custom-made for the Puritan preacher and scholar Timothy Dwight. It was Dwight who had so vociferously lamented a Constitution "without any acknowledgment of God."

A kind of genius, Dwight had graduated from Yale College as a teenager, was a military chaplain, local preacher, and finally the college's longtime president. He revived it as a center of learning but also as a place of old-fashioned religious awakenings, which he inculcated into his influential students. His imprint on New England Protestantism was indelible, for he reigned as Yale's clergyman-president from 1795 until his death in 1817. Dwight was author of the great "glory" poems and sermons about America, but it was a glory that he feared would be lost if Jefferson, a Francophile, were elected.

Two years before that happened, Dwight preached a July 4 sermon on the threat of the French apostasy and global conspiracy, "The Duty of Americans." Their duty was to revive religion, and he gave his listeners reason by interpreting the apocalyptic prophecies of the Bible.[18]

The French Revolution was no less than the Book of Revelation's "seventh vial," a tribulation to be poured out on a declining "Antichristian empire" such as France. Here was a sign of Christ's glorious return, he preached. The final judgment on such evil "certainly cannot be distant." Truth was the only weapon against the confusion of the age. He had no good words for Roman Catholicism, a waning empire in his view of providence. But the main villain was atheistic "philosophism."

Making matters worse, the philosophs had taken over the once "convivial" Freemasons, a British-based fraternal order with secret ceremonies drawing on the symbols of medieval stonemasons—and counting among its members Washington, Benjamin Franklin, and the anglophile Voltaire. More recently, Dwight went on, German rationalists had formed the Illuminati (Latin for *enlightened*), posing as a high order of Masons but spreading a message of disbelief, moral anarchy, and anticlericalism. To combat this, Dwight urged America to revive its custom of protecting the Sabbath. His crusade for Sunday laws was championed by reformist clergy for a century to come, manifest in attempts to close businesses and post offices on Sundays. In his own day, Sabbath religion was a bulwark against European infidelity:

> Where religion prevails, Illuminatism cannot make disciples, a French directory cannot govern, a nation cannot be made slaves, nor villains, nor atheists, nor beasts. . . . Our enemies must first destroy our Sabbath. . . . Shall our sons become the disciples of Voltaire, and the dragoons of [French revolutionary] Marat [de Sade]; or our daughters the concubines of the Illuminati?

The worst was still to come, however. Against Dwight's fondest hopes, Jefferson and the Democrats won the presidency in 1800. It seemed like the

Illuminati had won. For the first time, the great "covenant" of New England was on the defensive. A nation of diverse religious voices had created different systems, some Federalist, some Democratic; Puritans here and dissenters there. Belief and disbelief lived side by side. The solution was to keep preaching and swing America in the right direction. That battleground soon became the western frontier.

One cause of the American Revolution had been the colonists' disinclination to obey British dictates to stay along the coastline. They were not to go inland, riling Indian problems, and this peacekeeping mission was one reason England had sent a standing army to the colonies. Now the frontier was wide open and expanding at incredible rates. It was fertile terrain for the proselytizing sermon. The sermon that could speak in the frontier tongue, and catch the frontier spirit, was bound to hook a new breed of American.

II

National Period

(1800–1900)

How the nation moved west, populist preachers denounced elites, and elite preaching imposed order on cities and backwoods America. How an age of oratory began, sects multiplied, and utopian dreams became frontier experiments. How military heroes eclipsed orators and America found its "Manifest Destiny." How itinerant preachers and camp meetings tamed the frontier, and gave their methods to political parties. How polite "revivals" stirred New England, women gained a voice, and liberal religion was born. How democracy defeated Calvinism. How mass evangelism hit small commercial towns, abolition arose, and slaves preached revolt. How Catholics and Jews got their voice. How the North and South claimed chosenness, began a civil

war, and were mystified by God on the battlefield. How the South's "lost-cause" religion arose. How the urban North faced immigrants and Darwinism, and "princes of the pulpit" preached to wealthy classes. How urban evangelism saved souls and garnered headlines, and how the Social Gospel fought capitalism, Catholics backed labor, and populist movements became Christlike. How America declared Anglo-Saxon greatness in the face of foreign cultures, claimed colonies, and sent missionaries.

The Movement West

Frontiers of Sect, Class, and Sex

WESTWARD EXPANSION STRAINED THE IDEA OF A SINGLE American nation. The sermon encouraged this fragmentation, but it also tried to forge a national identity. It depended on who was doing the preaching. In the early national period, the number of preachers who had something to say increased exponentially.

The frontier culture was born when Americans crossed the Appalachians. To the south, thousands of pioneers took packhorses through the Cumberland Gap, where Virginia met Tennessee and Kentucky. One of those families was the Cartwrights of Virginia. Their young son, Peter, learned to preach by watching a new type of character on the frontier: the rugged itinerant. Peter Cartwright became one of the greatest of these religious vagabonds, typifying the national response to frenzied expansion.

The Cartwrights migrated to Daniel Boone's land of "turkeys and canes." They rented a farm in central Kentucky, then drifted south to Logan County on the state border, a place known as "Rogues' Harbor." Life was uncertain and violent. Peter was a "wild and wicked boy," playing cards, racing horses, and dancing. But by seventeen his heart had changed, and as a Methodist circuit rider, he was as quick with his fists as with his tongue. His family had

fought Indians, thieves, and exposure to reach Kentucky, but Peter contested frontier infidels, heretics, and assorted "errorists" such as Baptists, Presbyterians, and Mormons. He became a preaching legend.

The movement West was a national phenomenon. Most settlers through the Cumberland Gap carried their north-Britain customs westward. The Quaker culture of the middle colonies moved inland as well. By 1811 the federal government had begun building a National Road from Maryland to Missouri. The Erie Canal, connecting Albany and Buffalo, opened in 1825, and by boats and mules New England culture seeped into western New York and Ohio.

The nineteenth century was a period for unifying a continent. It began as a trickle of brave families cutting through forests, opening the frontier. During this process, the East Coast churches treated the trans-Appalachian settlements as missions, and they used the same method: itinerant preachers and public revivals. The Cartwrights had settled in a revival hot spot of Kentucky. In the spring of 1801, a Presbyterian "log college" missionary there began holding "sacramental meetings," which overflowed the log church. Peter, age sixteen, walked the five miles to investigate and was converted. "I went, with weeping multitudes, and bowed before the stand, and earnestly

The vernacular preacher Peter Cartwright confronted every kind of frontier disbelief and sect in his colorful career.

prayed for mercy."[1] Peter learned the genius of the "camp meeting." The greatest of them all came later that year.

Two hundred miles north of Logan County, a log meetinghouse stood at Cane Ridge, where cane bushes grew on the hilly crests of a dense forest. In August 1801, another Presbyterian meeting spilled out the doors at Cane Ridge. As more preachers arrived, and more stages and benches were erected, twenty thousand people poured in for a "protracted" summerfest and revival. Lasting several weeks, it featured fiery preaching, singing, eating, sleeping in wagons, shouting, running, and fainting, and not a little mischief and courtship. For some, the storied "love feast" of north Britain had come to America.

No one used the camp meeting better than the Methodists. Their first bishop, Francis Asbury, created the most rugged band of itinerant evangelists America had ever seen. They had hundreds of camp meetings going each year. "Methodist preachers were the pioneer messengers of salvation in these ends of the earth," Cartwright said accurately enough. That western earth was made up of Tennessee, Kentucky, Ohio, Indiana, and Illinois, and by their itinerant adaptability, Methodists got to the new settlements first. Any denomination of equal flexibility reaped success. In the first decades of the nineteenth century, the Methodists, Baptists, and Presbyterians far surpassed the memberships of the Congregationalists, Anglicans, and Quakers, who were more stationary and more wedded to formal education.

Despite its national government, the United States still was an assemblage of parts. The reigning ideology was liberty, defined a little differently by everyone. The pursuit of liberty set rural against urban, popular against polite, downtown against uptown. Americans bent their ears to a cacophony of interpreters, from preachers to politicians. In Congress, the orators Henry Clay of Kentucky, Daniel Webster of Massachusetts, and John Calhoun of South Carolina held audiences transfixed. When the tall white-haired Indian fighter General Andrew Jackson rode into Washington, D.C., as president in 1829, Jeffersonian democracy *and* Jacksonian democracy merged into a new spirit of the age.

These forces shaped American sermons. In turn, the preachers sculpted a new national rhetoric as well. Americans were in search of an identity. Different sermon styles divided the population into sects. Ways of preaching defined social ranks as much as anything else. There were highbrow and lowbrow sermons. In both cases, though, three great theological questions seemed to dominate this turbulent era. First, was salvation for the elect or

The lone circuit preacher, usually young and
single, was used by eastern denominations to
"civilize" the backwoods.

for everybody? Second, was religion primarily an individual experience or a
social affiliation? Finally, was salvation achieved instantly or gradually?

When Cartwright began his horseback circuit between "preaching sta-
tions," he was certain that Methodism had the answer. He quickly gained
a reputation for this unabashed confidence, and in maturity became a noti-
cable figure when he rode or strutted into a settlement, his complexion dark,
his black eyes deep set, and his jaw resolute. He wore a wide-brimmed hat,
white and soiled, and when it was off, his hair was always unruly. Cartwright
met every new social and religious current that the American frontier had to
offer. After fighting off rowdies, he debated skeptics. Then he battled "blas-
phemous doctrines" of rival sects. He vied with Campbellites and "Chris-
tians" who said the Bible was the only creed. He preached at Millerites who

predicted Christ's return, and roiled with working-class Universalists from New England and New York. In time, he met utopian Shakers, Rappers, and Mormons, and once debated "Uncle Joe" Smith, the Mormon prophet.

In these encounters, Cartwright had an answer to the three theological questions. Everybody could be saved, according to the Methodist use of Arminian, or free-will, doctrine. What was more, conversion was individual and instant. But afterward a believer should join a church and follow its doctrines. His favorite debating partners were the hard-shell Baptists and Presbyterians, who preached Calvinist election. Cartwright simply aimed his "Arminian artillery against their Calvinism," for the idea of democracy in salvation had great American appeal.

Lesser doctrines also were worth fighting for. In eastern Tennessee, the clash between Methodists and Baptists over baptism was legendary. It provided frontier entertainment. In 1804 three Baptists coaxed a settlement into full immersion. Cartwright rushed to the rippling creek to mount a challenge. "I cannot submit to be rebaptized," Cartwright declared. He had the sprinkled baptism of a Methodist. The Baptists retorted, "That is no baptism at all!" While the Baptists went to the meetinghouse to denounce Cartwright, he mounted a log outside. "The crowd gathered around me," he said. "I showed them the inconsistency of the Baptist preachers." He began Methodist conversions, and in a year his "Baptist friends blowed almost entirely out."

Nearly two decades later, Cartwright was still at it, fighting Baptists at a massive camp meeting, estimated at ten thousand, gathered in a poplar grove on the Goose Creek Circuit in Kentucky.[2] He was slated to preach at 11:00 A.M., and as a Baptist preacher waited his turn on the same preaching stand, Cartwright lowered the boom. "I took no text in particular," he said, but opened with four points: the purpose of baptism, who administers it, its proper mode, and finally this—"that all infants had the first and only indisputable title to baptism," for all adults had to undergo a conversion.

> Is not that Church which has no children [members] in it more like hell than heaven? If all hell was searched, there would not be a single child found in it; but all children are in heaven; therefore, there being no children [membership] in the Baptist Church, it was more like hell than heaven.

At this, the Baptist preacher rose to interrupt, Cartwright shouted back, and there may have been a scuffle. Either way, the crowds got what they wanted, and Cartwright claimed to have had a captive audience for three hours.

Although doctrine divided Methodists, Baptists, and others on the frontier, their humble station united them. Frontier preaching was as much about social class as anything else. Every frontier preacher lampooned city dwellers. They were effete, and their clergy even worse, especially in New England. Cartwright met his first Yankee on a circuit in east Ohio. What he had heard was true, for Yankees "could not bear loud and zealous sermons, and they had brought on their learned preachers with them, and they read their sermons, and were always criticizing us backwoods preachers."

For years, the frontier preachers resented how the missionary publications in the East portrayed western life as barbarous. Late in his career, though, even Cartwright had to acclimate to a city audience when he traveled to Boston for a national Methodist meeting. His preaching reputation had preceded him, but he felt stunted by the formal worship he encountered. Organs blared. Choirs performed. Men and women mixed in the pews. Cartwright toned down his sermon, and he paid the price. "Brother, we are much disappointed," the worshipers told Cartwright, the vaunted "pioneer" of the West. "We expected to hear a much greater sermon."

So he gave the Boston crowd what it expected. His next sermons used "Western anecdotes, which had a thrilling effect on the congregation, and

Anchored on preaching, camp meetings were social and emotional
events that arose by the thousands.

excited them immoderately, I cannot say religiously; but I thought if I ever saw animal excitement, it was then and there." Cartwright had delivered the colloquial sermon common to the frontier. It had folksy language and homespun tales. In these sermons, preachers made up wild stories, cracked jokes, attacked backsliders and heretics, and talked about barnyard life. The circuit preacher preceded the stump politician in this. Before long, the arts of preaching and political campaign speaking became interchangeable.

As Cartwright wandered the West, another kind of revival was taking place in the cultured centers of America, especially New England. It was not the revival of camp meetings and "Methodist fits," with their jerks, shouts, running, and the rest. The New England battle was not over baptism, but the doctrine of free will. Eventually, as will be seen, Cartwright himself entered these precincts of middle-class revivalism, where coat and tie, manners, and doctrinal subtlety prevailed. Cartwright never fully came around to this, but in New England he had a revivalist counterpart who was also worthy of the name. He was Timothy Dwight, the preacher-president of Yale College in New Haven, and his story was woven into the religious origins of the future Ivy League.

For a century already, Yale and Harvard had divided their turf. The liberals, who believed in reason and free will, had taken control of Harvard, so Yale was erected on Calvinist foundations in 1701. When the Harvard Divinity School became still more heterodox, the Calvinists there fled into the woods to open Andover Theological Seminary in 1808, the first Protestant "seminary" in America. Between Yale, located by an urban port, and Andover, off in the Massachusetts wilderness, the strict Calvinists had established their axis of influence. For the next fifty years it would do battle with Arminians, namely Methodists, and the "liberal system" of drifting Congregationalists.

At Yale, Dwight maintained New England's Federalist loyalties, upper-class predilections, and desire to have a "second" Great Awakening like the first. As New Englanders moved to the frontiers of Ohio, western New York, and southern Michigan, Dwight's allies moved Calvinist revivalism along the same route. For efficiency, Congregational and Presbyterian leaders agreed to a Plan of Union in 1801. The new "Presbygationalism" would share churches and clergy, uphold Calvinist election, and deal with the Arminian hordes, or Methodists, who drifted north.

A few years before Dwight died, his most famous student, Lyman Beecher, took up the mantle of revival. Ordained in 1799, Beecher served both Presbyterian and Congregational churches, and then he too moved West, helping found Lane Seminary in Cincinnati. Beecher's idea of revival was the creation

of religious societies for the "suppression of vice." He famously preached against dueling when Aaron Burr shot Alexander Hamilton, and he issued America's first sermon series on temperance, or abstention from alcohol.

The Calvinist watchdogs, however, were never at rest. The Presbygational system collapsed in 1837, mainly because of Old Light objections to creeping liberal, or Arminian, theology. Soon after Beecher arrived at Lane, he too was subject to heresy charges. The problem began in 1823 when he delivered a sermon on "The Faith Once Delivered to the Saints." As Dwight's leading student, Beecher had been a firebrand against the "liberal system," as the sermon title suggested. But he had opened his mind to free will.

New England was coming under the sway of a "new divinity," and some of it emanated from Yale. It emphasized God's "moral government" of the universe. In strict Calvinism, the glory of God was his arbitrariness. Moral government suggested reliable universal laws and free choices by human beings who, by their own volition, could follow God's principles, the highest being the "disinterested benevolence" of love. This divine system matched democracy, Beecher suggested.

> Men are free agents, in the possession of such faculties, and placed in
> such circumstances as render it practicable for them to do whatever
> God requires, reasonable that he should require it, and fit that he
> should inflict literally the entire penalty of disobedience. Such ability
> is here intended as lays a perfect foundation for government by law,
> and for rewards and punishments according to deeds.[3]

This sounded Arminian. Beecher had crossed the divide. So once he moved West, he stayed there, and Lane Seminary also liberalized. But the true "liberal system" still threatened the faith in New England, and the Calvinists took action in 1815. They labeled the dread liberal system "Unitarian."

At the time, the term *Unitarian* applied to doctrines developed in Poland and England. In London in 1791, the scientist and former Presbyterian minister Joseph Priestly had formed a Unitarian Society. He was ostracized for commending the French Revolution and, as a friend of Jefferson's, moved to Pennsylvania in 1794, where he started a small Unitarian circle. The liberal system was larger than Priestly's exploits, however. It had emerged among Anglicans, Presbyterians, and others as an all-points attack on strict Calvinism. Jonathan Mayhew's West Church was the first Puritan hub to go Unitarian. King's Chapel, the first Anglican parish in Boston, did likewise in 1785 when it removed the Trinity from its liturgy.

Finally, though, it was a young minister at Federal Street Congregational Church who stepped forward to grapple with the orthodox name-calling. In 1819 William Ellery Channing gave an ordination sermon that proudly accepted the Unitarian label for a certain "class of Christians in our country." The sermon was a manifesto of their beliefs. Channing had traveled to Baltimore for the ordination of Jared Sparks, who would serve a small Unitarian society there, and he preached on "Unitarian Christianity."[4] Channing zeroed in on two themes, the first being rational use of the Bible, which he viewed as a "successive revelation" culminating in the New Testament.

> Say what we may, God has given us a rational nature, and will call us to account for it. We may let it sleep, but we do so at our peril. Revelation is addressed to us as rational beings. We may wish, in our sloth, that God had given us a system, demanding no labor of comparing, limiting, and inferring. But such a system would be at variance with the whole character of our present existence.

By such laboring over the Bible, Christians came to a second realization. They found neither an arbitrary God nor a depraved humanity. They found a beneficent Creator, a loving and wise Jesus, and a progressing human nature. The new doctrine of Jesus exceeded even the offenses of Arminianism, for it revived the ancient Arian "heresy" that Jesus was foremost a human being. For Unitarians, Jesus came to teach the unity of God, not his triune multiplicity.

> We believe, that he was sent by the Father to effect a moral, or spiritual deliverance of mankind; that is, to rescue men from sin and its consequences, and to bring them to a state of everlasting purity and happiness. We believe, too, that he accomplishes this sublime purpose by a variety of methods.

In other words, Christians could charitably disagree on the exact mechanism of salvation, which might include moral instruction, forgiveness of sin, divine assistance, and the exemplary life of Jesus. The next year Channing formed the Berry Street Conference, and by 1825 these ministers led 125 congregations into an American Unitarian Association. Eventually, eighty-three of the oldest one hundred Congregational churches in New England joined the Unitarian fold. A golden age of Unitarianism began. It was a fountainhead of culture and religious liberalism. But by its second generation, it received a few bad reviews as chillingly rational. The Unitarians tried to reach

the frontier—Cartwright never met one there—and had moments of growth in the South. But a jest about their beliefs—the fatherhood of God, brotherhood of man, and "vicinity of Boston"—remained largely true.

On the frontier and in the city, Americans faced the challenge of creating a Christian culture, which meant a disciplined and decent culture. The orthodox and the liberals both made a contribution. The first was by hellfire preaching and moral courts on the frontier. The second was by the movement for "self-culture." If Cartwright's preaching and Lyman Beecher's "suppression of vice" societies reflect the first contribution, Channing's famous Unitarian discourse on self-improvement in 1838 stood for the second.

In 1838 the willowy Channing spoke in Boston before a working-class audience, the mechanics, mill workers, and stevedores that made New England run. The surprising title of his two talks was "Self-Culture," addressed to "the great fraternity" of the proletariat.[5] Self-culture, he said, simply meant growth, and his Boston talks foreshadowed all the future strains of optimistic humanism in American thought. He gave definitions and advice. Human virtue arose from the conscience. The conscience was aroused by duty and by creative learning. In a class-conscious age, a time in which capital and labor were political enemies, Channing said self-improvement was a sure path to happiness, surer than a revolution or ballot box.

Self-culture had many benefits. The abilities to speak well, appreciate beauty, and find material success were only a few. Self-culture was accessible. Read "superior minds" in books, he advised, and garner reliable information from good newspapers. But the true end, Channing warned, was not wealth. It was a true self. Christian religion was essential in this, he went on, and its highest ethic was a benevolent "disinterestedness"—love without self-interest.

Channing acknowledged criticism of his working-class program. Laborers faced physical exhaustion. They lacked leisure time. When they had it, frivolous entertainment was much preferred. Still, Channing recommended libraries and the theater. As labor organizers saw it, he was foisting a "pastoral" view on the workingman, preaching contentment when the proletariat needed a revolution. Indeed, Channing advised against political upheaval. "Party spirit is singularly hostile to moral independence," he told his audience. "Let not class array itself against class, where all have a common interest."

The idea of cultivation and "politeness" was not entirely alien to America. Its colleges had always had the classics, and figures such as John Witherspoon had spread Scottish moral philosophy, with its Christian instruction in proper

speaking, conduct, and citizenship. The push for politeness met a crying need in America's new society. Since the Revolution, its citizens had dropped all obsequious deference to "betters." The nation needed a substitute. It needed egalitarian good manners to referee a world of acquisitive striving. From Beecher to Channing, sermons on good manners became abundant, as were moral reform groups, printed etiquette books, and child-rearing manuals for anxious parents.

Still, politeness was a hard pill to swallow on the frontier. That went for evangelists as well. They suspected a new snobbery. The frontiersman smelled the same thing. They remembered how in Virginia, for example, the "effeminate" piety of the missionaries tried to rein in the manly life of the Cavalier.[6] Such a man enjoyed drink, property, women, and brutality. Knife fights and dueling upheld honor, and violence kept everyone in his place. To these rough-and-ready sectors of American culture, the new polite culture looked bookish. The frontier operated on an oral culture. It was loud, expressive, and emotional, and it respected audacious actions.

Peter Cartwright, a friend of the frontier, nevertheless soon had to take on the new American niceties. He successfully ran for state office in Illinois. Then, despite attempts to brand Abraham Lincoln as an infidel, he lost to him in the 1846 election for the U.S. House of Representatives. Lincoln said he liked to see a preacher "act as if he were fighting bees," and he may have had Cartwright's ilk in mind. As Cartwright accommodated himself to city manners, calm oratory, and stuffy worship, he lamented a "Yankee triumph." The frontier churches, once proud of their lowly, illiterate origins, gradually became decorous.

One reason was this: the literary culture of New England spread as quickly as the itinerant revivals. Literacy was not a monopoly of the elite. Circuit riders also were sellers of religious books. Religious newspapers and tracts were the first mass reading materials, dumped in bundles at every frontier hamlet and waterfront. Inevitably, the Methodists and Baptists after Cartwright valued learning, professionalism, and social rank. They turned camp meetings into summer conferences. Before the Civil War, Methodists founded more than thirty colleges and the Baptists more than twenty. The second religious awakening, unlike the first, produced institutions. Many a fiery evangelist retired a college president.

By all accounts, Arminian theology had won in America. It was the democratic faith, even as the mystery of election lingered on. The other two questions remained: Was salvation immediate, as revivals taught? And did

it involve a social experience as well? One 1813 sermon, preached at Park Street Church in Boston, put the first theological puzzle rather well, asking "whether regeneration is progressive or instantaneous."[7]

Being "born again" was nothing if not instantaneous. Ever since George Whitefield traveled the colonies, Americans had wanted things quickly. They wanted independence now, and then reform as quickly as possible. That American instinct was not mitigated until the late nineteenth century, when natural science proffered the theory of gradual evolution. But there were early signs. In colonial Connecticut, Thomas Hooker proposed a "preparation" for salvation, which could take months or years.

In a quirk of history, nearly a century after Hooker founded Hartford, the baton of "progressive" regeneration was taken up by another preacher of that city. He was Horace Bushnell, a Congregationalist trained at Yale and a popular preacher at North Church for most of his life. Bushnell shocked New England with the assertion that immediate conversion was not needed to be a Christian. The "new birth" could be ingrained in children through the organic means of the family. Bushnell preached that God offered grace through nature. By implication, revivals were not necessary. "The child is to grow up a Christian, and never know himself as being otherwise," he finally declared in *Christian Nurture,* a book that the Massachusetts Sabbath School Society swiftly pulled from circulation.[8]

Bushnell had answered the great theological question this way: salvation was gradual and organically tied to the family. In his lifetime, that view did not prevail. The revival held sway. Immediate conversion was a strongly held American doctrine. At the least, Bushnell was the rare American preacher who conducted popular and creative theology from his pulpit, not in the academy. The age called Romanticism had begun in Europe, and so had the new critical study of the Bible. Bushnell was first to infuse some of these sentiments into American preaching. He read Samuel Coleridge, the Romantic poet of England, and was persuaded that religion spoke to the human faculty of "intuition," not primarily to logic or reason.

Human language, in fact, was at best an approximation. It provided symbols for higher spiritual truths, and so it was with the Bible and theology, Bushnell argued. In the tradition of preaching, Bushnell wrote his sermons more as an art form than as a legal brief, even though he had studied law at Yale. It was his rejection of rationalism, he testified, that had saved him from religious doubt and that gave his preaching power throughout his life. His view of language, which revolted against generations of Puritan scholasticism, put him in trouble when he spoke about God and the Trinity, how-

ever. Calvinists accused him of heresy—but in Congregationalism, the local church rules, and he had North Church's lifelong support.

Bushnell served a congregation of merchants who were not curious about theology. But they were very interested in how to rear children. By answering this concern, Bushnell made his historic contribution to theology: salvation was gradual and it took place in a social context. A spare, sinewy man, Bushnell wrote his sermons in full and tended to swing his right arm in delivery. His gaze was almost ethereal, with gray eyes fixed under dark eyebrows and a broad forehead. He preached his ideas weekly, and eventually wrote them down. In the long run, the idea of Christian nurture shaped mainline Protestantism. Knowing God in Christ required "imagination," he preached in 1848, for it was an intuition that eluded pat doctrines.

> For the scriptures offer us the great truths of religion, not in propositions, and articles of systematic divinity. They only throw out bold and living figures, often contrary or antagonistic in their forms, the truths to be communicated. Language is itself an instrument, wholly incapable of anything more adequate, [requiring] a heart so quickened by the Spirit of God, as to be even delicately perceptive of God's meaning in the readings and symbols he gives us.[9]

For all his liberalism, Bushnell was deeply ingrained with the prejudices of New England Protestantism. He enthused over a politically Christianized America. During the Civil War he took an organic view of the society, saying that the death and destruction were an expiation for the sins of the entire American nation. As with all evangelicals, he was anti-Roman Catholic, especially after a trip to Rome. He wrote a critical letter to the pope that ended up on a banned index. But if the evangelicals of his day said Catholic settlements were the greatest threat on the frontier mission field, Bushnell disagreed: he saw "barbarism" as the chief menace in westward expansion. Later in life, he preached against equal rights for women, calling their suffrage a "reform against nature."[10]

In this era, women's role in society had become a part of the debate over salvation. During the First Great Awakening, the most dramatic examples of personal salvation recounted by Whitefield and Edwards, for example, had been women. Women certainly could be saved. They could be among the elect. They could testify to instant grace. But could women save others through speaking publicly? On this one, Bushnell would lose, for in Jacksonian America everyone had a voice. For women, it began among female

preachers. They were few in number, but what they started would end, a century later, in women's vote.

If Cartwright had not seen any Unitarians on the frontier, neither did he recall any female preachers. It was different in Philadelphia and New York. In those settings, two of the era's most significant lady orators got their start. The Quaker activist Lucretia Mott and the Methodist laywoman Phoebe Palmer were not the first to exhort up and down America, but they were the most consequential.

Since the days when the Society of Friends "quaked" and protested dead religion in England, critics of religious free-speakers had disparaged the "Quaker spirit." For much of American history, most female preachers had indeed appeared in dissident movements. Quaker missionary women preached in Manhattan, and one who would not cease in Boston was hanged. Up to the Civil War, female exhorters typically appeared in the ferment of Free Will Baptists, Millerites, the working-class Christian Connection and Universalists, utopian Shakers, the underground black church, and break-away Methodists.[11]

Mott and Palmer breached the walls of their official denominations, how-ever, and the impact was lasting. They became irrepressible public figures. This was accomplished by preaching, or what Palmer coyly called speaking in "social assembly." Like Mott, Palmer had to skirt the conventions of her time. "Preach we do not; that is, not in a technical sense," Palmer explained. "We would do it, if called; but we have never felt it our duty to sermonize in any way by dividing and subdividing with metaphysical hair-splitting in theology." Women felt like Mary, who simply "proclaimed a risen Jesus to her brethren."[12] The two women, fourteen years apart in age, with the older Mott born in 1793, shared a common task but probably never met, so differ-ent were their religious circles. In her own way, each reinterpreted the Bible in favor of female leadership, and then put it into practice.

The daughter of a Quaker sailor on Nantucket Island, Lucretia Coffin saw her first woman "preacher" as a youth when Elizabeth Coggeshall, a "public Friend," or traveling teacher, came through the sandy and windy precincts. Lucretia attended Quaker schools in Boston and Poughkeepsie, New York, and became a schoolteacher herself. When she married Quaker businessman and minister James Mott, they moved to the heart of American Quaker life, Philadelphia. Over their lifetimes, which included rearing several children, James excelled in small factories and, before long, Lucretia was recognized for her own "public" gift.

In early 1821 the Friends Meeting in Philadelphia licensed her, at age twenty-eight, as a teaching minister. She read the Bible and the works of

William Penn, the founder of the Quaker colony, and adored the sermons of William Ellery Channing, the Unitarian. Quakers did not have pulpit preachers. They had elders who often stood in quiet Sunday meeting to share inspiration, and public teachers who traveled, taught, and counseled. As a Quaker, Mott was quiet by nature. She was more amenable to the inner light than to the American Calvinism all around her.

But fiery Quaker preaching there was, and the exemplar of that day was Elias Hicks, a public Friend with a reformist temperament. He preached against slavery and urged Quakers to boycott slave products, such as cotton and sugar. In 1825 Mott and her household supported this "free labor" policy. Hicks constantly traveled, and once had lodged at the Motts' home. But his tour through the Philadelphia Yearly Meeting in 1827 forced even the peace-loving Motts to take sides in a Quaker schism that had roots abroad.

In England, where the London Yearly Meeting had parental status, the evangelical movement had united with the Tory party, and the Quakers were going along. Whereas once the Quakers had adhered to a free spirit and "Inner Light," now in London they mirrored Christian orthodoxy. They upheld the Bible, human depravity, the divinity of Christ, and a doctrinal conversion. The Quakers in America felt this pressure, and it only took Hicks to split them wide open. He preached the Inner Light. He was followed by the "country party," a wing of Quakers who also preferred an open, socially progressive ideology. The "city party" of well-to-do Philadelphia Quakers, however, followed the London church's orthodoxy.

As a result, a split ran through most Quaker communities in the United States. In Philadelphia, the larger group went with Hicks. They met at the red-brick Carpenters Hall downtown. The Motts deplored the "party spirit" but followed Hicks as well. They had breathed the democratic vapors of the Jacksonian age, and Lucretia felt a new freedom for activism on slavery and women's rights. She headed the women's meeting of the Philadelphia Hicksites. When they sent an appeasing letter to London in 1830, Mott suggested a change in grammar. She replaced "brotherly" with "friendly" and "brethren" with "brethren and sisters."[13] Even for Hicksites, this was too radical. London decreed them as heretics anyway.

Mott was now forty. She was surrounded by a faithful husband and all her children, but a new reformist company as well. Amid the sundry causes, she broke bread with radicals, doubters, and experimenters. In August of 1830, the Motts entertained a young "stranger" at their Samson Street home. William Lloyd Garrison, a journalist, had just escaped libel charges in Baltimore. The Motts agreed with his abolitionism, but not always his rhetorical methods. A New England churchgoer, Garrison had imbibed the conversionist spirit.

Slavery was sin. Sin must be expurgated immediately. He returned to Boston and founded the *Liberator,* the nation's most strident antislavery organ.

When Garrison called the first convention of the American Anti-Slavery Society in 1833, Mott was barred from attendance because she was a woman. In response, she helped organize the Philadelphia Female Anti-Slavery Society. Until the national society opened to women, she ran an Anti-Slavery Convention of American Women. When it was held in Philadelphia on May 15, 1838, a mob stormed Pennsylvania Hall, built by reformers, and burned it to the ground. They were incensed by reports of "amalgamation," or racial mixing, since a black woman had attended. The mob headed for Mott's house but was diverted and burned down a black church instead. Such incidents became routine. Mott faced mobs in Manhattan, and she charmed the gangs of New York. But it was the taunt of "imperious woman," she said, that nearly ended her preaching.

The reformers fought each other as well. With limited resources, they were forced to choose between slavery and women's rights. That volcano erupted in 1840 at the World Anti-Slavery Convention in London. The event barred women, including Mott. She preached at Unitarian churches instead. It was there that Elizabeth Cady Stanton, another scorned American delegate, heard Mott's rousing oratory. On leaving London, Mott suggested that they hold a women's rights conference in the United States. It took until 1848 to happen. When the women assembled for two days at the Wesleyan Methodist Church in Seneca Falls, New York, Mott gave the opening oration. The fruit was a Declaration of Sentiment, the first document for women's rights in America, and a trial balloon for the women's vote, an idea Mott reemphasized the next year in her "Discourse on Women."

Until a remarkably late age, Mott mounted horses and carriages and traveled the West. She orated and preached. In all, her modest image and character let her radical message reach moderate minds. She took on Bible interpretation, for example, at the Cherry Street Meeting House in Philadelphia in 1849:

> One of the abuses of the Bible . . . has been to bind silence on women in the churches, fasten upon her that kind of degrading obedience in the marriage relation which has led to countless evils in society and indeed has enervated, and produced for us a feeble race. Oh my friends, these subjects are subjects of religious interest and of vast importance. I would that there were successors coming forth in this great field of reform.[14]

Despite such boat-rocking, Mott was the perfect antidote to the more radical ladies who also burned great reputations on the populist speaking circuits. Fanny Wright, an irreligious English radical, traveled America stirring up Democratic worker's parties. Later came Victoria Claflin Woodhull, a spiritualist and publicist who advocated free love. In contrast, Mott was the dowdy church worker, a Quaker bonnet on her head and "thee" and "thou" on her lips. She had a nonthreatening edge in the revolution. After the Civil War, in 1869, the women's movement broke over these stresses. One branch went secular and radical, while the other worked for success in the conventional mainstream of mothers, daughters, and wives.

The conservative Methodism of Phoebe Worall, reared in lower Manhattan, could not have been more different from the Quakerism of Philadelphia. After Phoebe married the prominent doctor Walter Palmer, about the time of the Hicksite split, she began to make her mark on women's rights as well. The Palmers and their children lived their entire lives in lower Manhattan, showing that religious revivalism was not confined to the frontier. They attended Allen Street Methodist Church, at which Phoebe and her older sister, Sarah, caught the Spirit. Having moved their two families into one house at Rivington Street, the sisters held "Tuesday Meetings for the Promotion of Holiness."

Phoebe Palmer founded the holiness movement and showed that women could interpret the Bible and preach.

As Methodists, the sisters had one of John Wesley's unique doctrines to draw upon, and that was "sanctifying grace." The founder of Methodism believed that this "second" grace came after conversion and led to a holy and happy life. In 1835 Sarah declared that she had received sanctification in the prayer revival, and by the summer of 1837 Phoebe also declared her own "Day of Days." From that point forward, Phoebe Palmer was America's powerful advocate of second birth. She heralded a Christian perfection after conversion.

The knotty question, even for Wesley, was how to know of the "second" regeneration. Wesley said the first conversion came by a "strange warming" in the heart, and the second rebirth also had an emotional impact. At this point, Palmer offered a theological innovation. She said "sanctifying grace" was not emotional but simply a grasping of the promise of Scripture. That moment came by an individual's "altar covenant." It was a willful act of devotion. But it also needed a lifelong reinforcement by holiness, devotion, "entire consecration," and testimony of the sanctification experience. This was Palmer's "altar theology," and it began a revolution later called the holiness movement in American Protestantism.

Palmer's influence pulled her way beyond Manhattan. She keynoted revivals, a more sedate form of camp meeting, until about 1844. She and her sister also revolutionized American publications with such journals as the mass-circulation *Guide to Christian Perfection,* later called *Guide to Holiness.* Phoebe's talks became books, making it easier for critics to document their objections, which were many. Sanctification had to be emotional, critics said, or how would you know? Altar theology was a "shortest-way" gimmick. It was a throwback to Jewish altars. It was erroneous to say that "testimony" was required to halt backsliding. By setting apart a "sanctified" few, Palmer sowed division among the many.

But despite the naysayers, the Palmer phenomenon bore fruits. Holiness became an engine of social service. The sanctified visited prisons. Palmer and her husband were bound for China as missionaries, and when held back in 1847, funded others. They moved to the slums, helped revive a dying church, and opened Five Points Mission in that notorious gang haven. Her teachings gave rise to a dozen "holiness" denominations. They influenced new colleges, and were a seedbed for future Pentecostalism. The ideas also crossed the Atlantic. In England, Palmer inspired Methodists to found the Salvation Army in 1878.

Naturally, she faced male resistance in the churches. She did not advocate a secular feminism, or even "women preaching, technically so called."

But she pioneered feminism. She wrote the first extensive defense of women speaking in church. When Saint Paul admonished women not to speak in Corinth, she explained, it was a particular case, not a general principle. Paul had opposed usurpation of authority in crazy Corinth, not women prophesying in principle. She listed the cases of prophetic women in the Bible, and using the new critical methods, explained the historical context of the New Testament, including its patriarchy. She even tinkered with Bible language. From Romans, she changed "kinsmen" to "kins-folk."

As a speaker, Palmer had evolved from prayer-meeting testimony to rousing talks at revivals. But as her message matured, it has been left to history entirely in written works. None is better known than *Tongue of Fire on the Daughters of the Lord.* The popular book, which updated an essay collection from 1859, became a manifesto for women preachers and orators. Palmer more than anyone else established the Book of Acts, with its dramatic account of Holy Spirit baptism, as the key justifying text for women speaking "as the Spirit gave them utterance."[15]

> Please turn to the first chapter of the Acts of the Apostles. We see the number assembled in that upper room was about one hundred and twenty. . . . Let us observe that here were both male and female disciples, [and] was this promise of the Father as truly made to the daughters of the Lord Almighty as to his sons? See Joel ii. 28, 29. "And it shall come to pass afterward, that I will pour out my Spirit upon all flesh; and your sons and your daughters shall prophesy" When the Spirit was poured out in answer to the united prayers of God's sons and daughters, did the tongue of fire descend alike upon the women as upon the men? How emphatic is the answer to this question.

Using the persecution of Christ to good effect, Palmer said that silencing women was repression, a "crucifying process." She decried the "entombing of endowments of power." She called for a "resurrection" of women's "long-buried gifts," if not yet seeing them "occupy the sacred desk," or pulpit. As illustrated by this seminal book, Palmer's advocacy had taken on an edge, as if cutting through growing resistance. It was all in the Bible, so she preached accordingly.

Both Mott and Palmer, in their womanly ways, had linked personal conversion to social transformation. For them, the individual could indeed reverse the heart instantly, if desired. But the social impact would have to be persistent, long-term, and, therefore, usually gradual. Still, there was a third alternative to personal and social change, and it was gaining a powerful

influence in the 1830s and 1840s. This idea of change viewed it as one great apocalypse, the return of Christ from the clouds to destroy the world.

This was the teaching of the Vermont preacher William Miller, and from New England outward it gained a wide adherence. Cartwright debated Millerites on the frontier. "They would prophesy, and, under the pretense of Divine inspiration, predict the time of the end of the world," Cartwright said, astonished by Millerite sermons that calculated "the very day that God was to burn the world."[16] Miller was a preacher extraordinaire. He spent thirteen years calculating that Christ would come to destroy the world on April 3, 1843, and lectured widely on the topic starting in 1831.

By 1841, with a publicity agent and two publications—*Sign of the Times* and *The Midnight Cry*—Miller was an urban sensation. At Bible conferences, he revealed the symbols of the books of Daniel and Revelation. He published charts that proved his timetable. Thousands of citizens sold their goods and waited on hillsides in ascension robes, mostly in western New York, for the appointed hour. When it passed in 1843, Miller recalculated to the next year, and then adjusted a third time from March to October 22, 1844.

Two days after the October 22 deadline passed, Palmer wrote a letter to Miller. She urged him to clear up the "confusion of tongues" created by his prophesies. "Is it not your *duty* to sound a retreat?" she asked, asserting female leadership, and this to a captain who had fought in the War of 1812. "You, brother, were the *first* to sound the alarm," she wrote Miller. "Should you not be among the first, and most ready, to advise and urge the people to return to their various vocations?"[17]

In this early national period of America, it was only a small step from individual conversion to the idea of a coming millennium. Most Christian preachers said that no one could "know the hour." Still, utopia was an American obsession. No one knew the limits of the new nation. It clearly was chosen and clearly blessed. It had pulled off the American Revolution and won the War of 1812. In land, America had a continental empire by 1820. A year after Miller's final prophecy failed, a newspaper spoke of the nation's "Manifest Destiny." How the nation achieved that was a great topic of American oratory, and especially in its sermons.

Dreams of Utopia

Preaching American Identity

As the frontier settled, Cincinnati became a natural rendezvous point for new ideas about America's future. The city was only a few days' travel from where the Ohio River met the Mississippi. If preachers wanted to dispute America's fate, Cincinnati was the place. In April 1829, two social visionaries, the utopian socialist Robert Owen and a "restorationist" evangelical named Alexander Campbell followed that exact logic. They met for an eight-day debate on two "systems" for nationhood.

Owen was a wealthy Scottish industrialist who made seven journeys to America. He addressed Congress twice, met Presidents Monroe, J. Q. Adams, and Jackson, and displayed a utopian model of New Harmony, Indiana, in the White House. From New Orleans, Owen took a steamboat up the Mississippi to Cincinnati, where Campbell, a native of Ireland, was also headed. Campbell had founded the "Disciples" frontier sect in America. He wanted to "restore" the Bible's primitive Christianity to the world, and he too would take his message to both houses of Congress. Once he agreed to Owen's oratorical challenge, made in a New Orleans newspaper, Campbell came by horse and the Ohio River from the site of his future Bible college, which today is Bethany, West Virginia.

This was not the only great oratorical contest in Cincinnati in these years. The city also hosted contests between Catholics, Protestants, sectarian orators, and political theorists. Thousands traveled over the landscape of woods, farms and prairie, drawn to the riverboat town by sincere interest. They wanted to find out where the nation was headed in God's scheme of things.

Owen and Campbell met at the city's largest meetinghouse. They sat side by side at a table, and behind them in the pulpit a referee watched, giving each time to speak and respond. Owen preached his twelve utopian principles. Foremost, he believed that human beings were perfected from the outside, shaped by "superior impressions." Man grows perfect when "the circumstances or laws, institutions and customs, in which he is placed, are all in unison with his nature." Though an agnostic, and late in life a spiritualist, Owen spoke of "divine laws" in nature itself. They provided a moral code "sufficient to produce, in practice, all virtues in the individual and society, sufficient to enable man, through a correct knowledge thereof, to 'work out his own salvation.' "[1] External conditioning was the savior.

The evangelist Campbell was no less utopian in his "Christian system," but he believed individuals were changed from deep inside. From the frontier revivals, he had crystallized the belief in a Bible-based egalitarianism, requiring no creeds or ecclesiastical structures. Like Owen, Campbell had practical experience. He was a delegate in Virginia's first constitutional convention,

Evangelist Alexander Campbell and utopian Robert Owen met in Cincinnati
to debate the "American system" in 1829.

where he advocated separation of church and state and godly politicians. At Cincinnati, he defined utopia as "the reign of heaven, because, down into the heart it draws the heavenly feelings, desires, and aims." This power worked inside, a divine love that "will revolutionize the world; and how, my friends, but by introducing new principles of human actions?"

As Owen said elsewhere, the world was "full ripe for a great moral change" and it would be "commenced the most advantageously in the New World."[2] The Campbellites were no less optimistic about America. In 1830 their publication, *The Millennial Harbinger,* offered "the development and introduction of that political and religious order in society called THE MILLENNIUM, which will be the consummation of that ultimate amelioration of society proposed in the Christian Scriptures."[3]

The Cincinnati debate drew more than a thousand people every day. Owen and Campbell actually spoke past each other, as if giving eight-day sermons side by side. But the stakes were high. Each elaborated his own system. They were trying to define America's destiny.

Like Owen's utopian projects, many others in the young nation were short-lived and fell apart for lack of structure. One religious utopian, John Humphrey Noyes, assessed Owen's failure at New Harmony by declaring that there are only two ways to govern a community. "It must be done either by law or by grace," Noyes said. "Owen abolished law, but did not establish grace."[4] But Noyes's own "perfectionist" Oneida Community, founded in 1848 in Vermont and upstate New York, lasted only a few years longer. It attempted to build a "Bible Communism" that included "plural marriage," or series of conjugal relationships, said to uproot the possessiveness of monogamy. In all, the utopias that did last were bound together by religious enthusiasm or discipline, such as the celibacy of the Shakers.

In this colorful period, neither the utopians nor the "outsider" sects became alienated from the common belief of the age: America was chosen. The Mormons, who followed the prophet Joseph Smith, had a theology of American chosenness. Despite being ostracized at every turn, many Catholics tried to establish an "Americanist" version of their Roman church. The oratory of Protestant America was clear, and everyone went along on this common denominator: America was at the center of the providence, a "redeemer nation" with a "mission" and even a "Manifest Destiny." Every presidential inaugural has mentioned a providential Supreme Being, but between 1817 and 1845, all but one cited America's mission to be an exemplary system.

In religious terms, this was a postmillennial vision. For Bible believers, it was a thousand years of earthly peace before Christ's return. The preacher

Henry Dana Ward, speaking in Boston in 1840, predicted for America "a spiritual millennium in this world's flesh." Hardly anyone rejected this, "so firmly planted has this new faith become in all the churches of America."[5] Although the favorite Bible verse of the age, "Righteousness exalts a nation, but sin is a reproach to the people," drew on a Hebrew source in Proverbs, an evangelical tone extolling Christ over God as "governor" was on the rise.

Members of Congress typically were not pious. But in this era, the chaplains were distinctly evangelical. Most of the nation did not go to church. At most, in the antebellum period, just 15 percent of Americans were full members of Protestant churches. But perhaps three times that many were sympathetic nonmembers, attending houses of worship and thus exposing at least 40 percent of Americans to evangelical sermons.[6] In short, an evangelical minority dictated most of the national discourse.

From early on, evangelicals made up the pressure groups and swing votes that counted in elections. The American party system responded. It was partly cynical. Jefferson allowed worship in federal buildings to counter the image that he was an infidel. While chaplains prayed or spoke to open Congress, lawmakers read newspapers, chatted, or walked about. "I am accustomed when men are preaching, to occupy my mind with my political thoughts," said the Democratic lawmaker Martin Van Buren.[7]

Nevertheless, the political party system came of age using the oratory of preachers. In the age of political machines, the parties mimicked religious revivals to get out the vote. Religious and political passion overlapped in the 1820s and 1830s, a time when the great political debate was over how to advance "the American system." The Jeffersonian world of self-sufficient, yeoman farmers was gone. The national system, with its mixed economy and modern capitalism, was in search of a governing structure. At this turning point, the nation needed a moral guide. Some ardent Americanists preached a utopia and others a pure democracy or the spiritual "reign of heaven." The practical question was the means to this end: did utopia come by ever more liberty, or by ever more order? It was a sermonic topic for the times.

Defining America required drawing a line against foreign powers—more precisely, a line between Protestant America and Catholic autocracies abroad. The nation needed to settle matters with Roman Catholicism. For one thing, the Spanish empire had most of what America still wanted. For another, Irish immigration was making Catholics the largest religious group in sectarian America. The tensions were palpable. Eventually, the strain was personified in an oratorical contest between statesman John Quincy Adams and Bishop John England, a Catholic immigrant.

As secretary of state, Adams was the brains behind President James Monroe's foreign policy. The last of the old Federalist stock, John Quincy was the son of John Adams, the second president. He was a Unitarian who wept at sermons by William Ellery Channing. John Quincy Adams had spent years in Europe, watching Catholic governments and honing his diplomatic knowledge. When American newspaper editors began to espouse "Manifest Destiny" in 1845—namely, the conquest of Texas and other foreign territories, all predominantly Catholic—John Quincy Adams had already led the way. More than two decades earlier, Adams had guided President Monroe in espousing the concept of an "American continental empire."

Adams began his empire project in 1819 to stop Europe's piecemeal colonizing and spreading of Catholicism. He settled the United States–Canada boundary with Britain and took Florida in a deal with Spain, making America continental. Now it touched the Pacific, Atlantic, and Gulf of Mexico. When President Monroe gave his "Monroe Doctrine" speech to Congress in 1823, declaring that "American continents . . . are henceforth not to be considered as subjects for future colonization by any European power," he was announcing Adams's blueprint.

The blueprint had a spirit that few Catholics could be happy about, as Adams made plain in an 1821 oration for the Fourth of July. Speaking in Washington, Adams glorified the Protestant Reformation and rebuked the calumny of Catholicism. American democracy glowed against the medieval darkness of Catholic Europe, with its "pretentious system of despotism and of superstition." Protestantism brought the "triumph of reason," Adams said. "Released from the manacles of ecclesiastical domination, the minds of men began to investigate the foundations of civil Government."[8]

The speech by Adams, who would be elected president in about three years, demanded a Catholic response. The man who gave it was Bishop John England of Ireland, who had arrived in Charleston, South Carolina, just a few months before Adams's patriotic address. Most prelates sent to America had been French and German, but with the rise in Irish numbers, England was next in line for Rome's appointments. His arrival represented the first "Americanist" movement among Catholic believers. It grew for decades but was exhausted by the time of the Civil War. Thereafter, Catholicism became ghettolike, focused on its ethnic enclaves and devotional practices. The Americanist push did not revive again until the late nineteenth century. But Bishop England was the progenitor. And he began by challenging the anti-Catholicism of John Quincy Adams.

When the ship *Thomas Gelston* arrived in Charleston on December 28, 1820, Bishop England debarked to assume control of a "mission" diocese, a

territory including the two Carolinas and Georgia. As an Irish clergyman, he had dived into politics, demanding the vote for Catholics in British elections. He was probably sent to America as a break from those controversies. By 1822 England had founded the nation's first Catholic newspaper, *United States Catholic Miscellany*. The reorganization of his own diocese, which shared power between priest and lay leaders, paved the way for the first deliberative Catholic body in the United States, the First Provincial Council of Baltimore in 1829. So large and so Protestant was England's diocesan territory that on his wide travels by carriage, he preached more in churches of the "separated brethren" than even in his own Catholic parishes.

Soon after docking in South Carolina, England paid a diplomatic visit to Washington. But the chance to respond to Adams's famous July 4 oration came some years later. In November 1825, England traveled to the seat of American Catholicism, which was Baltimore, and then to Boston to preach the installation sermon for a new bishop. The return trip brought him through Washington on the eve of Christmas, and he stayed to give the Christmas Day sermon for 1825 at St. Patrick's Church, a modest white sanctuary just five blocks from the White House and only a bit farther from the U.S. Capitol. Adams had just been elected president by a vote of the Senate, since the election had resulted in a technical stalemate, though General Andrew Jackson had won the popular vote. For the last time, the New England order had held back America's populist rumblings, in which military heroes were greater than educated blue-blood diplomats.

Given the mood and the Adams victory, England decided to use his Christmas Day sermon to meet "foot to foot the 4th of July oration in which he so unkindly assailed us four years" earlier, he recounted.[9] He used Adams's words as his sermon text. The news got around and President Adams, whose inaugural address in March would have the normal religious flourishes, invited Bishop England for dinner. They talked church and state and world affairs. Soon enough, the bishop's allies in Congress expressed "their wish that I should preach for them," according to England.[10] The Democrats, out of power, always were interested in the immigrant and Catholic vote. For whatever reason, England got the preaching slot for Sunday morning, January 8, 1826, at the House of Representatives, a going custom on Capitol Hill.

At the time, the Catholic hierarchy in America avoided direct confrontations with anti-Catholic groups in Washington and elsewhere. England candidly described their approach as "fighting in detached squads."[11] When Archbishop Ambrose Marechal, primate of America, gave England permission to give his "Discourse Before Congress," it was under this piecemeal

strategy. The archbishop did not write Rome about the event or its aftermath. But he advised priests in Europe to polish their English sermon eloquence before arriving in America.

When Bishop England arrived at the House, he took the speaker's chair, and enjoyed watching President Adams's arrival. "The throng was so great that the President found it very difficult to get in," England claimed. The Supreme Court justices also attended. England spoke for two hours. Afterward, he came down and conversed with the president. So warm was the event that England forgave American slights against the "true" church. "But how can they believe without evidence?" he wrote a friend. "God will bless them & bring them to the truth."[12]

England discerned few Catholics in the audience. So most of his sermon described religion in general, with accents on Catholic tradition. He soon seized the topic of how a "foreign" religious authority, such as the Holy See, comported itself within democratic America.[13] Religion is a separate matter from civil authority and rights, and indeed Catholics did not believe the pope was "infallible," he explained. "I would not allow to the pope, or to any bishop of our church, outside this Union, the smallest interference with the humblest vote at our most insignificant balloting box," the bishop said.

He lauded the Constitution for keeping spiritual and civic authority "distinct and separate." It was wise and good to continue that separation.

> You have no power to interfere with my religious rights; the tribunal of the church has no power to interfere with my civil rights. . . . Any idea of the Roman Catholics of these republics being in any way under the influence of any foreign ecclesiastical power, or indeed of any church authority in the exercise of their civil rights, is a serious mistake [for] I believe there is not any portion of the American family more jealous of foreign influence, or more ready to resist it.

The Bishop England episode was part of how Catholics won a battle, but not the war. The era of Bishop England saw a remarkable debate on Catholicism in America. On the positive side, it involved both intellectual converts and brilliant immigrants like himself. A month after the sermon, England received his certificate of citizenship. In 1833, Congress appointed its first Catholic chaplain for a year, and in 1836 President Andrew Jackson made Roger B. Taney, a Catholic who worshiped at St. Patrick's, Chief Justice of the Supreme Court. Two remarkable converts, Orestes Bronson and Isaac Hecker, spoke specifically to their own American Protestant intellectual, utopian, and patriotic backgrounds. Despite Rome's opposition, they recommended an Americanized faith.

But less amicably, there also were bishops and clergy who celebrated a "church militant" in America. They battled for Catholic rights in public schools and urged conversion of Protestants. Typically, this group frowned on Bishop England's democracy, as was probably the case with Bishop John B. Purcell of St. Louis. Once again, a great debate on the American system was taken to Cincinnati, this time in the person of Purcell. The debate was instigated, naturally, by the evangelical Campbell, who issued the challenge for January 1837. For seven days at the Campbellite church, he and Bishop Purcell debated the Bible in schools, claims to truth, and Catholic infallibility. Naturally, both sides claimed victory.

A similar contest had arisen in 1835 at the Philadelphia Literary Society. The priest John Hughes clashed with Presbyterian minister John Breckinridge on the question, "Is the Protestant Religion the Religion of Christ?" The transcript became a widely read volume. The Campbellites' *Millennial Harbinger* cheered on Breckinridge in the great "Catholic controversy," saying it was solved by a return to primitive Christianity, "the Restoration of the Ancient Order of Things." Insult and acrimony attended this oral combat in Philadelphia. But it was tame compared to other events on the East Coast, where Catholic immigrants from Ireland and Germany were concentrated.

When the former priest Blanco White published his *Evidence Against Catholicism,* thirty-two Protestant ministers in Washington, D.C., signed it in a crusading spirit. The New England mainstays Lyman Beecher and Horace Bushnell agreed that "papal puppets" were eroding American freedom. Rioters burned the Ursuline Convent across the harbor from Boston in 1834, and a notorious tract on a Canadian nunnery, *Awful Disclosures,* swelled nativist fears. One political party tried to limit voting to native-born Protestants, and instigators of the 1844 anti-Catholic riots in Philadelphia formed the Native American party, known as "Know-Nothing" for its secrecy.

Bishop England died in 1842, before the worst. Nor did he witness the annexation of Texas, which assuredly made Catholics the largest religious population in America, though they still had to live defensively in major cities. Their dioceses and parishes became more tribal, inward, and devotional—more than Bishop England would have liked.

American politics before the Civil War remained a distinctly Protestant, even evangelical, affair. Protestants were nevertheless divided between Calvinism, with its organic view of society, and Pietism, with its cry for the primacy of individual conscience. The Calvinist system was an extension of the New England standing order. Morality came from the top down. It was

organized and filled with missionary spirit. In contrast, the Pietists wanted nothing of this Christian paternalism, and like their frontier fellow travelers, wished to be left alone. They wanted no cooperation between church and state, for this was tantamount to bureaucrats and ecclesiastics sticking their noses into private religious and moral beliefs.

As Daniel Webster of Massachusetts and John Calhoun of South Carolina debated the nature of the Constitution—whether it leaned toward national or state government—Protestants debated whether the Calvinist desire for order or the Pietist love of liberty was best for America. That debate occupied sermons for a half century. It lined up believers with one political party or another. At first, the New England Calvinists did not rely so heavily on government. In the early 1800s they organized voluntary societies for Bible distribution, Sunday schools, moral reform, and the rest. When this stalled, the power of government looked more appealing. In contrast, Pietists took their lead from New England's first famous dissenter, Roger Williams. He said government had no business in a person's mind, a place reserved only for God and the Holy Spirit.

These two religious views were instrumental in shaping America's "second party" system, which arose when the Democrats challenged the Federalist party in 1800. Calvinists and Pietists began to take sides. By the time that John Quincy Adams beat Andrew Jackson in the contested race of 1824, the Whig party, designed by former federalists, and the Democratic coalition were both in the making. The Democrats used Jeffersonian democracy as their rallying cry. Jackson, as a military hero, replaced the old "natural aristocracy"—lawyers, merchants, and clergy—as the archetypal leader of the people.

In general, Democrats favored states' rights, laissez-faire economics, and white supremacy when it came to moving Indians westward and extending slavery. Democrats won the support of poor whites on the frontier and in factories. They appealed to sectarians who feared clergy establishments, for some New England states still paid clerical salaries in the 1830s. In cities, Democrats drew immigrants, Catholic or Lutheran, and any group that resented New England. Into their fold came plenty of "scoffers" at religion. Skeptics, Jeffersonians, and Enlightenment individualists joined frontier sects to create a united front against Whiggery.

The Whigs were federalists who took on the name of England's old liberal Whig party, now at war with the "monarchy" of Andrew Jackson. Whigs advocated an "American System," centralized around a bank, internal improvements, and protective tariffs to aid business. The New England Calvinists, having tried voluntary reform societies, now joined a Whig government

program. In the 1830s, the Whig party defended moral and humanitarian reform such as temperance, closing the vast post office system on Sundays, and improving prisons and asylums. Its religious partisans defended Indian rights and opposed slavery, but also attacked Catholics and Masons as foreign interlopers.

The match-up of Pietists with Democrats and Calvinists with Whigs was never exact. For class reasons, liberal Unitarians voted Whig as did southern Presbyterian "Cotton Whigs." Well-to-do Episcopalians voted Democratic in opposition to huffy New England. As a rule, however, Democrats became the party of "outsiders," a mosaic of sects and groups that never had a stake in the historic Standing Order. In this oppositional mode, a mélange of atheists and Baptists, freethinkers and Lutherans, Freemasons and Catholics joined reluctant hands in a political alliance.

The partisan mood took the lid off clergy participation in politics, even as elected politicos. Ministers in record numbers, especially the evangelical variety, ran as Whigs and Democrats. They had oratorical skill and a population base. The firebrand John Leland, a Baptist separatist who extolled Jefferson and Jackson, served in the Massachusetts state legislature and scandalized urbane Bostonians with God-soaked rhetoric. Itinerant ministers, free of pastoral duties, became grassroots candidates for the new antislavery Liberty and Free Soil parties. Even Joseph Smith, with a concentration of Mormon voters in Nauvoo, Illinois, declared for the U.S. presidency.

Whatever the party, the winning theme was the people against some powerful enemy. Jackson proved this by two terms of pitting Americans against the "Money Power," or the corporations and banks. The "people" became a celebrity as sheer numbers, not powerful connections, won elections. By 1840 the nation was thoroughly politicized. There were constant elections at every level of government. The giant mood swing of presidential races came every four years. Parties refined their management and manipulation of the electorate. To cater to the masses, political machines mimicked frontier preaching and sectarian enthusiasm.

Having learned the Jacksonian lesson—for he won the popular vote three times—the Whigs copied the Democratic party's popular rhetoric. If Democrats were copiers of Federalist economic and military policy, the Whigs now stole Jacksonian myths of military heroism and a "Power" that oppressed the people. The "Power" was Jackson's monarchy, and the Whigs' hero was William Henry Harrison, an aged Indian fighter, brigadier general, and Ohio congressman. Harrison was born into relative privilege, but the Whigs gave him a backwoods aura. They said he was born in a log cabin. At campaign stops, Whigs gave out free alcohol, or "hard cider," and throngs showed up.

Nothing in American politics had yet worked like the "log-cabin" campaign. The Whigs swept into office. To participate, many of the clergy had to strike a moral compromise, and this stirred some soul-searching. Still, 1840 was a peak year of evangelical involvement, and the political oratory and color of the day looked a lot like American sectarian evangelism. In the aftermath, some clergy returned to shunning "party spirit" among Christians. Pure Pietists complained that the political folderol had undercut religious revivals in 1839 and 1840. The "enthusiasm" for a party, they said, was more fanatical than anything seen at the much-maligned camp meetings.

But a thunderclap finally came on inauguration day when Harrison, showing his manliness, spoke in the withering cold of Washington without a coat. He fell ill and died a few days later. In all this, the clerical oratory parted ways. Some said that never before, not even in war, had American morals sunk so low as in the 1840 political battle. It was a year of excesses, pandering, and "man worship." Other clergy divinized Harrison, preaching eulogies that made Sunday worship seem like the Fourth of July. Hymns were sung to a dead president. Vice President John Tyler declared a day of fasting and prayer. That was the occasion for one of the greatest preachers of the day—Charles Grandison Finney—to put his foot down. He too disliked the campaign, for it was opposite to his proposal for a true American system.

Finney dominated the pulpit at Oberlin, Ohio, a town that grew in a wooded clearing around his Christian college. A native of western New York, and quite at home in New England and New York City, Finney had been a Whig. He despised Jackson's treatment of Indians and his violation of the Sabbath by keeping the national post office open for "love of money."

By now, however, Finney had bolted the ranks of the Whigs, where he once had hope for morality. He was interested in the new antislavery parties, and from 1840 to 1844 he allied with the new Liberty party, led by one of his own divinity students, Theodore D. Weld, and funded by New York City's wealthy brothers Arthur and Lewis Tappan, Presbyterian evangelicals like Finney and Weld. But Finney was patriotic enough to heed Vice President Tyler's prayer-day decree. On that Sunday, he gave a most surprising sermon.[14] Politics and morals had become so wicked, he preached, that God had struck down Harrison.

Now who can wonder that he was taken away by a stroke of Divine Providence. . . . Who ever witnessed such disgraceful and bacchanalian scenes as very generally disgusted the eyes and grieved the hearts of the friends of virtue during the political struggle? What low, vulgar, indecent, and in many instances, profane measures were resorted to?

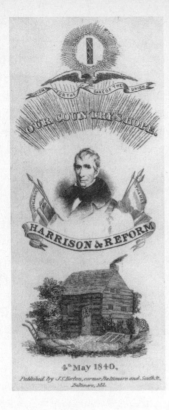

After inventing urban revivalism, Charles Finney preached that the vituperative election of 1840 was an American low point.

For a few years already, Finney had said that sectarian discord was at the root of secular political strife. He was an idealist about a utopian America, and suffered disappointment for it. He believed the kingdom might come in America. In a Boston hotel room after the Harrison debacle, Finney had a rousing debate with the apocalyptic William Miller, who was then predicting the earth's destruction in 1843. They argued over symbols in the Book of Daniel. Finney insisted that "stone cut without hands" was not Christ destroying the earth but the church overthrowing evil kingdoms by "enlightening their minds by the Gospel."[15]

At the least, Finney's astounding career as America's chief antebellum revivalist represented the victory of the Arminian belief in free will. It was the only theology that truly matched American democracy. He was also among the last great postmillennialists. He spent years preaching and traveling but finally withdrew to Oberlin, seeking "something higher," a way to individual and collective perfection. Finney's utopia did not arrive. But he was central to helping Christianity reconcile itself with an enduring American system, a system that joined capitalism with the nuclear family.

The road to this conclusion began in western New York, where he was born and where the Erie Canal changed the Mohawk Valley into a bustling corridor of small towns, merchants, travelers, and lawyers. The canal ran 363 miles from Albany to Buffalo and the Great Lakes. It was completed in 1825, four years after Finney, a young village lawyer, converted. The canal's "packets," or mule-drawn boats, carried thousands on the romantic journey west. In this commercial setting of small towns and general stores on the canal, Finney prospered as a lawyer. He was six-foot-two, had light brown hair, piercing blue eyes, and a hooked nose. And he was a master of argumentative logic. Then his fiancée took him to a revival meeting in 1821. Soon after, he had a "retainer from the Lord Jesus Christ to plead his cause."

Finney's preaching argued with lawyerly acumen. In God's courtroom, he mounted evidence of sin in the audience. He called for a "conviction," the self-conviction of a repentant sinner. During this anxious trial, a sinner could come forward to sit at the "anxious bench," one of the "new measures" Finney supposedly instituted along with allowing women to testify. Finney refused to go to a Presbyterian seminary. He learned his theology as he toured western New York, peaking in the winter of 1830–31. For six months, the flourmill town of Rochester nearly shut down as Finney preached.

From the start, Finney's financial support came from women's missionary societies, and for good reason. They were ardently concerned, as was Finney's fiancée, to bring husbands, sons, and the many footloose men on the Erie Canal corridor into church, and thus into civilization. Though he spoke like a lawyer, he also was colloquial. His blue eyes burned into his audience. He expected it to repent and convert. At a Finney revival, the social pressures were enormous, especially on the men brought by womenfolk.

The pressure also came from Finney's clear conviction about free will. He never felt comfortable with strict Calvinism, the backdrop of his Presbyterian faith. As Finney became famous, so did his freewill theology, constituting a triumph of Arminianism—more characteristic of Methodists—over Calvinism in antebellum America. His seminal sermon was "Sinners Bound to Change Their Own Hearts," given in Wilmington, Delaware, in 1828, and repeated often thereafter. To be born again requires only a "change of heart," which "consists in changing the controlling preference of the mind in regard to the end of pursuit," Finney preached. "You have all the powers of moral agency; and the thing required is, not to alter these powers, but to employ them in the service of your maker."[16]

Finney's sermon parables became well known, beginning with the story of the man who wandered to the edge of Niagara Falls and was saved from a deadly plunge by a bystander, who shouted "Stop!" The "stop" was like

God's Spirit saving the man, even though it might come through the voice of a preacher, and the action of turning from the precipice was individual free will. Finney was trying to illustrate how to solve the contradiction of human free agency and human inability due to sin. He called the solution a "gracious ability," a kind of semantic gloss over this perennial and ancient difficulty.

His parable about a woman in a Calvinist church continued in the Niagara Falls vein. For years, the woman's preacher called her to salvation. But after each sermon, he also warned against human exertion to get the blessing. One day the minister forgot to issue his warning, and the woman, tearful at her religious experience, approached him.

> "My dear Pastor, why did you not tell me of this before?" "Tell you of this before?" questioned the astonished pastor. "I have declared it to you every Sunday." "Yes," she replied, "but you have always told us, before you sat down, that we could not repent."

This was Finney's lesson against "cannotism." The sermon was a calculated swipe against the tradition-bound "elders" of Calvinist Presbyterianism, who stanched human effort.

> This is the result of the doctrine of "cannotism." If people believe it, they certainly will not repent. How can revival prevail? These dogmas have become fundamental doctrines, and those who do not hold to them are supposed to be heretics. Christ could easily turn upon the real heretics with rebuke, "Wherefore do ye make void the commandment of God by your traditions."[17]

With such a message, Finney produced his next great achievement. His revivalism pioneered support from evangelical businessmen. Their patronage was central to the Rochester apotheosis, and essential in all the Erie Canal towns. Business needed straight-arrow young men, and for this, nothing worked like a revival. Then Finney increased the scale. In New York City, he won the backing of the Tappan brothers, whose millions rested on trade, merchandising, and warehousing. The Tappans were New England evangelicals, soft Calvinists, and they wanted Finney to preach salvation and reform in New York City. They bought the largest theater in town, located in the notorious Chatham Street neighborhood, turned it into the freewill and abolitionist Second Free Presbyterian Church, and brought in Finney, fresh from the Rochester high point.

After eight years in western New York, Finney arrived in the city in 1832, to be buffeted by culture shock. He preached to the working class and against

slavery, and engineered revivals until even he, a bit cynically, called them "so much policy and machinery, so much dependence upon means and measures, so much of man and so little of God."[18] Still he persisted, and in 1834 gave in New York City his famous *Lectures on Revivals of Religion,* based on his experiences in Rochester and elsewhere and published as a handbook for preacher-imitators for generations to come.

The Tappans brought in other evangelical investors to build the largest and newest church in lower Manhattan, Congregational Broadway Temple. The circular design allowed Finney to preach to every man and woman in pews tiered upward to the dome ceiling, which featured a skylight. Along with preaching, however, Broadway Temple became a lightning rod over abolition.

The great financial crash of 1837 turned the tables. Finney decided to resign the Manhattan pulpit. Already for a few years, with funding from the Tappans, he had been preaching at Oberlin College, an experiment in true Christian living. After he left New York, in fact, rioting antiabolitionists burned down most of Broadway Temple. An image of Finney had emerged. He was the western revivalist who, by the canal and Hudson River, had steamed into the New York metropolis, hoping to bring an earthly millennium. After Rochester, he believed revivals could turn souls to the church, and the church could perfect society.

In this process, Finney gave a Christian seal of approval to a burgeoning capitalism. This was the time in America when the insular and clannish farm society, late of Jeffersonian myth, gave way to a transient world of money and exchange. The only social principle in the landscape was the market, and the only social unit that seemed to matter was the married couple. The transition was not smooth. Once people had lived a lifetime on a subsistence farm, but now they traveled the roads and canals, looking for employment. Finney preached against mammon and greed. But he offered a middle ground.

Finney believed that revivals could Christianize the marketplace. Individualistic capitalism could work in service of communal love. Under the love ethic of "disinterested benevolence," the wealthy would give charity. He hoped to show that revivalist enthusiasm, universal salvation, entrepreneurship, and benevolence combined into a productive society of business and the nuclear family. The man went into the sinful world to work, and returned sober and industrious to a Christian home of nurture. Simplicity of life and morals prevailed. Wealth was distributed for a greater good, whether in building churches, reforming society, or ending slavery.

Finney was at the center of all these American possibilities. Yet he finally looked for "something higher." He admitted that by focusing on immediate

conversion, his following had overlooked the concept of "progress" in their spiritual lives.[19] His last quest was for Christian social perfection. Having lived in western New York and traveled frequently to New England, Finney was familiar with the new utopian schemes. He visited some of the crank utopias, sincerely observant but seeing only heresy and corruption.

Finney had to distinguish the wheat, like himself, from the utopian chaff. By taking a middle path, though, he ended up angering both free-love utopians on the left and Calvinists on the right. To deal with the utopians, Finney preached a series of 1837 lectures against "modern Perfectionists," for his concept of "Christian perfection" was entirely opposite of their free-spirit quest, a perfect freedom of appetites. The utopians had "so many wild notions" and "held that they were not under obligation to obey the law." By espousing his own Christian perfectionism, however, Finney raised the hackles of Calvinists. They spread rumors that he too was a lawless libertine of sorts, or at least a heretic. As he recounted in his *Memoir,* "the cry of Antinomian perfectionism was heard, and this charge brought against us." Presbyterians and Congregationalists signed statements that condemned his perfectionism. The great Finney became a pariah.

But Finney would not denigrate perfection. He tried to define it in theory and practice. He located it in the act of willpower. It was a decision and willingness. It was love of God that motivated obedience to God's moral law—to do one's best, to share the faith, to work for justice. He had read Wesley's works of sanctification, especially his classic *Plain Account of Christian Perfection.* Finney also was persuaded that "an altogether higher and more stable form of Christian life was attainable." But rather than become a Wesleyan, he tried to build such a theology on Calvinism's "perseverance of the saints," or that the saved could not backslide.

Finney summed up his reflections in a series of lectures at Oberlin in 1840, published as *View of Sanctification.* "Sanctification is holiness, and holiness is nothing but obedience to the law. . . . The law of God requires perfect, disinterested, impartial benevolence, love to God and love to our neighbor. . . . This, and nothing less than this, is Christian Perfection." The Bible promised "the entire and permanent sanctification of the saints . . . in this life."

The quest for perfection enthralled Oberlin as well. Finney's teachings became known as the "Oberlin theology." The school had been founded for spiritual and physical training. Students did farm labor, studied good manners, and heard lectures on personal hygiene. They abstained from meat, tea, coffee, and sweet pastries. They dabbled in the new prescientific theories about how food enhanced moral and spiritual readiness. Students tried to

achieve Christian perfection as "the simplicity of moral action." They formed small holiness groups. And they voiced reformist agitation, especially against slavery.

Finney was never an all-out abolitionist. At times, the Tappans threatened to withdraw support because of his inaction. Finney believed that individual conversion altered social structures, and he had energy only for that task. His final stance on slavery was illustrated in his relationship to Theodore Weld, who as a college student in 1825 had converted at a Finney revival. A dynamic orator, Weld preached temperance, but finally was funded by the Tappans to attend Lane Seminary in Cincinnati and train to preach against slavery as well. There, in 1834, Weld led student debate on abolition. When the administration clamped down, a large group bolted, and thirty-three finally enrolled at Oberlin College. Weld, in fact, informed Oberlin that the rebel students would enroll at Oberlin only if Finney was hired as a professor of theology, which led to his sojourn there.

While Finney insisted, for example, that black students be admitted, he would not sacrifice saving souls for political advocacy. The break was clear when Weld said that Finney, although sincere in revivalism, "misconceives duty, for the sin of slavery in this country is Omnipresent."[20] At Oberlin, Weld joined the American Anti-Slavery Society, which, like a missionary agency, tried to have "seventy" agents preaching in the field, and trained to argue intelligently and negotiate mob violence, which had become common. Weld damaged his voice so badly that he had to withdraw to print advocacy, giving his last antislavery address on July 4, 1836. He married the southern abolitionist Angelina Grimke, and together their preaching had seeded the cause in northern churches like nothing else. Weld's tract on *Slavery As It Is* (1839) provided the content for much of Harriet Beecher Stowe's *Uncle Tom's Cabin,* a novel that helped spark the Civil War.

As many Oberlin students became traveling agents with the Anti-Slavery Society, faculty and townspeople began defying the Fugitive Slave Act of 1850. The statute required "all good citizens," under threat of arrest, to help federal marshals capture runaway slaves. Many northerners declared their own "nullification" of the measure. They expanded the Underground Railroad and on occasion rioted. At Oberlin, two professors engineered an escape route to Canada, and eventually the operation surfaced in controversy. In December 1858, just as Finney was packing his bags to evangelize in Britain, twenty Oberliners "rescued" a captured slave from a hotel room. For three days, the slave hid at a professor's home, and then fled into Canada. The twenty were jailed, tried in Cleveland, but finally released, returning to Oberlin to

torchlight parades and religious hosannas. Finney never commented on the episode. At this point in history, he had moved to the sidelines.

The national debate, once so yeasty in Cincinnati about the American "system," and in Oberlin about "perfection," now became one of national survival with slavery. It moved south, rippled across the border states, and rocked the North. Weld and others like him made the headlines, as did a new group of orators, the black preachers.

Words of Freedom

Exhorting Slavery and Abolition

BLACK PREACHING IN THE SOUTH HAD EMERGED BEFORE THE
Revolution as part of the First Great Awakening. But as slavery ex-
tended, and its labor system dominated the South, black preaching took on
a different kind of need. The black sermon either gave solace in a world
beyond or it was coded speech about liberation from, and even revolt against,
the white masters.

Growing up in North Carolina, David Walker had heard both kinds of
preaching. Walker was born to a free mother and slave father. He could travel
and work in the South, so he investigated its religious tendencies before mov-
ing to Boston. One day Walker caught a Charleston steamboat that took him
five hours upriver to a revival. There he found a "great concourse of people,
who were no doubt, collected together to hear the word of God." But now
came a sermon he had rarely heard. The evangelist told slaves to obey their
masters or be flogged. "Consider what was my surprise, to hear such preach-
ing from a minister of my Master [Jesus], whose very gospel is that of peace
and not of blood and whips."[1]

Two generations after the Constitution stopped short of abolishing slav-
ery, the sermon forced the topic back into the American conscience. The first

black leaders were preachers, and as slavery became a defining issue, white churches divided and took sides. From the pulpit came new justifications for slavery and the "southern way of life." Two cultures, North and South, alienated themselves to the breaking point, as each pursued a romantic vision of American culture and even the divine order of things. One was genteel and orthodox, the other theologically liberal, and both visions were given wide currency from the pulpits of the nation.

Walker, who arrived in Boston by 1829, noticed the regional difference, but also the pervasive discrimination faced by all American blacks. To make a living in the North, he sold used clothing on the Boston docks, and he self-published a pamphlet. When his famous "Appeal" to colored citizens began to circulate in 1829, it became the most incendiary tract of the era. It suggested that America was provoking God, and God might raise up a slave rebellion. "They chain and handcuff us and our children and drive us around the country like brutes, and go into the house of the God of justice to return Him thanks," Walker wrote. "O Americans! Americans!! I call God—I call angels—I call men, to witness, that your DESTRUCTION is at hand."

Black sailors took the tract south. Governors outlawed its circulation. Reportedly, slaveholders put a bounty on Walker's head, and for unknown reasons he died at home in 1830. The appeal could not have been read too

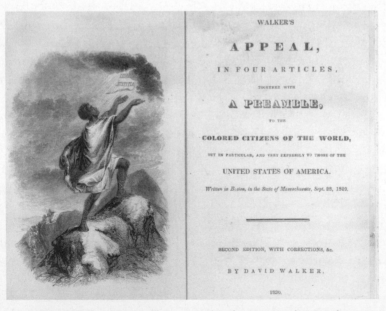

David Walker's "Appeal" was an early exhortation to slave revolt.

widely in the South. Literacy among the four million slaves was only 10 or 15 percent. Most slaves were isolated on farms or plantations. Perhaps only 12 percent attended a church of any kind where the Walker tract might have been read or discussed.[2]

Although Walker's appeal preached in text, there was also a growing tradition among black revival preachers that at least hinted at a coming judgment. That was the background of one black exhorter in southern Virginia, Nat Turner. He could read as well, and perhaps had read the Walker tract. The influences are unclear, and Turner himself attributed his visions of an apocalypse to signs from God, not something he read. One summer night in 1831 he rose from obscurity to become known across the South for attempting to lead a slave rebellion.

By the time of Walker's death, Turner had been sold and moved to the farm of Joseph Travis in Southampton County, Virginia. The farm was just outside the town of Jerusalem, the county seat, population 175. Turner was a good foreman. At age thirty-one, he also was a good preacher, probably a Baptist, although not ordained. Some called him "Prophet Nat." He had light skin, sharp features, and a wiry build, and he spoke with great articulation. He sang and exhorted at Sunday church services, held in slave chapels or secretly in woods and gullies. Turner even performed a full-immersion baptism of a white overseer convert stirred by his oratory.

All seemed as usual in the summer of 1831. Turner joined other preachers for occasional local revivals. One such day, he spent an entire afternoon preaching, joining the ranks of whites, free blacks, and slaves at Barnes's Methodist Church. It stood where Virginia bordered North Carolina, not far from the farm of Turner's master. Turner may have been seeking recruits, for only a few weeks later he led his bloody revolt, destructive and mismanaged.

The events unfolded in the early hours of Monday, August 21, 1831. Turner and six others, some of them "preachers," began a killing spree across nearby farms, gathering followers and weapons as they went. They were headed to Jerusalem. "Our number amounted now to fifty or sixty, all mounted and armed with guns, axes, swords and clubs," Turner recounted.[3] The rampage killed nearly sixty white men, women, and children. Turner wanted to strike "horror" in the land.

Since his youth, divine powers had tugged at him in visions and natural wonders. It was an apocalyptic age in America. Turner's visions a few years before the rebellion suited that temper: "I saw white spirits and black spirits engaged in battle, and the sun was darkened—the thunder rolled in the Heavens, and blood flowed in streams—and I heard a voice saying, 'Such is

your luck, such you are called to see, and let it come rough or smooth, you must surely bare [*sic*] it.'"

The attempted rebellion lasted only a day. Turner's cohorts were shot or rounded up for trial and execution. For six weeks, Turner lay in ditches or huddled in caves, but once captured he confessed in detail. The Virginia newspapers mocked him as "Captain-Preacher Nat." He went to the gallows saying he "did not feel" any guilt. He was a divine instrument of blind vengeance. Turner was gone, but his exploits changed the South. After Turner, the black churches were brought to heel. Slave codes were made stricter. The complaint of a North Carolina white captured the new restrictive mood. "It is strange to me that men can be so blind and Infatuate as to be advocates of Negroes Preaching to negroes," he wrote to a newspaper. "These veery Slaves would have Remained quiet but for this fanatic Black that has excited them in this diabolical deed."[4]

The Turner melee generated some compunction among white churches. They began to espouse more humane treatment of slaves and even said that God would judge them on this matter. In their care, the slaves should become Christians. Missionaries traveled to plantations with this message to pacify the slaves, though instruction in reading was banned. Free blacks left for the North. Independent black churches went underground.

Since the 1820s, when bitter disputes over extending slavery to new states rocked Congress, southern leaders had shunned the topic in public and in pulpits. They demanded that the federal postal service curtail sending abolitionist tracts. Many of the southern clergy were brilliant men of letters and Bible scholarship, and while they rarely had preached on slavery, they now thought about it intensely, and they eventually formulated a robust defense of the slave system. The censure on sermons discussing slavery soon would be lifted; pulpits were foreced to describe the slave order as a providential way of life for the South.

Whether Nat Turner was a cruel and inept "banditti" or an exemplar of black liberation, he was part of the second generation of African preachers in America. A half million slaves were brought to the colonies before 1760. By the time Congress abolished the trade, the population had grown still more, and traditions straight from Africa continued to thrive: ancestral practices of healing, magic, funeral rites, and interpreting signs.

Anglican missionaries did the first Christianizing work with slaves, and by the time of the Revolution had extinguished their indigenous beliefs. They offered a Christian theology instead, for both slaves and masters. Beginning in 1711, a series of influential sermons on slavery were preached in

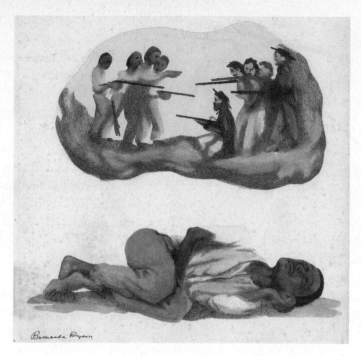

The preacher Nat Turner dreamed of a battle
between black and white spirits.

London and circulated in the colonies by the Society for the Propagation of the Gospel. In short, they said that "liberty" was a spiritual matter for the soul. Obedience was the slave's duty on earth, and Christian instruction and social ordering was the master's.

The Great Awakening in Virginia and the Carolinas broke down some of this Anglican rigidity. Revivalism became interracial. In a brief window, from before the American Revolution to the end of the slave trade in 1807, black Christianity took on its first clear identity. Some of the African heritage, damped down by Anglican missions for a half century, began to re-emerge and be combined with English revivalism.

The African and English revivalist expressions had features in common. So the real source of black religion in America is lost in the mingling of the two. Both kinds of revivalism, African and European, used fiery sermons. They eschewed ritual and relied on uneducated clergy. They attacked elites, evoked emotionalism, and prized collective worship. The country revival gathered a lower class, joining whites and blacks in a common resentment toward the upper classes.

For a time, the idea of ending slavery occupied even the ruling class. In about 1785 the Virginia Assembly reviewed proposals to abolish the institution. The Virginia Baptist Association condemned slavery as unscriptural. A little north, in Baltimore, the Methodist Church founded itself with a rule against slaveholding by clergy.

The economics of the South soon crushed those religious sentiments, however. As poorer whites obtained farms, and then plantations, they needed slaves as much as the aristocrats did. Clergy owned slaves. But more significantly, the deacons who ran their churches often were the biggest slaveholders in town. Before long, the church's mission in the South was strictly "spiritual." It had no say in such political, economic, and social matters as slavery. A church was a "spiritual body, and has no right to interfere directly with the civil relations of society," said the southern Presbyterian James H. Thornwell in 1847.[5]

The slave system gave black Christians two options: to organize within white churches and those churches allowed to blacks, or to operate underground, where they had a little more control. Black preaching developed in both settings, but in the less formal one, it was most common for the black preachers to express themselves as healers and shamans. Some could read the Bible, and others made up their preaching texts.

The greatest formality developed in the North, where the centralized Methodists operated. The first black denomination began in Philadelphia. It grew out of an African self-help society that split away from the white Methodists, creating Bethel Church and finally, in 1816, the African Methodist Episcopal Church (AME) denomination. Within two years, the AME's one thousand membership multiplied by seven, making Bethel a mother church for a network of congregations, abolitionists, and finally the Underground Railroad.

The Baptists, with their informal structures, grew fastest of all among southern blacks. They produced the largest association of slave church members in the South, perhaps 25,000 by 1800. In the South, a unique black sermon was born. English revivalists long had preached in singsong, or "whining," tones. But the black preacher developed a singular style, the "chanted" sermon.[6] The Bible's stories were known to slaves in an oral culture, and the preacher not only told those stories, he enacted their power.

In this old-style sermon, the preacher began in a spirit of weakness and reluctance. Only the Spirit could change him, and soon it did, in every utterance and muscle. The sermon began conversationally. It began calm and grandiloquent. Then the speaking became more rapid. The preacher gasped for breath, creating an oratorical beat. Each sentence became a meter, each

gasp or rap on the pulpit a rhythm. He stretched vowels to keep the beat, used "stall" phrases to catch the next thought. In time, his voice turned gravelly. It peaked in hoarse, raspy, and high-pitched shouts. Frenzied listeners also shouted. They clapped and jumped, and then abruptly the preacher stopped. He wiped his brow with a handkerchief. He recaptured a conversational tone.

Lasting twenty to forty minutes, the chanted sermon used simple language and dramatic delivery, with a sense of song, wordplay, and down-home examples. It adopted the European form of a text, an opening, a middle, application, and end. But when the chanting commenced, the preacher spoke as if he were a spiritual channel. The sermon was a stream of ideas bound not by logic but by the preacher's verbal and physical exertion. The black preacher stood out among the passive slave population. At one time, slaveholders could use the black preacher to exhort obedience and keep eyes on heaven. After Nat Turner, that assurance was no more.

Turner appeared in a decade when the political alienation of North and South had begun. The two sections disagreed on extension of slavery, but also on trade policy with England. In 1828 and 1832, for example, Congress imposed tariffs on British manufactured goods, increasing the cost of these imports. This helped New England manufacturers and western traders, but it raised the cost of living in the South, despite its growing export of cotton. Southern politicians decried the 1832 action as a "Tariff of Abominations" and then declared the doctrine of nullification. A state would simply nullify, or defy, a federal law. The hotbed of the doctrine was South Carolina. Its legislature passed an Ordinance of Nullification and funded an army. President Jackson reinforced federal troops in Charleston harbor. He repudiated the nullification doctrine, but then he maneuvered a compromise tariff, and South Carolina backed down.

Nullification had failed for the moment. The strained politics of North and South was quieted, at least until 1846, when the United States began to annex western territories, resurrecting the heated debate over extending slavery. In so divided a nation, one of the few organic systems holding America together were its denominations, especially the large ones such as the Methodists, Baptists, and Presbyterians. The Methodists were the biggest of all. And before political civil war broke out, Methodism experienced its own split over clergy owning slaves. Its preaching of division opened the way for states to leave the union.

A short time before, in 1837, the Presbyterian denomination had split over doctrinal differences, but it was informed by regional disagreements and the

contentious mood on abolitionism. "That mighty denomination is severed in twain at a blow," said the abolitionist William Lloyd Garrison.[7] The nation was now watching the Methodists, who had forbidden slaveholding by clergy from the beginning. They were not forced to contend with the full implications of nonslaveholding until 1844. As the Methodists would go, it seemed, so would go the nation.

For all its expansiveness, Methodism was a highly centralized denomination. The Methodist Episcopal Church for years had debated the balance of power between the bishop and the local clergy. North and South had predilections, the first supporting clergy assemblies, the second revering a strong bishop figure. A few mild constitutional crises seemed to have settled matters in favor of bishops, and yet the church also had reformed its General Conference, or national assembly, to include clergy delegations as well.

The Methodist Episcopal Church, just a few generations old, had illustrious bishops in its history. But in 1844 the two to watch were Joshua Soule, a native of New England, and a newly appointed bishop from Georgia, James O. Andrew. Soule, age sixty-three, was now senior bishop of the nation's largest denomination. He had seen the constitutional battles, brooked heresy charges for his sermons, and come out a strong advocate for the power of bishops. His words could not easily be dismissed.

At age sixteen in Maine, Soule had converted to Methodism and traveled as a "boy preacher." He was now six feet tall. His hair was swept back, and his strong jaw jutted forward. He wept over the salvation of souls in his sermons. His long black coat and stiff white collar made him look every bit the Methodist bishop. Once he was elected a bishop, Soule had moved west, living in Ohio for two decades and traveling the South as well. In time, southern believers were persuaded that Soule had given up his "Yankee notions," and that impression soon would be proved true.

Bishop Soule had never owned a slave, but his southern colleague, Bishop Andrew, would not be so fortunate. Andrew was made a bishop because he held no person in bondage. However, when his wife died, Andrew remarried. His second wife owned slaves, and under Georgia law she could not emancipate them. Serious cracks in Methodism already had appeared in 1843, when abolitionists left to form the Wesleyan Methodists. But the next year, Bishop Andrew had nothing but foreboding for the entire denomination. "The abolition excitement, I fear, has never presented an aspect so threatening to the union of the Church as it does at this moment," he wrote Soule. "I look forward to the next General Conference with no little apprehension."[8]

That conference gathered in May at Greene Street Church in New York City. It continued for ten weeks and drew about 160 clergy and lay delegates. The first week was dominated by sermons, speeches, and orations on slavery. Finally the conference surrendered itself to the slavery topic entirely. The first sparks flew when a majority upheld the suspension of a Baltimore minister who had become a slaveholder by marriage. The southern Methodists saw what was ahead and stiffened their resistance. As a committee struggled to draft a plan for "the permanent pacification of the Church," an abolitionist forced the case of Bishop Andrew to the floor.

Several times, Soule rose to speak.[9] He argued that bishops were protected by the constitution, short of an actual church trial. The abolitionists wanted Bishop Andrew to step down immediately. Tall and stern, Bishop Soule urged the assembly to bide its time, wait until 1848, and hold together.

I can be immolated on only one altar, and that is the altar of the union of the Methodist Episcopal Church. You cannot, all the powers of earth cannot, immolate me upon a Northern altar or a Southern altar. Here I take my stand, my position.

Soule had two other concerns. He counseled the young and zealous clergy not to be rash, beseeching them by "a voice from the tomb" of Methodist forefathers. He also announced that American society was watching. If the Methodists broke apart, or ran roughshod over their constitution, what hope was there for organized Christianity? "We are, too, before the tribunal of public opinion," he said, especially elite opinion. Was his church, he asked, in such a state of excitement—"I had almost said, of revolution"—that it could not follow its rules?

Finally, the New England delegation forced a vote. Along sharp sectional lines, the conference suspended Bishop Andrew. The southern delegates fought back. The action hurt "the success of the ministry in the slave-holding states," since they ministered to slaveholders, who now would angrily rebuff them. The only road to peace was separation, the South said, a "constitutional plan for a mutual and friendly division of the Church."[10] And so it was done: a Plan of Separation divided the church assets and allowed North and South to organize separate jurisdictions.

At first blush, the split seemed a wonderful solution. Both churches grew, powered by Methodist zeal. More ominously, the excitement of 1844 fired the imagination of southern politicians. Those who read the *Southern Christian Advocate,* edited by William Capers, a Methodist cleric in South Carolina,

had already caught the secession drift. Now it became true in New York. From his Washington office, Senator John Calhoun of South Carolina wrote Capers in New York City immediately. The Methodist doings "demand the gravest attention on the part of the whole Union and the South especially," he said. He invited Capers to "spend a day or two with us, in order to afford an opportunity of exchanging ideas."[11] This time at least, Capers avoided a Washington visit on the way home, so delicate were the politics of the hour.

Through the *Advocate,* however, Capers preached southern sentiment quite publicly. The Methodist split showed the country, he said, "that Southern forbearance has its limits, and that a vigorous and united resistance will be made at all costs, to the spread of the pseudo-religious phrenzy called abolitionism."[12] This sentiment was not surprising. What shocked was the decision of Soule to become the southern church's leader. The move was gradual. When the southern and northern delegates met separately in 1845, one side in Louisville and the other in Pittsburgh, the seven Methodist bishops still were at large, aiding both sectional camps.

Presiding in Louisville, Soule was "ardently desirous that the two great divisions of the Church might be in peace and harmony within their own respective bounds and cultivate the spirit of Christian fellowship, brotherly kindness, and charity for each other." It was not to be. The next year he declared "adherence" to the South. The financial agreement broke down, and an acrimonious legal fight took the warring Methodist factions to the Supreme Court. For the next fifteen years, Bishop Soule shepherded the southern church, first through numerical growth and then physical destruction.

The southern Methodists were not the only orators who looked to the Bible and found slavery justified. The institution, though evident in the New Testament, was explicated most fully in the Hebrew Bible. When the debate on slavery erupted, it brought into focus for the first time what America's rabbis had to say about American public policy and morality.

Relying on lay leaders for generations, America's small Jewish community did not see its first ordained rabbi installed in a synagogue until the 1840s. Language barriers still limited the rabbis' public role. But some mastered English. When the rules in Congress changed, allowing a rotation of ministers to open each day's session with prayer or remarks, the first rabbi was invited. It was 1860, and the obvious choice was Morris J. Raphall of New York City, a native Swede trained in England, and so articulate that his talks were serialized in the *Saturday Evening Post.* He was America's first public rabbi.

The prayer in Congress was only a start. The Christian debate on slavery, especially as southern theologians plumbed the Old Testament, forced

Raphall to clarify an official Jewish position. In January 1861 he preached on the "Bible View of Slavery." He argued that, yes, the Old Testament did literally sanction slavery. But Hebrew slavery, he preached, was more humane and protective of slave rights than the chattel bondage system seen in the South.[13]

The pressing question of the hour was the Fugitive Slave Act, enacted in 1850 and requiring "all good citizens" to help federal police capture fleeing slaves, or face charges if they did not. This onus single-handedly turned northern pulpits against the "slave power" in the South. On this topic also, Raphall interpreted his Hebrew Torah literally. Owners had a right to apprehend slaves who fled. So topical was Raphall's sermon that it was published and widely circulated. It was the first Jewish sermon ever to gain wide attention in the United States. In reaction, American rabbis for the first time publicly voiced their disagreements. Rabbis on the "reform," or liberal, side of American Judaism said the literal Old Testament was not a guide for modern days. The spirit of God's justice, the universal message of the Torah, abhorred human slavery.

The rabbis, taking to their pulpits, were arguing the same issue as the Protestant clergy. Was the Bible to be taken literally, or revered for its principles? Reformist rabbis preached the spirit of the text, and traditionalists its literal application. Beyond slavery, this difference in mode of interpretation, when applied to every law and custom in American Judaism, fueled two nascent American "movements." One was orthodox. The other was committed to modern adaptation, later called Reform Judaism; its openness pioneered the modern Jewish sermon, soon preached widely in English.

The 1850s was a decade of reckoning for the South. The region was eager to defend its way of life. The clergy, as its public intellectuals, played a leading role in that project. At one time, the South had Jefferson's agrarian ideal to boast, but that world had passed away. The southern way of life had congealed around an entire system of labor, culture, and leisure. For southern ideologues, it was more than a distinct hierarchical order. It was an exemplary system for the world. God's providence had given the system to the South. Explaining this social entity, which some call a "metaphysical Confederacy," required a number of resources. It was an amalgam of religion, nationalism, romanticism, politics, and social science.[14]

The clergy's role in the South was extensive. The 1850 census found 7,514 ministers in a population of 4.4 million free citizens.[15] The clergy often were the civic leaders. And that civic authority was constructed as much by preaching as by any political actions in Washington. The planter class, though

endowed with wealth and free time, did not rise to such intellectual occasions. The thinking aristocracy was a political class, giving the South its image of having a preoccupation with political theory. This political core was a class of action, however. If the clergy wanted to remain relevant, they had to match that activism in word and deed.

The man who did this best in the 1850s was the Presbyterian scholar James H. Thornwell, who was both pastor of First Presbyterian Church in Columbia and president of South Carolina College, a few blocks away. During the 1850s, when sermons and theological dissertations envisioned a metaphysical South, Thornwell was a pacesetter. He was called "the Calhoun of the church." Thornwell had studied in the North, indeed, at Harvard, and he did not like that region's industrial chaos and theological liberals.

The metaphysical imagery easily came to mind. The North was a mixed race, quarrelsome, and driven by crass commercialism. The South celebrated a purer European heritage, with its codes of honor. It had an organic and tiered society. It had genteel Cavaliers in the lead, while rapacious Yankees led the North. In this comparison, the South won not only on romantic grounds, but also by its superior labor system. Slaves lived far more securely than transient northern factory workers.

The case for the South was an entire package. One of Thornwell's sermons, preached on May 26, 1850, summed up all the points. From Columbia,

James Thornwell, the "Calhoun of the church," preached a southern way of life.

Thornwell had traveled the one hundred miles to reach Charleston, where Second Presbyterian Church had opened a school for slaves. He was happy to deliver its dedication sermon, choosing as his topic "The Rights and the Duties of Masters."[16] Charleston had seen its own rumors of a slave revolt in the 1820s. The ringleader, a black carpenter named Denmark Vessey, once held membership at Second Presbyterian before he joined the African Methodists, whose church was burned down in the white panic over the conspiracy.

It was years later now, and Second Presbyterian was doing its part— despite laws restricting black education—to bring Christianity to the slave. As Thornwell argued, such education brought a Christian acquiescence by the slave to the prevailing social order. Already, the church school boasted 180 Negro "scholars," or students.

In his sermon, Thornwell was acutely defensive of the abolitionist arguments in the North. They were the foil as he preached a justification of the southern order. Slavery was providential and biblically justified. No human system was perfect in a fallen world. Even slavery was ultimately a transient earthly order. But in the past and still today, he preached, it was part of God's earthly providence, both to spread Christianity and to civilize society. As a result, there was no "necessity of sudden changes." Thornwell had only to cite recent failed socialist and nationalist revolutions in Europe to make his case. Begun in France in 1848, and spreading to Germany, Italy, Austria, Hungary, and Bohemia, these parliamentary movements were short-lived, ending in a return of imperial rule by the next year. Thornwell said abolitionism would fail as well.

The South viewed slave society as an "ordinance of God ... whose beginnings must be traced to the unfathomable depths of the past." But the North saw society as a puzzle to be "taken to pieces, re-constructed, altered or repaired." Two kinds of society had come of age in God's providence, Thornwell preached. And he suggested that the South "bide its time" in confidence that God would vindicate its system. Slavery, he said,

> is one of the conditions in which God is conducting the moral probation of man—a condition not incompatible with the highest moral freedom, the true glory of the race, and therefore, not unfit for the moral and spiritual discipline which Christianity has instituted. It is one of the schools in which immortal spirits are trained for their final destiny.

During Thornwell's short time at Harvard, one of his classmates had been William Ellery Channing, who went on to declare the manifesto on

Unitarianism. Most Unitarians now were abolitionist. So Thornwell picked out one of their arguments to knock down: that slavery stole a black man's humanity. This was not true, Thornwell argued, because a slave has obligations, and to fulfill them requires character and free will. Thinkers of Channing's ilk had abstracted equality beyond the real world. The Bible did not have such a concept. It had only specific duties. It prescribed only moral attitudes for each social station. In his place, a slave was "as fully stamped with the image of God" as a white man "trained on flowery beds of ease."

Thornwell went on. Abolitionists ransacked the Bible. They confused "the letter and the spirit of the Gospel." By the letter, or facts, Jesus and Paul endorsed slavery. It was a system of duties, "a moral debt, in the payment of which they were rendering a homage to God." The master's obligation to the slave was religious and moral instruction, a duty the new church school was about to undertake. Slavery had brought the Christian faith to Africans. "Our design in giving them the Gospel, is not to civilize them—not to change their social condition—not to exalt them into citizens or freemen—it is to save them." To obey Jesus and overcome sin "is to be slaves no longer."

Although Thornwell mentioned his nemesis Channing in the sermon, his target was a broader ideology in the North. It was the spirit of infidelity. America was divided not only by two economic systems, but by rival worldviews.

> The parties in this conflict are not merely abolitionists and slaveholders—they are atheists, socialists, communists, red republicans, jacobins, on the one side, and friends of order and regulated freedom on the other. In one word, the world is the battle ground—Christianity and Atheism the combatants; and the progress of humanity the stake.

Despite such demonizing, the South and North had more in common than Thornwell could probably admit. Both were doing battle in an age of European Romanticism. The South had chosen the Scottish version, with stories of male heroes, feudal patriarchy, damsels, duels, chivalry, and a harmonious caste system. The North had drawn on German Romanticism, with its emphasis on critical thinking, insight, and intuition. As harmless as this sounded, the belief in intuition would spawn a new religious movement in New England, and some of its proponents were no less abolitionist than the Unitarians whom Thornwell had targeted.

In 1836 a small group of New England ministers and thinkers gathered at a home and called themselves the Transcendentalist Club. They shared perhaps one thing with the southern agrarian romantics. The Transcendental-

ists, who peaked in the 1840s and were consigned to legend by 1850, also had become disillusioned with New England's grubby, materialistic, industrial world. They were equally in pursuit of a more natural order.

Transcendentalism was inaugurated by a sermon given by Ralph Waldo Emerson. Trained as a Unitarian minister, Emerson left the ministry in 1832 and his book *Nature* became the Bible of the new speculative and literary movement. Under its umbrella came figures such as Henry David Thoreau, who argued for self-reliance in nature and lived at Walden Pond; the founders of the Fruitlands and Brook Farm utopian farm communities; and a line of major female literary figures.

Emerson's "Divinity School Address," given in the summer of 1838 at Harvard, was the real progenitor, however.[17] On the night of July 15, six graduating seniors and a few teachers and other students gathered to hear his graduation sermon in the small wood-paneled chapel on the second floor of Divinity Hall. Little noticed at first, the address became what Emerson called a "storm in our washbowl" when published. It was later turned to as a founding document. If the Unitarians had argued for a rational use of the Bible and benign application of Christianity, Emerson seemed to undercut Christianity altogether. He criticized the abuses of "historical Christianity."

Emerson began his address by celebrating "moral sentiment," that is, intuitive insight into moral and spiritual laws, which could never be received secondhand. Every person, Emerson told the students, possessed this sentiment. It was the "indwelling Supreme Spirit" and "essence of all religion." By neglecting moral sentiment, Christianity had fallen into two grievous errors. It exaggerated the personal and miraculous authority of Jesus Christ. And it looked upon revelation as an event of the past, dead and confined to biblical times.

The "assumption that the age of inspiration is past, that the Bible is closed; the fear of degrading the character of Jesus by representing him as a man;—indicate with sufficient clearness the falsehood of our theology." But Jesus himself knew better. Jesus "felt that man's life was a miracle," Emerson said, whereas "the word Miracle, as pronounced by Christian churches, gives a false impression; it is Monster." Belief had waned because people no longer could accept the old ideas of miracles and revelation, Emerson said. He was speaking against Unitarianism as well, for as rational as it was, its founders had retained belief in historical miracles.

Emerson called for a new generation of ministers and preachers to arise. They should awaken minds to the indwelling Spirit, the "eternal revelation in the heart." He recognized that Americans still turned to their churches to

find meaning in life, and that the two great gifts of Christianity had been the Sabbath and the art of preaching. Yet he called for a new kind of sermon. "Show us that God is, not was; that He speaketh, not spake."

Most American preaching was about tradition. Still, he said, preaching was paramount. It continued to be the most flexible and dynamic way of communication. But preaching is not doctrine; it is "new revelation" on a regular basis.

> Preaching is the expression of the moral sentiment in application to
> the duties of life. In how many churches, by how many prophets, tell
> me, is man made sensible that he is an infinite Soul; that the earth and
> heavens are passing into his mind; that he is drinking forever the soul
> of God? . . . And what greater calamity can fall upon a nation than the
> loss of worship? Then all things go to decay. Genius leaves the temple
> to haunt the senate or the market. Literature becomes frivolous.
> Science is cold. The eye of youth is not lighted by the hope of other
> worlds, and age is without honor. Society lives to trifles, and when
> men die we do not mention them.

The publication of the address caused a storm in New England. The Calvinists said it proved that Unitarians ultimately slide into paganism. Unitarians attacked Emerson also, however. But the Unitarian links to Emersonian thought were not hard to see. Emerson called Channing, who was the founder of Unitarianism, "our Pope," and indeed Channing had attended Transcendentalist Club meetings and did not condemn the "Divinity School Address." Other Unitarians picked up where Emerson left off, and none was so influential as the young and dynamic Theodore Parker, whom Emerson called "our Savanarola," after the monk who was burned at the stake in Renaissance Italy for preaching heresy.

The Transcendentalists who had gathered in the 1830s were in their twenties and thirties, though visited on occasion by senior clerics, such as Channing once or twice. But it was the young clergymen like Parker who took the new spirit of the age to heart. In its brief lifespan, Transcendentalism crafted a type of sermon that mimicked the literary essay. Both were more impressionistic than strictly logical. They mined images in nature, history, and literature as much as in the Bible. Parker used logic to great effect, especially in demolishing opposition arguments. But he too adopted a colorful, impressionistic oratory, aimed at reformist activism.

Though he never gave up his Unitarian ministerial credentials, Parker became the formal expositor of Transcendentalism from his pulpit, beginning

Transcendentalists Ralph Waldo Emerson and Theodore Parker supported abolition.

in West Roxbury. He had just turned thirty when Emerson gave his Harvard talk. He called Emerson's address "the noblest and most inspiring strain I ever listened to" and was amused by the offense it caused traditional Unitarians.[18] At stake was the customary idea of miracles, and for a time Parker joined that debate, even with a pamphlet, on the side of Emerson.

Then, in May 1841 he preached an ordination sermon in South Boston that became another manifesto in liberal Christianity. The sermon was titled "A Discourse of the Transient and Permanent in Christianity," and it adopted the modern theory that beliefs are shaped by times in history, and then history moves on, developing new ideas.[19] As a result, a few cosmic truths are permanent, but much else changes. Whereas the intuitive truths taught by Jesus endure, doctrines, theology, creeds, Christian rites, and even the church were passing.

In his sermon, Parker humanized Jesus more than even Emerson had. Jesus was a beacon of truth, not its only source. "It is hard to see why the great truths of Christianity rest on the personal authority of Jesus, more than the axioms of geometry rest on the personal authority of Euclid or Archimedes." The excellence of Jesus was human excellence, a wisdom, love, and piety that humanity also might attain. Christianity was "pure morality" flowing from the two commandments to love God and neighbor. From this flowed duties: reverence, humility, forgiveness, gentleness, charity, sobriety, forgiveness, fortitude, resignation, and faith.

Parker's sermon sparked outrage. Unitarians lodged a formal complaint, and Calvinists wanted him jailed for blasphemy. But his Roxbury church stood by him. In 1843, when the Boston Association of Unitarian Ministers asked him to resign, Parker refused. But he became more independent. A growing number of supporters formed the Twenty-eighth Congregational Society, rented the large Melodeon Hall, and hired Parker as minister.

During his installation in 1846, Parker preached that the "True Idea of a Christian Church" was found in moral action. His church became the center of Boston activism. His pulpit pioneered criticism of the North for complicity in slavery, and his Sunday speech against the Mexican War at Faneuil Hall in February 1849 drew federal troops armed with bayonets ("hireling soldiers of President [James K.] Polk," Parker announced). A riot nearly ensued. In Washington, Polk had declared that it was treason to oppose the war. Parker declared that he was guilty of "moral treason" if he did not decry American aggression on a weaker people.

> The friends of the war say, "Mexico has invaded our territory!" When it is shown that it is we who have invaded hers, then it is said, "Ay, but she owes us money." Better say outright, "Mexico has land, and we want to steal it!" This war is waged for a mean and infamous purpose, for the extension of slavery.

In this sermon, Parker responded to the taunts of opponents, who yelled, "Throw him over; kill him, kill him!" At one point, the soldiers raised bayonets to stop the oral clash from turning physical, as Parker continued:

> It is not enough that the slaveholders annexed Texas, and made slavery perpetual therein, extending even north of Mason and Dixon's line, covering a territory forty-five times as large as the State of Massachusetts. Oh, no; we must have yet more land to whip negroes in! . . . I say this war is mean and infamous, all the more because waged by a people calling itself democratic and Christian.[20]

Parker, who had the largest Sunday audiences after Henry Ward Beecher in Brooklyn, used sermon locutions such as a "house divided against itself . . . cannot stand" and "of, by, and for the people." The phrases influenced Lincoln's oratory a few years later. More than anyone, Parker spread the gospel of a "higher law"—the ultimate rationale of extralegal abolitionism. One essayist who heard the stout, balding Parker with his earnest look said he was "more like a ploughman than a priest" or national orator.[21] But in his lifetime, Parker became one of the nation's greatest preachers.

For romantics in both the South and the North, 1848 and 1849 were crucial years. The revolutions against autocracy in Europe arose and then failed. This proved to southern ideologues such as the Presbyterian orator Thornwell that history had gradually given American Christianity its slave system. Only God's providence could gradually take it away. The Transcendentalists always were a small, elite group, and the failed uprisings in Europe also marked a deflation of their own revolutionary spirit. To many of them, it seemed the social order would not change.

The Transcendentalists retired to being a Victorian middle class and followers of literary pursuits. Their exploits on farms, in a Concord library, or in a log cabin on Walden Pond seemed surpassed by a decade in which America acquired California, empires expanded, and wealth and machinery set the tone for national life. When Alcott Bronson left Transcendentalism to convert to Catholicism in the 1850s, he believed society had become too complex for individualists. Only a historic institution like the Catholic church could uphold a social order.

Yet the Transcendentalists who stayed in Boston became the hub of a new intellectual elite. After passage of the Fugitive Slave Act in 1850—which sent police prowling the North for truant slaves—Transcendentalists found themselves on the ramparts. They attended abolition rallies, demonstrated, and delivered antislavery speeches. The new activism was seen at different levels in Emerson, Thoreau, and Parker.

Emerson fought slavery in the abstract, for it was a state of mind as well as a labor system. Emerson equated chains to mental conformity. "I have quite other slaves to free than those negroes, to wit, imprisoned spirits," he said.[22] Now a professional lecturer, he delivered a series on "American Slavery" in 1854 and 1855. He was outraged by the fugitive slave statute but never turned full-time activist.

Thoreau argued for a nonviolent boycott of taxation as a way to end the political system of slavery. For this tax revolt he spent a short time in jail. He also preached of "higher laws." The ornery and irreligious Thoreau could not have imagined the lasting influence of his words on civil disobedience, or passive noncooperation. Parker, in his turn, struck out with direct political action. He preached, wrote letters to politicians, and sat on the Boston Vigilance Committee to protect fugitive slaves. His Boston home was a stop on the Underground Railroad, as was Thoreau's on occasion. Finally, Parker outraged the entire South by preaching that slaves had a "natural right" of self-defense against those who would enslave them.

The Transcendentalists appeared in the 1830s and 1840s as a reaction to the urban industrial revolution. Many of them ministers, they began as

intellectual radicals in Christianity, then moved on to social reform, whether in alternative communities, self-reliance, or abolition. Before and after the Civil War, they largely accepted free-market capitalism. Radical moral reform did not work, they believed, so they backed northern military pragmatism. In the end, the Victorian world of party politics, immigrants, and wealth disoriented them as much as it did anyone else. Their legacy became one of myth and literary achievement.

To some critics, the anarchic rhetoric of these New England romanticists caused the Civil War. As a twin to abolitionism, Transcendentalist preaching stirred a craving for immediate revolution, not gradual change. More likely, however, the extension of southern "slave power" in new laws and territories ignited abolitionist fury. The first Transcendentalists tried to make transformation of individual character the basis of social change. Thwarted, their impulse turned into general philanthropy, much as the Puritan doctrine of immediate "grace" shifted to social support of "do-goodism."

But New England, like the South, continued to have its purists. Although some purists constrained themselves to words, others promulgated fanatical, or heroic, action. Once the New England farmer, failed businessman, vigilante, and Calvinist believer John Brown appeared, the Transcendentalists had to pay attention. He was a "tall, spare, farmer-like man, with head disproportionately small, and that inflexible mouth," said Garrison, the abolitionist editor. Brown was reared on New England revivalism. He read "the ponderous volumes of Jonathan Edwards's sermons which [his] father owned." Brown often said, "Without the shedding of blood there is no remission of sin."

He shed that first blood in 1856 in "bloody Kansas," where citizens and mobs fought over electing a pro- or antislavery state government. Brown and his small band killed some of the southern slavers who came into Kansas as advocates. Kansas was a cause célèbre for abolitionist churches in the North. At Plymouth Church in Brooklyn, Henry Ward Beecher persuaded his abolitionist congregation to send a handful of rifles to Kansas in boxes marked "Bibles." It was a small measure, but "Beecher's Bibles" became a slogan for the church's gradual endorsement of force to end slavery.

Among the New England elite, Brown got funding from the "Secret Six," five of them Transcendentalists. The two most notable were radical Unitarian ministers, Parker and Thomas Wentworth Higginson. The funds went to support Brown's activities in Kansas and his final war at the federal garrison of Harper's Ferry, Virginia, in 1859. There, Brown rented a farm. He gathered a force of sixteen whites and five blacks and stored guns and 950

cast-iron pikes. Then, in October they struck, but the hoped-for slave rebellion never came. The Marines quickly captured Brown, and he was hanged.

For many Transcendentalists, Brown was a martyr. His life was a perverse sermon on atonement, which came only by blood. His last words on the gallows were, "I, John Brown am now quite certain that the crimes of this guilty land: will never be purged away; but with Blood." Herman Melville, part of the Transcendentalist literati, was dubious about Brown but said his long, wind-swept beard on the gallows was the "meteor" of the Civil War. Thoreau wrote "A Plea for Captain John Brown." Emerson said Brown made "the gallows as glorious as the cross."

In the South, the Brown fiasco rang like an alarm bell. The next year, liberal Whig Abraham Lincoln was elected president on the Republican ticket, home to the abolitionists. Now came the deafening oratory of Benjamin Morgan Palmer, a Presbyterian and preacher-secessionist. Palmer and Thornwell often had shared company, pulpits, and the pleasures of a fine cigar. Palmer decried the "higher law" of abolition from Savannah to Columbia, and now New Orleans. The higher law was a recipe for anarchy. It made the Constitution a lie. Now he assessed the 1860 election. Lincoln was but a "figure upon the political chess-board," Palmer preached, "moved by the hands of an unseen player," the atheistic abolitionists. Palmer preached secession.[23] A few weeks after his words, South Carolina took that first step. In a few months, the war to purge America was under way.

The God of Battles

Interpreting Victory and Defeat

A FTER LINCOLN WAS ELECTED, SOUTHERN SERMONS GAVE TWO kinds of advice, but the most fervent orators, led by the intrepid Benjamin Morgan Palmer, favored secession. Three weeks after the 1860 election, he was preaching "the probable doom of our once happy and united" America. The next month, South Carolina's legislature, meeting on December 20 in the high-columned, templelike First Baptist Church in Columbia, adopted the first secession articles in the nation.

Palmer's sermons rang out weekly from the stone and spire-topped First Presbyterian Church in downtown New Orleans. His oratory had left a long, distinguished trail across the South, from Savannah to Columbia, and now it led to a powerful pulpit in New Orleans. On this particular Sunday, he preached that in the face of secession, the South had four sacred duties: to self-preservation, the slaves, the world order, and God.[1] Two thousand heard his sermon, but in printed form ninety thousand copies circulated in southern states. One Confederate general in Mississippi later said that his oratory was worth a thousand soldiers. And who in the South could resist the oratory of one of its most eloquent native sons, a manly, cigar-smoking preacher with a salt-and-pepper beard and eyes like black bullets?

To the South the highest position is assigned, of defending, before all nations, the cause of all religion and of all truth. In this trust, we are resisting the power which wars against constitutions, and laws and compacts, against Sabbaths and sanctuaries, against the family, the State, and the church; which blasphemously invades the prerogatives of God, and rebukes the Most High for the errors of his administration, which, if it cannot snatch the reins of empire from his grasp, will lay the universe in ruins at his feet.

The South must go its own way, Palmer preached, as even the ancient Abraham and Lot separated to keep the peace. The serpent of northern abolition had invaded the southern Eden, slithered up a tree, and breathed hot on the southern neck, "hissing out the original falsehood."

The southern states, like emboldened men, had to meet and reclaim the power the Constitution had given them. Palmer preached secession. "Let them, further, take all necessary steps looking to separate and independent existence, and initiate measures for framing a new and homogeneous confederacy." South Carolina took the first step. Then in February five more states, including Palmer's Louisiana, met in Alabama to form the Confederacy and elect Jefferson Davis president. When the Confederacy demanded that Fort Sumter, located in the harbor of Charleston, South Carolina, be surrendered,

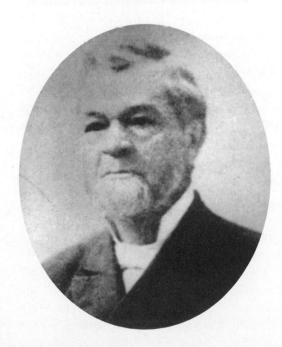

Benjamin Palmer was the South's most eloquent secessionist preacher.

a three-and-a-half-month siege commenced, ending in a Union retreat in April 1861.

Based on its Puritan roots, the United States had a long tradition of claiming a special covenant with God. The Confederacy had to establish such a claim overnight. So to spite the secular North, the Confederate constitution evoked the name of God. This divine sanction was further bolstered by Davis's propensity to declare days of fasting and thanksgiving. A long war was ahead, and these days typically were declared around military victories or defeats. The first one, however, came on June 13, 1861, before any real fighting had commenced. In New Orleans, Palmer preached on the Confederate mission in a sermon titled "National Responsibility Before God."[2] The North had committed five great sins, he said that Thursday, a political fast day, and probably the worst was its espousing "the pretensions of 'higher law,'" the death knell to all human orderliness.

In defending order and liberty, the South was refighting the American Revolution. "The last hope of self-government upon this Continent lies in these eleven Confederated States," he said, and it was no less than providential. "Two nations were in the American womb." Now, their separation was "decreed of God," said Palmer, proving once again his superb use of prose, which worked both in speech and in print. Palmer knew his audience well. He spoke to their pride and fears as southerners. He tapped the adventurous stirrings of young men, and roused the defensive instincts of mothers and fathers. Most of his audience owned no slaves. For them this war was a pure abstraction—until he framed it in moving appeals.

Soon for the South, the war became concrete in a battlefield victory. The two armies met at Manassas, Virginia, on July 21, 1861, for the First Battle of Bull Run. With such Christian warriors as Thomas "Stonewall" Jackson in the lead, the Confederates routed the Union army under the terrified gaze of northern picnickers, who were caught up in the dusty and chaotic retreat back toward Washington. The total in casualties was about five thousand, a staggering number, equal to the entire American loss in the war with Mexico.

For the South, the shock was sweetened by a first victory. One of many clergy to preach a thanksgiving sermon, and explain the ways of God, was the Episcopal bishop of Georgia, Stephen Elliot, who presided at Christ Church in Savannah. The church, which faced the main square of the well-designed city, was a cavalcade of history, with a marble altar table used by Anglicans John Wesley and George Whitefield, and displaying an imposing brass pulpit.

From this ledge of history, on the Sunday after Bull Run, Elliot preached that the Confederate army's victory had resulted from the sincerity of the

June 13 fast day. As covenant logic guaranteed, blessings came to a humbled South, a people who turned to God's ordinances. The victory, he said in "God's Presence with Our Army at Manassas," was "the most wonderful of all the manifestations" that God lived with the Confederacy.

> God has now so signally displayed himself to our wondering eyes, that the pillar of cloud by day and of fire by night was no more plain to the children of Israel. He has smitten our enemies in their most tender and sensitive point, their invincible power, and has taken from us the pride of victory by giving it to us wrapped in the funeral shroud of the brave and the young.[3]

The southern victories continued. The South's prowess confounded northern pulpits. Although the northern clergy overwhelmingly were Republican, they condemned Lincoln for inaction. They called the generals incompetent. But most of all, they lobbied to have the Constitution amended to show that theirs was a Christian America, more so than the rebellious South. With the start of the war, the North produced the nation's first "American flag culture," which was a new visual and rhetorical experience on a national scale. But ministers preached for more. Many wanted God put in the Constitution, and still others demanded that Jesus Christ and Scripture gain "supreme authority" in the founding document.[4] By the logic of the covenant, it was the North's failure to evoke God that explained its military defeat.

As this debate heated up, Lincoln pursued a compromise. He did not want to mingle church and state in the Constitution. His concession came late, but it invested the Union with a new motto. On April 22, 1864, the administration struck the first American coins to bear the phrase "In God We Trust." Lincoln stamped religion on the war in other ways. In his two great wartime orations, the Gettysburg Address and the Second Inaugural—which abolitionist Frederick Douglass said "sounded more like a sermon than like a state paper"—Lincoln alluded to the divine mystery of war.[5] He said it created sacred memory and purged an entire people of their sinful past.

The 272-word Gettysburg Address was probably modeled on ancient Greek funeral oratory, known to Lincoln through a recent burst in classical studies and speech-making. But his Second Inaugural of 1864 drew on Puritan oratory, the jeremiad, and themes from biblical texts in Psalms and Matthew. On the east side of the U.S. Capitol, the crowd stood in a field of mud. Lincoln told them that both North and South wanted easy triumph.

Both read the same Bible and pray to the same God, and each invokes His aid against the other. It may seem strange that any men should dare to ask a just God's assistance in wringing their bread from the sweat of other men's faces, but let us judge not, that we be not judged. The prayers of both could not be answered. That of neither has been answered fully. The Almighty has His own purposes. "Woe unto the world because of offenses; for it must needs be that offenses come, but woe to that man by whom the offense cometh."

Lincoln reached deep into the long-held American presumptions about the nature of God and his providence, and, indeed, America's standing under both.

If we shall suppose that American slavery is one of those offenses which, in the providence of God, must needs come, but which, having continued through His appointed time, He now wills to remove, and that He gives to both North and South this terrible war as the woe due to those by whom the offense came, shall we discern therein any departure from those divine attributes which the believers in a living God always ascribe to Him? . . . Fondly do we hope, fervently do we pray, that this mighty scourge of war may speedily pass away. Yet, if God wills that it continue until all the wealth piled by the bondsman's two hundred and fifty years of unrequited toil shall be sunk, and until every drop of blood drawn with the lash shall be paid by another drawn with the sword, as was said three thousand years ago, so still it must be said "the judgments of the Lord are true and righteous altogether."

The Gettysburg Address and Second Inaugural gave the nation a sacred memory, conciliatory words of judgment, and two of the nation's greatest secular sermons. Nevertheless, the war raged, and Lincoln was bent on total victory. In the same years that he composed such evocative prose, he also invented the scheme of total war in America.

In North and South, the clergy believed that God was in control of earthly events. Victory and defeat left them to plumb the mysterious depths of the covenant in their studies, prayers, and sermons. In the first two years, northern ministers had the worst of it, for they struggled to explain Union regress. At the end of June 1862, a lengthier battle flared again in Manassas, called Second Bull Run. After General Robert E. Lee smashed the Union army

there, his forces made their first lunge into Union territory. It looked desperate, even from faraway Kansas.

In the town of Leavenworth, James D. Liggett had just become pastor of the First Congregationalist Church, which stood near the river. Besides reading newspaper reports, it was the best place to go for news of the war. A month after Second Bull Run, Liggett decided to preach on why the Union armies were going down in defeat. But his sermon, "Our National Reverses," could only be understood against the political backdrop of the North in the first year of the Civil War.

When war began, both North and South denied that the conflict was over slavery. Abolitionism was not universal in the North, as A. L. Stone's preaching at Park Street Church in Boston showed. "It is not an anti-slavery war we wage; not a sectional war; not a war of conquest and subjugation," he said. "It was simply and solely a war *for the maintenance of the Government and the Constitution.*" For black clergy such as Bishop Daniel A. Payne, the African Methodist Episcopal church's man in Washington, this northern outlook left blacks ambivalent. In the first year of war, he said, "the South was earnestly invoking God against the North, the North invoking God against the South, and the blacks invoking God against both!"[6]

The North had its biblical warrants, of course. Even Christ did not rebel against the Romans, so how could the South revolt? The American Revolution was a legitimate revolt, for a colonial government was an absentee one, whereas the South had its voice in Washington, a national government "of divine authority," as preachers in the North asserted. For the Kansas preacher Liggett, however, this was a thin moral argument for war. So in his September 7, 1862, sermon—as Lee marched into the North—he set out to explain northern defeats.[7]

They came because the North was not fighting to end slavery. "Our President has said, and all his policy has been, to preserve the national life and slavery too, if he can," he said. But slavery and the oppression of blacks was the very sin that God was watching. It was a sin even of the North, with discriminatory black codes and offers to send slaves back to Africa. In this war, northern hearts seemed filled with hatred and revenge, not a desire to right wrongs. "I think I hear God saying to us—'Are you as a people, after all, ready to do justice? The rebels are fighting for Slavery; are you fighting for Liberty?'"

The North's defeats showed that its policy and attitude was not pleasing to God, and Liggett had found the perfect text in the Old Testament. The Book of Judges narrated how the small Benjamin tribe routed the large Israel

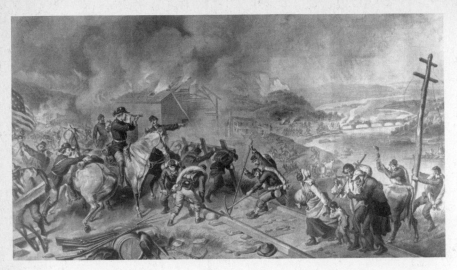

Northern and southern sermons grappled with victory and defeat, as when General William Tecumseh Sherman captured Atlanta and marched to the sea.

tribe, which was in the right. Israel asked the Lord, "Shall I again go out to battle. . . ?" The Lord replied, "Go up; for to-morrow I will deliver them into thine hand." The same could be true for the North, if with godly motives, it fought to end slavery.

Judging by the biblical story, Liggett asked, did God temporarily side with the wicked army in battle? "Certainly not," he preached. "But we must say that his power was exerted as to result ultimately in the greatest good to Israel." Israel needed to be sobered. Like the North, Israel ignored God, relied on its firepower, and went to battle for glory and revenge. "Israel had one Bull Run disaster," and then another, which finally changed its warring heart, making it go "to God with fastings, tears and confessions." The North needed to confess that it fought to end slavery. For his audience, Liggett offered a hard, but covenant-logical, answer.

God is always consistent with himself, and works for righteous ends. If his hand is for a time against even his own people, it is not in anger, not without a just reason, and for a glorious purpose. If he uses his enemies to scourge his own people, and to correct them, it is in mercy, and it does not follow that his favor is even temporarily with his enemies, and against his own people, but the contrary.

For the moment, the Liggett sermon hoped to explain why "God is against us, and yet not against us." It was a mystery the entire nation was handed at

the end of the Civil War. One million were dead, yet four million slaves were freed. Only the infrastructure of the South was destroyed, but across the nation 620,000 widows mourned. It was hard to judge winners and losers, and the mystery of God's ways. During the years of war, however, there was no more unanimous group than the clergy in both the North and South. They closed ranks behind regional patriotism. Few questioned their cause or the behavior of the armies they supported. There might have been dissent, but it came before the war, for antislavery ministers had fled to the North and prosouthern preachers had exchanged pulpits to end up in the South.

In practical terms, the North had "agressed" by entering southern territory. Northern clergy had to justify the war and military draft as a Christian duty to save the Union. The South made a different argument: its war cry was defense of the homeland, the repulsion of infidels, and preservation of a way of life. When it came to the ordinary men on the battlefield, however, it was not a class war. They did not fight as Cavalier aristocrats against mercantile Yankees. It was a battle between evangelical boys on both sides, young men reared on a diet of revivalism, preaching, and the simple Bible.

Both sides sent clergy and church aid into the field. The northern armies had chaplains and a service corps, the United States Christian Commission, backed in 1861 by the YMCA and wealthy philanthropists. Into the field went five thousand lay and clergy agents, bent on humanitarian service.[8] Still, they also preached 55,304 sermons and conducted 77,744 prayer meetings. The northern army experienced some revivals, held in camps during layovers. But it was nothing like in the South, if such accounts as *A Narrative of the Great Revival Which Prevailed in the Southern Armies* (1877) and *Christ in the Camp* (1887) are to be believed.

General Lee's Army of Virginia was the fountainhead of these great religious events. The army's camp revival of the 1862–63 winter sent ripples elsewhere, mirrored in smaller outpourings among frontline Confederate troops in Tennessee and Georgia. Times of high stress were the tinder, and evangelical chaplains, armed with religious literature, struck the match. In the South, sermons and religious books became more than 40 percent of all nongovernment publications, and still Bibles from England ran the treacherous blockades.[9]

Finally, the southern clergy had to make the best of a disastrous situation. They preached that the ultimate good result of the war was to convert so many young soldiers, even creating a martial Christian culture. Once, the manly Cavalier had scorned effeminate piety. But the war gave the South a Christian warrior, battle hardened, elevated by myth, and a model for a muscular evangelicalism that became the glory of defeated Dixie.

When the Union victories finally came, it was mainly by tenacity and manpower, and they came in the West. The Union's goal was to control the Mississippi River, and its army's occupation of New Orleans was the first major step. The great stone church of Benjamin Morgan Palmer was not harmed, but his flight in April 1862, a year after the war began, prophesied the future. He fled to Columbia, the capital of South Carolina, where he preached victory at all costs.

About this time, the Union was thinking about declaring slavery its casus belli, but it was for practical reasons, not spiritual, moral, or biblical ones, as Liggett might have liked. In the short run, Lincoln was looking for more soldiers; the first blacks in the Union army were making a difference. In any case, the first step came when Congress abolished slavery in the District of Columbia. The black churches had reason to celebrate, and that included Ebenezer AME Church in Georgetown, which set a thanksgiving day for Sunday, April 13, 1862.

The preacher that day was Bishop Payne. As the AME church's man in Washington, he had visited Lincoln to urge the measure. But Payne knew the challenges ahead, especially for his own people. He had spent a lifetime preaching progress by education, and he believed that the Negro learning process had to start in a free District of Columbia. The rush of slaves to the District, Payne knew, could prove a blessing or a curse. So on a day of celebration, he preached against sin. "Enter the great family of Holy Freedom," he preached, "not to lounge in sinful indolence, not to degrade yourselves by vice, nor to corrupt society by licentiousness, neither to offend the laws by crime." Say no to gambling dens and groggeries. But say yes to "the enjoyment of a well regulated liberty."[10]

Payne had a very practical prayer as well. The Union army still was closed to black recruits. As Payne prayed for that to change, knowing the social benefit, the White House mulled it over as a military necessity. By now, Lincoln had adopted a doctrine of total war. Soldiers were needed. Soon after Payne celebrated "holy freedom," Lincoln, in July, decided on an eventual act of emancipation. But first he needed a military victory. He needed to persuade Europe that the Union could win.

In the summer of 1862, the Confederates were at their high-water mark. Staying on the offensive, Lee's army rushed into Maryland. But when it collided with Union forces at Antietam Creek on the bloodiest single day in American history, it was repulsed, and Lee drew back. It counted for a Union victory, so a few days later, on September 22, 1862, Lincoln issued the Emancipation Proclamation. Now, the sermons of the North proclaimed a moral

cause, the freedom of the slaves. Before the war was over, 200,000 would break free and join the Union army, nearly one-third becoming casualties.

The next summer was a disaster for the South. On the same day, July 4, 1863, the Union armies turned back General Lee after the three-day battle of Gettysburg, and in Mississippi, General Ulysses S. Grant captured fortified Vicksburg, by which the South's cannons had controlled travel on the Mississippi River. The carnage at Gettysburg, a number that stunned, did not begin to reach the cities and homes of North and South for weeks. But the reality was certainly clear by Sunday, August 21, 1863, when Bishop Elliot mounted the pulpit at Christ Church in Savannah. Now, his eloquent sermon was a lament. The South's sins had brought defeat. He quoted from Old Testament prophets: "The crown is fallen from our head—woe unto us that we have sinned."

Bishop Elliot grappled with the same dilemma that Reverend Liggett had after Union defeats at Bull Run. How could the South fail if it was in the right, "fighting under the shield of the Lord of Hosts"? The South had suffered "wrong upon wrong" from the North for forty years. Secession was true to the American Revolution. Slavery had been forced on the South by the greed of the North, and the South had made it a "blessing" by bringing Christianity to the heathens; missionary work had changed them from a "tattooed savage to the well-bred courteous menial." The South was in the right. "We are guiltless," he preached.

He claimed that the Confederacy's Christian government, army, and resources still were a match for the North, but that something was missing. Now, the South was "unaccountably paralysed," almost slavelike. God had hidden his face. The title of the sermon was "Ezra's Dilemma," and from that Old Testament figure Elliot drew a lesson for the Confederacy.[11] After the Hebrews returned to Jerusalem from captivity in Babylon, Ezra was their priest and scribe. On the way back to rebuild the temple, Ezra preached that they should purify and separate themselves as a chosen nation. So they fasted at the river. They fasted for God's protection, the Bible said, instead of asking the king for a military guard.

Ezra's dilemma was in how the chosen people had suffered. Ezra's response, however, was not to rely on earthly armies, but to offer repentance for Israel's sin. Elliot preached the sins of the South: failure in its duty to the slaves, apathy, complaints, desertion, vanity, evil habits, and lust for money. Added to these were extortion, speculation, and profiteering, the unfortunate economic realities of any war. But a northern victory would be far worse than anything yet seen. Infidel armies would bring "theft, rapine, cruelty,

fornication, desolation," and more to the South. "They will swoop down upon the South as the hosts of Attila did upon the fertile fields of Italy."

The South had lost faith and backbone by forgetting the miracle of Bull Run, which for the Confederacy was much like the parting of the Red Sea was for Moses. The wail of widows and orphans could find solace only in the Bible, for scripture showed by Israel's example that God punishes his chosen for greater glory to come.

> Those of whom God is intending to make a nation to do his work upon earth, are precisely those whom he tries most severely. His purpose is to give them not merely victory, but character; not only independence, but righteousness; not peace alone, but the will to do good, after peace shall have been established. His plan, when his hand is upon a people for good, is to discipline as well as to support—to support through discipline, for moral discipline, like military discipline, gives strength and power. His severity goes along with his goodness; he so intermingles them that the one may temper the other and keep down effeminacy and presumption.

The South must follow the example of Ezra, he preached, an example of self-affliction in hopes of grace. In Richmond, the same desperation surrounded Jefferson Davis's hilltop home, which seconded as the Confederate capitol. Davis continued to proclaim fast and prayer days. By now, however, Richmond newspaper editors, who had once filled pages with glory phraseology, wrote cynically about Davis's piety when the city needed money, supplies, and armies. Nevertheless, Elliot and the ministers preached a "southern jeremiad" after Gettysburg. It was the only logic that reconciled an all-powerful God with the Confederacy's problems.

During 1864 the war of attrition grew in intensity. From Atlanta, the Union general William Tecumseh Sherman marched through the South, stopping in Columbia to shell the rebellious capital. Once again, Palmer—who urged the state legislature to keep fighting—joined others in fleeing the advancing Union army. Southern pulpits mirrored his tenacity when the population had already acquiesced. The pulpits preached against treason, desertion, graft, and corruption. They condemned profiteering and skepticism toward the Bible's jeremiad logic.

Still, Sherman was armed with a doctrine of total war and "military necessity." He pushed deeper into the South. His army of sixty thousand cut a forty-mile-wide swath of destruction, ending in Savannah. It was December 1864. Unlike most cities in the Union army's path, beautiful Savannah was

spared at Sherman's orders. Christ Church, with its great columns and pediment, stood serenely on its tree-lined square. But Bishop Elliot had fled. His inflaming sermons, like Palmer's, branded him for possible retribution.

In December, Union and Confederate fighting in Virginia still was fierce. Sherman took a room in a Savannah boardinghouse, at least until the Englishman Charles Green offered his Gothic Revival mansion, the city's most magnificent, as accommodations. It had running water, gas lighting, three reception halls for military business, and an upstairs office for Sherman. During Christmas, a flag-festooned celebration inside offered Savannah to Lincoln for a yuletide present. The secretary of war, Edwin M. Stanton, made his way down from Washington. He wanted to know what the black population in the South was thinking.

He and Sherman got their best intelligence on the evening of January 12, 1865, when they invited twenty black clergy to the mansion. They held their session in the upstairs office, with its chandelier, crackling fireplace, view of the street, and swirls of cigar smoke.[12] The preachers ranged in age from twenty-six to seventy-two. Nine were Baptist. Of the eight Methodists, all but one served at Andrew's Chapel in the city. Half of them were slaves, at least "to the time the Union army come," one preacher said. Their spokesman was Garrison Frazier, a sixty-seven-year-old Baptist, in ministry for half his life. Frazier had bought the freedom of himself and his wife eight years earlier, paying $1,000 in gold and silver.

Stanton and Sherman looked them over. Then their aide-de-camp read a list of strategic questions. Did they understand the Emancipation Proclamation, and was the Union viewed as being in the right? The Union brass found all of Frazier's responses amicable. The Baptist minister had kept his finger on the pulse. He said that slaves, if forced into Confederate fighting ranks, would go along but would flee at an opportune moment. In contrast, they would join Union forces without compulsion. "The ministers would talk to them, and the young men would enlist," he said. The Confederate surrender at Appomattox, Virginia, was still three months away, so this was good news.

But now, Stanton and Sherman began to realize the scope of the social dislocations. It was a visible reality in Savannah. Masses of freedmen had followed the Union army to the sea. How would four million freed slaves begin new lives? They put that local question to Frazier. Would freedmen rather live "scattered among the whites or in colonies by yourselves?" the aide-de-camp asked. "By ourselves," Frazier offered, for mixing would spur prejudice. When asked if there was "intelligence enough" among the blacks

to live under the rule of law, Frazier said there was "sufficient intelligence," and the ministers probably were the best evidence at hand.

From that meeting arose the short-lived Union policy of providing "forty acres and a mule" for the freedmen. The package was made up of surplus army herds and coastal rice fields abandoned by Confederate plantation owners. Under Union oversight, the political, military, and economic "reconstruction" of the South had begun. But it too was a kind of civil war, one that lasted until 1877, when the last federal troops left the South. Where possible, reconstruction began rapidly, especially in places where the black churches and their missionaries from the North played a role.

One of the strongest advocates of missions was Payne, the AME bishop. His fight for an educated ministry, in fact, had stirred a miniature civil war in the African Methodist Episcopal denomination. He had the same educational dream for black freedmen.

A child of free blacks in Charleston, Payne had lost his parents at age six. His grandfather, a free black, had fought the British in the American Revolution. Relatives supported the orphaned Payne. He went to school, found tutors, and adopted a self-education methodology advocated by a Scottish professor. Once, according to Payne's *Recollections,* a southern aristocrat tried to hire him as a traveling porter.[13] Payne declined, but got this lesson. "Said

Bishop Daniel Payne,
America's first black
college president, preached
emancipation and education.

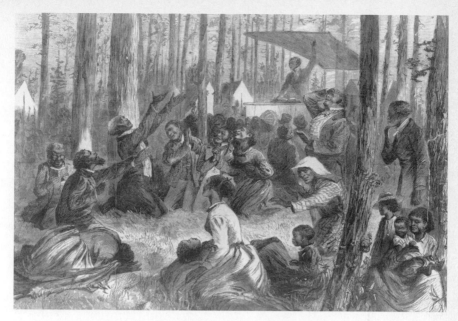

Freed slaves chose between the old revivalist religion (pictured) and the
formal worship of new black denominations.

he, 'Daniel, do you know what makes the master and servant? Nothing but
superior knowledge—nothing but one knowing more than another.'" So
Payne turned to learning, "and chained my mind down to the study of sci-
ence and philosophy, that I might obtain that knowledge which makes the
master." This became a divine calling after he was converted at a church
revival in Charleston. At home, in prayer, he heard "a voice speaking within
my soul saying: 'I have set thee apart to educate thyself in order that thou
mayest be an educator of thy people.'"

Payne opened a school for blacks. When South Carolina barred such secu-
lar instruction in 1835, he went north. He enrolled at the Lutheran Semi-
nary in Gettysburg, where he studied and was ordained a Lutheran pastor
in 1839, but not for long. While teaching in a Philadelphia school, Payne met
an AME bishop who persuaded him to join its clergy ranks. Soon after, he
was ruffling feathers. His five "Epistles on the Education of the Ministry,"
written in 1843, drew sharp attacks from the old-line clergy, who resented
the educated new breed.

As he often noted in preaching, "I have been strongly censured because
of my efforts to change the mode of worship." He was called a "devil" and
accused of "infidelity in its rankest form." The resistance was to be expected,

for Payne admitted that he faced a religion of "ignorant masses," one that preferred the "ring dance," "bush meeting," and a "fist and heel worship" while singing "corn-field ditties" that these simple people "regarded as the essence of religion." But Payne intervened, by preaching his new way and by correcting others, welcome or not.

He famously recounted one such case. "After the sermon they formed a ring, and with coats off sung, clapped their hands, and stamped their feet in a most ridiculous and heathenish way." At this, Payne went over to the leader. He took him by the arm and urged him "to desist and sit down and sing in a rational manner. I told him also that it was a heathenish way to worship and disgraceful to themselves, the race, and the Christian name."

The clergy told Payne of their difficulties. They feared that if they restricted the dances, or curtailed the worshipers with the loudest voices, it "would simply drive them away from our Church." Still, Payne persisted. He was made chairman of the church's Committee on Education. He instituted the responsive reading of Scripture, which at the time went a long way to improve black literacy. It remains a distinctive mark of AME worship. Then in 1852 Payne was made the church's sixth historic bishop.

Payne went through his own development, as illustrated by his sermons. Some sermons of the 1830s, abolitionist in tone, showed a "black power" phase. In mid-career, during the war, he preached encouragement, a "we shall overcome." As a senior bishop, Payne preached an ethic of love and industry to black Americans, and it well suited his new role—as the nation's first black college president.

As the 1863 battles of Gettysburg and Vicksburg became turning points in the Civil War, Payne was in Columbus, Ohio, helping to purchase Wilberforce College as an AME institution. He was named its president in 1865. Payne had met Lincoln, and still moved in Washington circles at the time of the president's assassination. The month after, Payne headed to Charleston. Like the decimated Fort Sumter in the harbor, much of the city was in ruins. The war had turned some churches into charred hulks. One Sunday, he preached at the Presbyterian Church on Calhoun Street, and that night regaled from the pulpit of Old Bethel, the church of his conversion.

For the southern ideologues, Payne's philosophical reflections were like salt in the wound. Payne had an awakening in burned-out Charleston, where a Union escort ushered him around. "It was there and then that I believed what I beheld was a prophecy of the future, that New England ideas, sentiments, and principles will ultimately rule the entire South."

The next year, in 1866, the AME held its fiftieth anniversary celebration, gathering at Allen Temple AME Church in Philadelphia, where the denomination had been officially founded. Payne, now historian of the church as well, gave the keynote "Semi-Centennial Sermon."[14] He used the concept of a builder, or workman, from the New Testament Epistle to Timothy. The worker is only ashamed of his ignorance and vice, Payne preached. Virtue came from God and revelation, but knowledge also came from nature and history, science, and philosophy.

The "dark past" hopefully was gone, and the biblical prediction—that "Many shall run to and fro, and knowledge shall be increased"—was upon the black race. It was a mandate for both black boys and girls. He urged women in particular to "descend" on the South, and, indeed, the black mission school became one of the most rapid developments after the war.

> The future demands educated women, in order that there may be educated wives, consequently educated mothers, who will give unto the race a training entirely and essentially different from the past. . . . The religious errors, the wild enthusiasm of the freedmen, are results of the slavery which had been operating upon them and their forefathers for nearly two hundred and fifty years, and cannot be removed in a day, nor by one man, nor one kind of human agency.

A spirit of revenge filled many pulpits in the North in the last seasons of the war. The toll in human lives finally was being counted. Across the war years the northern sermon swung to and fro. It first defended the Union, then crusaded against slavery, and now returned to espousing a divinely ordained United States of America. The southern jeremiad evolved in a different direction. At first, victory proved the South's cause was just, but then as victories slipped away, the pulpit finger pointed to slackers, traitors in faith and valor. Finally, in total defeat, the southern sermon announced that the South was smitten for a greater good, even a cosmic one. Of that mystery, God would reveal more in time.

During the war, the sermons of the clergy on both sides were never as optimistic as the remarks of politicians and civilians, who usually spoke of quick and easy victory. The clergy held out for ultimate victory. They urged no compromise. They declared that no sacrifice was too great. The rhetoric set a moral tone of self-righteousness, but also of blind patriotism. It was not always persuasive on the ground, however. The Civil War sermon failed to

boost enough voluntary recruitment. Both sides coerced men into the ranks. Glory on the battlefield did not draw the number of young men needed. Still, the sermon preached loyalty—to the bitter end.

In the chaos, collapse, and general amnesties that followed, the great Confederate orators emerged from hiding and headed home. Some of these clergy, who first had rallied Confederate secession, began a new crusade, the South's "religion of the Lost Cause." One of its high priests would be Palmer, the Presbyterian pulpiteer. He had fallen into despair after the defeat of Atlanta and reelection of Lincoln, and soon enough the cannons of Sherman's army had chased him out of Columbia.

Mary Chestnut, who kept a Civil War diary, recalled hearing Palmer preach in those dark days. "This man is so eloquent, it was hard to listen and not give way. Despair was his word, and martyrdom. He offered us nothing more in this world than the martyr's crown. . . . He spoke of our agony, and then came the cry, 'Help us, O God! Vain is the help of man.' And so we came away shaken to the depths." Palmer made his way back to devastated New Orleans, where the *New Orleans Times* caught his sermon in July 1865. He "had lost none of those powers which gave such a charm to his pulpit oratory. He seemed, however, to be more chastened and subdued than he was before." But Palmer preached future vindication. He led the cause of southern Presbyterian separatism and racially segregated schools. "Can a cause be lost which has passed through such a baptism as ours? Principles never die, and if they seem to perish it is only to experience a resurrection in the future."[15]

That was the heart of the southern jeremiad and the religion of the Lost Cause. Palmer had asked a burning question in his sermon. It would take a few more generations, and the emergence of the "New South," to answer it.

————•••••————

Reconstructing America

Progress, Darwin, and the Lost Cause

————•••••————

Fort sumter was nearly a heap of rubble on april 14, 1865, when a parade of Union ships, decked with colorful flags, arrived to raise the United States flag ceremoniously. Years of bombardment had reduced its five-story wall to slopes of dirt and brick. The man of honor in Charleston harbor that day was the Union general who had fled the fort at the onset of the Civil War. But the keynote speaker for the event was Henry Ward Beecher of Brooklyn, a celebrated abolitionist and the Union's best-known preacher.

Wooden steps guided officials into the fort, past fields of spent cannonballs, and down to a tall white flagpole by a gazebo flying patriotic ribbons. Like electricity, news had spread through the crowd of four thousand. "Lee has surrendered!" After the flag was raised, a hundred-gun salute, plus cannonades around the shoreline, filled the harbor with black smoke. As it cleared, Beecher began. He spoke on the glory and magnanimity of victory. "Ruin sits in the cradle of treason," he said. "Rebellion has perished." The flag showed that divine intentions had been clear, for God "hath ordained victory."[1]

For twenty years, Beecher had theatrically decried slavery from his Plymouth Church in Brooklyn. He had funded "Beecher's Bibles," or abolitionist rifles.

From his famed pulpit in
Brooklyn, Henry Ward Beecher
preached to a new Victorian
middle class.

On the church's semicircular stage, he twice held mock slave auctions. The
black slaves were light-skinned females, freed by donations from the pews,
one of whom was sent to school. So many worshipers filled his 3,200-seat
church every Sunday that the nearest trolley stop became known as "Beecher"
and the East River ferries from Manhattan as "Beecher's Boats." One Sunday
in 1860, candidate Lincoln had joined hundreds on the ferry, climbed the
slope to the Brooklyn streets, and taken a pew to hear Beecher.

A year later, Beecher used the same pulpit to criticize President Lincoln
for not making slavery the war's rallying cry. He harangued about military
indecisiveness but defended the Union cause. In 1863 he toured England and
Scotland to sway the British against the South, a tour de force of Victorian
oratory that resulted in but a modest prod to British foreign policy. Still,
Lincoln chose Beecher for the Sumter honor. After Lincoln and Grant, he
was the man best known in the North.

At Sumter, a cold ocean wind whipped so strongly that Beecher had to put
on his white felt hat to keep his long hair from flailing around. He gripped
his handwritten address and read word for word. It was hardly the exuber-
ant, extemporaneous oration for which he was known. Though he strained,
the crowds barely heard the long oration, which exceeded an hour and was
punctuated once by a military band. But this address was for political capitals,
newspapers, and history books. With biblical flourish, Beecher tied Moses to

liberated slaves and the Ten Commandments to great verities handed down by the war, "worth all they have cost," and under which "reconstruction is easy, and needs neither architect nor engineer."

Mostly, Beecher surveyed seven benefits of the war, especially to the South. The ideology of state sovereignty had been destroyed and the rights and duties of minorities upheld. Both North and South developed bravery, and blacks had learned a moral and military capacity. Southern industry was stimulated. The aristocratic class was destroyed. Education for ordinary whites and blacks would begin. The main villain of the sermon was the South's plantation aristocracy, which had profited from the slave system as lower-class men fought their war.

> Upon this polished, cultured, exceedingly capable and wholly unprincipled class, rests the whole burden of this war. . . . A day will come when God will reveal judgment, and arraign at his bar these mighty miscreants. . . . These most accursed and detested of all criminals, that have drenched a continent in needless blood, and moved the foundation of their times with hideous crimes of cruelty, caught up in the black clouds full of voices of vengeance and lurid with punishment, shall be whirled aloft and plunged downward forever and forever

Henry Ward Beecher spoke at Fort Sumter's flag-raising the same day that Abraham Lincoln was assassinated.

in an endless retribution; while God shall say, "Thus shall it be to all who betray their country;" and all in heaven and upon earth will say, "Amen!"

With the guilty named, and the good fruits of war realized, Beecher urged a positive look forward. "What, then, shall hinder the rebuilding of this republic?" he asked. Nevertheless, there would be much to hinder the future. That night, the Charleston harbor filled with the patterns of lanterns strung along the masts of dozens of ships. Rockets and guns produced fireworks declaring the end of the Civil War. At that very hour in Washington, President Lincoln had settled in at Ford's Theater to watch a play, and was shot dead by an assassin. The news reached Charleston the next day. "It was not grief, it was sickness that I felt," Beecher recalled. He returned by steamship to New York, where the black bunting of national mourning shrouded the city.[2]

A new era had begun, and Beecher was at the center of the many great shifts in religious oratory. At Sumter he had preached that God was in absolute control of human events, but it was an assertion that waned in post–Civil War America. Both North and South had claimed God's favor. The ways of God, and indeed his control of events, were hurled into mystery. Southern orators had to explain the Confederacy's defeat, or what the populace called the Lost Cause. By preaching a "religion of the Lost Cause," many evangelicals gave the South a resurrection story; its defeat was actually a spiritual victory, if the South could keep its martial and traditional values.

When war had lifted, regional difference emerged. In the North, great urban pulpits arose, speaking to its prospering middle class. On the frontier, popular education fostered a new kind of traveling orator. These were the developments of preaching in the Gilded Age, but nothing changed religious oratory like the new age of science. In 1859, on the eve of the Civil War, the Englishman Charles Darwin had proposed his theory of evolution, a scientific explanation of human struggle, and for many minds, an alternative to ideas about God's providence. Science was about to hit America in a big way, for the war spawned advances in machinery, medicine, transportation, and communications. Like few others, Beecher took up the banner of science, ending his career with eight famous sermons on evolution.

After Lincoln's death, however, the central issue was the political, military, and economic "reconstruction" of the South, a project undertaken by the victors in Washington, D.C. Years of political battle emerged over the methods of reconstruction, and radicals on both sides wanted nothing but retribution.

As always, Beecher had something to say on this, and it might have gone unheard except that few could ignore the role of the Beecher dynasty in America. His father, Lyman Beecher, had witnessed the American Revolution and afterward led New England's revivals and social reforms. Seven of Lyman's sons became clergy, and one of his daughters, Harriet Beecher Stowe, wrote the 1852 antislavery novel *Uncle Tom's Cabin,* a popular spur to abolition in the North. Henry Ward Beecher trained in oratory in the best New England schools. A Presbyterian, he served churches in Indiana, and then was recruited to Brooklyn.

Beecher had an orator's image to match his voice. He wore a great coat, his eyes looked sad, and his dark hair hung to the shoulders. He moved his pudgy figure with authority on a church or public stage, for he never stood in a pulpit. Still, he was an early type of America's "princes of the pulpit," those finest of the city ministers who preached to the rising middle class. They preached a God of reasonableness and law, a Jesus of love and affirmation, and a regard for human potential in the world. Beecher's admiring audience was a new middle class, less interested in doctrine and more concerned with moral reform and social order. In speaking to this growing sector, Beecher became America's Victorian orator.

One of Plymouth's members was Henry W. Sage, a tall and bearded man, a wealthy merchant and benefactor of Cornell University. To promote Beecher-style preaching, Sage endowed Yale Divinity School for an annual lecture series, beginning in 1871. He wanted to name it for his pastor, Henry Ward. But the pastor insisted that his father, Lyman, get the honor. Still, Henry gave the first and second series. Thereafter, the Lyman Beecher Lectures on Preaching at Yale became the premier American forum to track the art of homiletics.

After the Sumter speech in April 1865, reconciling North and South had not gone well. President Andrew Johnson, Lincoln's successor, imposed an "executive reconstruction" in which he, a Tennessee commoner, forced the Dixie aristocrats to beg and scrape for forgiveness. Johnson essentially gave that pardon, restoring white supremacy in the South. When Congress returned in December 1865, only to find Confederate politicians and generals in elected seats, there began a two-year fight to enforce a "radical reconstruction."

The war had produced amendments to the Constitution ending slavery, extending the Bill of Rights to states, and giving federal protection to the right to vote. The Radical Republicans, who swept into Congress in the 1866 election, divided the Confederacy into five military districts. States were required to write new constitutions that incorporated the federal amendments,

allowing blacks as convention delegates and barring Confederates. The federal intrusion was the South's worst nightmare, and its termination was called redemption.

Reconstruction lasted only a few years in most southern states. Virginia declared that it was "redeemed" in 1869, whereas Louisiana, Florida, and South Carolina had to wait until 1877. In that year, the Republicans gained the White House in a contested election by agreeing to withdraw federal troops from the South. Despite the racial conflict that continued, Reconstruction revived southern business. It built roads and railroads and established the South's first public school system, which improved white education tremendously.

The North soon tired of Reconstruction woes, but until then, a spirit of revenge prevailed. That was a centerpiece of Beecher's Sumter sermon. But back at Plymouth Church, his tune had changed. To the shock of Radical Republicans, Beecher began to preach conciliation with the South. It was not "wise or Christian for us to distrust the sentiments of those in the South that profess to be desirous, once again, of concord and union," he said.[3] He traveled to fifteen East Coast cities with his conciliatory address, "Reconstruction on Principles National Not Sectional." Beecher was not preaching equality of the races, however. He assured northerners that black political freedom was not social equality. He opposed racial intermarriage.

His ultimate offense to former allies was to side with the cause of Robert E. Lee, who was offered the presidency of Washington College in Lexington, Virginia. For radicals, this allowed Lee to shape more treasonous minds. Beecher urged trust for the man, who gave in to weakness. "And when the war ceased, and he laid down his arms," Beecher said, "who could have been more modest, more manly, more true to his own word and honor than he was?" Now, Lee simply had accepted an offer to lead a college. "Must he not do something for a living?"

Robert E. Lee, it turned out, lived foremost in the heroic myths of southern evangelical religion. There were two ways to respond to the South's defeat. The stoic and practical one was later called (in 1886) the New South by a newspaper editor of progressive disposition. The South lost, so the New South moved on, dismantling slavery, building on its strengths, and doing business with the North. The second way was the "religion of the Lost Cause," which alone answered the haunting question: if God favored the South, then why this disaster? The answer echoed Jesus's day on Calvary, where death was necessary for life. For the South's heart and soul, only this second interpretation turned defeat into redemption.

The evangelical faith of the postwar South was built
around the Lost Cause and its heroes.

If this new faith had a spirit, it also had objects. These were the statues, myths, and literature of the Lost Cause, and a new kind of southern preaching. It all came together one Indian summer day in Richmond, Virginia, when the first statue in the South of General Thomas "Stonewall" Jackson, the Christian warrior, was unveiled at Capitol Square. Virginia's "redemption" came with the election of a Democratic governor. Now, the Confederate memory was to be built.

On the morning of October 26, 1875, the procession ended at a platform, mounted by the governor, clergy, and dignitaries. A Methodist bishop opened with prayer. The audience was filled with gray-clad veterans. Also present was Jackson's thirteen-year-old daughter, who was cheered and wept for as she laid a wreath. But the sermon was given by a real clerical military hero, Moses Drury Hoge of Richmond's Second Presbyterian Church.[4] Hoge had advised top Confederates, opened their congress with prayer, and preached to 100,000 soldiers who had passed through training camps, headed for the field. From Charleston in 1862, Hoge slipped past the Union blockade to sail for England and bring back 300,000 Bibles and religious tracts.

Hoge had recovered from the dark days of defeat, which thrust him into a deep depression. He feared a dark contamination of the virgin South by New

England's infidelity, and himself felt like "a shipwrecked mariner thrown up like a seaweed on a desert shore." But he took the stage, tall, lean, and muscular with a stylish mustache, to build a southern future. It would be built on the memory of Confederate saints, and a warning—the essence of the southern jeremiad—not to become like the North.

In the oration, Hoge compared the day with ancient Greek ceremonies celebrating peace. But the South drew a Christian moral lesson, and added its heroes as a "new Pantheon" alongside those of the American Revolution. Jackson was the apotheosis, the "most unromantic of all great men," but still the "hero of a living romance." Southern preaching drew upon this romance for the rest of the century. Jackson was the Christian cavalier, "strong, adventurous, and indomitable." Tender as a child, he was lightning in battle, yet a poet before a beautiful flower. His Christian faith, Hoge preached, had made him "purer, stronger, more courageous, more efficient."

Hoge voiced a recurring theme to be heard in southern religious oratory, that a "baptism of blood" had resurrected a greater soul. Then came the jeremiad. It was a history lesson that warned against the collectivization of American society, begun by northern victory but driven by the kind of imperial forces built by all great wars.

> Republics have often degenerated into despotisms. It is also true that
> after such transformation they have for a time been characterized by
> a force, a prosperity, and a glory, never known in their earlier annals,
> but it has always been a force which absorbed and obliterated the
> rights of the citizen, a prosperity which was gained by the sacrifice
> of individual independence, a glory which was ever the precursor of
> inevitable anarchy, disintegration, and ultimate extinction.

Despite Hoge's foreboding vision, the South had already begun to build links to a better memory. These chords of memory were manifest in heroic statues, vast cemeteries, veterans' reunions, and evangelical sermons. Evangelical orthodoxy had always been the tenor of southern denominations. But now it rose to preeminence, led by the growing ranks of Baptists. Being a movement of memory, the religion of the Lost Cause was driven by veterans, army chaplains, and daughters of the dead. While old generals bickered about blame for defeat, churches put heroes in stained glass, re-created them in sermons, and backed "correct" history books for southern schools.

The sermons and poetics were distinctive. At Jefferson Davis's funeral in 1889, a Baptist preacher declared: "In all the galaxy of fame there is no

brighter constellation than that of the 'Heroes of the Lost Cause.'" Lee be-came the biblical Man of Sorrows. He had borne the suffering South, as if "pressed sorely upon him, a true crown of thorns." The slain Episcopal bishop Leonidas Polk, a general who strapped his sword over his robes, was "the Chevalier Bayard of our history." If generals were white-plumed knights, soldiers were martyrs of "sublime" virtue, legends equal to King Arthur, the Scottish rebellions of Sir Walter Scott, and the Greeks.[5]

All of this gave the South its new "civil religion." It was not a religion that, like the prophets, questioned the status quo. Instead it extolled the folk, the people of the metaphysical South, which still might be resurrected by memory. For the southern preacher, it could be resurrected in fact as well, for future behavior could align with Confederate virtue. In addition to the southern jeremiad, which warned against the urban materialism of the North, the southern sermon became a cry against individual moral failings, especially "King Alcohol." Since the days of the Puritan theocracy in New England, Calvinist preaching had been legalistic, setting out rules against individual sins and vices, from alcohol to frivolity. Now it became charac-teristic of southern sermons, and the memory of sacrificial soldiers became a scold against vice. They had died for the hard-won virtue of the South, and Christians must cherish that patrimony.

A central part of keeping the "folk" intact was the purity of southern women, as the sermon often reminded. The pulpit paid homage to "the virgin whiteness of our South." The South was like a "snow-white citadel of one Southern woman's virtue." Female virtue had repulsed the Union hordes. But the new fear was the free black, who would violate white daughters—much as slaveholders took black women at will for generations. Defense of the southern woman gave men a new heroic role, lost on the battlefield, but now expressed in manly evangelicalism. The believer is "a militant Christian," and "God's Church is an army," said the sermons. This was certainly not exclusive to the South. But it produced a generation of combative preachers, protective of women and militantly evangelical.[6]

The story of the postwar South was one of defeat, poverty, guilt, disillu-sionment, and isolation. In response, Southerners created a civil religion of memory, segregation, evangelical militancy, and female purity. Quite natu-rally, its sermons were less optimistic, less liberal, less democratic, less toler-ant, more homogeneous than those heard in most of the North. Conquest of personal sin, next to memory of a purer past, most characterized the South's religious oratory. Preach as they might, however, southern clergy could not stop the industrialization of the South. Wealthy benefactors supported

churches, and as in the North, clergy in the South could hardly bite the hand that fed them.

The civil religion of the North had an evangelical, even utopian, spirit as well. The northern publication *Christ in the Army* told that story, and it was claimed that as many as 200,000 Union soldiers had experienced a conversion in the field. The northern sermon certainly envisioned an evangelical blooming, as did the enduring "Battle Hymn of the Republic" and a renaissance of religious novels, some written by former soldiers.[7]

But the most defining features of northern culture were its scientific progress and its social diversity, arising from immigration. Victorious in battle, the North fast became triumphant in wealth as well. The combination of peace, industry, a growing middle class, and the rise of natural science distinctly shaped the sermons of the later Victorian age.

The sermon began to reach the public in new ways, both highbrow and lowbrow. For the elite, there were the Beecher Lectures on Preaching at Yale, and masters of pulpit rhetoric emerged in both North and South. It was an age of "romantic" preaching, a kind of sermon that was an alternative to the rationalist preaching of the Puritans and the hellfire tirades of revivalism. The Jewish sermon also came into its own, with the first American collection of rabbinic oratory published in 1881.[8] The lyceum, or public lecture, of New England mingled with the old camp meeting. As a result, the West and Midwest experienced the rise of the Chautauqua public education movement, often dominated by popular preachers.

Most of all, however, the civil religion of the North welcomed the new wealth of the so-called Gilded Age, so named for its glittery exterior. The postwar period reversed the church's reformist role and made it a handmaiden to industry. The industrialist Andrew Carnegie had coined the phrase "gospel of wealth," but most Protestant pulpits happily endorsed its underlying theology. Beecher, for example, stated that poverty was the result of laziness, lack of thrift or effort, or drunkenness. Successful businessmen governed church councils and vestries. In New York City, Trinity Episcopal on Wall Street was the largest landlord of the metropolis. From the urban suburbs, it was hard to see the new industrial system as anything but an opportunity, not a cannibal of the weak and transient.

For once, it seemed, the pulpit was freed from having to rail at society. Now, a new polish could be put on the sermon of moral uplift and eloquence. Wealthy benefactors underwrote the nation's "princes of the pulpit," and often to the benefit of excellence in preaching. Beecher would not live forever,

and his successors began to appear, with three of them of particular interest, one in the South, one in the Midwest, and one in the North. In Virginia, the Baptist scholar and preacher John A. Broadus became a national figure, advancing the art of preaching for posterity. In Cincinnati, Rabbi Isaac Mayer Wise Americanized Jewish preaching by adapting to classic oratory. Finally, the Episcopal priest Phillips Brooks, who came to prominence in Philadelphia and Boston, became a model par excellence, a preacher's preacher.

Broadus and Brooks, and to a degree Wise, navigated the new mainstream of romantic preaching, characterized by a flexible, or liberal, use of biblical texts. Their preaching was mindful of the new historical criticism of the Bible. The stiff structures of a neoclassical sermon or plain-style sermon were put aside for new creative alternatives.

With these notions in hand, Broadus wrote the nation's first enduring textbook on preaching in 1870. Sermons are built out of topics, structures, and deliveries, according to *A Treatise on the Preparation and Delivery of Sermons*. The topics can be doctrine, morals, history, or religious experience. The oratorical structure, Broadus went on, can follow the natural subdivision of a "subject" in the Bible or the order of a biblical "text," or it can be "expository," much as a Sunday school lesson ranges widely across Bible narratives. The delivery may be recited, read, or extemporaneous.

Broadus was the classic Baptist statesman. Before the Civil War, he held public office and taught Latin and Greek at the University of Virginia, founded by Jefferson. Indeed, in writing *A Treatise* his "chief indebtedness" was to Aristotle, Cicero, and Quintilian, the ancient rhetors. Broadus helped start the Southern Baptist Theological Seminary, which moved to Louisville, Kentucky, after the war. The school became a center of homiletics, the art of preaching. Even for Baptists in the North, Broadus was incomparable. He was invited to be president of the University of Chicago, funded by oil magnate John D. Rockefeller, Brown University in Rhode Island, and Crozer Seminary outside Philadelphia, all Baptist institutions. But Broadus declined. He cultivated his preaching revolution from the South.

In traditional Protestantism, the New England Congregationalist Horace Bushnell had opened the way for romantic preaching by proposing language that was symbolic, not literal. From his pulpit, he said the truth behind biblical and theological words was grasped almost mystically, by intuition. The meeting with Christ was personal, not rational or logical. In time, speculative theologians would call this encounter "the sublime." It was an experience of awe—emotional, ethical, and perceptive of beauty, both human and natural.

Preaching on the sublime increased. The idea soon included the identification of a new God-given human faculty, and that was "imagination"—something that Puritans and Bible literalism had long viewed with suspicion.

Broadus was orthodox enough as a Baptist and New Testament scholar. But his idea about the "application" of the sermon put him into the growing romantic mainstream. The sermon did not win by reason (Puritan) or fear (revival). The preacher had to give his audience motives to accept the gospel message. Motivation was needed to overcome doubt, sinfulness, and worldly temptations, Broadus argued. Therefore, the sermon had to stir the imagination. "In order to excite any passions by speech, we have to operate chiefly through the imagination."[9] He tied imagination to eloquence.

In this, Broadus stood in the long wake of classic rhetoric, going back to the Scotsman Hugh Blair, whose *Lectures on Rhetoric and Belles Lettres,* published just after the American Revolution, was the model how-to book on oratory. John Witherspoon at Princeton furthered this, and the overall legacy was echoed in Broadus. They agreed with Blair that preaching was simply one branch on the great tree of rhetoric. "Preaching and all public speaking ought to be largely composed of argument," Broadus asserted. "Even the most ignorant people constantly practice it themselves, and always feel its force when properly presented." Hence, one kind of argument was the Christian sermon, which Blair defined as "a serious persuasive Oration, delivered to a multitude, in order to make them better men."[10] Preaching was rhetorical coaxing applied to a religious subject and audience.

This was an idea that Rabbi Wise, an Albany rabbi who moved to Cincinnati, took seriously. In that city, Wise became the first president of Hebrew Union College and the foremost developer of modern Jewish oratory. Though he felt the sermon was mainly for congregational instruction, not public debate, he expanded it in ways that made the Jewish pulpit a voice to be reckoned with in America. The Americanization of the Jewish sermon could only have happened then, about 1880, for the nation's 270 synagogues still were mostly Reform, and the overwhelming Orthodox migration, with its insistence on Hebrew, was several years away.

Wise adapted Blair's *Lectures* to Jewish needs. Blair's analysis of the speaker, sermon, and audience was novel to traditional Jewish instruction. From *Lectures,* Wise took the ideas of one topic per sermon, clarity of speaking, use of gestures, and preaching without a manuscript. He argued for Jewish sermons that opened with a scriptural text, common in Christian pulpits and advocated by Blair. The Reform movement, with it Germanic roots, adopted this oratory as part of its cultural assimilation. It crossed a new divide in the

Rabbi Isaac Mayer Wise
"Americanized" Jewish
preaching by adapting it to
classical rhetoric.

spring of 1867. A Reform rabbi preached at the First Congregational Unitar-
ian Church in Cincinnati, an ecumenical act both praised and criticized, but
never to be reversed.

For Christian preaching in the Gilded Age, John Broadus represented
a tradition that, while orthodox enough, viewed preaching as persuasive
rhetoric. Others insisted that a sermon was a unique spiritual event revealing
the power of God and Christ in the life of the orator, a kind of revelation,
not mere persuasion. In their day, Broadus and Phillips Brooks, the great
preacher in Boston, did not openly disagree on this topic. But they repre-
sented the great divide, which widened in the twentieth century. One pro-
pensity was to make preaching into polished rhetoric. The other, in contrast,
tried to make the preacher a channel for God's surprising words.

Brooks was not extreme in this second approach. He left to posterity his
famous maxim that "Preaching is the bringing of truth through personal-
ity."[11] Personality was not charm. It was the ability of a preacher to manifest
God in his life, deeds, and words. It is necessary "that the Christian preacher
should be a Christian first," said Brooks. The preacher stands between God
and the public, listening and observing in both directions. From that midway
position, the purpose of the sermon is the "moving of men's souls." Although
Brooks did not say much about organizing topics or structure, his sermon

"Help from the Hills" illustrates a typical approach.[12] He began with a single verse, in this case Psalm 121:1—"I will lift up mine eyes unto the hills, from whence cometh my help"—and before turning to the Bible event, and listing applications to life, he opened with a clear premise:

> Many people seem to think that the escape from trouble is everything, without regard to the door by which escape is made; and that the finding of help in need is everything, no matter who may be the person of whom the help is sought. But really the door by which we escape from trouble is of more importance than the escape itself. There are many troubles from which it is better for a man not to escape than to escape wrongly; and there are many difficulties in which it is better to struggle and to fail than to be helped by the wrong hand.

Having studied at the evangelical Virginia Theological Seminary of the Episcopal Church, Brooks was ordained in 1859. In 1871, after a decade of prominence in Philadelphia, he accepted the downtown Trinity Church pulpit in Boston, his home ground. He remained pastor there for the next twenty-two years. Proclaiming such doctrines of faith as the Incarnation and the Trinity, Brooks nevertheless accepted evolution, which challenged the literal biblical idea of human origins. He preached on humanist topics and rarely tortured a Bible text for its meaning.

In his counsel on preaching, Brooks said that times had changed. The scientific worldview had brought fatalism. Society had become tolerant, relativistic, and preoccupied with fashion, commercialism, and sentimentality. It no longer accepted the Bible as arbiter of moral and historical truths, Brooks said. The preacher's challenge, therefore, was personally to be a compelling Christian, and let sermons express that vitality. "While there have been many centuries in which it was easier, there has been none in which it was more interesting or inspiring for a man to preach," Brooks said.

To match Brooks's preaching, a benefactor rebuilt Trinity as one of the most beautiful edifices in America. Dedicated in 1877, Trinity looked like a Romanesque church and gingerbread castle combined. Vast and open, the interior had red walls, arches, stained glass, and murals, and its pillars sent a great square tower upward.

Invariably, Brooks preached to a certain class of America and to a certain sector of Boston. But ordinary citizens had access to famed Victorian orators as well. Some traveled into the big city by the expanded railroads. More, however, took advantage of a growing alternative: an outing to see famous speakers on a rural circuit between smaller towns. It began in western New

York, where a Methodist minister was thinking about how to reach the postwar masses. John Heyl Vincent, a former circuit-riding minister, had just become secretary of the Methodist Sunday School Union. The nation needed Sunday school teachers. So in 1874 Vincent turned a summer camp at Lake Chautauqua into an educational retreat, funded by a prosperous Akron, Ohio, manufacturer.

The first session on August 4, 1874, focused on decorous learning, shorn of any revivalism. But Chautauqua was fun. A miniature to-scale Holy Land landscape was constructed as a teaching tool, and the evening featured concerts and fireworks. For the 1875 session, Vincent wanted to bring a celebrity.

Gilded Age Americans heard "princes of the pulpit" such as Phillips Brooks in Boston and famous speakers at Lake Chautauqua in western New York.

He first tried Beecher, who was willing but caught up in a court case. Vincent still had an old Illinois friend, however. His name was Ulysses S. Grant, now a retired president. Grant happily obliged. When Grant arrived with a flotilla of decorated steamboats, fifteen thousand people gathered to welcome the most famous person in America.

The Chautauqua concept was too good to contain. Soon the New York organizers created the Chautauqua Literary and Scientific Circle, a four-year reading club that drew in tens of thousands who followed a reading program of religious, classical, and scientific works. The idea of lakeside gathering also spread, especially to the Midwest. In Ohio, Indiana, Illinois, and Iowa, "little Chautauquas" sprang up, ever expanding the billing of celebrities and preachers on circuits served by railroads. No longer beholden to New York, these summertime "independents" ranged from five days to a month long and featured speakers, courses, concerts, and recreation.

By the 1870s and 1880s, the Chautauqua movement was giving order to homesteaders in Oklahoma, Nebraska, Kansas, and the Dakotas, where wagons and railroads dropped them, often unprepared, in harsh environments. Chautauquas spurred regional gatherings, bringing "eastern" knowledge to the Great Plains, inspiring discouraged outliers. The events broadened narrow views and, before long, motivated various kinds of religious and political groups to form, especially the populist farmer movements. Adult education had begun in America. Some schools gave credit for a Chautauqua course. In the 1880s, Chautauqua's education coordinator, the Baptist preacher William Rainey Harper, practically designed the University of Chicago, and then became its president. Theodore Roosevelt called Chautauqua "the most American thing in America."[13]

The movement, now hundreds of tent-style Chautauquas, did not peak and expire until 1924, a "jubilee year" that boasted events at ten thousand locations, and then it faded away. But in its early stages, Chautauqua pioneered something new for preachers: the speaker's bureau. The former newspaperman James Redpath, who had coordinated tours of notables that included British novelist Charles Dickens, revived his "talent" business after the war. With its business element, Chautauqua became comfortably ecumenical, featuring celebrities such as Catholic Bishop John Ireland and the Zionist preacher Reform Rabbi Stephen Wise of New York City, depending on the location and audience. Whatever the faith, the speaker often was squeezed between entertainers, political orators, and reformers.

Nevertheless, Chautauqua was predominantly a Protestant affair, and in this tradition, the all-time favorite was probably Baptist minister Russell

Conwell of Philadelphia. By way of Chautauqua, Conwell gave the most delivered sermon in American history, "Acres of Diamonds." He preached it in his own sanctuary, and then six thousand times on the circuit.

When Russell Conwell came to town, a canvas banner stretched across Main Street. Then the "crew boys," athletic young men, arrived by train to set up the lakeside tents. The next day Conwell, or another celebrity, arrived and a parade commenced to the site. The buoyant Conwell, a New Englander, lawyer, and former Union army captain "born again" in the field, was a can-do evangelist. He pioneered the "institutional church" movement, in which a local congregation became a full-service affair. His Baptist Temple had a gymnasium, reading rooms, two hospitals, and a thriving Sunday school. He spun off Temple University and a divinity school, merged in Massachusetts one future day as Gordon-Conwell Theological Seminary.

Evangelical to the core, Conwell was an early advocate of "prosperity theology." His "Acres of Diamonds" was a peroration about God's will for Christians to become rich.[14] It took faith, a work ethic, honesty, and self-affirmation. God makes the tycoon, Conwell suggested. His examples ranged from John Jacob Astor, America's first millionaire from selling furs and land, to Conwell's contemporary, John Wanamaker, the Philadelphia department store magnate, who built revival temples and turned them into stores. But this was a gospel also of the simple inventor who struck it rich. As Conwell put it, the diamonds were not buried afar, but in everyone's backyard.

The famous sermon opened with an exotic story of an adventure in Arabia by the ancient Persian pilgrim Al Hafed. Then it was filled with anecdotes of unlikely American characters who, by a little thinking, got rich. It was a sermon style to be imitated for generations after. A grabbing story opens. Inspiring case studies—real or invented—are told. The stories prove that the good things in life are achievable for all, especially if one can find the needs of others, and invent something to supply them. Conwell's most famous case study was Al Hafed, the hapless Persian hero.

> Had Al Hafed remained at home, and dug in his own cellar, or underneath his own wheat field, instead of wretchedness, starvation, poverty and death in a strange land, he could have had *acres of diamonds*. . . .
> You ought to make money. Money is power. Think how much good you could do if you had money now. Money is power and ought to be in the hands of good men. It would be in the hands of good men if we comply with the Scripture teachings, where God promises prosperity to the righteous man.

Conwell was a hard man to pigeonhole. He never was charged with heterodoxy by evangelical allies. Yet he was an early expositor of "positive-thinking" spirituality, on the one hand, and the Social Gospel mandate to change social structures, on the other. Like a Chautauqua banner on Main Street, he was a streamer for the gospel of wealth.

In 1875, when Vincent had asked Beecher to be the first Chautauqua celebrity, the Brooklyn preacher had to defer. In January he had gone on trial in a New York civil court after an embittered publishing colleague, Theodore Tilton, sued him on charges of adultery with his wife, Elizabeth Tilton. The disputed "affair," to which Elizabeth had confessed, would have stayed discreet, except that a feminist publicist and advocate of free love, Victoria Woodhull, published the rumor in her national gossip magazine in late 1872, leading to public uproar, a church trial that exonerated Beecher, and finally the Tilton lawsuit. In July 1875, a divided jury deliberated for six days but could not arrive at a verdict. The Chautauqua invitation to Beecher proved that his reputation survived even this, though he clearly was too busy to head out on the speaker's circuit.

Seven years later, his oratorical gifts intact, Beecher was ready for a new topic of the hour, which turned out to be Darwinian evolution. He always stayed abreast of modern thought. Well before the Civil War, he had observed the rise in popularity of the British philosopher Herbert Spencer, who coined the term *survival of the fittest* and later was credited with espousing Social Darwinism, in which the evolution of superior classes pushes inferior ones into extinction. Spencer, an engineer and *Economist* editor, said that human society progressed as it became more complex, industrialized, and free-market, with freedom the ultimate fruit. Beecher wrote Spencer in 1866, sharing his enthusiasm for the new social vision, which Beecher Christianized. "The peculiar condition of American society," he wrote Spencer, "has made your writings far more fruitful and quickening here than in Europe."[15]

Despite the Civil War, American intellectual circles had debated Darwin's *Origin of the Species* since its publication in 1859. His treatise on human evolution, *Descent of Man*—that modern man "descended" from early apes—stirred new reviews and debates in 1871. Beecher contributed his thoughts a decade later in a *North American Review* essay, "Progress of Thought in the Church."[16] He rejected orthodoxy's view that the Bible had a "mechanical perfection," as well as Calvinism's medieval notion that God ordained human corruption. "The future is not in danger from the revelation of science," he wrote.

Late in 1882 Beecher was invited to be part of the closing remarks at a farewell dinner for Spencer, who had just finished an American tour. The evening at New York City's Delmonico's restaurant had been long, and the room was suffocatingly thick with cigar smoke. The novelty of Beecher, of course, was as a churchman friendly to evolutionary thought. As it turned out, his remarks reignited the fading evening, ending it with a standing ovation for all. In opening, Beecher said that as a "revivalist" he was forced to look at original sin, and thus compare Saint Augustine and Calvin with Spencer. While fundamentalists believed in fallen man, they disdained evolution even though it was the same thing, the "hypothesis that we are but the prolongation of an inferior tribe." If humanity descends far enough, he asked, what does it matter if it was from a monkey?

Once the laughter died, Beecher presented an idea that he would build upon in the future. He said God reveals himself in Scripture *and* in earth history. "There is a record in geology that is as much a record of God as the record on paper in human language," he said to applause. Beecher concluded with a prayer. In some circles thereafter, Beecher was associated with Christianizing evolution, and he took on the mantle gladly.

Most of the responses to Darwin among American theologians and preachers were not so affable. Princeton theologian Charles Hodge's book *What Is Darwinism?* answered that it was atheism. Evolution by randomness disputed design in nature and history, and this made God and providence impossible, Hodge argued. His short book, a brilliant argument, became the basis for countless sermons across America, especially among evangelicals and fundamentalists.

Two other kinds of religious responses arose: to ridicule Darwin's theory as preposterous or to try to harmonize it with Christian doctrine. The role of monkeys in human evolution, naturally, was the bludgeon of all humorous ridicule, from whichever side. For Beecher's part, he reversed the ridicule to shame Bible literalists. He applied this on a national lecture tour, and the date February 7, 1883, at the Central Music Hall of Chicago was typical. "There are a great many men," he said, "who think it is unworthy of the dignity, of the glory, of man to have come down from a monkey; and so they make a little pile of mud and call that the beginning of man—created out of dust. Which is the worst, a living monkey or a pile of mud?"

But Beecher was preeminently a harmonizer, perhaps the first from the American pulpit. At Harvard the botanist Asa Gray, a friend of Darwin's and an orthodox Congregationalist, had from the start Christianized random

evolution, saying that God retained a role as overall guide. Beecher took much the same position, arguing with the power of rhetorical persuasion, contrasting wisdom with ignorance, but less bound to technical details in nature. He made his case in a sequence of eight sermons, delivered from May to June 1885, which Plymouth Church telegraphed to leading newspapers for publication.

The third sermon, "The Two Revelations," became the classic, for in it Beecher gave points of harmony between science and faith and attacked stubbornly orthodox believers in the same sweep.[17] Indeed, he defended scientists, marveling at the "assault made by Christian men upon scientific men who are bringing to light the longhidden record of God's revelation in the material world." Beecher argued that the Bible and the earth reveal two different aspects of God's will; both can be believed without contradiction. Where the orthodox found contradiction and infidelity, Beecher found harmony, and a goad to progress in religion. The two revelations, geology and Genesis, enlivened the Christian faith. He built this argument on John's Gospel, that "All things were made by Him."

> How he made them—whether by the direct force of a creative will or
> indirectly through a long series of gradual changes—the Scriptures
> do not declare. . . . Science is but the deciphering of God's thought as
> revealed in the structure of this world; it is a mere translation of God's
> primitive revelation. If to reject God's revelation of the Book is infi-
> delity, what is it to reject God's revelation of himself in the structure
> of the whole globe?

As champion of a new scientific priesthood, Beecher lived to see the start of America's great celebration of science, the Centennial Exhibit of 1876. He almost lived long enough to hear the remarkable announcement of the U.S. Census Bureau in 1890: the American frontier had closed.

The Centennial, celebrated in Philadelphia, cheered technology. It was billed as the "greatest spectacle ever presented to the vision of the Western World." One in five Americans visited the vast and festive exhibit grounds, whose centerpiece was the fourteen-acre Machinery Hall. In the middle was the Corliss Engine, a steam-powered behemoth four stories high. Hundreds of machines were connected to the Corliss for their steam power. When President Grant ceremoniously flipped the Corliss's switch, the entire hall came to life. Machines moved by belts, shafts, arms, pulleys, and gears. They did everything from saw wood and spin cotton to punch dies and print newspapers.

On Sunday, June 25, the Machinery Hall was closed to the public. In the silence Alexander Graham Bell, who had just patented the device, demonstrated that his telephone could work. It was the start of modern communication, the germ of radio and television, and all that they would do to shape the American sermon. The frontier also reached a turning point. On that same day, Chief Sitting Bull and five thousand braves destroyed the army of General George Armstrong Custer at the Little Big Horn River in Montana. Now, the "total war" policy of the Civil War was focused on the last Indians, who were either exterminated or tamed by 1893, the date of the next great exhibition in America.

That was the Columbian Exposition in Chicago, a year late in opening to celebrate Christopher Columbus's "discovery" of America, but as spectacular as promised. At this exposition, the historian Frederick Jackson Turner gave his famous paper, "The Significance of the Frontier in American History." The paper cited the 1890 census, which had just declared the end of the American frontier. "At present," the census bureau said, "the unsettled areas have been so broken into by isolated bodies of settlement that there can hardly be said to be a frontier line." There was no longer a western movement. Turner said the frontier had been internalized by Americans, as cultured European Christians had been churned into frontier democrats, individualists, pragmatists, and sectarians.

Whether the frontier had exclusively molded American character was a much-debated thesis, but by the time of the Columbian Exposition the sculptor working on this American character was the city. The exposition was called the White City, and it represented a nation fast becoming urban. America was looking for markets and colonies abroad, and it was trying to keep its Christian faith as it exported, even by military flotilla, that same Anglo-Saxon religion to other countries. This was the next age of the sermon, and its purveyors naturally made their way to Chicago, upon which the eyes of the world were set.

The White City

Urban Tales and Imperial Designs

T HE WHITE CITY, AS THE COLUMBIAN EXPOSITION IN CHICAGO was called, stood for the American triumph since Columbus had arrived four centuries earlier. In oratory and exhibits, the great fair showed how the Anglo-Saxon race stood apart. The Midway Plaisance, or main promenade, displayed exotica from seventy countries, and for six months, twenty-seven million visitors took in its cultural wonders beside Lake Michigan.

For Victorian America, the world overseas may have offered the greatest curiosity, but the city offered the greatest challenge. Urban centers like Chicago were siphoning off rural Americans, producing suburbs, but also congestion and industrial squalor. Beyond the White City, these factors shaped religious rhetoric in America. Abroad, there was a mission for Anglo-Saxons. At home, urban evangelism and labor movements mixed with a new Social Gospel, a resurgent Catholicism, and the first taste of American imperialism.

The city also produced the commercial newspaper, which lived on headlines. A prince of the pulpit might be quoted in Monday's paper. But only a two-fisted urban evangelist grabbed the front page. The man of this Victorian

hour was Dwight L. Moody. He once was "crazy Moody" to the Chicago press; now it was 1875, and he was a conquering hero. Moody had led two years of urban crusades in Great Britain, and the response was electrifying. Queen Victoria, who declined attending—"it is not the *sort* of religious performance which I like"—nevertheless had noticed.[1] England had stopped for this Chicagoan, a man who had succeeded by selling shoes and teaching the Bible to boys at the YMCA. Moody was an American triumph in Victoria's court. On his return to a New York dock in 1875, the native of Massachusetts had a press corps glued to his heels.

Now it was 1893, almost twenty years later, and the Columbian Exposition was about to bring Moody to center stage in the city where his long ministry had been born. For Moody, life was one drama after another. His sermons were filled with simple, heartrending stories. Dying sons, redeemed profligates, prayerful mothers, sick children, and long-suffering wives populated his sermons. Some of these stories he surely invented. But others had a kernel of truth, such as his own journey home from England, which became the subject of a sermon too.

In November 1892, Moody and his son boarded the swift ship *Spree,* headed from Southampton to New York. Three days out, Moody was lying on a couch "congratulating myself on my good fortune," despite his usual seasickness.[2] Suddenly a terrible crash shook the ship. The propeller shaft had broken, cracking the stern. The Atlantic flooded in, and the ship's great bow rose in the air. The *Spree* floated powerless, waiting for rescue. It was an awful night, "the darkest in all our lives," Moody recounted. "Several hundred men, women, and children waiting for the doom that seemed to be settling upon us!"

Moody called a prayer meeting in the first cabin. He read verses from Psalms and doubted if a single skeptic was among the crowd. For all his preaching on death, Moody trembled. He had worked under fire in the Civil War. He had made rounds during cholera epidemics in Chicago. But now, "It was the darkest hour of my life." Back at his cabin, he prayed, "Thy will be done!" and then slept soundly, at least until his son shook him awake at 3:00 A.M. The steamer *Lake Huron* had pierced the lonely darkness. The *Huron* towed the *Spree* across a thousand miles of ocean, back to Montreal.

In London, a doctor had warned Moody against excitement since his heart was weak. But on that darkest night, Moody made a vow. "If God would spare my life and bring me back to America, I would come to Chicago, and at the World's Fair preach the Gospel with all the power that He would give

me." Moody's six-month project to send an army of preachers into the ranks of millions of visitors to the Columbian Exposition was the last major campaign by the nation's greatest evangelist.

Despite Sabbatarian protests, the fair stayed open Sundays. Moody tapped into the Sunday crowds by dividing the city in three around the river—north, south, and west. From May though October, the span of the exposition, his team used churches, rented every available auditorium, and pitched large tents abutting the White City's 633 acres. They spent $800 a day, and sometimes more. They sent out "gospel wagons" and midnight teams to skid row. In June, Forepaugh's Circus arrived in town. So for two Sundays Moody rented its massive elliptical tent, seating ten thousand. "Ha! Ha! Ha! Three Big Shows!" said a circus advertisement. "Moody in the Morning! Forepaugh in the Afternoon and Evening!"

Dwight Moody preached one of
his last great crusades outside the
Columbian Exposition of 1893.

In the exposition's final weeks, Moody's men had 125 preaching locations in action every Sunday. It all built toward a special day in Chicago, October 8, the anniversary of the 1871 fire that had burned the city to the ground. On this day, 700,000 visitors streamed into the exposition, up and down the eighty acres of the exotic Midway Plaisance, and over to the gigantic Ferris Wheel, never before seen. Moody could not bypass the drama. In one of the largest halls available on Chicago Day, he preached his "Fire Sermon."[3]

Moody took his listeners back twenty-two years, to the evening he had preached at Farwell Hall downtown. On his way home, the night sky turned red. The inferno swept up his church, then his home, and Moody fled. His only regret was about his final words at Farwell Hall that Sunday night. Moody had preached about Jesus, using a Bible text on his life. He concluded with, "Take this text home with you and turn it over in your minds during the week." After a week, "we will decide what to do with Jesus of Nazareth." By the next Sunday, Chicago was in ashes. His audience was scattered, some of it even destroyed. Now, on Chicago Day, Moody struggled against tears of regret, for he had waited too long. "What a mistake!" he cried.

I have never dared to give an audience a week to think of their salvation since. If they were lost they might rise up in judgment against me. . . . I want to tell you of one lesson I learned that night, which I have never forgotten, and that is, when I preach, to press Christ upon the people then and there, and try to bring them to a decision on the spot. I would rather have that right hand cut off than to give an audience now a week to decide what to do with Jesus.

Obviously, Moody applied the lesson well. His name stood for aggressive, unrelenting evangelism. At revivals, his staff handed out "reply cards" urging people to declare a "decision" or leave an address. A heavyset man with a dark beard, Moody dominated his urban age, with its spirit of getting things done. As a preacher, he mastered the homespun sermon. It was said he delivered it like a businessman making a deal, cut-and-dried. But its sentimentality worked. He was pro-business, persuaded bankers, magnates, and merchants to underwrite his revivals, and threw support to Republicans. Competing newspapers flocked to his city crusades for scoops, stories, and the occasional scoffing at big-time evangelism. Theodore Roosevelt imitated Moody's cutting hand gestures.

The 1893 Chicago campaign marked a peak of Moody's mobilization of evangelical persuasion. He preached salvation on the spot, and speculated that Christ might return at any moment, bringing the world to an end.

Moody had surrounded the White City, but he was not invited inside. Its inner workings were the purview of liberal Protestants, Catholics, and the leaders of ten historic faiths, all of them in Chicago for the exposition's Parliament of the World's Religions.

The Catholic presence was striking. At the time, the Vatican forbade mixed worship. But now the church had a cardinal in America, James Gibbons of Baltimore. With permission from Rome he had helped dedicate the White City on Columbus Day 1892. Now, in crimson robes, he was central to the procession that opened the interfaith Parliament. It was Monday morning, September 11, 1893. Gibbons took his place on a great stage with men and women of different faiths and tongues, some with turbans, bright tunics, somber cassocks, and shaved heads.

As the day unfolded, Gibbons gave his response to the opening addresses.[4] It was his duty to present Catholic truth claims wherever he went, he said, but only by appeal to the conscience and the intellect. "Though we do not agree in matters of faith," he went on, "thanks be to God there is one platform on which we all stand united. It is the platform of charity, of humanity, and of benevolence." The Good Samaritan in Jesus's parable helped a person of a different faith and nationality. "That is the model that we all ought to follow."

In an age of organized labor and industrial strife, Cardinal Gibbons had won Vatican support for labor, the great Samaritan issue of the Gilded Age. The church hierarchy had polarized over such issues, with Gibbons on the progressive side. The conservatives, hearing of Gibbons's Chicago remarks, for example, were critical. By espousing Christianity as charity, not doctrine, Gibbons bordered on liberal heresy, they said. Still, the Catholic Congress that met alongside the Parliament—there were dozens of such auxiliary sessions—heard talks about labor issues. The decade grew more chilly, however, and Rome would eventually charge the progressives with "Americanism." But by then, American Catholics for the first time had their footing. Gibbons, a preaching priest, had led the way.

Born in Baltimore, Gibbons had been reared in a workingman's environment. Dockworkers and shipbuilders were his first parishioners. After the Civil War, he was made a bishop in North Carolina, where he ministered to workers in the burgeoning textile mills. In 1871 he preached a sermon on "Man Born to Work: or, Necessity and Dignity of Labor."[5] He would repeat it many times. "I would rather grasp the soiled hand of the honest artisan, than touch the soft, kid-gloved hand of the dandy," he said. He admonished the workingman to three things: avoid idleness as if it were thievery; be ac-

tively interested in the employer's business success; and be content in the city where providence had placed him. Transience did not help. "A strolling family gathers very few coins or greenbacks in their perambulating wheel of fortune."

Life for Catholic workers was no different in the great depression years of the 1870s, so Bishop Gibbons's sermon stayed the same when he moved to Richmond. The first American unions had begun to organize. In 1869, for example, garment workers in Philadelphia formed the Noble and Holy Order of the Knights of Labor. The Knights had rituals, a handshake, a password—and a growing Catholic membership. To the church's hierarchy this smacked of a secret society, much like the Masons. After a decade, the high-profile Catholic mayor of Scranton, Pennsylvania, became Grand Master Workman of the Knights. A church decision had to be made: approve the union for Catholics or declare it anathema?

Gibbons's influence prompted the Knights to drop their ritual, replacing it with a public identity and a workingman's oath of honor. Now archbishop of Baltimore, Gibbons met the Knights close up, and he was impressed, even as Rome was suspicious and industrial leaders started to accuse Catholic agitators of organizing workers. The next depression, in the 1880s, swelled the group's size and Catholic popularity, however. The Third Plenary Council of Baltimore in 1884, at which Gibbons presided, gave the first official response: the church accepted labor unions, but not secret societies.

Then came the great labor strikes, a new and violent phenomenon on the American scene. In Baltimore, drivers and conductors on the railway struck for shorter hours and won a twelve-hour day. The Knights led a strike on the Southwest Railway that ended in clashes. The Haymarket Square riots in Chicago stamped labor with the image of bomb-throwing anarchists. Labor was fast losing its reputation amid the violence, and as the lower-class Knights lost credibility, the American Federation of Labor moved in. But the Vatican by then had endorsed the Knights of Labor as compatible with the faith.

Gibbons had been the crucial voice in swaying Rome, which then went even further. In 1891 Pope Leo XIII issued the encyclical *Rerum Novarum*, or "On the Condition of the Working Person," the church's first decree on social justice. "The condition of the working population is the question of the hour," the pope said. *Rerum Novarum* defended private property and condemned socialism. It supported labor unions' pursuit of collective bargaining, a just wage, and decent working conditions. The church had a duty to "point out the remedy," and this was taken as a cue by many Catholic priests and lay workers in America.

As Cardinal James Gibbons won Catholic church support for organized labor, events like the Haymarket riot undercut labor's credibility with American pulpits.

Two years later came the Parliament of the World's Religions, and *Rerum Novarum* was on display. On the fourth day, the address of an ailing Gibbons was read in his absence. He spoke on how Catholicism supplied "the needs of humanity," foremost by taking the pagan West and shaping it with Christian values, with light to the mind and comfort to the heart.[6] The church took a world of tribes and tongues and formed one culture, aimed at "the social regeneration of mankind."

Like all the spiritual leaders, Gibbons was not there to change his own mind. The Indian swami Vivekananda of Bombay famously said that no religion needed to convert another. "The Christian is not to become a Hindu or a Buddhist, nor a Hindu or a Buddhist to become a Christian," the swami said in perfect English. Although Gibbons might have disagreed, on his day to speak he gave a personal testimony. He was drawn to the church by its

antiquity, continuity, and "more forcibly" by its organized benevolence, with its defense of orphans, workers, and the downtrodden. The Savior, he said, sanctified manual labor.

> Before Christ appeared among men manual and even mechanical work was regarded as servile and degrading to the freemen of pagan Rome, and was consequently relegated to slaves. Christ is ushered into the world, not amid the pomp and splendor of imperial majesty, but amid the environments of an humble child of toil. He is the reputed son of an artisan, and His early manhood is spent in a mechanic's shop.

The strong Catholic showing that year came as the church in Rome and the United States were coming to loggerheads. On the one hand, the Vatican had bestowed on America a new status by sending there its first apostolic delegate. He was also a watchdog, however, and as his assessment reached Rome, the Vatican issued the first papal letter about troubling American trends. In *Longinqua Oceani,* addressed to Gibbons in 1895, the pope worried that a vibrant American Catholicism, enamored of church-state separation, endangered Europe's church-state unity. American Catholics, the pope said bluntly, had no government canopy or royal patronage, which was troubling to the Holy See. The letter put a political cloud over U.S. Catholics until the 1960s.

When the United States in 1898 declared war on Spain, a loyal Catholic nation, the "Americanist" controversy glowed white-hot. In its heat, liberal Americanism fell to pieces, although the serene Gibbons survived. So did Catholicism's perennial ties with labor. When, in 1907, a new pope declared "Modernism" a heresy, Gibbons was untouched. He remained the most popular Catholic bridging the two American centuries, a beloved lighthouse in the sea of American Protestantism.

By the time of the Columbian Exposition, the nation's Protestant pulpits were no longer quiescent about capitalism. During the era of organized strikes, the pulpits had supported crackdowns. They hailed federal troops and Pinkerton police as "soldiers of the cross." Industrialist Andrew Carnegie and the pulpits spoke as one in a "nationwide crusade against anarchism." Strikes were the tyranny, not corporations. Moody preached conversion and self-help, and the romantic sermons of the Gilded Age spoke of universals, such as love, salvation, and personality. There was no call for social upheaval. Only the rare sermon touched on wages or the hours in a workday.

Eventually, the clergy had to contend with their working-class constituents. They read muckraking reports in newspapers about industrial sins.

Once the urban reality came home, the Protestant landscape underwent a dramatic reversal. The idea of "social salvation"—the new Social Gospel—appeared first in seminaries and among activist clergy, but then spread widely. The Social Gospel linked the loving personality of Jesus with modern industrial workers. It asked businessmen, "What would Jesus do?" Its cry was "the kingdom of God," and in 1893 one of its founders came forward at the Parliament of the World's Religions.

He was the Congregationalist minister Washington Gladden, who would spend a third of a century preaching in Columbus, Ohio, where he also sat on the city council. A Pennsylvania native, Gladden was evangelical at heart. But he admired the new theology, with its insights on symbolic language and historical criticism of the Bible. His popular 1891 book *Who Wrote the Bible?* introduced churchgoers to this modernist vantage on the Old and New Testaments. His theology sprang from Jesus's Great Commandment to love, not from moral legalisms. Although Gladden preached social salvation, he never became a socialist. Even so, his criticism of capitalism was sharp as a rapier. In the shadows of the White City, his topic was "Religion and Wealth."[7]

He explained that Jesus had left behind a dilemma. He had rich friends but also said, "Ye cannot serve God and Mammon." Clearly wealth and religion could coexist, so the question was the divine balance. Wealth was an excess of exchangeable goods, Gladden said, and on this the preponderance of biblical teaching was wary. Wealth easily produced pride, extortion, cruelty, and oppression. It fathered bribery in public life and debauchery in private life. Each Christian must therefore discriminate between use and abuse, but society had a larger question: how to distribute wealth.

Much of humanity not only lacked wealth but starved, and Gladden suggested that there must be a better system, yet to be discovered. Meanwhile, as strength and skill produce wealth, the strong control distribution. "We can not believe that such a system can be in accordance with the will of a Father to whom the poor and needy are the especial objects of care." Speaking in September 1893, Gladden had a ready example of how the "existing industrial order" distributed wealth. That year, one of America's great "rushes" began on two million acres of Cherokee land in Oklahoma. In September, 100,000 homesteaders made the final dash, with the strong elbowing to the front. "Was the land divided among the neediest, or the worthiest," Gladden asked, "or the most learned, or the most patriotic?"

Religion offered a different way to distribute wealth, Gladden said. It should be distributed for the greatest good result, first of all. The "divine plan" was not a "communistic" system, which overlooked human talents, but

one that viewed wealth as a means to improve character and society. The mechanism was not yet clear, but the morality was self-evident, Gladden said. "The wealth of the world will be rightly distributed only when every man shall have as much as he can wisely use to make himself a better man, and the community in which he lives a better community—so much and no more."

A public speaker and Sunday preacher, Gladden infused all his talks with the same spirit. Few Americans would sit through a sermon on social or industrial analysis, and Gladden knew this well enough. The Social Gospelers worked through Jesus, and his personality, to raise consciousness about economic justice in the kingdom of God. As Gladden once preached, Jesus was the "Prince of Life." He offered more "life" in his resurrection *and* in improved labor relations, according to this Sunday sermon.

> The wage question is at bottom a question of more or less life for the wage-worker. . . . All industrial and national policies are to be judged by the amount of life which they produce and maintain—life of the body and of the spirit.[8]

In Gladden and his heirs, the sermon took a dramatic turn from both Beecher and Brooks, and from Moody. Those three had tacitly endorsed the capitalist order. The Social Gospel, born of new views on industrial society, also gained steam with the new farm and populist movements. The gospel of wealth was not gone, but it began to face fierce counter-oratory, such as that of Cornelius Wolfkin in New York City. The "hard-hearted, tight-fisted businessman that grinds down employees," according to this Baptist preacher, was deep in sin.[9] Eventually, every large church tradition had its American disciples of social reform in the pulpit.

Gladden was the most recognized pulpit preacher of the Social Gospel, being invited twice to give Yale's Beecher Lectures on Preaching. But theologians and sociologists were needed as well, and in great measure those shoes were filled by the Baptist thinker Walter Rauschenbusch. As a young pastor, Rauschenbusch discovered the meaning of the Social Gospel in the slums of Hell's Kitchen in New York City. The seventh in a line of ministers, Pietists all, Rauschenbusch had trained at German universities and considered foreign missions, but at age twenty-five he became a minister at the impoverished Second Baptist Church on West Forty-fifth Street, a rough Manhattan neighborhood of tenements, sweatshops, orphans, and crime. Eventually he returned to his native Rochester, becoming a professor of church history.

When the White City opened in Chicago, Rauschenbusch was in his seventh year in Hell's Kitchen. During his work at Second Baptist, he had spent another year in Germany, studying the new sociology of religion. He was full of such ideas in 1893. As the older Gladden took the Parliament rostrum in Chicago, a younger Rauschenbusch headed to a different forum, a national Baptist Congress in Augusta, Georgia. The Congress meetings were the last effort between northern and southern Baptists to communicate, an effort finally abandoned when each side agreed to stop sending literature or missions into the other's jurisdiction. Soon after 1893, the Congress became a synonym for northern Baptists. Rauschenbusch emerged as their chief sociological spokesman.

At the 1893 Congress he spoke on "The Church and Money Power," arguing that the Christian left wing, composed of dissenters and the lower classes, gave church history its vitality. During the Reformation, he said, an Anabaptist proletariat—sprouting from Switzerland and opposed to state churches and infant baptism—rose up against the Catholic and Lutheran establishments. In his view of history, Rauschenbusch also credited the English Puritans, and those who founded New England in general, with having the same left-wing spirit. In all social clashes, he said, theology was tangled in economic interest.

> That Catholics and Lutherans united in crushing out the Anabaptists is by no means solely due to theological convictions, but to class interests aroused to fury. . . . The middle class began to come into its inheritance at the Reformation, in religion, politics and social enfranchisement. The lower classes have had to wait till our own generation; they have now achieved their political rights; slowly they are also achieving their social rights; and in so far as Christianity is really sharing in the people's movement, it is recalling the church to its ancient hostility to money power.[10]

In all his works, Rauschenbusch emphasized the "kingdom of God" as the heart of the Social Gospel. The chief money power of modern America, namely the "last entrenchment of autocracy," was the corporation. With its capitalist monopoly, profit motive, and lack of ethics, the corporation was no better than a "little monarchy" of old, he said. As with uprisings in the past, modern industrial America demanded a new class revolt, led by a belief in social justice, union-led democracy, collective property rights, and a spirit of cooperation and equality.

If not the most famous preacher, or most practical engineer of the So-
cial Gospel, Rauschenbusch was its most prolific writer and theorist, filling
magazines and publishing the mass-interest *Christianity and the Social Crisis*
(1907). The booklet spread the cause to all denominations, even the YMCA,
and established him as the leading voice of the movement. In 1917, a year
before Rauschenbusch died, his lectures at Yale, *A Theology for the Social
Gospel,* set down his insistence that a systematic Christian theology had to
remain central to the new social creed. He left that legacy by interpreting
many classic doctrines in social terms. He was making a plea for a truly Chris-
tian socialism. Yet the kingdom of God, he summarized, was not confined to
churches alone.

> It embraces the whole of human life. It is the Christian transfigura-
> tion of the social order. The Church is one social institution alongside
> of the family, the industrial organization of society, and the State.
> The Kingdom of God is in all these, and realizes itself through them
> all. . . . The Church is indispensable to the religious education of
> humanity and to the conservation of religion, but the greatest future
> awaits religion in the public life of humanity.[11]

For the nation's Protestant middle class, this earthly "kingdom" was still a
radical proposition, for it often demanded great sacrifices from the well-off.
A more friendly element was still needed for the Social Gospel to touch the
America heart, and it turned out to be the ebullient confidence in the Anglo-
Saxon race so much in evidence at the White City exhibition.

The prophet of this patriotic gospel was Josiah Strong, pastor of First
Congregational Church in Cincinnati and a man whose ancestors had settled
Massachusetts Bay Colony in 1630. Strong was inspired by American inge-
nuity, efficiency and statistics, and it seemed that God had put these tools
particularly in American Protestant hands. He was secretary of the Congre-
gational Home Missionary Society. The western frontier was closing and the
metropolis rising. By having a new vision, money for missions, and social sci-
ence, Strong preached, Protestants could cooperate to preserve rural values
amid the new urban swell. They could bring the kingdom of God to every
person on earth.

Strong preached this from his local pulpit, but nothing sold it to Americans
like his 1885 book, *Our Country: Its Possible Future and Its Present Crisis.* The
bestseller was a padded update of pamphlets long issued by the Society. The
public was ready for visions of progress and the Anglo-Saxon mission to up-

lift the world. Strong recognized that Anglo-Saxonism was really a "mixed" race, more a culture than a bloodline. But he was unabashed in preaching white American Protestantism as a "race of unequaled energy, with all the majesty of numbers and the might of wealth behind it."[12] The nation had the largest liberty, purest Christianity, and highest civilization. America would spread globally, for it had "developed peculiarly aggressive traits calculated to impress its institutions upon mankind." Like no one else, Strong preached the amalgamation of Social Darwinism with the Social Gospel.

> Is there room for reasonable doubt that this race, unless devitalized by alcohol and tobacco, is destined to dispossess many weaker races, assimilate others, and mold the remainder, until, in a very true and important sense, it has Anglo-Saxonized mankind?

Strong moved from pulpit to civics at will, founding the American League for Social Service and promoting church cooperation. He laid the foundations for American ecumenism. In fact, his evangelical credentials were so solid that other evangelicals quoted him chapter and verse. Strong issued the call for foreign missions, but it was a younger acolyte who made them his life's work. His name was John R. Mott. More than once, Mott, a Methodist layman and leader of the Student Volunteer Movement, quoted Josiah Strong in his own inspiring missionary talks.

In 1900 the sprightly Mott stood before a throng at Carnegie Hall in Manhattan. He was thirty-five, boyish in his dark hair and wide eyes, but with a few world tours already under his belt. In addressing the Ecumenical Missionary Conference, a type of meeting that had convened since 1893 in the United States, Mott updated his standard theme. For a decade or more, he had preached "the obligation of this generation to evangelize the world." Now he did so again, adding new benchmarks, setting new goals, and passing on fresh enthusiasm.[13]

Examples abounded of such a global achievement. Look at the British empire, he said. Consider Western military prowess and match it with a possible missionary prowess. Then Mott went on to quote Josiah Strong, whose authoritative words said, "There is money enough in the hands of church members to sow every acre of the earth with the seed of truth." For more than a decade, Mott had helped build the nucleus of Protestant missions. It was made up of Christian college students. They took a pledge to serve, and needed only training and money to carry out the task.

The idea had been conceived in 1886 when a group of college students met at Dwight Moody's Mount Hermon retreat in Massachusetts for a YMCA

gathering of prayer and Bible study. The topic of missions arose quite by accident. Inspiration prevailed, and one hundred students signed a pledge: "We are willing and desirous, if God permit, to become foreign missionaries." With the "Mount Hermon Hundred" as a core, students across the country began taking the pledge, though it rarely was honored. Nevertheless, a movement was born. Mott was its young representative. He was straight from the ranks. His Carnegie Hall message, as usual, was urgent.

> The present generation is one of unexampled crisis in all parts of
> the unevangelized world. Failure now will make the future task
> very much more difficult. . . . For the first time in the history of the
> Church, practically the whole world is open. We are not justified in
> saying that there is a single country on the face of the earth where the
> Church, if she seriously desires, can not send ambassadors of Christ.

A man of numbers and geography, Mott estimated that if just "one fiftieth" (2 percent) of college graduates who were Christians set off to mission fields, every human being would hear the gospel. With the British Commonwealth and Europe thrown in, there were missionaries to spare. "We have workers enough to send," he enthused. Doors to nations had opened. Inventions had made communication and travel rapid and extensive.

Although the student movement was its own entity, little was done without mingling with the YMCA, the institutional mainspring of evangelicalism in the United States. Mott held posts in both the Student Volunteer Movement and the YMCA. During the First World War he led the YMCA's support for the armed forces, practically a monopoly operation. The Second World War was too vast for a similar YMCA program. But for humanitarian relief, the well-connected Mott used the "Y" and anything else to alleviate human suffering. All the projects—missions, humanitarian work, and ecumenical talks—began to converge after the Second World War. The result was the World Council of Churches. Its efficiency and role in Western Christendom was up for interpretation. But Mott's global humanitarian work was unassailable.

In 1946 he received the Nobel Prize for Peace. His address at Oslo City Hall, with the world listening, was a sermon on leadership, Christian and otherwise. All leadership required vision, righteousness, and ethics, he said. "Let me emphasize the all-important point that Jesus Christ summed up the outstanding, unfailing, and abiding secret of all truly great and enduring leadership in the Word: 'He who would be greatest among you shall be the servant of all.'" By embodying that, Jesus became "leader of leaders."[14]

America's new vantage on the world in about 1900 also changed the face of Jewish preaching. The topic of Palestine, or a homeland to which Jews could return, spawned the new movement of Zionism. Begun at a Zionist congress in Switzerland in 1897, the quest for a homeland rapidly divided American Jews. Reform leaders objected vehemently, while the more traditional Orthodox and Conservative movements rallied. Reform rabbis, who no longer included a return to Zion in their prayers, said that America "is our Palestine, this city our Jerusalem." In 1899 the great Jewish preacher Isaac Mayer Wise dismissed the topic of "a ridiculous miniature State in driedup Palestine."[15]

In time, however, Reform orators such as Rabbi Stephen S. Wise of New York City made Zionism their cause. The call for a homeland gained appeal as Britain struggled to rule the territory after the First World War and as anti-Semitism began to rise in Europe in the 1930s. With the onset of the Second World War, America's Reform rabbis finally assented that Zionism had "no essential incompatibility" with modern, liberalizing Judaism. After a slow response to Zionism in the late Victorian age, the topic became a cardinal feature of Jewish preaching in the United States, peaking with the defeat of the Axis powers, and continuing today.

The Anglo-Saxon pride of the Victorian era had its downsides, in the hindsight of history. In the American South, segregation became ironclad. The Confederate states formalized segregation in railcars in the 1880s. Tax and literacy requirements erected barriers to black voting. The Supreme Court upheld the Jim Crow laws in 1896, and the separate-but-equal doctrine had a political and legal sanction for the next sixty years.

Pride in white culture was one thing the South still shared with the North. The "religion of the Lost Cause," however, was still important in Dixie. It continued to mark out southern alienation. The statues and cemeteries had done their part. But education and memory were a constant project. Many former Confederates put their shoulder to that task. None was better at it than the Baptist preacher John William Jones, who had made special friends with the aging Robert E. Lee.[16]

Jones had served as a chaplain in the Army of Northern Virginia. He sidled up to Lee after the general became president of Washington College in Lexington, Virginia. Jones arrived as pastor of Lexington Baptist Church. He evangelized on the campus, which Lee, an Episcopalian, had made ecumenical. After preaching at the college chapel once, Jones saw Lee coming toward him. By Jones's account, Lee thanked him profusely for his sermon. "You struck the very key-note of our wants," Lee said. "We poor sinners

need to come back from our wanderings to seek pardon through the all-sufficient merits of our Redeemer."

Jones did not divinize the great Confederate leaders. But if Lee was a Christ figure, Jones was Saint Paul the evangelist. After Lee died in 1870, Jones began a career as seminary agent, Sunday school missionary, and finally the gatekeeper of the Confederate memory. A stocky man of talent and energy who was always impeccably dressed and wore a stylish goatee, Jones mastered the art of using the Lost Cause as a tool for evangelism. To ensure the "correct" view of the past, he wrote a *School History of the United States* and had a hand in the *United Daughters of the Confederacy Catechism for Children.* He also produced a lively account of Confederate army revivals, *Christ in the Camp.*

Most important, in his role as watchdog on "correct" history, Jones became secretary of the Southern Historical Society. He edited its voluminous papers, wrote popular biographies and essays, and developed a popular lecture called "The Boys in Grey." He was chaplain to the main veterans' group.

The Lost Cause, however, was being eclipsed by the New South. His final mission, Jones believed, was to teach Confederate veterans how to die as Christians. In 1900, as Northern missionary groups met in Manhattan, Jones delivered a sermon in the South on the ninety-second anniversary of Jefferson Davis's birth. It still was a sacred day. He used the New Testament text of Hebrews, with its reference to a "cloud of witnesses," the beloved ghosts of former days. But Jones made a heroic point to his audience of veterans, who felt the palpable "cloud" of the deceased still present.

> Will you, then, old comrades, suffer one who respects, honors, and loves you to say this faithful word? Patriotism is not religion, and to have been a true soldier of your country does not constitute you a soldier of the Cross.

Conversion of the heart, and not waving the Confederate flag in battle, was the final means to wear "the crown of glory."

The alienation of the South was soon to end. Its termination was aided by the Anglo-Saxon pride sweeping America. Then came the Spanish-American War in the spring of 1898 and the American conquest of the Philippines. Southern men proudly enlisted. The war allowed the religion of the Lost Cause to modify its meaning. Originally, it had honored the rights of states to have slavery. Now, the southern soldier enlisted to save Cubans from Spanish enslavement and to spread liberty.

Across the races, the war united. Black preachers, mindful of grousing about the "white man's war," said blacks should fight as well. "If you say this is a white man's war, then you are bound to accept the doctrine that this is a white man's country," said Henry Hugh Proctor, the Yale-trained minister who led Atlanta's most elite black church, First Congregational. "This is God's country," said the black preacher and statesman. "We are not Afro-Americans, but Americans to the manor born."[17]

The one note of opposition to the militancy toward Spain came not from a minister but from the Democratic political figure William Jennings Bryan. The Nebraskan opposed the jingoistic tone of the hostilities with Spain. Bryan was the best-known figure in the Democratic party. He was its presidential candidate three times, beginning with the 1896 nomination after he gave his famous "Cross of Gold" speech. The speech was an appeal for economic fairness toward western and southern farmers, small merchants, and workers.

A lifelong Presbyterian, Bryan was at home with religious oratory. His failed bid for the presidency in 1900 persuaded him to take up religious topics, which were popular and close to his own heart. Bryan was a Chautauqua favorite. "I might reach and influence some young men who avoided the churches," he said. To many, Bryan was a preacher who had stumbled into politics. His three stock Chautauqua lectures were religious, beginning with "The Prince of Peace," the most famous. He cast a mild criticism on Darwinism, defended the "miraculous" in Christianity, and hoped to instill faith in a rising generation.[18]

> There are honest doubters whose sincerity we recognize and respect,
> but occasionally I find young men who think it smart to be skepti-
> cal; they talk as if it were an evidence of larger intelligence to scoff
> at creeds and refuse to connect themselves with churches. They call
> themselves "Liberal," as if a Christian were narrow minded. . . . Some
> go so far as to assert that the "advanced thought of the world" has
> discarded the idea that there is a God.

Bryan's second talk was "The Value of an Ideal," also in defense of religion, and the third "The Price of a Soul." This last oration, while having personal application, took America to task for losing its soul by gaining the world, and this by imperialism and war. Bryan was the era's foremost preacher against imperialism and for peace. His 1900 speech, "Imperialism," included a criticism of Christian justifications, heard from pulpits, of violence in the Philippines.

The religious arguments for imperialism ranged widely, Bryan contended, from a passive belief in providence to a violent militancy. He said America

After three failed bids to become Democratic president, William Jennings Bryan turned to religious oratory.

had to be consistent in its principles. If it claimed freedom, it must give it to other nations. If it cited the Bible, it must live by the teachings of Christ. "Who will say that we are commanded to civilize with dynamite and prose-lyte with the sword?" Bryan asked. "Imperialism finds no warrant in the Bible. The command, 'Go ye into all the world and preach the gospel to every creature,' has no Gatling gun attachment."[19]

Bryan chided ministers whose sermons called for violence against natives who rejected American rule. The work of American missionaries was at stake. "Let it be known that instead of being the advance guard of conquer-ing armies, they are going forth to help and uplift." The missionaries were citizens of a country that respected the rights of other nations. It was not a message the jingoists wanted to hear.

For a time at least, the new imperialism had the domestic effect of re-directing the religion of the Lost Cause and dampening sectionalism. The Spanish-American War got it started, as southern boys enlisted, and it began to peak with the 1912 election of Woodrow Wilson, the first southerner to occupy the White House since 1869. When Wilson reversed himself and led America into war in 1917, southern pulpits were his trumpets. The religion of the Lost Cause found a new focus, a fight against the German "Hun" for a liberty akin to that of states' rights a half-century before.

The South felt it had warned America about Germany, which had instigated historical criticism of the Bible. The Hun was the fountainhead of liberal Protestant theology, and its universities imposed rationalism on Christian faith. With Wilson in the White House and war in the offing, the South felt released, and Confederate veterans paraded for the first time in Washington. President Wilson told their convention that God's mysterious ways with the South had become clear. Dixie would be part of "the great world purpose," an "instrument in the hands of God."

At Arlington National Cemetery, a Confederate monument was christened. The Civil War had been fought over ambiguities in the Constitution, Richmond's Methodist bishop, Collins Denny, preached. The monument gave North and South a "seal of a fraternal union." Their young men now were united, headed to Europe to fight tyranny with freedom. That day, veteran soldiers in gray finally carried the Stars and Stripes.[20]

When the White City was erected in Chicago, none of this overseas conflict was anticipated. The notion of peace by international understanding filled the air. The Exposition hosted a Universal Peace Congress. Six years later, in 1899, delegates from twenty-six nations met at The Hague to promote peace, formulate principles for the conduct of war, and found a Permanent Court of Arbitration. But to no avail.

The American pulpit had taken a stance on war and peace since the New World settlers skirmished with Indians. The pressure on sermons always was toward patriotic conformity. Still, a divided voice arose on the eve of the American Revolution and the War of 1812. The wars with Mexico and Spain, fought for Texas, Cuba, and the Philippines, showed less dissent. The White City had tried to represent an era of international exchange. The Parliament of the World's Religions stood for interfaith amity. The siren of war, however, drowned them out. The sermon turned American participation into a holy crusade, a fitting start for the new century.

III

The Modern Period

(1900–)

How America traded peace for a crusade in a First World War, and preached cautiously in a Second World War. How temperance gave women the vote and the nation Prohibition, and how fundamentalists battled modernists on doctrine and Darwin. How radio changed the sermon, created celebrity, and carved out American religious identities. How belief in sin changed preaching, and how psychology also became popular. How a postwar religious revival offered peace of mind, and a Catholic bishop became a television icon. How Pentecostalism, positive thinking, and Billy Graham backed the American Way of Life, and in a nuclear age anticommunism defined faith. How church and state got separated, black oratory spurred civil rights, and

Vietnam shook the 1960s and 1970s. Amid left and right, how a "new homiletics" adapted, and a U.S. president and the Religious Right revived a "city upon a hill." How sermons addressed terrorism and war, and how Americans are ambivalent about religion and politics. How Benjamin Franklin's "publick religion" today has four habits of mind made by the sermon.

Modern Times

A Battle over Women, Booze, and Bibles

AT THE START OF THE NEW CENTURY, THE SPANISH-AMERICAN war rapidly lost its glorious shine, and the pulpits of the nation began to cry out for peace—at least until the First World War changed the mood overnight. The American sermon often seemed to be either all for peace or all for war. It was a fitting polarity, for the first modern American decades would swing the pulpits in every directions over war, culture, prohibition of alcohol, the vote for women, and belief in the Bible itself.

When it began, the call for peace seemed to have no limits. "Let every Methodist pulpit ring out clearly and insistently for Peace by Arbitration," said the church bishops in 1912.[1] Women's groups issued a "World Peace" Sunday school course, and industrialist Andrew Carnegie poured $2 million into the Church Peace Union. On Peace Sunday in 1909, an estimated fifty thousand sermons tackled the subject. Woodrow Wilson joined the American Peace Society, and Theodore Roosevelt won the Nobel Peace Prize. It seemed that William Jennings Bryan's wail against war and imperialism had suddenly been heard.

Then came one of the most dramatic about-faces in American religious oratory. The war in Europe, begun in the summer of 1914, took nearly three

years to snare the United States. The May 1915 sinking of the British vessel *Lusitania,* with unwise Americans on board, had been the crystallizing event. But its opening phases were ones of rapid escalation. In the Easter season of 1917, when Wilson declared war, the Episcopal minister Randolph McKim mirrored many national pulpits when he preached, at his downtown Washington, D.C., church, on "America Summoned to Holy War."[2] Germany, he said,

> must be beaten to its knees; it must be crushed, if civilization is to be saved—if the world is to be made safe for Democracy. . . . This conflict is indeed a Crusade. The greatest in history—the holiest. It is in the profoundest and truest sense a Holy War.

The first step in militant oratory was the sermon on preparedness. The peace societies disintegrated, and in their place the new League to Enforce Peace urged "going to war to enforce peace." For Thanksgiving Day 1915, ministers overwhelmingly responded to a Committee on National Preparedness request to preach on that theme. Preparedness was "distinctly Christian," as the message from one Baptist pulpit put it. The next May, 130 clergy marched in New York City's preparedness parade.

The war changed America's religious landscape, both in oratory and in organization. It spawned vast new centralized church bureaucracies. The pulpits recruited soldiers and sold Liberty Bonds. The Protestant and Catholic chaplain corps mushroomed, and the YMCA became an unofficial arm of the military. The American Bible Society many times overfulfilled its slogan, "A Khaki Testament in Every Kit."

The sermon took on an official and unofficial voice, the latter reaching heights comparable to McKim's "holy crusade." With the help of the Federal Council of Churches, once a peace organization, the government's Committee on Public Information distributed sample sermons. The committee held six hundred meetings nationwide, giving thirty-three thousand ministers "official" information for their sermons.

Only the churches, however, could sprinkle holy water on the military endeavor, and it came willingly. One Methodist pulpit called for defeat of the "hellish Hunnish hordes," and the Presbyterians in assembly judged the war "most just and holy." Glimmers of Social Gospel idealism were still evident: victory in Europe might bring the kingdom of God. This psychological shift from peace to war, especially a war on foreign soil, was bumpy but inexorable for the nation's preachers. The Sermon on the Mount was true, they said

to themselves, but an exception had to be made for the "hellish Hun," the devil incarnate. The war was righteous because the vicious Hun raped and maimed, or so the stories said. Wartime sermons were a primary vehicle for unspeakable German atrocity stories.

Darkness and light filled sermons. The Good Shepherd became the apocalyptic Christ, whose word was like a sword. "Christ was the greatest fighter the world has ever seen," the Methodist J. Wesley Johnston preached. In another minister's sermonic spin, "the sword of America is the sword of Jesus." Soldiers were missionaries. One minister declared that the Expeditionary Force was the "church in action." The battlefield was a sanctuary. It had rituals, fasts, feasts, and choirs of cannons and machine guns.[3] Clergy who dissented tended to keep it private, and those who went public were drowned out or censured.

The First World War ended with no clear victory. It produced more civilian deaths than military casualties. The battlefield's futile dynamic finally astonished the world. The war's profiteering, moreover, astounded American taxpayers. Congressional probes found that munitions companies had stoked the war fervor. Professional propagandists had floated the "atrocity" stories, much to the embarrassment of East Coast pulpits. When all of this was laid before the American clergy in the next few years, an awkward silence followed. Never again, not even in the Second World War, was the naïve spirit of a "holy crusade" the unanimous tone of America's wartime sermons.

In fact, pacifism returned with a vengeance. New York ministers who had preached on atrocities now declared a strict antiwar stance. "The glory of war comes from poets, preachers, orators, the writers of martial music, statesmen preparing flowery proclamations for the people, who dress up war for other men to fight," preached Harry Emerson Fosdick, who had served briefly as a battlefield chaplain, at a 1934 peace rally.[4] Sherwood Eddy, an evangelical missionary with the wartime YMCA, became a voice for absolute pacifism. Despite these sentiments, the European disarmament conferences failed. The peace treaties were broken. The world slowly remilitarized.

What the war era gave America was a blank check for vituperative oratory that some evangelists cashed in gladly. Militant oratory, especially among the rising fundamentalists, became a cultural badge of honor. On the other side, a cynicism about religion's rubber-stamping of war produced a generation eager to hear a more skeptical analysis of the "will of the Lord," and indeed the Bible itself. Novelist Ernest Hemingway's "lost generation," the Roaring Twenties, and isolationism were responses to war exhaustion, and a new "modernist" preaching spoke to that audience.

The most surprising products of the war years, however, were two titanic reforms that followed the armistice. One was the passage in 1919 of the Eighteenth Amendment, which banned alcohol in the United States. The second was the Nineteenth Amendment, giving women the vote. Both had wartime causes. Rationing had cut alcohol production, and so the iron was hot for political action. The war had also brought women into the workforce, removing the last cultural obstacles to women's equality at the ballot box.

It took more than war, however, to produce Prohibition and women's suffrage, and that story goes back to the preaching of three unlikely allies, the Quaker suffragist Susan B. Anthony, the Methodist educator Frances Willard, and the "baseball evangelist" Billy Sunday. Anthony and Willard, both peace mongers and pioneers of women's public speaking, reached the status of America's two most famous women, ending their days as the Spanish-American War flared. Sunday, a self-educated Iowa farm boy with the National League's base-stealing record, rose to fame on the fervor of the First World War. As different as these three orators were, their religious oratory combined to produce the astonishing reforms of early modern America.

Like most women who became orators in the nineteenth century, Susan B. Anthony began with the cause of temperance, or abstention from alcohol. In time, she became the nation's most prominent speaker on the women's vote, a mission she eventually shared with Willard, who was nineteen years younger. Born into a Quaker household in rural Massachusetts, Anthony taught school for ten years, and gave her first public talk in a small New York town for the local Daughters of Temperance. At the time, she believed women suffered most from drunken, abusive men.

In time, the vision widened and she would team up with women's rights advocate Elizabeth Cady Stanton. Anthony was the energetic itinerant speaker, while Stanton, home with children, coauthored speeches and the movement's manifestos. Together they published the short-lived journal *Revolution*. When it failed in 1870, Anthony paid off its $10,000 debt by six years of public lectures, charging $75 an appearance. "I come tonight neither as an orator nor a philosopher, but as a representative of the working women," she typically began, more with hard logic than evangelical bravado.[5] Stern in appearance, wearing tied hair and a black dress, Anthony was nevertheless the optimist of the early movement. She combined a theology of equality, progress, and immortality that covered both sexes. The "true woman," she said in a speech of that title,

will be her own individual self,—do her own individual work,— stand or fall by her own individual wisdom and strength. . . . She will

proclaim the "glad tidings of good news" to all women, that woman equally with man was made for her own individual happiness, to develop every power of her three-fold nature, to use, worthily, every talent given her by God, in the great work of life, to the best advantage of herself and the race.

Never having married, Anthony constantly struggled against public images of the "old maid." She tried to defy them, declaring an "epoch of single women" who could fend for themselves. She used lectures and petitions in hopes of leveraging property rights and the vote for women. By the 1870s, however, she was convinced that a dramatic legal wedge was necessary. She used herself as the sharp edge. On November 5, 1872, Anthony walked into a store in Rochester, New York, and voted in the presidential election. She was not the first woman to do so, but she was the most famous. Two weeks later she was arrested. Despite delays as prosecutors moved the trial's venue, the date was set for June 1873 in a nearby county.

In the weeks preceding the trial, Anthony circulated, every day giving her "Constitutional Argument" speech to curious crowds.[6] "It shall be my work this evening," she began, "to prove to you that in thus voting, I not only committed no crime, but, instead, simply exercised my citizen's right." The speech reveled in how women had every responsibility men did but were denied the ballot. She was particularly acerbic in how the law used the semantics of sex to ostracize women, now that even the right of former slaves to vote was limited to "males" in the Constitution. While the Supreme Court held that male pronouns were generic, the term *female* was so absent in federal and state documents that in Anthony's own case, the clerk of court had to change "him" to "her" to make the illegal-voting charge stick. Anthony would say:

But, it is urged, the use of the masculine pronouns he, his, and him, in all the constitution and laws, is proof that only men were meant to be included in their provisions. If you insist on this version of the letter of the law, we shall insist that you be consistent, and accept the other horn of the dilemma, which would compel you to exempt women from taxation for the support of the government, and from penalties for the violation of laws. . . . I insist if government officials may thus manipulate the pronouns to tax, fine, imprison and hang women, women may take the same liberty with them to secure to themselves their right to a voice in the government.

At the end of the trial, the judge directed the jury to deliver a guilty verdict. He gave Anthony her right to speak before sentencing but cut her off as she began a version of the "Constitutional Argument." She was fined $100, which she refused to pay. By being freed by bail, thanks to her lawyer, and the judge's desire to moot the case, Anthony lost her chance for a Supreme Court appeal. So a St. Louis woman got there first in 1875, but the Justices rejected her lawsuit. The next year Anthony was back on the circuit, headed for Philadelphia, where she and other suffragists issued the "Woman's Declaration of 1876" during Fourth of July ceremonies in Philadelphia.

At that same time, Frances Willard also was in Philadelphia, attending its Centennial exhibition with the Women's Christian Temperance Union. She wanted to speak on the women's vote but was asked to stay mum, for Union leaders said Christian temperance women should not "trail our skirts in the mire of politics." Soon afterward, however, Willard took her message on the road. When Anthony heard of this, she wrote to Willard, congratulating her, a very famous evangelical woman, on coming out for suffrage: "I rejoice that at last you have obliged the 'innerlight' as the Quakers say—the 'divine inspiration' I say, and put under your feet all the timid conservative human counsels." Willard brought to the cause a unique oratorical strategy, and finally America's largest women's group, the Union, formed just two years before the Centennial.

Willard hailed from Evanston, Illinois, a suburb of Chicago. The sister of a minister, she aspired to that as well but instead became a teacher, newspaper editor, and administrator of a Christian college for women. With a foot in both education and temperance, Willard realized her gift in speaking. The great urban evangelist Dwight Moody also noticed her talent. He invited Willard to share his stage during New England revivals. In those months, she both learned the power of evangelical speaking and gained national recognition. But the Moody-Willard alliance did not last. In the cause of temperance, Willard shared public podiums with female Unitarians and liberals, which was not Moody's idea of upholding orthodoxy. She believed in pledge cards not to drink, whereas Moody demanded conversion to Christ.

In this man's world, Willard always mulled ordination, still a century off for the Methodist church. Meanwhile, she had also inherited from her mother a "pet heresy"—the idea of a woman's right to vote. Her own epiphany came just before a temperance address in Columbus, Ohio, in 1876. As she knelt in prayer, "there flashed through my brain a complete line of argument and illustration."[7] She had found a strategy: giving women the local vote led to

"home protection," for it would bar alcohol and saloons from neighborhoods and counties.

Armed with this idea, Willard soon crossed her "Rubicon of silence." She gave her first "women's duty to vote" address later in the Centennial year at a temperance camp meeting, gathered at Old Orchard Beach, Maine. The women's "home protection" vote, she said, not only stopped vice at the city limit but balanced the growing immigrant Catholic vote, which was over-turning Sabbath laws and expelling the Protestant Bible from schools. Before long, Willard changed her stock temperance address, "Everybody's War," to the new "Home Protection." She preached it countless times, adjusted to events and audiences. It contained all the main points of persuasion and strategy.[8] Vice is active, but virtue passive, she told mixed audiences. Virtue can fight back with women's political power, for by their vote,

> the rum power will be as much doomed as was the slave power when you gave the ballot to the slaves. In our argument it has been claimed that by the changeless instincts of her nature and through the most sacred relationship of which that nature has been rendered capable, God had indicated woman, who is the born conservator of home, to be the Nemesis of home's arch enemy, King Alcohol. And further, that in a republic, this power of hers may be most effectively exercised by giving her a voice in the decision by which the rum-shop door shall be opened or closed beside her home.

The women's vote saved everyone time and effort, she continued. Already, working women took hands from washtubs to sign petitions, and upper-class women dressed up to persuade men at saloons on Election Day. Why not just vote themselves? Nonreligious women would come along, and "Catholic women would vote with Protestant women" to protect the home. Women had a vested interest. They made up two-thirds of the nation's eight million churchgoers, and four-fifths of all teachers. "Let us not limit God, whose modes of operation are so infinitely varied in nature and in grace." She even used military metaphors, envisioning mothers "clad in the garments of power" walking beside their sons.

With this speech, Willard paved her way to the Temperance Union presidency, which she won in 1879. "When we desire this 'home protection' weapon, American manhood will place it in our hands," she told the annual assembly, representing the largest female force in America. Two years later the group backed the vote: "Home Protection where Home Protection is the

strongest rallying cry; Equal Franchise, where the votes of women joined to those of men can alone give stability to temperance legislation."

The bigger step was inevitable. In 1892, the Temperance Union organ, the *Union Signal,* endorsed full voting rights as a "natural right," not just a practical remedy for ousting saloons from neighborhoods. In her presidential address that year, Willard articulated the natural rights argument. Nature, and therefore God, had given women a vote, for they too were part of the consent of the governed. Twenty years after Susan B. Anthony was arrested for voting, the mainstream of Christian women in American had taken up publicly the same constitutional and philosophical argument: God and the Constitution had made women politically equal to men.

Like Anthony, Willard was a single woman and an attractive speaker. Late in life she described herself as a "Protestant nun." She tied back her light brown hair. Her bright blue eyes gazed through pince-nez spectacles. Clad in her standard uniform of a brown or black dress, with a sky-blue tie at the throat, she mastered the use of womanly qualities, including deference, to control the building of a massive political alliance. Foremost, she said, was to avoid alarming males, for men "must be convinced that womanliness can never be legislated out of being."

Reformer Frances Willard became the best-known female speaker of her era, beginning with a "Home Protection" sermon for the women's vote.

Similarly, her movement had to show that the vote would not collapse the "women's sphere," so important to rearing families and being Victorian. She built a bridge between the two trajectories of female culture at the time, one radically feminist and offensive to men and the other dedicated to nurturing children and pampering men after the workday. Her political acumen was matched by her tireless travels, which were possible for a single woman.

During the 1880s, the Temperance Union grew nearly tenfold to 200,000 members. For the decade Willard averaged at least one meeting or speech a day. In the early 1880s she went South, where an assertive woman raised eyebrows. But with a moral high tone and courtesy, she rooted her feminism there as well. In South Carolina, the *Baptist Courier* called her appearance womanly enough, and her address a "literary gem."

On this reformist trajectory, however, Willard naturally mingled with the more exotic causes of her age. She brought a "do-everything" ethic to the Temperance Union, which at first meant many methods but soon became every cause. She worked with Knights of Labor, Fabian socialists, the Prohibition party, and the sociological experts. Finally, she felt free to declare that in Christian churches, the "white male dynasty" was the only group "lording it over every heritage, and constituting the only unquestioned 'apostolic succession.'" Owing to her efforts, in 1896 the Methodists' General Conference voted to seat female delegates at its 1904 assembly. By then she was dead. What remained was her book, *Woman in the Pulpit,* which listed all the reasons the Bible and history did not bar women from ordination.

In Chicago, where the Temperance Union had its large ornate headquarters, Billy Sunday was setting records for the Chicago White Stockings, living the life of a celebrity, and making good pay. But Sunday saw fellow ballplayers slide into debauchery and alcoholism. In 1886 he wandered downtown to the Pacific Garden Mission and was converted to Christ. Like Willard, Sunday had come under the towering shadow of Moody's legacy. He helped with the YMCA, quit baseball in 1891, and traveled with Moody's protégé J. Wilbur Chapman until William "Billy" Sunday came into his own. He launched his first crusade in Iowa in 1896 and was ordained a Presbyterian minister seven years later.

Willard had been shaped by the age of peace, but Sunday's point of reference was the era of imperialism and the militant crusade of the First World War. That age matched his manly style. No one gave Germans and pacifists more hell than Billy Sunday, an "athletic preacher" who climbed on fixtures, slid on stage, and broke furniture to make his oratorical points. "If you turn

Evangelist Billy Sunday invented a bombastic style imitated by many as he decried pacifists, Germans, and the liquor industry.

Hell upside down, you will find Germany stamped on the bottom," he famously preached. The crowds loved it. But in the cause of temperance, which finally became Sunday's greatest cause, he endorsed "home protection." In fact, he gave a manly shoulder and shove to the women's vote in America.

That put him in alliance with the Temperance Union, but only in common rhetoric. Sunday's kind of organization was the powerful Anti-Saloon League, founded by a crusading Methodist bishop in 1893. The League was politically astute, and its allies effective agitators. The physically formidable Carry Nation was a good example. After she prayed, she reduced saloons to shards of glass and splinters of wood. She was arrested about thirty times. She paid her fines by selling souvenir hatchets and lecturing on demon whiskey. It was a spirit that Sunday could only admire.

In this post-Moody era, crusade evangelism was much imitated, and Sunday was imitated most of all. In 1911 some 650 professional evangelists crossed the country, and another 1,300 were part time.[9] They all had gimmick names: Rodney "Gypsy" Smith, Dan "Cyclone" Shannon, "Sin Killer" Griffin, and more. Preachers seized reputations as the "cowboy," "labor," "singing," "businessmen's," "railroad," or "boy" evangelist. Most of them imitated Sunday's bombastic style. But during his peak years of 1908 to 1918, no one surpassed Sunday. He was a benchmark, and the last of his crusades, held in May 1930, marked their disappearance for another twenty years.

Since the days of Charles Finney, revivals had been organized around immediate conversion, either at a front bench, on a commitment card, or by walking down the sawdust-covered aisle. Sunday's goal was no different, but his performance was. His preaching was physical, loud, funny, and combative. Some called it religious vaudeville. He knew his audience: the white male who went to baseball games, the Protestant workingman who felt squeezed between the rich, the rabble, and the immigrant. Sunday played on their frustration. He criticized the "diamond-wearing bunch." Then he attacked the "low-down, whiskey-soaked, beer-guzzling, bull-necked, foulmouthed" worker who slacked off or beat his wife—often code for the European immigrant.

Sunday's most famous oration became his "booze sermon," given hundreds of times. It was titled "Get on the Water Wagon" and became part of Prohibition lore. In Maine, the young writer E. B. White put down in his diary for May 14, 1917, "Yesterday I heard Billy Sunday deliver his booze sermon."[10] The sermon was printed in pamphlets and ran full-length in newspapers. Sunday used the standard arguments in Anti-Saloon League literature in the sermon, but its delivery was nonpareil.

The sermon began with Jesus casting out devils and putting them in swine. When Jesus sent the swine over the cliff, the hog businessmen railed at losing a profit. And so the sermon went, profits versus morality. The saloon cost taxpayers more in social problems and crime than it paid grain farmers or the villainous eastern money interests. "It is the dirtiest, most low-down, damnable business that ever crawled out of the pit of hell. It is a sneak, and a thief and a coward," he preached.[11]

The nation had many mills. Sawmills for boards, paper mills for paper, and gristmills for flour. Gin mills used boys as their grist, Sunday explained, turning to his trademark comical dialogue. "Say, saloon gin mill, what is your finished product?" he asked rhetorically. He answered, "Bleary-eyed, low-down, staggering men and the scum of God's dirt." Personal liberty could be license, when it came to drink, and moderate drinking a slippery slope. As ever, Sunday challenged his listeners to exhibit manhood. They should puff out their chests, protect womenfolk, fight whiskey, and indeed seal their own fates.

I say, "What is that I hear, a funeral dirge?" What is that procession? A funeral procession 3,000 miles long and 110,000 hearses in the procession. One hundred and ten thousand men die drunkards in the land of the free and home of the brave. Listen! In an hour twelve men

die drunkards, 300 a day and 110,000 a year. . . . I beseech you, make
a fight for the women who wait until the saloons spew out their
husbands and their sons, and send them home maudlin, brutish,
devilish, stinking, blear-eyed, bloated-faced drunkards.

After the sermon, the crowd was asked to swear an oath to vote for prohi-
bition. The effect was seen one night in Detroit. It was September 21, 1916,
and Sunday held a men-only meeting at the temporary tabernacle erected
for his crusade. Men from the auto plants thundered into the building, an
estimated twenty-nine thousand. The choice of the "booze sermon" was not
accidental. In November, Michigan voters would decide on banning alco-
hol, and Detroit was a strongly wet vote. Billy Sunday was in town for two
months, preaching right up to Election Day on November 7.

On these sorts of crusades, Sunday often was combated by the Personal
Liberty League, his chief opponent besides the liquor industry. Sunday usu-
ally won the battle. At a Baltimore revival, for example, he could draw 100,000
people, but the League only 2,400. Still, the League marshaled its forces for
Detroit. In October, the liberal and agnostic lawyer Clarence Darrow arrived
to offset Sunday's propaganda. At the opera house, he told a group of labor
union members, "Liberty is the only thing worth fighting for, and they are
attempting to deprive us of our liberty."[12]

When the dust settled, Detroit had narrowly voted for alcohol, but the
vote's thinness—because more autoworkers voted dry—gave state prohibi-
tionists a victory. In such votes, Sunday's whirlwind tour and "booze sermon"
often gained the credit. Prohibitionists in other towns tendered strategic in-
vitations. When a prohibition vote was coming up in New Jersey, Sunday
became the first preacher to get inside the statehouse in Trenton to address
a joint assembly. Once there, he jumped on top of the speaker's desk to rail
against alcohol.

Before the First World War, nine states and many cities and counties had
voted themselves dry. In 1913 the only national law on the subject prohibited
shipping hard liquor into states that opposed the commodity. The next year, a
mass parade descended on Washington demanding a constitutional amend-
ment prohibiting the production and sale of alcohol. When the war rationed
alcohol, the political moment arrived. In 1919 Congress enacted the National
Prohibition Act, or Volstead Act, over President Wilson's veto, and enough
states ratified it to amend the Constitution.

After this, Sunday dropped his booze sermon and came up with another
to cheer enforcement: "Crooks, Corkscrews, Bootleggers, and Whiskey

Politicians—They Shall Not Pass." For all his manly preaching, which made fun of foreigners, limp-wristed men, and assertive women, Sunday took one progressive stance: the vote for women. This might have helped the next great reform. In 1920 Congress gave women the vote, and the states added the Nineteenth Amendment to the Constitution.

Willard's oratory about her "pet heresy" had certainly destined this fate. Indeed, women's suffrage lasted, but Prohibition was gone in fifteen years, repealed by the Twenty-first Amendment to the Constitution.

If the women's vote and repeal of Prohibition meant anything, it was that traditional society now was dealing with "modernism," a secular ideology updating everything with democracy, utility, and science. It was seen in a liberalizing of doctrine, a dramatic debate on Darwin and the Bible, and interest of even clergy in the new science of eugenics, or improvement of the human hereditary line. The ethos of the time, as illustrated in Billy Sunday, allowed for a vituperative debate among Christians. They debated the role of the Christian pulpit, in fact, as much as any particular social topic.

As a result, the 1920s gave America some of its most enduring heroes and villains. For titanic pair-ups, none compared with the fundamentalist leader William B. Riley and the modernist Harry Emerson Fosdick. Then, on their coattails, came the famous Scopes "Monkey Trial," a gladiatorial ring for the Bible-believing William Jennings Bryan and Chicago lawyer Darrow, scourge of the American courtroom.

It was both the best of times and the worst of times for a literal view of the Bible. For the group of orthodox Protestants that came to be known as fundamentalists, the corrupt world proved that Christ would return soon. Before the Civil War, evangelical preachers such as Finney had tended to believe that God would establish his "thousand year reign" of peace on earth before Christ returned from the clouds. This "postmillennial" view had faded. The creed of Moody now prevailed: the world was a sinking ship, and the preacher manned a lifeboat. The hour was near. Naturally, fundamentalists took a great interest in the "dispensations," or unfolding, of God's final plan, a fulfillment of Bible prophecy, in America and the world.

A prelude came between 1910 and 1915, when orthodox theologians and thinkers produced "The Fundamentals," a collection of mass pamphlets. These printed stances, which battled Modernism, had little effect until the dynamic preacher William Riley of Minneapolis organized a movement of Bible and prophecy conferences. The keynote idea was "The Return of Our Lord." But the movement also defended a set of core doctrines besieged by Modernism. While the list often was longer, the doctrines typically were five:

the virgin birth, atonement on the cross, bodily resurrection, bodily second coming, and the infallible Bible.

As a litmus test, however, the return of Christ on the clouds took preeminence, for as fundamentalists argued, once a person accepts this doctrine, he or she accepts all others. Riley's greatest achievement, and a watershed of his movement, was the great World Conference on Fundamentals, which drew six thousand people from forty-two states to Philadelphia in late May of 1919. The event featured eighteen leading fundamentalists, all of whom attacked Modernism as the new enemy. But in its dispensational spirit, the gathering's most honored figure was C. I. Scofield, famed editor of the premillennial study Bible, whose footnotes deciphered prophecy in great detail.

Riley used Martin Luther, the originator of the Reformation, as his comparison. He said the World Conference was probably more significant than Luther's nailing of his ninety-five theses to the door of Wittenberg Castle Church in 1517. Just as Luther had battled the papacy, and John Wesley and Jonathan Edwards had battled deism, the American pulpit now faced "a new infidelity, known as 'Modernism,' " Riley said in the opening oration.[13]

His address defended the five great doctrines, but his masterly oratory was wrapped around the magnificent image of a rushing river that hit a great rock at the "Great Divide" in the Canadian Rockies. At that point, the river splashed and flowed east or west. And so it was with Christ the rock.

> For men to separate over the "Rock-Christ," is to part so widely that their after meeting becomes impossible. He is indeed a rock of offense, and the more study we give the Christ of Moderns, the more profoundly are we impressed with the fact that "their rock is not our rock,". . . The skeptical sons of believing fathers are giving new meaning to the words of the Lord: "I am come to set a man at variance against his father." Faith is dearer than flesh.

Riley, a tall, dignified figure with a hooked nose, lambasted the liberal Social Gospel, with its "fellowship in social service," for saying that the kingdom of God was inside people, a gradual evocation of good works by preaching. The "federation" movements and "theological bolshevism" of liberals threatened to crucify Christ again. Liberals wanted to bring the unregenerate world into the church, when it was time for the church to be "called out" of the world, for the day was near: judgment would come from the sky. Then came the millennium. "The reasons for His return are manifest in a world wild with confusion, reeking with anarchy, writhing with pain," Riley preached. "For one thousand years He will be the world's one and only KING."

Riley proposed a nationwide movement supporting more Bible confer-
ences, journals, newspapers, and schools. The Bible mandated this vision,
according to the exhaustive preaching of Riley and others. "It is the rock on
which the whole theory of evolution—Modernism itself, makes shipwreck."
After the Philadelphia event, organizers spread across the country to mount
more Bible conferences, stirring an unparalleled cultural debate among Prot-
estant churches for the next decade. The impact was felt especially inside two
northern denominations, the Baptists and Presbyterians. They became the
center of the great fundamentalist-modernist controversy.

Both the Baptists and the Presbyterians met annually, and among Baptists,
the church of Riley, the ruptures began in earnest in 1920. Legislative mo-
tions urged the denomination to declare the fundamental doctrines. In a few
years, however, the Riley forces were turned back, and they splintered off
to form a new Baptist movement. The Presbyterians were no less polarized,
and two of their members became lightning rods. One, the layman Bryan,
had fundamentalist backing to be the denomination's moderator. Bryan ran
twice, but church middle-of-the-roaders blocked him. The other lightning
rod was Fosdick, an ordained Baptist but a "special minister" at First Presby-
terian Church in New York City. In time, Fosdick was identified as the arch-
modernist. The Presbyterian assembly would demand his doctrinal loyalty,
so he moved on.

Before that happened, however, Fosdick helped bring the fundamentalist-
modernist controversy to its most celebrated peak. Having seen fundamen-
talists trying to drive out liberals, especially in the foreign mission field,
Fosdick prepared a warning shot sermon for May 21, 1922, titled "Shall the
Fundamentalists Win?" His well-educated congregation did not find any-
thing alarming in the homily. But a member of the church who was the lib-
eral head of a large public relations agency repackaged the sermon. Giving
it a new title, "The New Knowledge and the Christian Faith," he trimmed,
added subheads, and sent it to every American minister with an address.
Naturally, it provoked a storm in the nation's pulpits.

In his sermon, Fosdick distinguished among fundamentalists, conserva-
tives, and liberals. In an age-old pattern, conservatives only wanted to con-
serve the faith, whereas fundamentalists typically launched "a campaign [of]
bitter intolerance" to deny other Christians that venerated name.[14] Through-
out history, he went on, science and belief have invariably clashed.

Whenever such a situation has arisen, there has been only one way
out: the new knowledge and the old faith had to be blended in a new

combination. Now, the people in this generation who are trying to do this are liberals, and the Fundamentalists are out on a campaign to shut against them the doors of Christian fellowship. Shall they be allowed to succeed? It is interesting to note where the Fundamentalists are driving in their stakes to mark out the deadline of doctrine around the church, across which no one is to pass except on terms of agreement. They insist that we must all believe in the historicity of certain special miracles.

Fosdick surveyed these miracles, offering instead a liberal vantage on the virgin birth, an inspired Bible, and the second coming. A modern understanding was essential for "this new generation," who might lose faith when faced with archaic dogmas. Either way, Fosdick said, Christianity had room for both, even though fundamentalists hoped "to drive out of the evangelical churches men and women of liberal opinions."

The chief fundamentalist counterattack came from the distinguished Presbyterian minister Clarence Macartney of Philadelphia. He corresponded with Fosdick to make sure he got his rebuttal right. Then, Macartney preached "Shall Unbelief Win?" with the exact same strategy: to publish and send it nationwide. The sermon presented the same case as the World Conference on Fundamentals. Meanwhile, other fundamentalists joined in mimicking Fosdick. In New York, John R. Straton, a Baptist speaker at the World Conference and a famous evolution debater, preached on "Shall the Funnymonkeyists Win?"

Fosdick saw the writing on the wall. He stepped down from the Presbyterian pulpit in 1925, took a trip to the Holy Land, and then returned to lead Park Avenue Baptist Church nearby. The congregation was in store for a dramatic transformation. By 1930 it had moved into a new sanctuary, the grand Riverside Church, built by John D. Rockefeller, in Morningside Heights, as modernist a bastion as any American neighborhood could become.

As Fosdick seemed to step aside, William Jennings Bryan stepped forward, taking up his last great oratorical cause. Already by 1920, the liberal journal *Christian Century* had recognized that antievolutionism was "Mr. Bryan's New Crusade." After 1923, when Bryan lost his bid for Presbyterian moderator—the last in a lifetime of failed elections—the evolution topic consumed his career.

He believed that the root evil of modernism, with its attack on the Bible, was the theory of evolution. Bryan's concern began with probing the cause of the First World War. "And, if my analysis of the situation is correct," he said

in 1916, "the cause is to be found in a false philosophy—in the doctrine that 'might makes right.'" He too had learned of the Prussian military's interest in Social Darwinism, that nature gave superior species, or races, the right to dominate inferior ones. By 1923 Bryan was certain of this. Darwinism "had become the basis of the world's most brutal war."[15]

As a populist and lifelong Bible Christian, Bryan—the "Great Commoner"—cringed at this ethic of might, especially since it was being backed by the "guesses" of science, as he defined Darwinian theory. As Bryan warmed up for his crusade against Darwinism, the science of heredity also was coming of age. It was an outgrowth of evolutionary studies but focused on the characteristics handed down from parents to children. In light of evolution, heredity was the key mechanism for how family lines and races developed.

As with Social Darwinism, the topic of heredity had interested a small group of ministers active in the Social Gospel movement of the 1880s and beyond. Indeed, it was Josiah Strong, an evangelical missionary voice, who urged "racial uplift." A kindred spirit was Oscar Carleton McCullough, minister of Plymouth Congregational Church in Indianapolis. Since he worked in the city, his preaching and ministrations looked at urban problems and social policy. One that seemed paramount was: some impoverished families seemed perpetually in "extreme destitution."

Having formed the Plymouth Institute for public lectures and research, McCullough studied the family history of one household, the Ishmaelite family. Using city records on family trees, relatives, and marriages—a total of 250 families and 1,692 people—he found that the Ishmaelite family line never escaped from destitution. The 1888 findings, paired with another famous study, *The Jukes: A Study of Crime, Pauperism, Disease, and Heredity,* popularized the idea that heredity could lock people into a destiny of inferiority.

In short, science offered a moral conundrum to the Christian social ethic. Was charity to the poor and criminal, such as the Ishmaelites and Jukes, simply perpetuating suffering and social decline? From the point of view of the kingdom of God, was it not more altruistic to let the inferior line decline? As one Baptist minister in Nebraska wrote in 1908, "there are grave dangers in the modern philanthropic effort to care for the unfit, dangers that must be recognized and avoided or the race will pay the forfeit."[16]

In time, eugenics took on this aura of discriminating against the feeble. But the first Christian application was to enhance the healthy, and that produced a new Christian movement for hygiene. Its first sermon came on Easter Sunday, 1912, when Chicago minister Walter Taylor Sumner, speaking at the Episcopal Cathedral of Saints Peter and Paul, announced that he would

thereafter require a "certificate of health" before blessing holy matrimony. The medical examination looked at family background and disease as well as current health.

In his mild form of eugenics, Sumner adapted to the ethical debates of his age. The debate was not only about breeding of inferior family lines—imbeciles, cripples, or criminal types—but also about the impact of immigration on American racial types. Pacifists argued that war killed off the best young men. Warmongers measured Anglo-Saxon racial superiority against German bloodlines. Soon enough, government policy and organized science stepped forward and asked help from the churches. Indiana, in 1907, was first to legislate to "prevent procreation of confirmed criminals, idiots, imbeciles, and rapists." Both the American Eugenics Society and the Race Betterment Conference, first held in 1914, expanded their public-education agendas.

For clergy and eugenics reformers, there was plenty of biblical material to integrate into the new social science. Racial purity was an evangelical good, part of the nation's moral uplift. The Old Testament offered ample examples of proper hereditary mixing. It was believed that Jesus was of superior genetic stock, the Son of God taking flesh. Protestant and Catholic theologians divided on sterilization, which was legally contested and rarely legislated. Still, sermons responded to the annual "Race Betterment Day." Some clergy entered their families in "Fitter Family" contests at state fairs, and others left ministry for eugenics research. As the pulpit gave Bible texts on purity, the American Eugenics Society issued its popular publication, the *Eugenics Catechism.*

Bryan was aware of the racial debates in his own Anglo-Saxon society. But the nub of the issue for him remained Darwinian materialism, with its claim that human beings were nothing more than animals. Bryan did not dispute animal evolution, only human. He opposed Bible teaching in schools on the same grounds that he rejected the teaching of evolution: both taught a kind of religious theory, best left to parents and churches. But, with the publication of new biology textbooks, evolution was being taught in public schools, and it was here that Bryan's last battle was joined.

Kentucky had been the first state to attempt passing an antievolution law, but no state would succeed until four years later, when Tennessee did the deed in March 1925. The year before, Bryan had swung through the state, speaking on "Is the Bible True?" and inspiring the Tennessee governor and lawmaker John W. Butler to write and pass the Butler Act. It banned state schools from teaching against the "divine creation of man," and thus banned instruction on human evolution.

In New York City, the fledgling American Civil Liberties Union (ACLU) wanted to challenge the law and advertised in the *Chattanooga News* for a teacher who would file suit. The advertisement became the topic of serious conversation at the Dayton, Tennessee, drugstore one spring day. Town businessmen arranged with substitute teacher John Scopes to initiate a lawsuit. It could bring much-needed publicity to the rural town. The storeowner, who was chairman of the school board, called the newspapers to say that town officials had arrested Scopes for teaching human evolution, which he believed he had done, since it was in *A Civic Biology,* the textbook approved for Tennessee high schools.

The fight was on. Riley's World Christian Fundamentals Association met in Memphis that year and chose Bryan as its legal representative, an odd move but one that the Tennessee state prosecutor welcomed. The ACLU summoned Scopes to New York City, and just as quickly, Darrow intruded himself in the process. The ACLU, concerned about a serious court precedent, did not welcome Darrow's showboating reputation. But Scopes had the last word: he wanted the great labor lawyer, whom Scopes's own father had admired. The circus in Dayton already had begun, Scopes reasoned, so why not match Darrow against Bryan.

Defense attorney Clarence Darrow (standing center) admitted the guilt of John Scopes (seated center), blocking William Jennings Bryan from delivering a closing "sermon" at the Scopes "Monkey Trial."

Bryan and his wife arrived in Dayton by train to banners, bands, and testimonial banquets. Darrow and his wife came in the next day. They too were banqueted, and Darrow sentimentalized his own small-town origins. The trial ran for eight days. The question of fact was not in dispute, and in nine minutes the jury ruled that Scopes had violated the state law.

But the trial was held mainly to publicize Dayton, and to pit Bryan and Darrow against each other. They could entertain the nation, and also preach their views to America. In this, Darrow had the better of Bryan. In his long opening address, he ridiculed fundamentalist intolerance. He extolled American freedom of learning and the virtues of science. What was more, Darrow followed a precise legal strategy. On the very last day, he conceded his client's guilt, so the case went directly to the jury. There were no closing arguments. Thus, Darrow undercut Bryan's plan to give a final plea, which was to have been Bryan's great sermon on America, the Bible, and Darwinism.

Bryan also blundered. He was an old friend of Darrow, and the Chicago labor lawyer had supported Bryan on the Democratic ticket. To Darrow's sarcastic antics, Bryan offered himself as an "expert" witness on the Bible, a superior source to the guesses of science. In this exchange—a saga of two aged men with sweating brows, open collars, and suspenders and shirt sleeves—Darrow needled his opponent into saying he believed some of the most stunning claims of the Bible: that a whale swallowed Jonah, the sun stood still, Eve came from Adam's rib, and a serpent's crawl was a curse, not natural. As Bryan said, "one miracle is just as easy to believe as another."[17] Darrow's grilling, all of it broadcast on national radio, began gently.

Darrow: You have given considerable study to the Bible, haven't you, Mr. Bryan?

Bryan: Yes sir, I have tried to.

Darrow: Well, we all know you have. . . . Do you claim that everything in the Bible should be literally interpreted?

Bryan: I believe everything in the Bible should be accepted as it is given there.

In time, Bryan would stumble over a fatal issue for Bible fundamentalists, who believed the world was created in six literal days about six thousand years ago. Bryan said the days were probably "periods," and he conceded that God's act of creation "might have continued for millions of years." Darrow had succeeded in pitting Bryan against the fundamentalists, who

were shocked that their champion had accepted the ancient time scale. By the end of the day, antagonism had grown. Bryan and Darrow were on their feet, shaking fists. If Bryan won his side of the argument, it was only on brief occasions.

> Your honor, they have not asked a question legally, and the only reason they have asked any question is for the purpose, as the question about Jonah was asked, for a chance to give this agnostic an opportunity to criticize a believer in the word of God; and I answered the question in order to shut his mouth so that he cannot go out and tell his atheistic friends that I would not answer his question. That is the only reason, no more reason in the world.

This was on the last day of testimony. It was the dialogue that riveted the nation, for Bryan's great closing speech never came. Some lamented that it was the "greatest sermon never heard." Bryan was ready to go on the road with his speech. But three days after the trial ended, he died peacefully in his sleep.

The stakes in Dayton were high for two reasons. Culturally speaking, the fundamentalists had lost. Second, the trial was the first to be broadcast by radio, making it a national sensation and a revolution in technology. It changed the sermon in America. In his testimony, Bryan had gotten the trial's meaning correct. "They did not come here to try this case," he said. "They came here to try revealed religion." In mock anger, Darrow responded in kind: "You insult every man of science and learning in the world because he does not believe in your fool religion." At this, the judge intervened. But the true meaning of Dayton had been announced, and on national radio.

The American Eugenics Society took heart. The next year, it sponsored the first of three eugenics sermon contests, the topic being "Religion and eugenics: Does the church have a responsibility for improving the human stock?"[18] The prize was a substantial $500, four hundred more than Scopes was fined for his misdemeanor. Hundreds of clergy participated, mostly Protestants, but also some Reform rabbis. Sermons came in from New Orleans, Nashville, San Francisco, Austin, Brooklyn, small towns in Kansas and Nevada, and many more.

The Minneapolis preacher Phillips Osgood won for his "The Refiner's Fire," preached at St. Mark's Episcopal Church on May 8, 1926. God was the Refiner of human nature, but with the new science of healthy breeding, society helped God's creative work. Before this, the idle, criminal, ignorant,

insane, and promiscuous had diluted society. Now they could be winnowed out before they were conceived and born.

> We see that the less fit members of society seem to breed fastest and the right types are less prolific. . . . Taking human nature as it is and not ignoring any legitimate emotion or tendency, eugenics aspires to the refiner's work [for] until the impurities of dross and alloy are purified out of our silver it cannot be taken into the hands of the craftsman for whom the refining was done. . . . Grapes cannot be gathered from thorns nor figs from thistles.

Sermon themes ranged widely in the contests. But after Scopes, many ministers argued the harmony between religion and science. One group of clergy wondered if heredity determined "religious sense." In the sermon contest, held again in 1928 and 1930, George C. Fetter of First Baptist Church in Ottawa, Illinois, spoke for many. "The church can help popularize the knowledge now in possession of the scientists," he said.

The Scopes trial, thanks to radio, certainly popularized the debate between science and the Bible. Chicago's WGN radio had turned a misdemeanor into "the trial of the century." After the first week of trial, most of the 150 reporters had left. But WGN stayed, and an entire nation heard Darrow's examination of Bryan. Although a few states passed antievolution laws, and some lasted until the 1960s, after Dayton, the fundamentalists turned their backs on the public debate. They withdrew into subcultures. When they returned for public battle, it was partly by the same power that had disgraced the great Bryan—the power of radio.

Radioland

Preaching Faith, Fear, and Fun

DURING AN EASTER VACATION IN 1936, A BIG MAN WITH A golden voice and his wife, "Honey," sat in their car in the California countryside and listened to a sermon on the radio. As Charles Fuller sank back into his seat, he marveled that the sermon was his very own. In tiny waves, his own voice was coming out of the sky, and it spoke to him through his dashboard.

Fuller had given that sermon a few weeks before in a hot, stuffy Los Angeles studio. It had been "transcripted" onto a phonographic record for re-broadcast, the very cutting edge of radio technology at the time. On this day, a radio station somewhere was playing the sermon record. "It was indeed a strange and thrilling experience, and caused us to marvel at modern invention," Fuller recalled.[1]

It was natural for an evangelical such as Fuller to rise to prominence in radio, for it was a mass medium. The first "broadcast" sermon came when Dwight L. Moody preached over one of Thomas Edison's telephone lines. But it was a feat that would pale against developments after the First World War. On the night of November 2, 1920, Pittsburgh residents with a "radio music box" heard the presidential election returns. It was the first public

radio transmission, sent out by Frank Conrad, a Westinghouse engineer who had begun his KDKA station in a garage.

The genie was out of the bottle. Two months later, KDKA engineers disguised in choir robes set up microphones at Calvary Episcopal Church in Pittsburgh to broadcast the nation's first airwaves sermon. On-air advertising arrived in 1922, and the commercial conglomerates were quickly in the ascendance. First came AT&T and RCA, which produced wires and radio boxes, and finally the National Broadcasting Network, Columbia Broadcasting System, and Mutual Broadcasting Network. The nation's preachers negotiated with these behemoths, sometimes cooperating, other times rivaling them, but always changing the American public.

Few things drew the American public mind together in the 1920s and 1930s like radio. Before its commercial launch, only a political campaign, a national disaster, or a war could focus America's attention all at once. As a form of mass entertainment, radio created new kinds of communities in America. In a fragmented society, the radio sermon played this same role by way of giving a voice to different religious personalities. Their preaching created cultural pockets, fund-raising bases, and even political movements.

By his radio preaching, Fuller brought fundamentalists into the cultural mainstream, a trend later called neo-evangelicalism. Other radio preachers had their fortes as well. From New York City, Harry Emerson Fosdick sent urban pastoral preaching over the airwaves. Catholic priest Charles Coughlin offered populist political rhetoric from the Midwest. In Los Angeles, Pentecostal preacher Aimee Semple McPherson offered spiritual entertainment like no one else.

Radio had changed the face of mass evangelism. In a few afternoons, for example, Fuller could reach more people than Moody, the last great itinerant, spoke to in a lifetime. By the late 1940s, on his "Old Fashioned Revival Hour" and "Pilgrim Hour," Fuller had forty million listeners. He became Mutual's largest customer, spending $1.6 million a year for airtime. At one point, Fuller's program was the most listened to on American radio.

Radio also changed the sermon, turning fiery oratory into conversation. Some radio preachers, however, such as Walter A. Maier, founder of the "Lutheran Hour" on CBS, preferred the fire. Maier shouted and yelled. "Before he goes on the air he whips off his coat, vest, shirt, tie, and belt, advances to the microphone in his undershirt, and preaches with flailing fists," said one observer.[2]

Fuller pioneered something different, and it was only possible on radio. With his wife as foil, he presented a conversational sermon. It was delivered

as if to a listener in the next chair in a living room. Grace "Honey" Fuller read letters from listeners. Based in low-key California, Fuller provided a sunny simplicity and directness. Two years before his Easter-vacation sermon aired, his ministry had been struggling for solvency, and his "Heart to Heart" sermons reflected a Depression-era intimacy.

> I pass on to you a little of the comfort wherewith Mrs. Fuller and I have been comforted. We have come to know God in a new way because of the trials we have been going through in the past three years. We have known what it is to have much sickness; financial losses; to have those turn against us and seek to hurt us who we thought were true friends.[3]

Fuller's rise to success was singular, but his story was fairly typical. Like Maier, who began in an attic, Fuller started as a lone operation. Big, athletic, and trained in chemistry, Fuller was converted to Baptist ministry. His initiation in radio came in 1927 at an Indianapolis Bible conference, where he was asked to preach into a radio microphone. The next year, Fuller began remote broadcasts from a back room in his Calvary Church in Placentia, California. They were carried for five years by KGER in Long Beach. He soon formed the Gospel Broadcasting Association to raise money on the airwaves, and in 1937 he was on Mutual's western circuit. When the Mutual broadcasts went nationwide, Fuller absorbed the cost of $4,000 a week, raised from loyal listeners, and became a national institution.

As Fuller's fame grew, he was asked to raise money for a range of good causes. But he stuck to ensuring the "Revival Hour's" survival. The program evoked nostalgia for a bygone era of Christian unanimity, which perhaps had never existed but now was created by airwaves. At the height of Fuller's preaching, he broadcast "live" Sunday worship from the 4,400-seat Long Beach Municipal Auditorium, a great barrel-roofed stucco building, surrounded by lawns and palm trees and located on the festive waterfront with its boardwalk amusement park.

Fuller and Honey preached from Long Beach for fifteen years, dispensing their "heavenly sunshine" with a large banner out front and flags snapping in the sea breeze. On the chattering radio box it broke "through the din and clamor of swingwhoopee, croonings, and news broadcasts to almost startle a weary world," said one syndicated columnist.[4] Fuller had a transient and curious audience each week, but on radio he reached millions. Transcripted as well, the program was sent worldwide for use the next Sunday. A photo of Fuller once showed him with a stack of pages, all handwritten sermons, piled

like a pillar to his shoulder. One of them, spoken from the Long Beach stage to "the great radio audience," began with:

> Please take your Bibles and turn to Isaiah the first chapter, verse 18, where you find seven marvels of God's mercy and His divine compassionate love. . . . Have you ever noticed that it is the custom in the jewelry shops to display diamonds on a dark cloth background? And by doing so, the contrast is made more plain between the light and the darkness. It's more marked. The diamonds shine with more brilliance against the dark purple or black background. Now that's exactly what God has done in this first chapter of Isaiah. Over against the background, dark and damnable as it is, this diamond with its seven facets of God's mercy shines above the brightness of the noonday sun.[5]

Besides fund raising, Fuller pioneered another path for evangelical radio preaching. When Mutual dropped him in 1944, he wove together a national network of independent stations and was able to maintain his growth and funding until the American Broadcasting Network took him on board. As the more mainline groups—Protestant, Catholic, and Jewish—gained free time on networks, fiery evangelicals and fundamentalists could not even pay for airtime. So they bought their own stations, providing the impetus for a future "electronic church" and televangelism, full of cultural and political implications. As one such evangelical, Fuller had helped pioneer this future trend.

Developments in Manhattan revealed a world far different from that of Fuller. The commercial networks wanted upscale and nonsectarian preaching, but plenty of fundamentalists wanted to buy time to do the opposite. A policy was set, however, and it lasted forever. The head of the Federal Council of Churches' radio division, Frank C. Goodman, "battled successfully for years to keep sectarianism and denominational propaganda off the air, and has succeeded," a contemporary said.[6]

From the start, radio executives looked for celebrity. Early radio had quickly demonstrated its potential for creating national drama, as the 1925 Scopes "Monkey Trial" proved. For more than a week, the *Chicago Tribune*'s WGN radio spent $1,000 a day renting AT&T phone lines to transmit events from Dayton, Tennessee, to Chicago, and then beyond. The investment paid off in publicity. WGN was credited with bringing "the trial of the century" to America. The search for clergy celebrity began even earlier.

One morning in late 1922, an official with New York's WEAF traveled to Brooklyn for a breakfast appointment with S. Parkes Cadman, the minister at

Central Congregational Church. Two decades in the pulpit had made Cadman, a native of England, a popular speaker. But he had gained even wider attention for his Sunday afternoon talks, men's hour, and question-and-answer sessions at the Bedford branch of the YMCA. The WEAF man wanted to broadcast Cadman's Sunday sermons, but the preacher had a better idea: broadcast the YMCA afternoon talks. Cadman worried that Sunday worship on radio would cut into other churches' attendance, a perennial concern as radio preaching spread across the nation. Cadman agreed to air the YMCA talks, and in January 1923 an institution was born, Sunday at the "Bedford Y."

This made Cadman the first "radio preacher" in America, but hardly the last. His public stature was important before radio tapped him. Cadman was a chaplain with the National Guard on the Mexican border during the First World War, and later a favorite on the Chautauqua circuit as far west as Ohio. During his second year on WEAF, Cadman was elected president of the Federal Council of Churches. He held the post for four years. After that, he was elected the council's "radio minister."

As the networks formed, Cadman was elevated to an NBC slot. He took a cab from Brooklyn to NBC's Cathedral Studio in midtown Manhattan. The studio, high in a skyscraper, was like a tiny church, gray and gold in its art nouveau decorating scheme, and had a choir waiting. Cadman would become the voice of the "National Radio Pulpit," a program that carried on long past his death in 1936.

Cadman had appeal to a wide audience. This did not mean, however, that he had no competition. Over at RCA, they had also been looking for a famous preacher. They had taken their appeal to Harry Emerson Fosdick even earlier, in the summer of 1922, right on the cusp of the preacher's battle with fundamentalists. Although that radio deal fell through, in the fall of 1924, in Fosdick's last months at First Presbyterian Church, he finally was on the airwaves, delivering a repeat of his Sunday sermons at the WJZ studios. In another year or so, NBC owned all the New York stations. But there was still a semblance of competition. Fosdick aired on the "blue" classical music network, flagshipped by WJZ, and Cadman on the "red" contemporary music channel, with WEAF as the home station. It was simple enough, compared to the jungle that religious radio would soon become.

Fosdick's radio career began with studio sermons in the afternoon, then evenings, and then he switched to live sermons from Park Avenue Baptist Church, where he moved after leaving the Presbyterian pulpit. Finally, in 1927, he settled into a 5:30 P.M. studio slot, and thus began the "National Vespers" broadcast, for which he did not miss a Sunday for nineteen years.

His longevity made him the national voice of mainline Protestant radio. This stature only increased when he moved to Riverside Church, a cathedral-like edifice built specifically for him by John D. Rockefeller, Jr., a fellow northern Baptist. Opened in 1930, the gothic church seated twenty-four hundred worshipers and thrust its great bell tower three hundred feet in the air.

After more than a decade on the air, Fosdick stood out among a cadre of talented radio preachers at NBC. In 1938 the network's National Religious Radio banquet at the Waldorf-Astoria Hotel made Fosdick's eminence plain. The Federal Council of Churches now sponsored most of the radio programs, which NBC produced as a public service. NBC had the best stable of notable preachers. Fifteen were at the fete, including the then hardly known Norman Vincent Peale. Each had two minutes to speak. Fosdick, called "dean of all ministers on the air," was given ten. He explained how preaching to a "con-

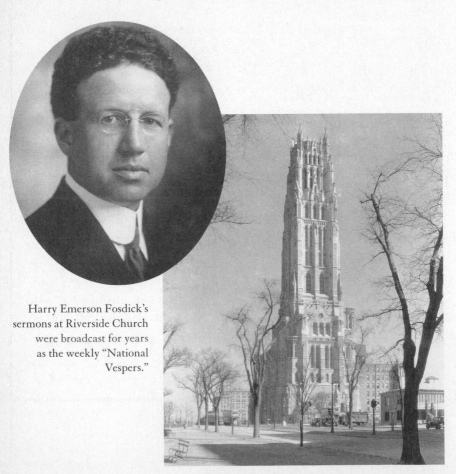

Harry Emerson Fosdick's sermons at Riverside Church were broadcast for years as the weekly "National Vespers."

tinental congregation" broadens a minister's vista. "What one says on the air must be universal, catholic, inclusive, profoundly human."[7]

By the time Fosdick moved to the great Riverside Church, his Manhattan audience had become quite urbane, not quite in the same social circles as many of his radio listeners. Either way, Fosdick believed he was speaking to Christians who, while secure in their faith, were constantly perplexed by modern developments. The program, which had begun with only a midwestern reach, had gone international. He was particularly popular in the South, despite his modernist credentials. As hundreds of thousands of letters would show, his listeners included factory hands, clerical workers, laborers, farmers, and loggers. By his retirement in 1946, Fosdick reached about three million people each week.

For his pulpit preaching, Fosdick carefully wrote every sermon, adeptly reading them as if engaged in a direct conversation with his congregation. Fosdick had a large, soft, friendly face, a small body, and bushy hair. To one observer, he looked like a well-dressed butcher-boy. He preached without gestures to focus on the words. The millions who heard him compared his high tenor, with a slow cadence, to the Brahman enunciation of Franklin D. Roosevelt, a voice well known from his "Fireside Chats" on radio. Fosdick simply shortened his pulpit sermons for radio, down from thirty-five minutes to twenty. Otherwise, he saw "no difference" in their style or substance.

Both in the pulpit and at the NBC studio, Fosdick preached a new kind of sermon. He called it the "project method," and his growing number of imitators recognized it as "pastoral preaching." It came to him at a Baptist pulpit in New Jersey. "Little by little," he said,

> the vision grew clearer. People come to church on Sunday with every kind of personal difficulty and problem flesh is heir to. A sermon was meant to meet such needs; it should be pastoral counseling on a group scale. . . . No sermon which so met a real human difficulty, with light to throw on it and help to win a victory over it, could possibly be futile.[8]

In 1928 he wrote for *Harpers* his famous essay, "What Is the Matter with Preaching?" revealing his structural secret. "Every sermon should have for its main business the solving of some problem—a vital, important problem, puzzling minds, burdening consciences, distracting lives." It was audience-centered preaching, and it worked on an assumption about human self-interest that was benign enough. "There is nothing that people are so interested in as themselves, their own problems, and the way to solve them," Fosdick wrote.

"That fact is basic. No preaching that neglects it can raise a ripple on a congregation. It is the primary starting point of all successful public speaking." So, he closed, "preaching is wrestling with individuals over questions of life and death, and until that idea of it commands a preacher's mind and method, eloquence will avail him little and theology not at all."[9]

Fosdick adopted his model not so much from modern psychological theories, though he was familiar with the work of Sigmund Freud and William James, as from his own experience. It began with training in oratory and rhetoric in his college days. He enjoyed formal debate. He had worked hard, and partly because of this, had experienced a youthful nervous breakdown. As a result, he could empathize with people on the edge, a modern commonplace of limits, exhaustion, and anxiety. Preachers missed this dimension, he famously said, because they were so enamored of Bible events: "Only the preacher proceeds still upon the idea that folk come to church desperately anxious to discover what happened to the Jebusites."

So he methodically developed something different. Another influence, which Fosdick acknowledged, was the new education theory of Columbia University philosopher John Dewey, who worked a few streets away. Dewey said learning began with a "felt difficulty," a problem to solve. Information could not simply be poured into the mind. It came by trial and error, a testing for solutions. Fosdick agreed with the beginning point: a human problem. His "project" sermon used Bible wisdom and other knowledge to arrive at some resolution, at least for the time, or as a way of analyzing the situation.

For ministers of the day, "counseling" took place in a pastor's study, where parishioners aired personal, family, ethical, or theological quandaries. Fosdick tried to do this for everyone in the open. After the Second World War began, he preached "When Life Reaches Its Depths," a typical counseling sermon. He began with Psalm 42:7, "Deep calleth unto deep at the noise of thy waterspats." He wanted to say that a deep God speaks to deep human struggles.

> Every serious life has that experience, where the profundities within
> ask for an answering profundity. No longer do the shallows suffice.
> Life within faces some profound abyss of experience, and the deep
> asks for an answering deep. So when deep calls unto deep and the
> deep replies, we face the essential experience of religion. This explains
> the deathless hold that religious faith has upon the human spirit. . . .
> While irreligion thus takes all depth of meaning out of the universe,
> it leaves man still with the deep in him—depths of trouble, of love,

of moral need, of ethical devotion, of spiritual insight—the same old profound experiences that man's nature has known throughout its history. But in irreligion when these deeps within call for a responsive depth, only the shallows are there to answer.[10]

Fosdick went on to defend religion, while noting the tragedy of irreligion, by looking closely at those five human experiences: trouble, love, moral need, ethical devotion, and spiritual insight. By opening with a problem, he said, he did not aim for mere discussion. He wanted to offer the Bible's unique perspective, mingled with other sources. A good sermon, he believed, brought feelings of repentance and resolve, renewed faith, a feeling of power from God, and the will to overcome temptation. Preachers had to plant their Sunday topic inside each listener, generating a personal experience, which was no small task. On radio at least, it seemed far easier to rile political passions, as soon became evident at a pulpit in Michigan.

As Fosdick moved into Riverside Church and Fuller launched his Gospel Broadcasting Association, a new radio voice emerged in the Midwest: Charles Coughlin, a Catholic priest at the Shrine of the Little Flower in Royal Oak, Michigan, twelve miles north of Detroit. He had given homilies on Detroit radio and was picked up by CBS in 1930. In a field of considerable religious talent, Coughlin rose to the top as a political preacher. He was about to weigh in heavily in a fiercely contested presidential election.

It was 1932, and the Depression-rocked Republican administration of Herbert Hoover faced a Democratic slate that featured two of the party's messianic figures. One was New York's Catholic politician, Al Smith, and the other its governor, Franklin D. Roosevelt. The party convention in Chicago nominated Roosevelt, and not only did he coin his "New Deal" campaign phrase, but he picked up Father Coughlin as an ardent political advocate in Radioland.

Coughlin had harshly criticized Hoover, whose solution to the 1929 economic crash was to let things mend by laissez-faire, or government's benign neglect. Since entering the priesthood in Toronto, Coughlin had shown a talent for drama and gesture. He crusaded for the canonization of Saint Thérèse of Lisieux, which came in 1925, the year Coughlin was made pastor of the Shrine parish. His radio sermons brought devout money into the parish.

When he turned political, his attacks were on bolshevism, socialism, and corporate greed. They always included assaults on birth control, Prohibition, pacifism, and internationalism. But his public listeners responded most of

all to his calls for social and economic justice, so this became his emphasis. Neither the millionaires nor the federal government were doing enough to help the needy, he preached. His audience of lower- and lower-middle-class citizens, rural and urban, grew from Maine to California. His preaching, like Maier's, was assertive. "If the promoter and financier and industrialist believed in the doctrines of Jesus Christ," Coughlin railed, "he would no more exploit his fellow man than he would sell the Master for thirty pieces of silver."[11]

Before Election Day 1932, Coughlin had preached "Roosevelt or Ruin!" and after it, "Roosevelt and Recovery." It was said that the silver-tongued priest helped draft Roosevelt's first inaugural address and that he may have been up for a Washington post, the latter a rumor that fell flat. By 1934 the "radio priest" was attacking Roosevelt. They had their last meeting in 1936 at Roosevelt's home in Hyde Park, and then their two destinies diverged. In Coughlin's oratory, the New Deal had changed from a great "Christian experiment" to the "black bread" of a White House dictator. Roosevelt had failed to "drive the moneychangers from the temple."

Having lost political favor, Coughlin still had a national pulpit, a radio outlet, a covy of wealthy backers, and the constant donations of his radio audience. With typical prowess, he hired a team of investigators in Washington to deliver him charges and scoops for his political homilies. He preached from a studio at the Shrine of the Little Flower. In 1931 CBS dropped Coughlin after he berated the network on the air, and NBC kept its distance under its ban on commercial religious broadcasting. So Coughlin created his own radio empire, the Radio League of the Little Flower. Anchored at two flagship stations, WOR in New York and WJR in Detroit, he spent $500,000 a year buying airtime. He ended programs with: "This hour has been made possible by the outstanding financial support of the radio audience."

With Coughlin and Roosevelt, the first great political war on radio had begun. On March 12, 1933, Roosevelt began to broadcast his "Fireside Chats." In a personal and reassuring tone, he repeated the theme that the only thing to "fear was fear itself." Father Coughlin was no mean contender. At his peak in the 1930s, the Detroit priest had thirty million listeners. He also organized politically, founding the National Union for Social Justice in 1934 and grounding its "Sixteen Points" in the papal "social encyclicals" of Leo XIII and Pius XI. Although not the first to present Catholic social teaching as a third way between the "cancerous growths of decadent capitalism" and the "treacherous pitfalls of red communism," Coughlin exceeded all other attempts with indomitable flair.

The oratory of "radio priest" Charles Coughlin created a Depression-era political movement.

His final legacy was sharp contention with American Jews. By 1939 he was buying sixty-minute segments on national radio and giving much of it over to denouncing Jewish conspiracies. Jewish gold had made both parties "banker's parties." In his sermons he often tried to extricate himself from charges of anti-Semitism, but then he only waded in more deeply, as in one January 1939 broadcast.

> When the persecution of the Jews in Germany was the chief topic of the day, I had occasion to invite the religious Jews of the United States to join us in a crusade to end all persecution, both of Jews and of Christians. In making my plea, I was careful to distinguish atheistic Jews from religious Jews. I regretted that callous silence in the press and on the radio had permitted the assassination of millions of Christians to go unnoticed. I rejoiced that extraordinary publicity was given to persecuted Jews in Germany. It was also pointed out that if Jews rightly challenged Christians for their sympathy against Nazi persecution, it was logical for Christians to challenge Jews for theirs against Communist persecution—particularly when so many atheistic Jews played such a prominent role in the birth and organization of radicalism in Russia.[12]

Finally, the pope and Coughlin's clerical superiors shut him down. Under the Espionage Act, moreover, the U.S. government banned the mailing of his

inflammatory magazine, *Social Justice*. The magazine published "The Pro-
tocols of the Elders of Zion," an alleged plot of world Jewry, and plagiarized
Nazi propagandist Joseph Goebbels. Radio stations began dropping him in
1940. His journal folded two years later, and he abruptly dropped from pub-
lic sight. He remained as pastor of the Shrine of the Little Flower until 1966
and died in 1979 with few in America noticing.

For his era, Coughlin had tapped into two powerful elements of Ameri-
can oratory, patriotism and popular Christianity. The Constitution and the
Apostles' Creed were identical. Father Coughlin's advocacy had great appeal
even to Protestants. "Radio broadcasting," he said, "must not be high hat. It
must be human, intensely human. It must be simple." He melded passion,
conspiracy, and just enough detail—usually shocking economic statistics—to
give his talks a feel of authority. For the masses, he seamlessly linked reli-
gious doctrine with public policy, purgatory with oil reserves, the way of the
cross with Prohibition. His holy trinity, however, tended to be fear, resent-
ment, and paranoia.

Other radio preachers built their audiences on Depression uncertainties.
The Depression elicited two emotions from America. In the upper Midwest,
Coughlin had played on the darker of these Depression moods. In sunny Los
Angeles, where unemployed men also lined the streets, there was no one like
Pentecostal preacher Aimee Semple McPherson to play on the joyful side.
She too would hit the airwaves and make the big time.

An itinerant preacher, McPherson settled in Los Angeles in 1918, a tale
that became well known from her autobiographical sermon, "Milkpail to
Pulpit," preached each year on her birthday. She was a Canadian farm girl
reared on "oatmeal porridge" who walked five miles to school. Converted in
1907, she became a missionary in China, where her first husband died. She
traveled America in a beat-up "Gospel Car" covered with slogans. By 1923,
she opened Angelus Temple, her massive religious theater-in-the-round.
The next year she became the first woman to own and operate a radio station
in the United States.

Like McPherson herself, Americans west of the Mississippi were flock-
ing to the orange groves of southern California. Every day old jalopies
stuffed with farm families rumbled into town, kicking off the dust of the
land behind them. McPherson offered them excitement and hope. Funda-
mentalist churches in southern California grew faster than any other kind.
They filled up with small-town and countryside Bible folk who had headed
west. When the migration peaked in 1924, the church of the auburn-haired
McPherson was high on the list of city sites to be seen. At Angelus Temple

and in Radioland, as she called it, American Pentecostals were for the first time being given a self-image, and it was being provided by a talented and audacious woman.

McPherson melded Holy Spirit happiness with the giddy entertainment of the Roaring Twenties. Designed for theatrical preaching, Angelus Temple had thirty-five hundred red-velvet seats and space for an orchestra and mass choir. Every Sunday evening, moreover, the working classes were treated to "illustrated sermons." This mode of preaching, a short play with narration, had been pioneered by Evangeline Booth of the Salvation Army. But McPherson perfected the art.

Props and actors filled the church hallways. Worship services featured backdrops of a Garden of Eden, Vesuvius erupting, Sodom and Gomorrah, and a snowy Valley Forge. McPherson rented costumes, special effects, and stage managers, and brought in a camel to show that it could not get through the

Aimee Semple McPherson gave Pentecostals an
identity through her Hollywood panache and radio
preaching at Angelus Temple.

eye of a needle. A few times, Charlie Chaplin sneaked in to watch. "Half your success is due to your magnetic appeal, half due to the props and lights," he told her.[13] Mostly, McPherson narrated the story, but she also acted, once riding onstage as a motorcycle cop to say that the audience was speeding to hell.

McPherson had tiptoed into Radioland in April 1922, quite by accident. At the Oakland, California, Blossom Festival she was asked to give a revival service. She entered Rockridge radio station a little intimidated. The electrical apparatus and cameraman were distracting. So she focused on the unseen audience. "All I could think of was the thousands at the Blossom Festival, the sailor boys, mothers' boys on the ships at sea, the sick in the homes where receivers had been installed, and I prayed and preached and prayed again and did most everything but take up the collection."[14]

Two years later, after a few appearances on the *Los Angeles Times*'s radio station, she launched her first KFSG broadcast from Angelus Temple. It was during the Los Angeles Radio Exposition, and she was showered with attention by business and civic leaders. As it turned out, the blossoming of Angelus Temple coincided with her rise as a radio star. She usually broadcast from the sanctuary, but as the work expanded, a "gray room" studio was also built upstairs. From the start, Angelus Temple sported two great steel towers, rising 250 feet above the ground, to hold her broadcast antenna. She had a Class-A five-hundred-watt transmitting station, signals that traveled 150 miles, and excellent sound. Stations could pick up the signal and send it farther.

Although McPherson spoke homespun things to common farmers, and often retold familiar Bible stories, she also erected images of progress, industry, and technology. Her sermons dwelt on surging electricity, rising skyscrapers, and swelling railroads, each an illustration of putting a life in spiritual order.

The railroad track must needs be laid, every tie in place, every rail fastened and the last spike driven before the great transcontinental express can go through. It takes a great deal longer to lay the track than for the express to pass by. In coming for healing, make sure of the condition of the track; you are inviting the express of God's unlimited power to come over. Remember that in making railroads, the hills must be laid low, the valleys exalted; pride must flow down before Him and the rough places made smooth. Do not spend so much time worrying and scolding because the train does not come more quickly. You care for the track,—God will take care of the train.[15]

By all accounts, McPherson had the looks and voice to succeed. Five-feet-six-inches, and taller with her beehive hairdo, she had hazel eyes, a full figure, and a round face with smooth complexion, all worthy of comment by her male listeners. She typically wore a white nurse's uniform and blue cape. When preaching she held a Bible, and although her notes were slipped inside, she was a master of memory. She rolled her *R*'s, spoke in short, choppy sentences, and used one- and two-syllable words, and she could mimic a range of voices in her sermon dialogues. "Her voice is a full-throated contralto, and her enunciation in quick speech is excellent," one Hollywood reporter said. "No actress sounds more clearly the last letters or takes advantage of vowels and diphthongs with greater effect."[16]

McPherson could also change her image, using times of personal scandal to good evangelistic effect, much as gossip magazines increase sales. Two years after opening Angelus, McPherson mysteriously disappeared from the Ocean Park beach. She was presumed drowned but then turned up on the Arizona-Mexico border, claiming that three men had kidnapped her. Eyewitnesses, however, put her at seaside Carmel, on a tryst with a former KSFG radio engineer. She almost went to jail for fraud. Her estranged husband finally got his divorce, and she entered a third marriage that would also fail. Still, McPherson cultivated her allure. She cut her curls short and wrote a screenplay of her life, *Clay in the Potter's Hands*.

The power of her preaching has been attributed to her use of the Bible, everyday stories, and finally the promise of healing.[17] Biblical authority came first: "I don't believe it's God's will that you be deaf because the Bible said that Jesus walked up and said, 'Thou deaf spirit come out of him.'" Next came stories, such as when a pelican flew into a power line near Glendale Boulevard, leaving a sparking wire on the street and bringing electric streetcars to a halt. "God's power is a livewire!" she preached. A master storyteller, she introduced her audience to the hungry man who learned that his train ticket included a first-class meal, and another who fell over the Santa Monica palisades on a dark night. He hung on for dear life. Finally he let go, but dropped only a few inches. The message: let go and God will heal. Similarly, healing by the Holy Spirit was the ultimate shock.

McPherson ranged across every subject, but invariably seemed to end at the promise of healing. Each week she preached and ministered at "stretcher days." The sick moved down to the stage "until the front row beside the altar resembles a great convalescing ward," the *San Jose Mercury Herald* observed. McPherson also offered healing on radio, a true innovation. At her church

she put olive oil on foreheads and prayed for healing, but now she urged listeners to touch the radio as she touched the microphone, a Holy Spirit connection. "As I lay my hands on this radio tonight, Lord Jesus, heal the sick, bridge the gap between and lay your nail-pierced hand on the sick in Radioland."

By now, small-scale radio preaching was not a novelty. Many set up microphones in back rooms and bought time on weekends. But McPherson was the first to bombard the airwaves around the clock. She was noticed in Washington. When, in 1927, Commerce Secretary Herbert Hoover ordered her to stay on her designated radio frequency, her telegram showed the brassy confidence of an experienced broadcaster. "Please order your minions of Satan to leave my station alone," she said. "You cannot expect the Almighty to abide by your wave length nonsense." She complied, however. She increasingly emphasized her secular educational programs and was never denied a license.

As a station owner, moreover, her airtime was unlimited. She often gave twenty sermons a week to fill the hours. She was the first religious broadcaster to imitate full-plate commercial networks, with their on-air personalities and sitcoms. Commercial radio had created the "national narratives" of Superman, Sam Spade, and the Green Hornet. McPherson did the same. She had Studio Janitor, Red Comet, and Jim Trask: Lone Evangelist.

Like her scripts, McPherson's thirty-five years of preaching were a saga, ending with twenty years of fame at Angelus Temple. Hollywood could not have written a sadder ending. Estranged from her family and unhappy, she overdosed on sedatives at an Oakland hotel after preaching to open a new congregation in the movement she founded. She was only fifty-four and might have done even more with modern broadcasting. The year McPherson died, she had been licensed to construct a television station.

Television soon eclipsed radio, and both of them nearly washed out the need for the old-fashioned, long-winded, traveling orator. More significant, however, is that radio preaching did not undercut church attendance, as feared, but it did create new national narratives and what today are called virtual communities. For culture and politics, these communities of the airwaves became as substantial, for example, as New England and the "metaphysical South" had been in fueling a civil war. Political orators did not necessarily mimick religious ones, but they interacted in ways that infused secular broadcasting with the qualities and techniques of religious enthusiasts.

Radio sermons built solid subgroups in society. The preachers balkanized, but they also built bridges. Fuller upgraded fundamentalism with a more mainstream image, a platform on which a superstar like Billy Graham could

land. A new intellectual institution, Fuller Theological Seminary, was built on the "Revival Hour," and now is the nation's largest theology school. From his New York perch, Fosdick cultivated a different audience, offering grace for the status quo, but also a prophetic criticism of war and materialism. Father Coughlin pioneered hate radio, a legacy that endures.

McPherson shaped the first American image of Pentecostals. Future faith healers and charismatic movements built upon that foundation. "I know people who say, 'My, you should see Sister McPherson. She talks too loud and she waves her arms,'" she often preached. Her critics wanted her to be a pillar of salt, but wouldn't that look grand: "I'd be talking to a whole lot of empty seats. I'm glad I am alive." Although her church and radio empire did not outlast her, they gave rise to a Bible college and a Pentecostal denomination, the International Church of Four Square Gospel. Both spurred the modern charismatic movement.

The year that Charles Fuller listened to his recorded show in a car during Easter vacation was the same year that the pioneer of religious radio, S. Parkes Cadman, died. The period between Cadman and Fuller brimmed with novelty, and then radio preaching became commonplace. Television offered the next novelty. But for a generation of preachers, who were tempered by world war, defining the "American Way of Life" seemed more important than technical gizmos. The sermons of the 1950s gained a new power in America by aiming either at popular dreams or at intellectual doubts.

The American Way of Life

Popular Faith in an Insecure Age

IN THE EARLY 1950s *LOOK* AND *LIFE* MAGAZINES REGULARLY featured the "religious revival" in America, particularly a group of picturesque sermon-givers that included Billy Graham, Oral Roberts, Bishop Fulton Sheen, and Norman Vincent Peale. As the picture magazines of the day, *Look* and *Life* naturally focused on popular religion, a growing part of the "American Way of Life."

They did not overlook, however, the Protestant intellectuals who questioned the easy evangelism of the 1950s, and this polarity captured what the decade was about in terms of preaching. Popular religious culture was in tension with a new intellectual class of preachers, a class that critically scrutinized American believers and their behaviors. In a decade of prosperity and Cold War anxiety, the popular-style sermon offered simple answers, merging salvation with suburban American normality. The intellectual preacher argued the complexity and angst of the modern world, urging Americans to think.

That complex view of life was the drumbeat of Reinhold Niebuhr, a popular university preacher. He also showed up in *Look* and *Life,* often analyzing the religious revivals of the 1950s. His *Life* essay in 1957 commented on Billy Graham's evangelism, then on view in a sixteen-week New York

City crusade. "Its success depends upon oversimplifying every issue of life," Niebuhr said. Far from bringing simple goodness, he added, every advance in religion and civilization mixes good and evil. Although Graham avoided the pitfalls of past revivalists, he still "offers Christian evangelism even less complicated answers than it has ever before provided."[1]

Following the Second World War, the preaching of the 1950s was an attempt to move on from such a catastrophe, but also to grapple with its aftermath. In moving on, the pulpit flourished, especially as it gave Americans a religious dimension for the American Way of Life in a hostile world. America had never heard such optimistic preaching, and never would again. On the other hand, the 1950s were steeped in the moral ambiguities left over by the war. It had produced untold casualties, the Holocaust, the use of atomic weapons, and now a Cold War threat. A simple morality, as Niebuhr suggested, was no longer appropriate to Christian preaching.

A brief review of the American sermon shows how the preaching of the preceding three decades had produced the pulpit mood of the 1950s. After the "holy crusade" of the First World War, American pulpits arrived at the Second World War with a far more mixed voice. Preachers looked back on the holy crusade with an uneasy conscience. One result was a burst of pacifism in the 1930s. As late as the autumn of 1940, when America began leasing ships to embattled England, the anti-interventionist Harry Emerson Fosdick preached that "it is not the special function of the Church of Christ to help win a war."[2] The opposite stance, which became known as Christian realism, sanctioned just wars, with all their moral ambiguities. Accordingly, the former pacifist Niebuhr launched his interventionist journal *Christianity and Crisis*, preaching the necessity of battle in Europe.

In the season before America declared war on Japan and Germany, President Franklin Roosevelt realized that American preachers were not in his pocket and that he had to coax them into supporting his war plans. In key speeches, he identified intervention in Europe as a contest for Christian civilization. He summoned church leaders as advisers. Chaplains, who had been considered more like orderlies in the First World War, were upgraded in rank.

When war came, however, American pulpits made distinctions not heard in 1917. Sermons emphasized the sin of all nations. They spoke of the need for Christians to retain communication across warring lines. The love of Jesus was not obsolete, many preachers explained, but tragically, love was not applicable to national conflicts.

Ministers supported the war but resented state control. They cried foul when New York mayor Fiorello La Guardia tried to hand out canned

sermons. Denominations fought the government move to cancel draft exemptions for seminarians, the next generation of clergy. Each tradition—liberal Protestant, evangelical, Pentecostal, Roman Catholic, and Jewish—believed it was an essential pillar for postwar democracy. Among three options—crusade, pacifism, and "cautious patriotism"—most pulpits followed that middle path.[3] For all the waste and destruction, a Cleveland minister preached in 1943, Americans had kept important values.

> We are more realistic than we were in the last war. So far as America is concerned, the war is being waged without hullabaloo, without hysteria, without hurrahs, and—to a surprisingly large extent—without vindictiveness and hate. We realize we are engaged in a grim and detestable business . . . our consciences are troubled by killing.

A New York rabbi preached, "In a world debauched by unscrupulous propaganda, hold yourself and your generation fast to religion's eternal standards of truth." And as the war closed, evangelicals worried that a secular wartime bureaucracy was undercutting church colleges: "Liberal and Christian education in America now faces the threat that all education in the future will be directed for government purposes."

The preaching that led up to the 1950s, however, was not entirely shaped by war and public policy. There remained the pastoral, ecclesiastical, and biblical dimensions, and all three saw a revival through the midcentury. Both Fosdick's pastoral preaching and the new emphasis on positive psychology encouraged more sermons on human needs, delivered as if they were counseling in a minister's study. This type of sermon tried to deal with a precise human dilemma, not a doctrine or ancient Bible event.

The second trend was a renewed interest in preaching about rituals and traditions, such as saints' days, during a worship service. Liturgical preaching, especially among Anglicans and Catholics, explained the richness of a ritual heritage and its meaning for the day. Sermons geared themselves to a church calendar, marked holy days, and used historic readings and doxologies as a context for preaching. It was a formalism suited to formal churches and was never adopted by evangelicals.

The third development was the most significant, judging by its impact on Protestant seminary training. In the early 1930s, the English translation of Swiss theologian Karl Barth's *Epistle to the Romans,* with its new emphasis on preaching "faith alone," began to influence American pulpits. This was the start of the biblical theology movement, also carried to America by Barth's colleague, Emile Brunner, who taught at Princeton's theology school. Also

called neo-orthodoxy, biblical theology rejected the romantic sentiments of the Social Gospel, with its emphasis on creating the kingdom of God on earth. Looking at the reality of human sin, biblical theology proclaimed God's act of redemption in Christ, revealed on the cross and in the Bible.

Preaching was not persuasive oratory, according to the Swiss theologian and preacher. It was revelation that judged the world. "There is no basis in human experience for the concept of preaching," Barth said. "It is a purely theological concept resting on faith alone." Preaching's only goal is "to point to divine truth." As American Barthians would say, preaching is telling the mighty acts of God in Christ. "Only preaching which sets forth the Bible story can do this, and that which fails to do it is something other than preaching," said one Barthian in his Beecher Lectures on Preaching.[4]

Even the liberal Fosdick came under the influence of neo-orthodoxy, though he frowned on its "dogmatic" Christ: "My first contacts with neo-orthodoxy's effect upon the preacher were very disillusioning." Still, he too began to preach the reality of sin, as in his "The Church Must Go Beyond Modernism" sermon, delivered from the Riverside pulpit in 1935. "Underline this: Sin is real," he said, raising liberal eyebrows. "Personal and social sin is as terribly real as our forefathers said it was, no matter how we change their way of saying so. And it leads men and nations to damnation as they said it did, no matter how we change their way of picturing it."[5]

These trends—pastoral, liturgical, and biblical—began in the ethereal realm of theology and were mana primarily for church intellectuals, not the masses. After the war, the 1950s accentuated this class division. While American culture for the first time esteemed its intellectual class, most citizens were caught up in its popular mood. Despite Niebuhr's lament over simplicity, the American sermon had to be simple. The GI Bill, which sent millions of postwar soldiers to college, raised American educational standards. But in 1945 they were modest: 25 percent of adults were high school graduates and 5 percent college trained. Here was the vast terrain of popular religion, and no one mined it like evangelist Graham and faith healer Oral Roberts, whose Pentecostalism represented a "third force" in American religion.

On a 1946 flight from Seattle to Minneapolis, the young Graham held on to his seat as the plane hit a snowstorm and then landed in a farm field. Determined to be on time, Graham continued his trip by horse-drawn wagon. As lead evangelist of Youth for Christ, Graham had been summoned by the dean of American fundamentalism, William B. Riley.

Riley's Bible school, an outgrowth of his Baptist Temple in downtown Minneapolis, had evolved into Northwest College. He eyed Graham as his

successor. Trained at Florida Bible College and Wheaton College, Graham did not quite have the necessary credentials. But he was a preacher for the new generation: colorful, contemporary, and faithful to the Bible. "Dr. Riley startled me by saying privately that he believed I was God's man to replace him as president of the Northwestern Schools."[6] On his deathbed the next summer, the white-haired Riley pointed his finger at Graham, quoting the Bible as it rained and thundered outside.

When Riley died in late 1947, Graham rushed back from a Mississippi crusade to preach the funeral sermon, a sign that he was Riley's successor, which irked at least one local candidate. Graham was installed as interim president, and during that four-year stint garnered the titles of "youngest college president" in America and, soon, its most famous evangelist. He was a winning young man, but the key was to win support from the nation's power brokers. At this Graham excelled.

It began with Riley, but followed through with William Randolph Hearst, the newspaper magnate. Hearst first noticed Graham when he spoke at the great wartime Youth for Christ rally at Soldier Field baseball stadium on Memorial Day in 1945, with an emphasis on fighting a national plague of juvenile delinquency. Graham was back on Hearst's radar screen in 1949, when the young evangelist, now independent, opened his crusade in a large tent in Los Angeles. Two days before the revival began, President Harry S. Truman announced that the Soviet Union had tested a nuclear bomb. The threat was perfect material for Graham's crusade sermons.

> Western culture and its fruits had its foundation in the Bible, the
> Word of God, and in the revivals of the Seventeenth and Eighteenth
> Centuries. Communism, on the other hand, has decided against God,
> against Christ, against the Bible, and against all religion. Commu-
> nism is not only an economic interpretation of life—communism is a
> religion that is inspired, directed, and motivated by the Devil himself
> who has declared war on Almighty God.[7]

Such preaching impressed Hearst, ensconced at his San Simeon castle on the central California coast. He sent his famous two-word telegram to "puff Graham." Hearst reporters and newspapers across the country put Graham on the front page. To startled readers, Graham preached that communists were "more rampant in Los Angeles than any other city in America." The result, as in the jeremiad of old, was the divine calamity, a topic that Graham took to all the great gothams in the United States. "In this moment I can see

Billy Graham preached salvation and anticommunism and
brought fundamentalism into the mainstream.

the judgment hand of God over Los Angeles. I can see the judgment hand
about to fall."

Graham took that same jeremiad to New England and the South. He
won patronage from South Carolina governor Strom Thurmond, a Demo-
crat who ran for president as a segregationist, though Graham diversified
his political contacts as well. A Massachusetts lawmaker secured Graham
and three associates a meeting with Truman in 1950. After exiting the Oval
Office meeting, Graham repaired to the White House lawn. The four men
prayed on bent knees, and Graham told the press all that Truman had dis-
closed. Infuriated, Truman stanched any future Graham visits. Nevertheless,
Graham became personal chaplain to nine of the next ten presidents.

After the Truman White House visit, Graham headed to Texas for finan-
cial support. The oil industry was booming, and he made friends with oil
millionaires and silver magnates. His ministry's first two feature films—*Mr.
Texas* and *Oiltown U.S.A.*—were about oilmen converting to Christ. Graham
built on such support, aided by radio preaching and wide travels. Then in
1957 he became the talk of New York City for his long crusade, culminating
in a Sunday rally at Times Square. For social critics, Graham was now the

"high priest of American Civil Religion." He blessed the American Way of Life in an anxious Cold War era.

About the time Graham was summoned to Riley's sickbed, another young man, tall with slicked-back dark hair, was renting the Education Building in downtown Enid, Oklahoma. His name was Oral Roberts. On May 25, 1947, he had gathered twelve hundred people for his afternoon service. For a few weeks, Robert had held healing services at his small church, but this was his biggest step. He preached a sermon, "If You Need Healing—Do These Things." Then he put it into practice by receiving people in the healing line.

The sermon was published as a booklet, its copies running to tens of thousands. It became a fund-raising tool when Roberts put his healing ministry on television. The son of a preacher, Roberts was born into the Pentecostal Holiness church. In this, he could not have been more alien to Graham's fundamentalist tradition. Yet the two men succeeded for the same reason: the

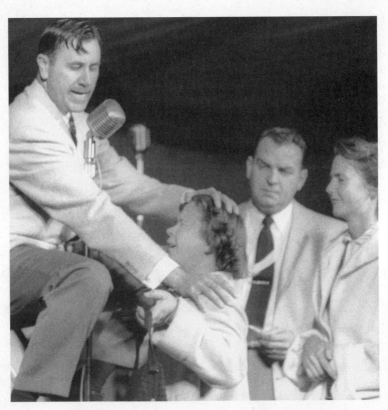

Oral Roberts brought faith healing into the mainstream
of American life after the 1950s.

charismatic power to preach. After receiving the Holy Spirit, which meant speaking in tongues, Roberts entered ministry. His wife, who played piano, helped in his pastorates and traveling revivals. They settled in Enid, Oklahoma, in the fall of 1946. Soon Oral was convinced that God had called him to "heal the sick and cast out demons."

Now, in downtown Enid, he preached his six-point sermon to hundreds, sharing his own experience of healing. In 1935, on the high school basketball court, Roberts had collapsed, his body racked with tuberculosis. He also had stammered for much of his life. His father ardently prayed but finally took Oral to a traveling faith healer, waiting at the end of the line until the night was almost gone. But he made it, and Oral remembered one thing. The faith healer screamed into his face, "You foul tormenting disease, I command you in the name of Jesus Christ of Nazareth, come out of this boy!" A short time . later he was healed.

As Roberts explained it in "If You Need Healing," healing was a way of life.[8] It began with the realization that Jesus came primarily as a deliverer, and that if God healed one person, he would heal everyone who asked. Healing was a long-held Christian belief, he preached. Emperor Constantine's pious mother, Helena, sought pieces of the true cross to heal. The woman who touched Jesus's garment felt the "healing virtue" enter her body, just as Jesus felt it leave his own. In a word, healing was free.

> If this sounds too good to be true then please read and believe this scripture where Jesus said, ". . . I am come that they might have life, and that they might have it more abundantly" (John 10:10). Jesus, then, is a fountain of life [and his] greatest thrill is over the faith of humanity as they release it for liberation from evil powers of sickness and disease and from fear and frustration.

So in the six-point sermon, the first step was faith, and next came the faith-moment at which God healed, typically right now (third). Healing endured if the person declared victory and joined a believing group. Of the six elements, Roberts's most innovative was the last—his point-of-contact doctrine. Aimee Semple McPherson touched her radio microphone to send out healing, but Robert formalized and expanded on the practice. In later versions of his sermon, he spoke of ten thousand healing cloths sent out every month. By touch, people were delivered from ailments. "Likewise many lay their hands on their radio as a point of contact during our Healing Waters broadcast," he said. "Through this means they release their faith and through faith they are healed during the 'prayer-time' of the broadcast."

In the summer of 1947, Roberts resigned from his Enid church and moved to Tulsa, which became the seat of his lifelong ministry. In 1951 *Life* magazine discovered him as "a new revivalist" with sizable faith-healing rallies. He might establish himself "as a rival of Billy Graham," *Life* reported, elbowing in with his "colorful sermons" and something fundamentalists did not offer: faith healing.

Both Graham and Roberts had brought their popular preaching under the rubric of the American Way of Life, and in this they were not really rivals. Most important, they brought two subcultures—fundamentalist and Pentecostal—into the American mainstream. In time, Graham had to speak of "ultra-fundamentalists," those who damned any Christians who disagreed with them. Although Roberts seemed outlandish to the national press, he was mild compared to some Pentecostals, and he soon proved his mainstream purposes. Roberts built a university and a hospital, and finally joined Methodism. Both Graham and Roberts became ecumenical, and Graham handed the evangelical olive branch to faith healers when, in 1967, he gave the keynote address opening Oral Roberts University.

Part of this middle ground shared by Graham and Roberts was institutional, represented by the National Association of Evangelicals, founded in the 1940s and eventually joined by Pentecostal churches. For this, the ultra-fundamentalists began to call Billy Graham—who had been anointed by fundamentalism's Abraham, William B. Riley—a dangerous liberal. They attacked his antiseparatism in religion, but also censured him on race, for he desegregated audiences in northern crusades. One evening at the New York City crusade, Martin Luther King Jr. opened with prayer, only several months after he had led the successful Montgomery, Alabama, bus boycott.

Earlier still, ultra-fundamentalists had decried the 1950 translation of the Revised Standard Version of the Bible, a translation to which Graham had no great objections. Working under the National Council of Churches, the Bible-revising teams turned to the original Greek and Hebrew, aiming to clarify obscure passages that were beautiful but obtuse in the popular King James Bible. Among others, the text from Isaiah 7:14 became a battleground.

> Therefore the Lord himself shall give you a sign; Behold, a virgin
> shall conceive, and bear a son, and shall call his name Immanuel.

Using the best original Hebrew, the Revised Standard committee changed "virgin" to "young woman," and all hell broke loose. Fundamentalists had already accused the National Council of heresy and communist infiltration. Now, the most irascible literalists had another stick of dynamite to seize

upon. One of the first to make headlines was Baptist minister Martin Luther Hux, who took his stand at Temple Baptist Church in rural North Carolina on Sunday evening, November 30, 1952. He believed the Isaiah translation attacked the doctrine of the virgin birth. So for two interminable hours, he preached on "The National Council Bible, the Master Stroke of Satan."

Then Hux led his congregation, bearing small American flags, from the white-frame church to where he mounted a flatbed truck. He was expected to burn a Bible, but instead he tore out the Old Testament page for immolation. "This has been the dream of modernists for centuries," he roared, "to make Jesus Christ the son of a bad woman."[9] Hux was local color compared to other national foes, who rallied under slogans such as "Per-Version of the Bible" and "The Devil's Masterpiece." At the forefront was the fiery radio preacher Carl McIntire in New Jersey, founder of the newest fundamentalist movement, as if a latter-day Riley. He decried Graham as a dangerous "compromiser."

In the long run, popular religion had its national benefits, illustrated in how Billy Graham so naturally became the gray eminence of American piety. More than any other American preacher, he came to personify what Benjamin Franklin had called public religion. The secular media eventually called him America's Pastor, especially for his role in calming the national soul in times of tragedy. In the 1950s, however, the popular religion of a Graham or a Roberts was part of the national quest to combine individuality with an overwhelmingly new state collectivism. The war had collectivized America beyond recognition: government bureaucracy, assembly-line industries, rationing, price controls, subsidized veterans' education. Under a wartime motto of total victory, America had cultivated an "us against them" mentality, and now it refocused on Cold War enemies.

Religion took on a collective quality as well. This postwar revival grew on a boom in families, making religion a communal affair. Traditional values were revived, since it was modern innovations such as fascism and communism that had ruined the rest of the world. In one popular interpretation, every American was a "Protestant, Catholic, or Jew," each an equivalent democratic religion. Sabbath attendance, at the highest level in U.S. history, was a secular value as well as a religious one. Every popular journal, from *Life* to *Good Housekeeping,* ran major features or long-term series on religion in America. Hollywood produced religious blockbusters, and a string of religious novels and advice books became bestsellers.

But it was also a decade in which religion tried to tease out the individual from this great "lonely crowd." The demand for conformity, consensus,

and patriotism was great, especially in the Cold War battle for freedom. At the same time, however, respected voices warned of America producing a "military-industrial complex," "mass society," and the "organization man." Sermons played with this ambivalence, but popular religion focused on the individual by appealing to "you." Graham closed his crusades with, "This is your moment with God," and Roberts preached on whether "you need healing." On television, Bishop Fulton Sheen said, "Thank you for inviting me into your home." He noted that "people are different from masses." Norman Vincent Peale advertised, "Are you missing the life of success?" Graham, Sheen, and Peale all wrote bestsellers on the ultimate quest of the individual: peace of mind, success, and happiness.

Mass media reinforced the "you," and for the first time religion became an exceedingly private affair, despite social conformity. Belief in God was nearly unanimous even as 40 percent of Americans belonged to no church. Americans could opt for religious movies and novels, now in mass circulation, or turn to paperbacks by Thomas Merton, Karl Barth, Reinhold Niebuhr, Paul Tillich, and C. S. Lewis. Existentialism, speaking to the "I" if not the salesman's "you," also gained American fans, with its specific formulation for a Protestant, Catholic, Eastern Orthodox, or Jewish believer.

Nevertheless, the culture of the 1950s still allowed for belief in a complete "system." All of life could be lived as a fundamentalist, existentialist, Freudian, neo-orthodox Protestant, Thomist Catholic, scientific humanist, or Marxist. This had been the project of modernity, to unify all knowledge, and in that sense the 1950s was the last "modern" decade. In religion, however, the intellectuals and the populists lived in separate universes. No popular preacher became a noted theologian, and few intellectuals broke into popular culture. The notable exception, perhaps, was Fulton J. Sheen. He was a highly educated professor before achieving television celebrity. "I am discussing subjects in a university sort of way," he said. "But I'm bringing them down to the level of the people."[10]

One famous episode reveals Sheen's style. On a Tuesday night, February 24, 1953, millions of Americans turned on their black-and-white televisions to see the sparkling-eyed bishop, replete in robes and skullcap and standing next to a four-foot Renaissance statue of the Madonna and Child and a blackboard, preparing to give his popular weekly homily. For this episode, Sheen narrated the burial scene from Shakespeare's *Julius Caesar*. But he inserted the names of the Soviet leaders at a funeral for Joseph Stalin. On March 5, nine days after his Shakespearean talk, the real Joseph Stalin died. The Sheen prophecy was a sensation.

For good reason, Sheen's TV ratings for his "Life Is Worth Living" program surpassed his evening competitors, Milton Berle and Frank Sinatra. One of his many career awards, given by the Freedoms Foundation at Valley Forge, honored Sheen for oratorical contributions to "the American way of life." As a talented public speaker, Sheen began his rise in the classrooms of the Catholic University of America. In the 1930s, when Father Coughlin's hate radio was in decline, he began giving the church's "Catholic Hour" on network radio. Each of his homilies, cleared by church officials, was adapted from a class lecture or a talk to converts. He was also tapped for the popular Lenten sermons at St. Patrick's Cathedral in New York City. In 1949 his book *Peace of Soul* became a bestseller. The next year Rome made him head of the U.S. arm of the Society for the Propagation of the Faith, and in 1951 auxiliary bishop of New York.

About this time, an enterprising monsignor took Sheen to the Dumont television network, run predominantly by Catholics, which was amenable to trying a network program. They produced it live at midtown Manhattan's

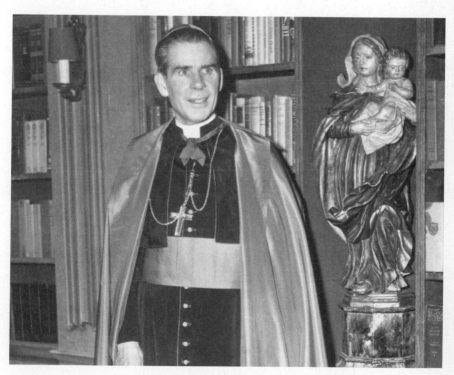

Bishop Fulton J. Sheen appeared on his "Life Is Worth Living" television
program in full raiment, backed by a library and Madonna statue.

Adelphi Theater, which seated one thousand, and used a set that looked like a rector's study with bookshelves. Sheen debuted on February 12, 1952, and in the next five years did 127 shows, moving to NBC and then jumping to ABC. His viewing audience may have reached thirty million.

When Sheen switched from radio to television, one distinct factor changed: he excluded Catholic doctrine from the TV presentations. Until then, he had spoken directly to a growing and proselytizing American church, a new cultural force as, between 1940 and 1960, it doubled in size to forty million. Converts to Rome gained headlines, and Sheen had brought some of them over, from Congresswoman Clare Boothe Luce to auto magnate Henry Ford II. During his 1951 Easter sermon on the "Catholic Hour," for example, Sheen extolled both Mary and the Church of Rome.

> Though the Iron Curtain be rolled down against the Gospel of Christ in Russia and the Bamboo Curtain against the Church in China, be assured that He Who split the Rock, and gave the earth the only serious wound it ever received, that of an empty tomb, will one day roll up the darkness before the light, and He Who you thought dead will be walking with the wings of the morning. Be not cast down at all the talk of the atom bomb, asking yourselves in despair: "Must we die?" But rather, in light of the Resurrection, ask: "Must we be reborn?" Though the scientists steal an atom from the sun, split and fission it, as does the sun, remember when the Lady of Fatima visited the earth, she brought the sun with her, clothing herself with it as a garment, to remind us that the sun and its fission belong to her and to life, not to the godless and to death.[11]

On television, Cold War politics remained, but particular Catholic doctrines about Rome and Mary, for example, faded out. "Never once was there an attempt at what might be called proselytizing," Sheen would explain. His Christian generality, in fact, made him the most popular religious figure on American television. "I am on television for the same reason I enter a pulpit or a classroom. Namely, to communicate and diffuse Divine Truth." He explained his method. He started with something everyone knew, and over the next thirty minutes "would gradually proceed from the known to the unknown or to the moral and Christian philosophy."[12]

By way of Sheen, some Americans began to shed their anti-Catholicism. The Catholic church, with its visible legion of priests and nuns, had become America's fastest-growing religion. Sheen, a midwesterner, showed just how American Catholicism could be, and millions of his viewers were Protestants

and Jews. By the middle of the 1950s, two-thirds of American homes had a TV set. The TV dinner went on the market in 1954. That same year, people first saw the bishop in dazzling color. His deep-set eyes now were set off by purple robes, magenta cape, red cap, and a large gold pectoral cross. He was a short man but looked large in his cape and on camera.

Sheen was the rare prelate with formal oratorical skills. He spoke impeccably, adding some acquired Irish brogue and Oxford accent. His sense of timing was unrivaled, as was his ability to be self-effacing, as in one TV opening:

> Is life worth living, or is it dull and monotonous? Life *is* monotonous if it is meaningless; it is *not* monotonous if it has a purpose. The prospect of seeing the same program on television for a number of weeks is this problem in a minor form. . . . Repetition does generally beget boredom. However, two beautiful compensations have been given a television audience to avoid such boredom: one is a dial, the other is a wrist.

The sermon's point was soon clear. A monotonous life, rather than prompting people to seek deeper meaning, caused them to "keep changing the ideal," and even launch revolutions, mainly out of boredom. In contrast, the monotonous rising sun could be exciting each day, if one were in constant pursuit of God's ideal: "When Divine Life came to this earth, he re-echoed the lesson of the Thrill of Monotony."[13]

During his first year on television, Sheen's themes reflected his general repertoire.[14] The dominant topic was communism and the ideology of atheistic materialism. Next in frequency were human subjects such as character, freedom, suffering, fatigue, teenagers, and boring work. He also spoke on sundry topics, such as the Irish, mothers, and scientists. A recurring topic was the failure of Freudianism to explain human angst, which he diagnosed spiritually and with Bible characters. He talked often enough about the life of Jesus. And while aware of modern critical scholarship on the Bible, Sheen preached from it as if in Sunday school.

He often slipped into humor, as when opening with "Long time, no Sheen." He thanked "my little angel" to explain how his blackboard got erased between camera shots. When he aired opposite Groucho Marx's "You Bet Your Life," he said that "viewers will now have a choice of two Marxes—Groucho or Karl." After his first season (1952), Sheen won the Emmy for "Most Outstanding Television Personality." At the ceremony, he thanked "my four writers," Matthew, Mark, Luke, and John.

Off stage, a humorless contest developed between Sheen, the nation's most popular priest, and New York's Cardinal Francis Spellman, the nation's most powerful priest. They were aligned in their anticommunism, but when control of church money became an issue, personal rivalry prevailed. In their own ways, both Sheen and Spellman had courted the anticommunist symbol of the era, the Irish Catholic senator from Wisconsin, Joseph McCarthy. Eventually they both distanced themselves from the self-destructive lawmaker. By then, however, Sheen had already contributed his part to the "red scare" of the 1950s. He made vague allusions to communists in higher education, where presumed "guardians of the nation's heritage have been to the greatest extent its traitors." Upon that mood, demagogues like McCarthy rose to power, peaking in McCarthy's accusatory Senate hearings in 1954.

Soon afterward, Spellman and Sheen came to dramatic loggerheads. Their feud hinged on two disputes over money, the first arising in 1955. Spellman wanted Sheen to hand over funds from his Society for the Propagation of the Faith to enhance the cardinal's work in government-surplus food relief in Europe. Sheen would not budge. Spellman warned Sheen that he was "a very foolish man," but the cardinal failed to persuade the ailing Pope Pius XII to oust Sheen as head of the society. About two years later, Spellman and Sheen had a final showdown, again over millions of dollars related to surplus government food, in this case mostly powdered milk. Spellman had given the food to Sheen's society for charitable distribution but, even though it was U.S. government free surplus, wanted millions in payment. Sheen refused. By now, Spellman was investigating Sheen's life for a peccadillo, but in Rome, the TV bishop won a second round of support from the pope.

On American turf, however, Spellman ruled. He quietly forced Sheen to quit his TV broadcasts. Sheen announced his retirement from television in October 1957, a departure "dictated by spiritual considerations" and a desire to raise money for the poor. A few years later, Sheen made a brief comeback with two short television series. But after the pope made him bishop of Rochester in 1966, where he lasted only three years before resigning, Sheen faded from the scene. He spoke in his autobiography of the "cross," which was Spellman.

The bitter rivalry had ended Sheen's television career, but not before he left one significant legacy. His half-hour on television was the first religious broadcasting to include commercials, inserted before and after his homily. At the time, the *New York Times* pointed out that, with commercial backing, Sheen "undoubtedly is going to have the largest regular audience of any

prelate in history." With hindsight, one chronicle of television history did not dim that prediction, saying that "*Life Is Worth Living* was probably the most widely viewed religious series in TV history."[15]

If 1952 was a remarkable year for Bishop Sheen, a Catholic preacher who won an Emmy Award, it was a magical year for a Methodist preacher who overcame his inferiority complex to rock bestseller lists with his *Power of Positive Thinking*. Norman Vincent Peale, an early "church growth" pastor, had struck upon a winning combination. He joined New Thought, or mind-cure, spirituality with mainline Protestant doctrine, preaching it from Manhattan's oldest church, Marble Collegiate, with Dutch Reformed roots.

A small-town Ohio boy and son of a Methodist preacher, Peale became a defining figure in the twentieth century with his "positive thinking." A simple preacher, he offered a self-help message for success and showed the usefulness of faith. For an anxious American middle class, which worried about making the grade, his advice went out on radio, television, and in print, establishing a media empire that surpassed that of any of his contemporaries. More than any revivalist before him, Peale reached every corner of America; he was a booster of free enterprise who said "the sky was the limit under the American way of life."[16] The theological critics railed at "Pealism," but the populace happily embraced it. His mass-media success was emblematic of the era. His book surpassed the bestseller record of the Christian novel *The Robe,* but only after he appeared on two top television talk shows.

Peale began his first pastorate at a faltering church in Brooklyn, New York. By astute use of publicity and advertising, he grew its membership from one hundred to nine hundred in three years. Then he moved to a university church in Syracuse, New York, and began his interest in New Thought, an American tradition going back to Christian Science, what William James called the mind-cure movement and later historians dubbed "harmonial religion." The common thread was to find divinelike powers in the mind and treat evil as negative thought, or a lack of a harmonized spirit. In one sermon, Peale spoke of a person "harmonizing life with the spirit of Christ," which became a trademark theme.[17]

Now that he was a sought-after quantity, Peale accepted an invitation to pastor Marble Collegiate, a moribund church, because it gave him the freedom to do national preaching. He went on daily radio (except Saturday) with "The Art of Living," and it lasted for forty years. He and his wife hosted "What's Your Trouble?" on weekly television and kept up national speaking engagements. His published sermons gave rise to the formidable Sermon

Norman Vincent Peale's "positive thinking" became a popular religious topic in the 1950s.

Publications, which eventually produced the highest-circulation organ in the nation, *Guideposts* magazine, the veritable *Reader's Digest* of positive American religion.

Peale had turned to full-blown positive thinking in 1934, after nothing else at Marble Collegiate seemed to work. He changed his preaching style. He came out from behind the pulpit and began speaking more as a stump orator. He had always used simple preaching and writing but he more resolutely avoided complex theological issues. Before entering the ministry, Peale had been a newspaper reporter at the *Detroit Journal*. He credited that experience with teaching him to use short, punchy sentences and concrete dramatic stories of the kind that filled his beat: fires, crimes, and sports.

He built each sermon on a single theme, but its backbone was a chain of stories. Like Fosdick, Peale started with everyday human problems: insecurity, professional failure, heartache, despair. Peale stood in the line of great storytellers like Russell Conwell, whose "Acres of Diamonds" was a string of fortune stories. Similarly, Peale preached an endless stream of vignettes, before-and-after case stories, tales of obstacle and success. He typically used nationally known figures, and not a few salesmen and businessmen filled the stage. From the start, Peale had followers in every corner of American culture, and he became the quintessential ecumenical Protestant.

Peale never understood why theologians criticized his ideas; he never analyzed his own roots. Others were willing to do that, including his father, a preacher who had studied medicine. He said his son preached "a composite of Science of Mind, metaphysics, Christian Science, medical and psychological practice, Baptist Evangelism, Methodist witness, and solid Dutch Reformed Calvinism."[18] Whatever the label, Peale's audience felt at home combining a traditional church setting with belief in cosmic spiritual powers. He used traditional terminology but offered an alternative to fundamentalist revivalism and abstruse neo-orthodox preaching. In this, Peale was less a conformist than a revolutionary, for he led a kind of popular rebellion against creedal Protestantism.

One of Peale's defenders, the writer Allan R. Broadhurst, surveyed hundreds of Peale's sermons and found forty-one distinct themes. To highlight Peale's orthodoxy, the Broadhurst study, *He Speaks the Word of God,* showed that God and Christ were by far the cardinal Peale topics. The second most frequent, however, was "Thought." This idea—that "thoughts and mind attitudes determine the situation of a person's life"—showed up in seven of every ten Peale sermons. For twenty years, Peale's subjects had stayed the same. The power of "thought" was "consistently embedded in what can only be described as a primarily conservative Protestant theology."[19]

But Peale was a kind of scientist of faith as well. As early as 1934, when Fosdick preached pastoral counseling, Peale had brought Freudian psychiatry into the precincts of Marble Collegiate, a stone and steepled church in the shadow of the Empire State Building. Peale teamed up with a respected therapist. In 1937 they opened a clinic in the church basement and soon after wrote *Faith Is the Answer: A Psychiatrist and a Pastor Discuss Your Problems.* The clinic trained pastoral counselors and increased its national reach by going independent in 1951 as the American Foundation for Religion and Psychiatry.

The science extended to Peale's spiritual techniques, which had the aura of a methodology. He preached the trinity of "picturize, prayerize, and actualize."[20] Problems had numerical solutions, such as ten steps to solve an inferiority complex. Energy was the key. As *The Power of Positive Thinking* explained, "the principles of Christianity scientifically utilized can develop an uninterrupted and continuous flow of energy into the human mind and body." That flow, in turn, brings "the release of spiritual energy" in both God and the believer. Peale was vague on energy. Sometimes God supplied the power. At other times God released a person's inborn power.

On occasion, thought itself seemed to *conquer* physical obstacles, as when he offered this: "By channeling spiritual power through your thoughts, you can rise above obstacles which ordinarily might defeat you." At other times, the spirit helped one *avoid* insurmountable obstacles. Indeed, his book promised the reader a "method by which we can control and even determine" whether daily life offers good or bad "breaks." Either way, in all the cases, the fruit was the same: optimism, security, tranquility, health, and personal, social, and business success. It was the goodness at the heart of the American Way of Life.

The criticism of Peale peaked as his *Power of Positive Thinking* passed its third-year mark as a bestseller. The neo-orthodox, perhaps unaware of New Thought's long history, said that Peale preached manipulating God for material benefit. He bypassed the "character ethics" of patient work and instead preached mental magic. One prominent minister in psychology offered an enduring critique of how, in anxious times, Peale supplied a "cult of reassurance."[21] Pealism was an act of mirror-gazing, a narcissism that Christianity should try to mitigate.

While such criticism stung, nothing flattened Peale like a thunderbolt that struck him during the 1960 presidential race, when he was attacked on all sides for a "Peale group" conspiracy, led mostly by evangelical Protestants, to undercut the election of John F. Kennedy, a Catholic, to the White House. Under the barrage, Peale receded for a while, but rebounded, as if a character in one of his sermons, "The Tough-Minded Optimist."

> A psychiatrist is reported to have said, "The chief duty of a human being is to endure life." At first such a remark is impressive and of course not without truth. Life with all its pain and sorrow must indeed be endured. Anyone who has lived for very long is well aware of that hard fact. But this is not the whole story by any means. And the rest of the story highlights one difference at least between Christianity and psychiatry. For whereas psychiatry says the chief duty of a human being is to endure life, Christianity teaches that a man's chief duty is to master life. The formula is stated in I John 5:4, "For whatsoever is born of God overcometh the world: and this is the victory that overcometh the world, even our faith." The kind of person who is able to implement such a faith I like to describe as a "Though-Minded Optimist." . . . Difficulties and problems, however complicated and even hopeless, do not in any sense abash or overwhelm him [for] he is aware that good is always inherent in the difficult—that in the long run the universe is loaded in favor, not of the bad, but of the good.[22]

This was a theology, of course, for which fellow preacher Reinhold Niebuhr had small patience. Niebuhr never directly confronted Peale, but in 1955 he aired an assessment of such popular religion in a *New Republic* article, "Varieties of Religious Revival." Peale spread a "dubious religion" that played on optimism too simple for the "collective problems of our atomic age." At least Graham had kept a doctrine of sin. But even Graham's preaching on "wickedness" was a type of individualism. Neither Peale nor Graham offered anything to "solve our collective moral and political dilemmas." Still, Niebuhr welcomed the revivals. They raised religious questions, buffeting even the secular university. He welcomed the power of religious mystery, even in its popular form, as an antidote to the hubris of scientific certainty.[23]

A former pastor in Detroit, Niebuhr gave hundreds of sermons in his lifetime. But he lacked the springboard of popular religion. His audience was the educated classes, and his pulpit the seminary and university chapel. Asked one admiring educator, "Has there been any preacher in our time who could speak so well to the intellectuals outside the church?"[24] In the Midwest, the preacher Niebuhr had become known through his journalism and appearances at venues like the Chicago Sunday Evening Club, which featured the nation's best preachers. He was a strong pro-labor voice in the "Battle of Detroit," the failed effort to unionize Ford Motor Company in 1926. When he moved to New York City as an activist, preacher, and professor, the urbane were his typical audience. He spoke to a class cynical about holy crusades and formulas for salvation.

Reinhold Niebuhr was a preacher who criticized some aspects of the popular "American Way of Life" faith.

Typical of Niebuhr's audience was the media potentate Henry Luce, editor of *Life*. He liked Niebuhr's "Christian realism." It retained religion, including the Sermon on the Mount, but allowed America to build its army and expand in defense of democracy. Luce incorporated Niebuhr's vision into his media declaration of the "American Century," for many traditional theological ideas had now become secular beliefs. By 1960, American intellectuals, shorn of old-fashioned Bible beliefs in a covenant and providence, gathered around the idea of a national purpose. Upon this idea America built its doctrines of containment, spreading democracy, and a moon launch—all reflecting a deep-seated American memory of divine election.

To this kind of world, Niebuhr preached paradox. America might be chosen, but it also was judged. It was a people caught in God's cosmic drama of mercy and judgment, sin and holiness, freedom and death. America might be a democratic global savior. But it was also as sinfully self-interested as any other nation. Every Christian lived in "ethical tension," not peace, because experiencing justification by faith—a sense of forgiveness—came only when optimism broke down. Niebuhr could not preach reassurance, but only the "uneasy conscience." This was not popular religion, and it could not compete for mass audiences with Graham, Roberts, and Sheen, or with Peale's power of positive thinking.

But Niebuhr did preach, and extensively. He spoke in torrents of words. His arms made sweeping gestures, and because he was tall with a hooked nose, some thought of a hawk preaching. Niebuhr used dialogue, as if he talked to God or the devil. But mostly, his preaching was intellectual. It tried to stimulate the mind, especially with his remarkable use of dialectics and contrasts, playing one idea off another and moving to the next. He preached from notes or less, so very little of his oratory is left for history, except two volumes of his more sweeping sermons from the 1930s and 1940s, *Beyond Tragedy* and *Discerning the Signs of the Times,* a total of twenty-five "sermonic essays."

Niebuhr did not preach the "you" of popular religion but the "we" of the human condition. A critic of Social Gospel idealism, he also chided "moralistic preaching," with its list of dos and don'ts. The gospel was about the "paradox" of human sin and human freedom. His sermon titles reflected this paradox, as in "As Deceivers, Yet True." Preaching paradox opened minds to the need for faith, reliance on a transcendent God, a call to ethical duty, and placing ultimate hope in Christ beyond history. Like Fosdick, Niebuhr recoiled at the "dogmatic Christ" of Barthian biblical preaching. But he also rejected the pastoral preacher's emphasis on solving personal problems.

Niebuhr preached on a panoramic canvas where individuals disappear. For example, in the sermon "Mystery and Meaning," he preached not on particular sins but on the nature of sin:

> We can say it is due to the fact that man exists at the juncture of nature and spirit, of freedom and necessity. Being a weak creature, he is anxious for his life; and being a resourceful creature, armed with the guile of spirit, he seeks to overcome his insecurity by the various instruments which are placed at his disposal by the resources of his freedom. But inevitably the security which he seeks for himself is bought at the price of other men's security. Being an insignificant creature with suggestions of great significance in the stature of his freedom, man uses his strength to hide his weakness and thus falls into the evil of the lust for power and self-idolatry.[25]

Niebuhr began sermons with a declaration of his idea, either in a paragraph, a telling sentence, or an exposition of a Bible verse. When he began with a Bible verse, it was used to support his theme, which usually preached contrasts, not solutions. To make his point, Niebuhr spoke in what one contemporary called a "disciplined stream of consciousness."[26] He drew his illustrations mostly from history and contemporary events, and he culled from philosophy, art, and literature as much as from Scripture. On some occasions, he devoted an entire sermon to a Bible text. On others, he treated Scripture and Christian doctrine as "mythological," as symbols and analogies, not historical and scientific accuracies.

He was criticized in turn. Even the neo-orthodox said that Niebuhr hardly preached the Bible or doctrine, missing such topics as the church and the Holy Spirit. At best, he tacked on a Bible reference in the last five or ten minutes. Nevertheless, Niebuhr's preaching universally was taken as Christian and biblical. When he preached on the life of Christ, however, it was to show paradox, the clash of suffering and triumph. As the world clutched at its mistaken idea about a messiah, Jesus went to the cross for his victory. "Every easy assurance of triumph for the Kingdom of God falsifies the human situation and beguiles men into false conceptions of the tragedy of human existence," Niebuhr preached. The church, in turn, was not a bed of roses. It was "that place in human society where men are disturbed by the word of the eternal God." But men and women went inside nevertheless, for the church was where "the word of mercy, reconciliation, and consolation is heard."[27]

What emerged in the 1950s, the last modern decade, was a civil religion for the American Way of Life. The 1960s decided to question that civil religion,

so clear was its profile. In common, the 1950s preachers opposed totalitarian-
ism. Only Niebuhrians criticized American arrogance and easy faith, but this
was an elite theory. Popular religion won the day. Evangelicalism survived
the Cold War with energy to spare. Peale's positive thinking and Roberts's
faith healing became a basis for a more diverse "spirituality." Bishop Sheen,
who bolstered the anticommunist Catholic church, helped mainstream that
faith in America, making it easier in 1960 for the first Catholic, the Democrat
John F. Kennedy, to be elected president.

But the 1950s revivals had tiptoed around the topic of race. The Supreme
Court ended the legitimacy of school segregation in 1954, and the National
Guard was called out in Little Rock, Arkansas, in 1957 to enforce that stance.
As a southerner, Graham had been most sensitive to altering the race situ-
ation, whereas Niebuhr absorbed it into larger social issues. When Martin
Luther King arrived on the scene, he had plenty of black preaching tradition
to draw upon. But he also applied what Graham and Niebuhr had shown
him, quite at a distance, as he entered his first pulpit in Montgomery, Ala-
bama.

From Left to Right

Promised Lands and Cities on Hills

T HE DEXTER AVENUE BAPTIST CHURCH IN MONTGOMERY, Alabama, had a history of being provocative, both to its refined black membership and to whites. One week in 1949, Vernon Johns, its pastor and the first black preacher published in *Best Sermons,* posted a new sermon title on the outdoor bulletin board, "Segregation After Death." Another title, which prompted the Ku Klux Klan to burn a cross on the church's front lawn, read: "It's Safe to Murder Negroes in Montgomery."

Not surprisingly, the congregation finally voted to urge Johns to step down, which he did in early 1952. The search was on for a new, well-spoken pastor. In 1954 Dexter found just the right man, the twenty-five-year-old preacher Martin Luther King Jr. They liked his educated preaching and hoped that young King, son of the well-known "Daddy King" of Atlanta, Georgia, would keep the peace.

The next year, Rosa Parks, a working-class Methodist, NAACP secretary, and youth worker at a black Lutheran church, decided not to move from a no-man's-land section on a segregated bus. So the driver arrested the forty-two-year-old seamstress. King was thrust into the leadership of an eleven-month bus boycott. The civil rights movement had begun, and for three

decades after 1955, America would see some of its most diverse and radical incarnations of preaching and religious oratory.

By the end of the twentieth century, every form of sermon would be tried. With imitation and innovation, the sermon responded to great changes: civil rights, the clash of church and state, feminism, the mass media, the Vietnam War, and the rise of the new Christian Right. At the start of this epochal period, King's biblical theme had been the "promised land." His oratorical activism soon was imitated by a conservative movement, which adopted as its biblical theme Puritan John Winthrop's "city upon a hill." It was an activist era on the left and right, and it began with the career of King.

Dexter was a dignified congregation, and in Vernon Johns, who had matriculated at the University of Chicago Divinity School, it had had one of the best-educated clergymen. Now, the church heard of someone like him, a "Mike King," finishing a doctoral degree at Boston University. King preached a trial sermon in January 1954, using a well-polished homily, "The Three Dimensions of a Complete Life." It was an allegorical interpretation

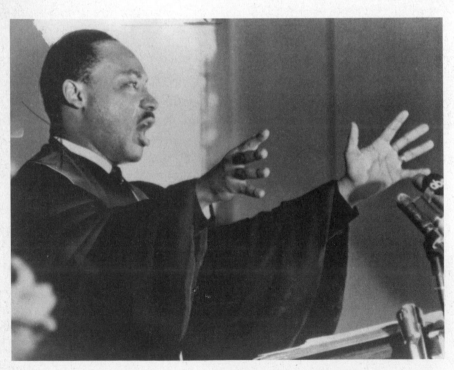

Martin Luther King Jr. introduced Americans to classic black
preaching as part of his civil rights work.

of Revelation 21:16, which gives the dimensions of the New Jerusalem: self-respect as the length, love of neighbor as the breadth, and love of God as the height. He and the congregation did not like the emotionalism of much black preaching.

King's father was disappointed that his son had pursued an academic career. Young Martin mulled the idea of a comfortable life as a university professor. He was familiar with black folk-preaching. But as in "Three Dimensions," he imitated an oratorical style of white liberals, from Fosdick to Brooks, and of black contemporaries such as Benjamin Mays, a South Carolinian trained at the University of Chicago and president of Morehouse College. King used cultured preaching in his first year at Dexter, while completing his philosophy doctorate in Boston.

By all accounts, that early choice in oratory style changed when he was thrust before the excited throng at Holt Street Baptist Church soon after Rosa Parks's arrest on December 1, 1955. Her supporters began a leaflet campaign for a one-day boycott of buses on Monday, December 5. The protesters formed the Montgomery Improvement Association to carry the project forward. King was tapped because he was a young minister, able to do what the old guard could not. With cameras rolling, King took the pulpit that night at Holt Street, dressed in suit and tie, looking young at twenty-six, perspiration on his brow.

Soon he realized the organizing power of call-and-response preaching, a type of verbal exchange frowned on at Dexter. "For many years now, Negroes in Montgomery and so many other areas have been inflicted with the paralysis of crippling fear (Yes) on buses in our community. (That's right) On so many occasions, Negroes have been intimidated and humiliated. (That's right.)" His preacher's rhythm turned on the phrase *There comes a time*.

There comes a time when people get tired of being trampled over by
the iron feet of oppression. [sustained applause] There comes a time,
my friends, when people get tired of being plunged across the abyss of
humiliation, where they experience the bleakness of nagging despair.
(Keep talking) There comes a time when people get tired of being
pushed out of the glittering sunlight of life's July and left standing
amid the piercing chill of an alpine November. (That's right) [applause] There comes a time. (Yes sir teach) [applause continues].

Eventually, the sermon employed King's favorite Bible aphorism from the Book of Amos: "We are determined here in Montgomery to work and fight

until justice runs down like water (Yes), [applause] and righteousness like a mighty stream."[1]

Early in the boycott, King received the first phone calls threatening his life. His home was bombed. But his oratory was restrained and succeeded at promoting nonviolence. On November 13, 1956, the Supreme Court upheld a lower court's order to desegregate buses in Alabama, and the Montgomery City Lines soon was integrated. King went on to organize a national movement of ministers, later called the Southern Christian Leadership Conference, and in February 1957 was the first black preacher to appear on the cover of *Time* magazine. In May he gave his first national protest address, "Give Us the Ballot," at the Lincoln Memorial.

For some time, King had envisioned the civil rights movement operating like an evangelistic rally, creating masses of people, pricking the public conscience, and shaming racists and politicians. He even had talked with Billy Graham about this prospect. But Graham could not risk desegregating crusade events in the South. While attending Crozer Seminary, a Baptist school outside Philadelphia, King had studied the neo-orthodox criticism of the idealistic Social Gospel. King saw that in a sinful world, ordinary people would not give up their power structures without being coerced.

In his life and work, King would say much about the superior power of love and the passive-resistance strategy of Henry Thoreau and Mahatma Gandhi. But finally, he decided that love was only a personal strategy, for power politics, in the Niebuhrian sense, was the social lever to coerce a racist system into justice. The idea was evident in his Holt Street sermon. "Standing beside love is always justice, and we are only using the tools of justice," he said. "Not only are we using the tools of persuasion, but we've come to see that we've got to use the tools of coercion." Social change took education and an appeal to the "higher law," but also boycotts and legislation. After 1958, King adopted this power strategy.

As an orator, he addressed black worship services, mass meetings, and white audiences. As needed, he excluded using a Bible verse or exuberant climax, but his style was the same. The churches shared his assumption that the God of Exodus was the God of black Americans. "Whenever God speaks, he says, 'Go forward!'" he preached to them.[2] Thanks to television, King introduced Americans of all races to classic black preaching, not the folksy, caricatured genre of the 1936 movie *Green Pastures,* with "de Lawd." Still, like old-fashioned black preachers, King started slow and articulate, with large words and concepts. Then the pace built. The sermon or talk ended with heightened oratory.

To great effect, King used a technique of ending a declaration with the first words of a next sentence, as in "There comes a time," or "I have a dream." By his oratory he lifted the mean encounters of demonstrators with police dogs, or black children with white hatred, to the abstract and majestic levels of being battles for love and justice, which thrilled his tired, sweaty audiences. He elevated their small, painful events to cosmic levels, and he did this before the mass media.

But none of this was entirely spontaneous. Over his years of training, King collected a large quiver of set pieces, or "commonplaces"—such as "iron feet of oppression"—that he used with guaranteed effect. He borrowed from other great preachers, including Vernon Johns, and he invented phrases of his own. King adopted the Christian realism of American neo-orthodox theology, but he viewed preaching differently. It was not supernatural proclamation. Like Cicero, King believed that preaching aimed to persuade people and make them act. His oratory excelled, and it brought action.

None was more representative than his "I Have a Dream" address at the March on Washington in August 1963.[3] It aimed to pressure Congress and the White House to pass civil rights legislation, to urge blacks to keep up their "creative protest," and to assure whites that no violence was intended. One hundred years after the Civil War, he said, blacks still faced segregation and discrimination; they were an island of poverty in a sea of wealth. The marchers had come in recognition that the Constitution and Declaration of Independence made promises to all Americans, like a promissory note. "In a sense we have come to our nation's capital to cash a check," King said.

> It is obvious today that America has defaulted on this promissory note insofar as her citizens of color are concerned. Instead of honoring this sacred obligation, America has given the Negro people a bad check which has come back marked "insufficient funds." But we refuse to believe that the bank of justice is bankrupt.

He urged blacks to continue the civil rights struggle "on the high plane of dignity and discipline," avoiding violence and "meeting physical force with soul force," and going to jail when necessary. He acknowledged "veterans of creative suffering," and urged them to believe "that unearned suffering is redemptive."

> I have a dream that one day on the red hills of Georgia the sons of former slaves and the sons of former slaveowners will be able to sit

down together at a table of brotherhood. I have a dream that one day
even the state of Mississippi, a desert state, sweltering with the heat of
injustice and oppression, will be transformed into an oasis of freedom
and justice. I have a dream that my four children will one day live in
a nation where they will not be judged by the color of their skin but
by the content of their character. I have a dream today. . . . When we
let freedom ring, when we let it ring from every village and every
hamlet, from every state and every city, we will be able to speed up
that day when all of God's children, black men and white men, Jews
and Gentiles, Protestants and Catholics, will be able to join hands and
sing in the words of the old Negro spiritual, "Free at last! free at last!
thank God Almighty, we are free at last!"

Although King had warned against the "tranquilizing drug of gradual-
ism," militant black leaders were not satisfied. Street protests began ending
in violence, as was the case in Memphis in March 1968, when six thousand
demonstrators joined a strike by sanitation workers. King fled the resulting
violence and looting, but returned on April 13, repairing to Mason Temple
that night. He spoke of reaching the mountaintop, seeing "the Promised
Land," noting that Pharaoh kept the Hebrews in slavery by their fighting
among themselves.Unity and nonviolence would beat Pharaoh, just as it had
dealt with police chief Bull Conner, fire hoses, and paddy wagons. "We don't
need any bricks and bottles, we don't need any Molotov cocktails," he said.

Instead, he preached boycott power. He cited a number of companies that
discriminated. But for now, the protest was focusing on the rights of garbage
collectors, and its task was a "dangerous unselfishness," exemplified by the
Samaritan who helped an injured man. On the way to Memphis, people had
warned King that "sick white brothers" might do him harm.

We've got some difficult days ahead. But it doesn't matter with me now.
Because I've been to the mountaintop. And I don't mind. Like anybody,
I would like to live a long life. Longevity has its place. But I'm not con-
cerned about that now. I just want to do God's will. And He's allowed
me to go up to the mountain. And I've looked over. And I've seen the
promised land. I may not get there with you. But I want you to know
tonight, that we, as a people, will get to the promised land.

The next day, while standing on a balcony at the Lorraine Motel, King
was shot by a sniper.

In the King era, the Supreme Court ruled against segregation in 1954 and 1955, and Congress passed civil rights acts in 1957, 1960, 1964, and 1965. They ended all statutory segregation and extended federal protection to black voters. But at a time when King's religious voice became customary, the Court began to secularize the public sphere as well. Back to back, in 1962 and 1963, the Court expelled organized prayer and Bible reading from the nation's public schools.

During the 1950s, tensions between Protestants and Catholics overshadowed most church-and-state topics. The two groups disagreed on parochial schools, birth control, the dogma of the Assumption of the Virgin Mary, and the White House's perennial desire to send an ambassador to the Vatican. The issue of prayer and Bible reading in schools still was to come. But for a moment, all of this was pushed aside by one riveting event: the Democrats' nomination of John F. Kennedy, a Catholic, for the presidency.

Kennedy, who personally was not religious, dealt with the topic head-on. "By nominating someone of my faith," he said in his nomination speech, the party "has taken on what many regard as a new and hazardous risk." But for voters for or against him, he said, "religious affiliation" was not relevant. "My decisions on every public policy will be my own, as an American, as a Democrat, and as a free man." Then he recalled the words of Isaiah that the people who wait on God fly like eagles and never tire. "We too shall wait upon the Lord," he said. On the campaign trail Kennedy moved quickly to allay Protestant misgivings. In mid-September, he told the Greater Houston Ministerial Association, "I am not the Catholic candidate for president." He was the Democratic candidate. "I do not speak for my church on public matters, and the church does not speak for me." [4] Kennedy had turned the tables, and the "Catholic issue" faded.

The Supreme Court's rulings on the Bible and prayer in school came on Kennedy's watch, and it forced the latent divisions among Catholics into the open. The American Catholic hierarchy was perhaps quickest and sharpest in condemning the high court, whereas Kennedy said the nation should follow the wisdom of its supreme judges. The ruling had surprised most Americans. Almost casually in 1940, the Court had extended the establishment clause—that government shall not "establish" religion—to the states. Little by little, the Court sorted out state funding for student "release time" to learn religion, "blue laws" against Sunday commerce, and tax exemption of churches. Finally, it came to prayer and Bible reading in public schools.

So far, the Court said, states had achieved "neutrality" toward religion by funding students, not institutions, and by simply continuing historical

practices to "accommodate" widespread public values. Organized prayer and Bible reading, however, were hard to present as neutrality, and the Supreme Court decided that both were an establishment of religion. In its 1962 prayer ruling, the Court tackled a prayer drafted by the New York Board of Regents in 1951: "Almighty God, we acknowledge our dependence upon thee, and we beg thy blessings upon us, our parents, our teachers, and our country." Then in 1963, the Court combined Bible reading cases from Pennsylvania and Maryland—where the Schempp and Murray families filed lawsuits— and ruled the practice unconstitutional. At the time, a third of the nation's schools began the day with a prayer, and 42 percent required a Bible reading. Both were most common in the South, and then in the Northeast, but minimal in the Midwest and West.[5]

The Court offered a consolation, however. Much of the nation's religious heritage, from "In God We Trust" on currency, to chaplains in Congress, were "secular" customs and not an establishment of religion. Like the Catholics, the nation's Baptists divided sharply, opening the way for their future rhetorical differences. All Baptists cherished church-state separation. But some saw school prayer as a local parental or state right, far different from an ambassador to the Vatican state. Liberal Baptists cheered the Supreme Court. They agreed with the liberal *Christian Century,* which noted that children still could pray, for "private prayer . . . remains untouched." The

The Schempp family of Pennsylvania successfully challenged Bible reading in public schools at the Supreme Court in 1963.

Court "rendered a service of greatest importance to true religion as well as to the integrity of a democratic state."[6]

School prayer became a defining issue for Sunday pulpit oratory and a new political movement. When the Court, in 1973, ruled that abortion was legal, the new Christian Right had its two domestic war cries. To fight back, preachers began to quote other Supreme Court texts, from the 1952 comment that "we are a religious people whose institutions presuppose a Supreme Being," to the 1892 Court assertion that "this is a Christian nation." Preachers also found the 1961 Supreme Court footnote that "secular humanism" was "among religions in this country." Thus was born a rallying cry: "secular religion" would dominate public schools absent Bible reading and prayer.

Despite the excitement over civil rights and church and state relations, much of mainline Protestantism was lamenting a decline in the power of the sermon. "It is incontrovertible that preachers today do not wield the influence that their predecessors did fifty years ago," one prominent New York City minister wrote in the 1966 edition of *Best Sermons*. He said that the word on the street was plain enough, "that preaching is becoming an anomaly and the preacher an anachronism."[7]

The civil rights movement, and an increase in secular solutions to modern life, persuaded many clergy that action, not talk, was the way of the future. The venerable journal *The Pulpit* reflected the mood in 1969. It dropped its *Pulpit* title for a new name, *Christian Ministry*. As preacher-professor Robert McAfee Brown said on Good Friday in 1971, he had decided to deliver his sermon "not in a church but on a pavement, not with words but with a deed." At the time, he and other demonstrators were blocking a draft-board entrance in Berkeley, California.[8]

Nevertheless, preachers struggled with their historic art and infused it with new approaches and theories. Although Berkeley became a brand name for protest in this era, it was Yale University that provided the fullest laboratory for the sermon's accommodation to the radical era. There, the Beecher Lectures on Preaching, held annually at the Marquand Chapel of the Yale Divinity School, grappled with new directions in the 1960s and 1970s. A short way across campus, Battell Chapel became a second locus for applying the sermon to contemporary events. Battell was the pulpit of the chaplain of Yale, William Sloane Coffin Jr. who held forth on every issue of the day.

From time immemorial, the Beecher Lectures had been a forum for white Protestant males, mostly in the Congregational and Presbyterian heritage of Yale and the founders of the lectures in 1871. Some of this began to loosen up in the 1960s. Topics such as "The Audacity of Preaching" and "Faith and

Secularity" began to appear. By 1970, one series was a mixed media presentation, more akin to a rock concert light show than a discursive lecture. Then in 1974 the black Presbyterian preacher Henry H. Mitchell, using the title "The Recovery of Preaching," was the first Beecher lecturer to address what African American preaching might offer European oratory.

Black sermons have power "by means of art rather than argument," Mitchell said.[9] They use narrative and celebration. Mitchell had written the seminal book *Black Preaching*. But as a midwesterner reared on formal English, he said, he probably had begun preaching in that "language of the oppressor." Then he learned "the mother tongue of the Black ghetto," a "new tongue that was never a watermelon accent or Amos-and-Andy dialect," but real for his audience. Thus, Mitchell said, preaching was about how an idiom gave a community its identity. "Everybody in the ghetto fancies that White preachers 'can't preach a lick,'" he said, friendly enough. In the years of Mitchell's Beecher lectures, not a few ministers were scandalized by such idiomatic stage musicals as *Godspell* and *Jesus Christ Superstar.* Still, Mitchell argued that good preaching was a cultural voice driving a narrative, excelled in by black oratory, but first invented in the Bible itself.

Overall, the quest for powerful storytelling became the new trend in homiletics. It was called narrative preaching, age-old, but with ever new twists. Feminist, black, and Latino preachers promoted narrative preaching, for they all had stories of "liberation" to tell. Marginalized preachers used the Bible more, according to this movement, because they needed a source of authority. "Women and minority preachers are generally more biblical in their preaching," said two Latino ministers, because women and minorities believe that "when they preach, they have no status given them by society."[10]

To a degree, that changed for women as many began receiving ordination in the early 1970s. Feminists brought a special kind of storytelling, as embodied in the second woman to give the Beecher Lectures at Marquand Chapel. The Old Testament scholar Phyllis Trible, in her "Texts of Terror: Unpreached Stories of Faith," unlocked tales of biblical women and their oppression, but also their victories. A later collection, *The Book of Women's Sermons,* reported on how "women's voices were often received as discordant in tone and content" in American pulpits, and how a woman in a pulpit can still be a political act, even as women simply rely on their "experience" for content and standpoint: "Women tell stories about their lives and relationships."[11]

Whether spoken by males or females, the narrative sermon was the last possible revolt against the enduring Puritan plain style. The Puritan sermon was "deductive." The preaching began with a Bible verse and doctrine,

which the sermon set out to prove. The only rebellion left, therefore, was the "inductive" sermon, which was tried in the 1970s.

Inductive preaching lays out evidence or looks at puzzles, not revealing the core "message" until the end. As the pieces add up, the preacher draws a conclusion or leaves that to the audience. The sermon tries to mirror human conversation and the television age. In both, flat declarations are trumped by images, buildup, and surprise endings. "I've been accused of being sneaky when I preach," said Disciples of Christ minister Fred Craddock, a chief promoter of inductive preaching. Listeners think he still is on a long introduction when the sermon ends—and they are left to draw the conclusion. "I don't usually come in the front door," said Craddock, then a professor of preaching at Emory University in Atlanta. "I come in the back door, or the basement." When he gave his Beecher lectures in 1977, he did not talk about proclamation but about "overhearing the Gospel."[12]

At Yale's Battell Chapel, campus chaplain Bill Coffin both declaimed and told stories, beginning in 1958. As university preacher, he spoke weekly to a

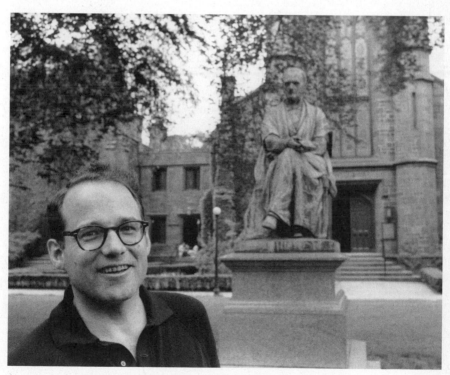

William Sloane Coffin Jr. shown here in 1963, was chaplain at
Yale University's Battell Chapel for eighteen years.

local Congregational church, to the campus community, and to constant visitors. The university preacher could do what the parish minister usually could not: take up polarizing political topics of the hour and not lose a job. During the 1960s, amid issues of race, poverty and Vietnam, many liberal clergy were ousted for raising such topics in local churches. Having a university pulpit doubtless shielded Coffin. But he also was a preacher par excellence, hard to match for stirring religious interest on campus.

The name resounded in Manhattan. Coffin's was a wealthy family line. William's uncle was a great Presbyterian minister who rose to be president of Union Theological Seminary. William Junior cut a similar profile. He was handsome, square-jawed, and athletic. His horn-rimmed glasses hid his radicalism at heart, and in age his receding hairline mimicked the swept-back gray hair of a maestro. Coffin had served in army intelligence during the Second World War and left theological studies to be a Central Intelligence Agency spy in Germany during the Cold War, mastering Russian and indulging in counterspy intrigues. The insider's look, however, stamped him with a belief in U.S. duplicity, even as his government argued American purity in foreign policy.

Having left the CIA, Coffin entered Yale Divinity School. He was ordained, and soon returned as Yale chaplain, a post he held for eighteen years. His job was to preach, organize all campus chaplaincies, and help students and faculty on pastoral matters. But Coffin hardly was tied to campus. In May 1961 he took busloads of students for Freedom Rides in the segregated South, and himself was arrested at Baltimore and in St. Augustine, Florida. That summer, he helped train the first group of Peace Corps workers at a camp in Puerto Rico. By 1962 *Life* magazine numbered Coffin in the "Take-Over Generation," and he lived up to the reputation.

Resistance to the Vietnam War draft was the cause Coffin took almost to the breaking point. In 1965 he joined other clergy in forming a Vietnam "emergency committee." The group, which called for a Vietnam ceasefire, later became Clergy and Laity Concerned About Vietnam, a hub of policy activism that involved 10 percent of the nation's ministers. But draft resistance was a student action. It began in Boston in the spring of 1967 and was building toward a national protest event by fall. When the students came to Coffin for an endorsement, he agreed.

By now, Coffin's critics were accusing him of using students as political fodder. But he swore by his chaplain's duty. "It's my job as chaplain to raise issues," he later told the *New York Times*. "I called them in simply to point out that civil disobedience is a possibility they must face." He and his clergy allies

declared that "we too must be arrested" if students were nabbed for defying the 1967 Selective Service Act. Coffin rejected burning draft cards. His alternative was to turn in the cards at the Department of Justice, and this plan led to some colorful preaching events at Yale and in Washington, D.C.

The call for a draft card turn-in went out on October 2. In the media fanfare, Coffin offered Battell Chapel "as a sanctuary from police action for any Yale student conscientiously resisting the draft." Yale's president quashed the idea, but national events proceeded. On October 16, five thousand people rallied against the draft at Boston Common. Some burned their cards on the Common, but 213 draft resisters took them to a rally with Coffin at nearby Arlington Street Unitarian Church. Before they handed Coffin their draft cards, he mounted the pulpit and preached. October 1967 marked the 450th anniversary of the Reformation, so he urged "a new reformation, a reformation of conscience" that might require paying a price.[13]

The big march on Washington—a rally of fifty thousand at the Lincoln Memorial and a protest of thirty thousand at the Pentagon—was scheduled for Saturday, October 21. So on Friday morning, hundreds showed up with Coffin at the Justice Department, turned in a briefcase full of cards, and heard Coffin's address. "It is not wild-eyed idealism but clear-eyed revulsion that brings us here," he said. "We admire the way these young men who could safely have hidden behind exemptions and deferments have elected instead to risk something big for something good. We admire them and believe theirs is the true voice of America, the vision that will prevail beyond the distortions of the moment."

Across the river at the Pentagon, the next day's protest unraveled in a clash with police. But the student protest movement had begun. Among the draft cards handed in by Coffin, the largest group came from Yale, a total of forty-seven. The FBI was on campus by Monday, visiting the Divinity School. It also was parents' week on campus. The Yale president felt obligated to question Coffin's entanglement in private student decisions. That weekend, Coffin preached his response at Battell Chapel, with the president there.

It was now Reformation Sunday, so Coffin preached about Martin Luther and the pope, a sly reference to Coffin and the president. "Truth is always in danger of being sacrificed on the altars of good taste and social stability," said Coffin, whose rich, gravelly voice carried a New York accent. He showed that Luther's letters to his confessor were neither tasteful nor tactful.

So what the Christian community needs to do above all else is to raise up men of thought and of conscience, adventuresome, imaginative

men capable like Luther of both joy and suffering. And most of all they must be men of courage so that when the day goes hard and cowards steal from the field, like Luther they will be able to say "My conscience is captive to the word of God . . . to go against conscience is neither right nor safe. Here I stand. I can do no other. God help me."

Coffin was an eloquent and winning preacher, much to the chagrin of conservative patriots. While he was at Yale in the 1960s and 1970s, there was no spiritual declension emanating from Battell Chapel, as even his critics conceded. Although Yale became the hub of draft resistance in the northeast, the campus never descended into destructive revolt, as was common elsewhere. The Yale Corporation saw this relative calm, as did fellow Yale clergy, and they credited it to the chief chaplain's broad, interested, world-engaging embrace. For his actions in 1967, Coffin was indicted for aiding and abetting draft resistance. But an appeals court overturned his conviction, and the government dropped the case.

Coffin often preached from the Old Testament, comparing American foreign policy to the exploits of Hebrew kings. He was also adept at linking the psychological lives of biblical characters to contemporary lives. But he was always game for the topic of America's role in the world. As he said in his own Beecher lectures in the fall of 1980, the new "biblical unit" was not the tribe, nation, or race, but the entire interrelated world and its physical environment.

Coffin's Beecher lectures took note of the election battle between Jimmy Carter and Ronald Reagan, and the Iran hostage crisis, in which he played a mediating role by talking to mullahs in Iran. But his main topic was nuclear war. He gave a detailed description of what would happen if a Soviet warhead hit Manhattan. In the fourth of his series, he took stock of American preaching. He admitted that, whereas twenty years earlier ministers were competing for "success," they now had to find victory in their "defeat at the hands of the world." Times had changed. "Nobody knows anymore what it means to be a successful minister."

In his view, not every minister was meant to be a "great preacher." But every good pastor could preach well enough by virtue of thoughtfulness and honesty. "Every sermon, I don't care what you are saying, ought to be a pastoral visit," he said. And when clergy were powerless as individuals, they had a collective voice in society that remained relevant. If not preach, he said from ample experience, "Call a press conference."[14]

When the Cold War ended in the early 1990s, and Coffin had moved to the pulpit of Riverside Church, and then to leadership of a national anti-nuclear-weapons movement, he preached on the legacy of Puritan John Winthrop's "city set upon a hill." He preached that America's chief sin was self-righteousness. It was unable, with all its power and bounty, to admit it also was a sinful nation that oppressed and ruined other peoples. The notion of American purity and virtue, he said, was under every American's skin, if not in his or her mind.

"I think this pride is our bane and I think it is so deep-seated that it is going to take the sword of Christ's truth to do the surgical operation." Since Winthrop had spoken, he showed, American oratory often boasted of America as God's elect. But the nation's "pride-swollen face"—a favorite sermon refrain—closed its eyes to neglect at home and arrogance abroad.

No nation, ours or any other, is well served by illusions of righteousness. All nations make decisions based on self-interest and then defend them in the name of morality.

But Americans had a moral choice, and freedom to be honest. He said the world would be "safer and saner" if "we Americans got over our self-righteousness."[15]

In this era of antiwar prophets, the liberal Protestant clergy were not the only critics of America's behavior in the world, for some Roman Catholic clergy joined the jeremiad chorus as well. Along with Coffin, the Jesuit priest Daniel Berrigan and his brother Philip, a Josephite priest, had helped organize the early "clergy against the war" movement. They would make as many headlines as the Yale chaplain, and for good reason. The prosecution of the "Berrigan brothers," which included a dramatic FBI chase scene, ended in long prison terms for both of them, beginning in 1970.

The saga of the Berrigan brothers came at a time of great ferment in the Catholic priesthood. The secular sixties had overlapped with the Second Vatican Council of 1962–65, changing how America's priests saw their public roles. The confusion made it a decade when record numbers of men began to leave the American priesthood. But it was also a period when priests were told to re-emphasized preaching. The Council, popularly known as Vatican II, had urged better sermon-giving, while still keeping the Eucharist central to worship. Before the homiletics revival arrived, however, another kind of Vatican II icon captured the public imagination—the radical priest.

Daniel Berrigan preached against
the Vietnam War and went to jail
in 1970 for destruction of draft
records.

The Berrigans filled those shoes. The youngest was Philip, a big, thought-ful man with a crew cut. He served on the battlefield in the Second World War, but had felt indignant about the racial segregation in Army camps in the South. Years later as a priest, he joined the civil rights and antiwar movements, becoming the first Catholic minister jailed in America for civil disobedience. Daniel Berrigan took up activism later, a Jesuit poet who felt mugged by reality after being a military chaplain in Germany.

By 1965, the Berrigans and their now-famous colleague, Trappist monk and author Thomas Merton, had formed an interfaith coalition against the Vietnam War. But Philip was the first to provoke his own arrest. He and three others—the "Baltimore Four"—poured blood on Selective Service re-cords in the Baltimore Customs House and handed out paperback Bibles. As they waited for the police to arrive, Philip declared that "this sacrificial and constructive act is meant to protest the pitiful waste of American and Viet-namese blood in Indochina."

Daniel took his first celebrated stand in early 1968 by making a trip to Hanoi to repatriate three American prisoners of war. Then in May 1968, he and Philip and seven others—the "Catonsville Nine"—walked into draft board offices in Catonsville, Maryland, and removed 378 files, which they burned in the parking lot outside. Their challenge was to American religious groups. "We confront the Catholic Church, other Christian bodies, and the synagogues of America with their silence and cowardice in the face of our

country's crimes," they said. "The religious bureaucracy in this country is racist, is an accomplice in this war, and is hostile to the poor."

The culprits were tried, sentenced, and told to report to federal marshals on April 9, 1970. Philip waited for agents to pick him up at St. Gregory's Parish in Manhattan, where he was to appear at a peace rally, and Daniel simply disappeared. For four months he became a radical hero. A typical recorded message was "This is Father Daniel Berrigan speaking from the underground." Between New England and Washington, D.C., several people helped Daniel Berrigan elude the FBI. He showed up at a Holy Cross College reunion, released statements and sermons, wrote magazine articles, and did an NBC interview with Edwin Newman in a Connecticut motel room. Eventually a documentary, *The Holy Outlaw,* recorded the escapade for the world.

Then, in mid-August, "We embarked on the most outrageous project of all," Daniel said. He had been invited to preach at First United Methodist Church in Germantown, Pennsylvania, on Sunday, August 2, 1970, with all due precautions taken. It seemed worth trying. "Through a sermon, a message could be conveyed to Christians," he said, adding that being wanted by the FBI "should be considered normal for peacemakers." The sermon listed the cost in lives in Indochina, using a rhetorical stretch of statistics.

> Dear Friends, how do we translate in our lives the bombing of help-less cities? How do we translate in our lives the millions of Vietnamese peasants perishing. . . . How do we translate to the truth of this morning's text the 50,000 children napalmed? How do we translate on this summer morning the 50,000 Americans dead? . . . There are a hundred ways of nonviolent resistance up to now untried or half-tried, or badly tried, but peace will not be won without . . . the moral equivalent of the loss and suffering and separation that the war itself is exacting.

The sermon was awkwardly Lincolnesque in its insistence that suffering must pay for suffering. It was recorded on film and later made the rounds. "From that day, Mr. Hoover would spare nothing to bring me to ground," Daniel said.[16] Berrigan fled to a new safe house on Block Island, Rhode Island. But by sending a letter to Philip in Lewisburg Federal Penitentiary in eastern Pennsylvania, he alerted the FBI to his whereabouts. Agents posed as bird-watchers and then swooped in for Daniel's arrest. It was August 1970. The Berrigan revolution was postponed, but not over. In the 1980s both brothers were out of prison and arrested again for protesting nuclear weapons.

The preachers on the left had stolen the spotlight from the anticommunist conservatives, but the pulpit on the right had hardly disappeared. In Texas, fundamentalist Billy James Hargis pounded away on radio and the speaking circuit with his Christian Crusade. He was a trendsetter for the times to come, denouncing the liberal media, becoming the first televangelist to fall due to scandal—and warning America of a great conspiracy.

Both sides, left and right, preached about conspiracy in the land. Conspiracy had been a deeply ingrained American way of thinking since the colonists fought King George III two hundred years earlier. After the Berrigans were rounded up, Hoover had them indicted for a conspiracy to kidnap Henry Kissinger and blow up Washington buildings. Conservatives believed the Berrigan plot was true, proved or not. On the left, the radicals portrayed the American "system" as a war-making, money-making conspiracy, and liberals believed that as well. But no one preached conspiracy like Hargis, who happened to be on the right wing of the era.

A short, overweight man with slick black hair and a voluminous voice, Hargis was a Christian Churches minister in Arkansas, Oklahoma, Missouri, and finally Texas. The Christian Echoes National Ministry he founded became better known as Christian Crusade. His oratory, like that of his hero Billy Sunday, was powerful and dramatic. While he could not match Sunday in vituperation, he excelled him in conspiratorial and apocalyptic preaching. "Satan is using Communism to bring about his godless one-world government, the anti-Christ regime, and the Battle of Armageddon," Hargis said. By the 1970s, Hargis was advancing his theories along several avenues: radio, magazines, television, books, summer youth training in Manitou Springs, Colorado, and an ideological American Christian College.

The key strategy was to stir fear, Hargis readily conceded. As he preached in "Christ the Great Destroyer," calumny was everywhere. "We have barely scratched the surface of the voluminous record of participation in communist front activity by clergymen."[17] He held out the prospect of national calamity in his spellbinding sermon "Three Things That Could Happen to America." Hargis preached that the key to conspiracy was that it could not be proved, so devious was its plot. Nothing was as it seemed. The only proof was denial by the accused media outlets, clergy, or politicians. His attack on the media came in "A Free Press: Leading America Leftward." At least communists were openly atheistic. Media liberals were secretly anti-Christ.

Hargis was a prototype of many future televangelists, an emergent force in the 1980s. He presaged most of them by his unabashed fund-raising appeals, called "prayer auctions," and foreshadowed a few notable others by his

fall as the result of a media investigation. In February 1976, *Time* magazine published "The Sins of Billy James Hargis," which asserted that Hargis was sexually promiscuous with both his female and his male college students. He resigned and denied nothing.

Whenever Hargis was questioned about the "facts" in his preaching, he rebutted by claiming a "communist smear," and now it was the same. The media-driven sex scandal was "The Great Smear." Hargis made a comeback. In 1985 he attacked Billy Graham as a communist stooge for being politically neutral during an evangelistic visit to the Soviet Union. Graham was "duped once again into serving as a propaganda tool for communists," Hargis proclaimed.

But as every extreme invariably moves to the center for longevity, the religious oratory of the right also found its middle ground. It came by the mingling of two representative figures of the 1980s, the preacher Jerry Falwell and the politician Ronald Reagan. Together they celebrated the Puritan concept of a "city upon a hill" and engaged in a culture war no less spirited than Martin Luther King Jr.'s civil rights marches, which had looked for the "promised land" in America.

The route to a unified rhetoric on the new Christian Right passed directly through the White House of Jimmy Carter, a "born-again" president who overwhelmingly won the evangelical vote. In time, however, fundamentalist clergy who visited 1600 Pennsylvania Avenue indicted him for promoting "secular humanism." They said he was giving away the store, both to liberals and to the Soviets. Religious conservatives were agitated on other fronts as well. Not only had the Supreme Court banned school prayer and allowed abortion, and the Internal Revenue Service begun to probe Christian schools, asking about racial segregation, but the Middle East had exploded. The biblical state of Israel, founded in 1948, had expanded its borders in 1967 during the dramatic Six-Day War, and some evangelicals were calculating dates for Christ's return.

In the late 1950s, Falwell had begun his media outreach with a local thirty-minute radio broadcast in Lynchburg, Virginia, that eventually evolved into the syndicated television program "Old Time Gospel Hour." He became known for his 1965 sermon "Ministers and Marches," which questioned the nonviolent "intentions" of civil rights protests and warned that communists would take "advantage of a tense situation in our land." As he said, "Preachers are not called to be politicians, but to be soul winners." In a decade, however, Falwell would call that sermon "false doctrine," explaining that his conversion to political activism came with the 1973 Supreme Court ruling allowing

From his local Baptist pulpit, Jerry Falwell led a conservative
political movement, Moral Majority.

abortion. "People were shocked and surprised by the changed emphasis they
heard in my preaching," he said in his autobiography. "Suddenly I was call-
ing for all-out political involvement by the Christian community."[18]

With musical talent from his new Bible college, Falwell hit the road in
the bicentennial year of 1976, leading an "I Love America" tour to 141 cities,
eager to alert other churches to their political roles. "Preaching against the
'social Gospel' became for some fundamentalists and evangelicals an excuse
to ignore Christ's calling to feed the hungry and heal the sick," Falwell said,
hoping to change the national mood.

Falwell was only the latest minister to use electronic ministry. But the
political bent seemed novel. In a front-page story, the *Wall Street Journal* fea-
tured his ministry as the start of the "Electric Church" in politics. He led one
more national musical-and-preaching tour, "America, You're Too Young to
Die," and was back in Lynchburg in May 1979 to found Moral Majority. Sto-
ries vary on who was the real mastermind of the group. In any case, Falwell
met with a group of media-savvy Republican political activists from Wash-
ington and was made figurehead of the "movement." Falwell worked almost
entirely through his broadcast outlets and a network of Independent Baptist
churches. Looking for a good political story, however, the national media
made the Moral Majority larger than life.

To his credit, Falwell was a fundamentalist who put a conservative pub-lic consensus above sectarian purity. When Kennedy ran for office, Protes-tants from Graham to Peale had met privately to undercut the possibility of a Catholic taking the White House. Falwell, on the other hand, rhetori-cally opened his Moral Majority umbrella over Catholics, Jews, Mormons, and other religious sects quite at odds over doctrine. He praised Catholics for being pro-life first, with evangelicals filling in the ranks behind. As "life issues" began to dominate pulpits and headlines, evangelicals added rock music, drugs, pornography, and finally homosexuality to the movement's agenda. They advocated a military buildup and support for Israel.

While fiercely defending the liberty of belief, a Baptist trademark, Falwell seemed to endorse what Benjamin Franklin had called public religion, or an atmosphere of moral decency. Hence, the Moral Majority succeeded at dis-tilling a "family values" agenda that began to win wider and wider support, as if separated from any particular evangelical firebrands. Critics, pointing to so many southern roots, said *family values* was a code name for racial segre-gation of families. Nevertheless, opinion polls showed a growing American "majority" siding with the values revolution, though a string of "new" Reli-gious Right leaders gained only tiny margins of endorsement.

The common ground between Falwell and America was seen, for example, in a typical address he gave in Atlanta on March 26, 1982, titled "Strengthen-ing Families in the Nation."[19] Lifetime heterosexual marriage was threat-ened on five fronts, he preached: economic pressures on mothers, moral permissiveness, television, "plain busyness," and the threat of secular human-ism in the nation's cultural institutions. The nation must return to a "Judeo-Christian ethic" so parents can

train up a child in the way he should go and when he is old he will not depart from it. Rebuilding families is just coming back to the old biblical principle of getting them into the Word of God and by precept setting the example before them on a daily basis, letting them see Christ in Mom and Dad, and then that local church becomes the confirmation, the reinforcement center.

Of the seven solutions that Falwell's address offered America, some had support from an overwhelming majority: the nuclear family, moral decency, the work ethic, viewing the home and church as divine institutions, and allowing some kind of organized prayer in public schools. Other policy is-sues, however, hinged on precise religious doctrines, not a general consensus.

These were Falwell's calls to ban abortion, unequivocally support Israel, and teach literal Bible creationism in public-school science.

By itself, Falwell's preaching and even the Moral Majority would have failed to spark so much attention if not for the 1980 presidential candidacy of Ronald Reagan. That galvanized the new Religious Right, which at the time believed in a top-down moral revolution. Reagan was a surprise survivor of the Republican National Convention, and now he was on the road. A savvy and secular California political machine surrounded him, but it was quick to put the Religious Right on the campaign's radar. The turning point came on August 12, when Reagan flew into Dallas to address the most elite Christian conservative policy forum, the National Affairs Briefing.

Preachers had always helped American politicians with their rhetoric, and the same happened with the Religious Right in the 1980s. Following the private advice of one Texas preacher, Reagan told the 2,500 ministers in Dallas, "I know you can't endorse me, but I want you to know that I endorse you." Later, when President Reagan addressed the National Association of Evangelicals, he followed a suggested talking point as well, giving his famous phrase that the Soviet Union was "the focus of evil in the modern world." The bully pulpit had welcomed the conservative religious movement into mainstream politics and produced a national dialogue about what is "evil" and good. But Reagan was a great orator in his own right. What he brought to the new movement was a Puritan image he had polished since his days as governor of California: the city upon a hill.

Reagan used it in his 1976 bid for the GOP presidential nomination. He invited voters to assure future generations "that we did protect and pass on lovingly that shining city on a hill." On election eve in 1980, he told voters that he had "quoted John Winthrop's words more than once on the campaign trail this year—for I believe that Americans in 1980 are every bit as committed to that vision of a shining 'city on a hill,' as were those long-ago settlers." In his farewell television address, he said: "I've spoken of the shining city all my political life." What John Winthrop had imagined

> was important because he was an early Pilgrim, an early freedom man. He journeyed here on what today we'd call a little wooden boat and like the other Pilgrims, he was looking for a home that would be free. . . . [I]n my mind it was a tall, proud city built on rocks stronger than oceans, windswept, God-blessed, and teeming with people of all kinds living in harmony and peace; a city with free ports that hummed with commerce and creativity. And if there had to be city

walls, the walls had doors and the doors were open to anyone with the will and the heart to get here.

On that winter night, the retiring Republican president said the city was "more prosperous, more secure, and happier than it was eight years ago."[20]

Reagan had allowed political oratory to claim a traditional religious function. In ways, politics overshadowed the pulpit. The high priest's "city on the hill" eclipsed the prophet's "promised land." The new religious movement, mostly conservative, had borrowed the oratory and activism from its recent predecessor, the liberal church activism of the sixties. But as ever, when politics begins to sweep aside the pulpit, the preachers of America draw back to reflect. They ask anew the purpose of the sermon, and acknowledge the limits of politics to give life meaning.

The Reagan revolution soon became ancient history. In the span of four hundred years of American preaching, it was but an episode. In war, peace, and crisis, the role of the sermon in America was looked at again, as if anew.

The "Publick Religion"

The Sermon as Four Habits of Mind

F OR FOUR HUNDRED YEARS, THE AMERICAN SERMON HAS ECHOED through the nation's geography and its cultural regions. It has adapted to its audience, changed along with new technologies, and participated in great events. By doing so, it has changed the course of American history. More clearly than ever, however, the sermon has taken on a dual role. It has one territory inside the sanctuary of believers, and yet another role in what Benjamin Franklin called the nation's "publick religion."

The journey has been a long one. The sermon addressed its first American audiences in marshy Virginia, desert New Mexico, frigid Quebec, and stony-soiled New England. Then it penetrated the Appalachian barrier, traveled the Ohio and Mississippi Rivers, and crossed the Great Plains, conquering a vast silent space. The railroad took it from the East Coast to the West, changing the frontier and forcing the sermon again to adapt to its audiences and environments.

Technology was a second architect of religious oratory. The first generations of New England clergy had sermons printed in Britain, and then they became commercially viable commodities for colonial American presses. The mass media began with religious tracts and newspapers in the early

nineteenth century, and much that passed for copy actually was the minister-editor's sermons. Preaching from urban pulpits hit telegraph wires and became news in metropolitan newspapers. And then came radio in the 1920s. Thereafter, a modern preacher could reach more people in one day than an old-time evangelist contacted in a lifetime.

Despite this wider and faster reach of the sermon, every age has bewailed the decline in its power. American society inexorably has grown more secular and diverse. One way to summarize the sermon's great trajectory across American history, therefore, is to look at its role inside the sanctuary, and its influence on the nation's "public religion" outside. The inside story is about homiletics, the specialized art of preaching. The outside story is about four habits of mind that the sermon has given America's "civil religion," or "civil piety": the belief in national chosenness, a need for comfort, the challenge of judgment, and a tendency to see conflict as a battle between good and evil.

At the beginning, the sermon in America was a sectarian affair, a precise kind of homiletics delivered to a well-defined religious community. The Puritans, for example, had their plain style and subdivisions, and they believed that preaching ferreted out the elect. Soon, the rhetorical arts were added to this. On the eve of the American Revolution, Hugh Blair's *Lectures on Rhetoric* in Scotland, combined with John Witherspoon's *Lectures on*

The American sermon has built what Benjamin Franklin called a
Publick Religion that rose above sectarian differences.

Eloquence at Princeton, gave an American generation guidance on the art of "pulpit oratory" and eloquence in public speaking. Frontier camp meetings vied with this tradition, offering a vernacular rhetoric that was rough-hewn and bombastic. If low-brow oratory spread with revivalism and stump politics, its high-brow cousin was preserved in the rise of American colleges, with their academic chairs for a Professor of Pulpit Eloquence and Professor of Sacred Rhetoric.

During the Gilded Age, textbooks on preaching such as John Broadus's *Treatise on the Preparation and Delivery of Sermons* began to set a national standard. At the same time, Yale Divinity School inaugurated the Lyman Beecher Lectures on Preaching, a venue for specialized study of the American sermon. Naturally, professional preachers debated the sermon's exact purpose, and that is an issue down to the present: is it a supernatural proclamation, or is it persuasive oratory applied to a religious and moral topic? Either way, the world outside the sanctuary became more secular after the Civil War era. The Sabbath no longer was sacred, and the sermon had new and entertaining competitors, from journalism and dime novels to radio and film.

With each new era, homiletics professors wrote about the dawn of a "new preaching," which would address the changing times. From the 1920s to the present, the anthology series *Best Sermons* became a barometer for the sermon's status in American society, and the first editor was cautiously pessimistic. "There is a widespread impression that the pulpit has lost its bearings, and that from its message the note of authority and the thrill of momentousness have died out," he offered in 1925. "The pulpit has fallen, not upon evil days, but upon other days."[1]

These "other days" spurred a number of responses inside the sanctuaries and seminaries. The twentieth century produced pastoral preaching, liturgical preaching, and perhaps most influentially, biblical preaching, following on Swiss theologian Karl Barth's argument that a sermon was nothing but "human language in and through which God himself speaks, like a king through the mouth of his herald."[2] The popular preaching of the 1950s blended seamlessly into the American Way of Life, and so the 1952 volume of *Best Sermons* exulted, "This is the age of preaching. The sermon is coming back into its own."[3]

But then came the 1960s, when many Americans began to question their institutions, including their houses of worship. The homiletics debate now turned on "relevance," and whether action was more important than mere oratory. Seminarians trained for action and advocacy, and in many cases the

fine art of preaching fell by the wayside. "A lot of men went into the ministry for reasons other than preaching," one pulpit-watcher said in 1979. "They were interested in social action, so now we're stuck with them."[4]

The 1960s and 1970s began the "new consciousness" in preaching. It spawned a radical rhetoric, which used biblical and human stories to tell of how marginalized groups, such as women and racial minorities, were oppressed. Preaching now required "social criticism" of both contemporary society and the old-fashioned ways of interpreting the Bible, which had been controlled for centuries by white males. Preaching was about "liberating the text," finding new role models. A final contribution to homiletics was the idea of "inductive preaching," which emphasized telling stories that reached a conclusion at the end of the sermon, not the beginning.

The innovations in preaching, meanwhile, stirred up conservative evangelical homiletics, which looked askance at the liberal developments. On the crest of televangelism and the Religious Right, preaching of the "old-time religion" experienced its own revival. The demographics of the church audience also shifted dramatically. Although a handful of megachurches are much talked about, there is a far greater number of middle-to-large churches that house half of the nation's churchgoers, who attend expecting to hear good preaching. These churches make up only 10 percent of the total number of American congregations, however. And that means that half of America's churchgoers hear sermons from just one-tenth of its preachers.

Clearly, good-enough preaching is keeping Americans in the pews. In 1989 a *Best Sermons* volume noted a general excellence: "At present, there may be fewer much-discussed pulpit heroes than there were a generation or two ago," its editor said. "But there might also be so many more preachers who are as competent as those heroes were that they get lost in the crowd." Today, the "best" preachers may hardly be known, except among their peers. A mid-1990s survey to identify the twelve "most effective" sermon-givers in the English-speaking world produced ten Americans. But of these ten, probably only Billy Graham would be known in the wider American culture.[5]

In an epoch in which singular preachers no longer seemed to stand out, Graham owed his eminence to several factors, the first being sheer longevity. He had befriended all political parties, and every nation, and had preached to more people on earth than anyone else. His mixture of gravity with simplicity bode well for preaching in a media age. To the last, his crusade preaching offered one thing: a guaranteed message, crystal-clear, and designed to help listeners make a "decision" for God. More than ever, he filled the shoes of

"America's Pastor" in 1995, when he spoke at an Oklahoma City memorial service just days after antigovernment terrorist Timothy McVeigh blew up a federal building, killing 168 people.

> I have been asked the question several times, many times, "Why does God allow it?" Why does a God of love and mercy that we read about and hear about allow such a terrible thing to happen? . . . I don't know. I can't give a direct answer. I have to confess that I never fully understand—even for my own satisfaction. I have to accept by faith that God is a God of love and mercy and compassion—even in the midst of suffering. . . . The Bible says God is not the author of evil. And it speaks of evil in 1 Thessalonians as a mystery.[6]

Against the towering influence of such men as Graham, or Martin Luther King Jr., for example, homiletics may be described today as having a general merit but not a great social prominence. That prominence may be looked for, as this book has tried to do, in the more nebulous world outside the sectarian sanctuary, where sermons have mingled with great public events and produced the nation's civil religion.

For the sermon's role in public affairs, the place to look typically has been American politics, national tragedies or wars, and presidential rhetoric, especially the inaugural addresses. Here is where church and state, homiletics and public oratory, tend to overlap on a national scale, if only for moments in time.

In politics, the elections of 2000 and 2004 revealed something about religious oratory in the present day. In both elections, Americans remained comfortable with how their religious traditions—Protestant, Catholic, Jewish—took moral stands on domestic and international issues. The patterns of rhetoric were fairly predictable. Still, only a third of Americans during the 2000 presidential race wanted clergy to "discuss politics" in their pulpits. In general, contemporary Americans have viewed preaching by evangelicals and African American ministers as the most political. In 2000, moreover, Americans still viewed the Republican party as a better "protector of religious values" than the Democratic party.[7]

But the Republican party is losing that advantage over the Democrats, according to trends. Both parties now are eager to win the "religious vote," and the current shift in political rhetoric suggests this bipartisan appeal to "values" voters. As a result, political alignments are in flux, even as they grow firmer as well. In the 2004 election, for example, the Protestant majority that usually backed Republicans showed its first modern split: mainline Protestants

divided evenly between the Republican and Democratic tickets.[8] But most of all, the nation is religiously polarized. Orthodox Protestants and Catholics overwhelmingly side with Republicans, and Democrats retain a lock on modernist Protestants, blacks, Catholics, Jews, and secular Americans.

A second territory for the public sermon has been national tragedy and war. The terrorist attack of September 11, 2001, is a dramatic example. Two months afterward, the number of Americans who said they believed religion was becoming more influential had doubled, an astounding jump in public opinion (from 37 percent to 78 percent).[9] Worship attendance spiked after the terrorist attacks, though it fell flat again with the new year. Still, religious rhetoric played a central role in sorting out human questions. "I heard some of the best sermons I have ever heard in my life during the weeks that followed the attacks," said Barbara Brown Taylor, a well-known Espicopalian preacher and teacher. "Preachers who had been wondering how they were going to hang on until retirement suddenly remembered what they were supposed to be doing."[10]

Three days after 9/11, moreover, the nation gathered around television sets to hear a live national sermon—given by Billy Graham at the Washington National Cathedral. His words echoed the Oklahoma City bombing sermon: tragedy brings a nation together, reminds of the fragility of life, and urges a people to turn to God. At age eight-two, Graham again drew on America's two great traditions, the revival and the Puritan jeremiad.

> We've always needed God from the very beginning of this nation. But today we need Him especially. We're facing a new kind of enemy; we're involved in a new kind of warfare, and we need the help of the Spirit of God. The Bible words are our hope: God is our refuge and strength, and ever-present help in trouble; therefore, we will not fear, though the Earth give way and the mountains fall into the heart of the sea.

The prophet Jeremiah foretold that the human heart is deceitful above all things, Graham went on. Although evil and loss remain a mystery, "I have to accept by faith that God is sovereign." Unlike Oklahoma, 9/11 hinged on international affairs. But Graham did not mention any "providential" element in America's new fight. Instead, he urged individuals to consider their standing with eternity. He called the nation to collective hope and repentance. "We need a spiritual revival in America," he said, echoing words heard in times of trouble since Puritan days.

Eighteen months after Graham's sermon, the United States launched a war against Iraq. On March 20, 2003, television screens filled with the "shock

and awe" of missile and tank attacks on Baghdad. In the weeks before the invasion, most American churchgoers heard their ministers speak about the possibility of war (six in ten). But only a fifth of the nation's ministers took an explicit position for or against invading Iraq. When ministers did, they nearly always repeated the decree of their denomination. Black and Catholic pulpits leaned antiwar, and evangelicals proinvasion. Either way, only a tenth of all Americans arrived at their view of the war based on religious beliefs or decrees by clergy.[11]

As before, religious rhetoric was universally sympathetic to those at risk in the war, such as soldiers, but it was not unanimously behind administration policy. This majority-minority pattern is standard in American sermonic history. Most religious rhetoric has supported military vigor, from the days of King Philip's War through the Revolution, Mexican-American War, Civil War, Spanish-American War, and the wars of the twentieth century. But the cautious or dissenting sermon has always allowed for moral reflection. To different degrees, the minority-report sermon has always detailed moral arguments against a national policy.

A third area in which religious rhetoric crosses the boundaries into public policy has been in the inaugural speeches of U.S. presidents. George Washington's first inaugural set the tone with its allusion to the "Great Author," "Parent of the Human Race," "Almighty Being," and "Invisible Hand" guiding America. By contrast, Washington's "Farewell Address" was far more prescriptive, asserting that "Religion and Morality are indispensable supports" for democracy. Invariably, the inaugurals became a secular extension of the election-day sermons begun in New England. Since the 1960s, historians have plumbed presidential inaugurals, and it was this quarry that produced the modern debate over America's "civil religion," or "civil piety." Clearly, the inaugurals have retained the general theme of a Supreme Being guiding America by providence, and even giving the nation a mission.[12]

When the religious symbols, ceremonies, and other moral assumptions of American public life are added together, some historians say, there exists a concrete civil religion. It puts the affairs and actions of the nation under God; America is thus justified by divine fiat. Critics of this view have said that a "religion" must be a far more concrete reality. So what America really experiences in inaugurals and all the rest is a "civil piety," mere rhetoric that keeps a balance between church and state. Presidential inaugurals, for example, never give Americans tough religious mandates of the moment, as a preacher or priest might. Inaugurals feature only nostalgia for God's founding purpose and a millennial hope for a golden future.[13]

Ronald Reagan's first inaugural, delivered in 1981 from a pulpitlike structure adjoining the Capitol, portrayed America as a "nation under God."

Every White House occupant is aware of the tradition of religious rhetoric, according to Michael Gerson, George W. Bush's chief speechwriter for five years. When Bush uses religious speech, "They're not code words; they're our culture," Gerson says. Because these words are imbedded in all American rhetoric, based in the Bible and manifest in generations of sermons, there is no need for "scrubbing public discourse of religion or religious ideas." Modern Americans may be surprised by such religious rhetoric from presidents, but that is only because they are unaware of American history and how biblical themes pervade American letters and speech.

Today, Gerson said, the White House uses religious rhetoric in four traditional categories: for comfort in time of tragedy; to show the historical influence of faith on social justice; as a literary flourish; and in support of particular policies. But a fifth category now is treated more carefully: the American claim to be chosen by providence. As president, Bush has dissected providence gingerly. At a prayer breakfast he said America can "take comfort

are far from our understanding."
m to know all the ways of provi-

ca's cosmic mission, the idea of
as a part of the American mind.
the idea there, and it is only the
on's contribution to civil religion.
ons are not preached in *general,*
ds."[15] As evidenced by the fore-
ions of specific sermons has pro-
culture. Nebulous as they may
pect to hear, and respond to, in
the nation's aspiring oratory.

1. The belief that America is a chosen nation has its secular counterparts, variously known as Manifest Destiny, our national mission, the American Way of Life, the "national interest," and finally "national greatness" when America became the world's sole superpower. All of these beliefs set America apart from other nations, though every nation has a natural tribal pride. The idea was planted in America with sermons about a "new Israel" and a people in covenant with God, parallel to the Old Testament drama. Chosenness has cloaked the nation both with moral responsibility and with self-righteous arrogance.

Chosenness also has an individual dimension. The Puritan revolution was about people discerning whether they had a personal "conversion," and thus were among the elect. The drama of conversion, and individuals seeking confirmation of their status before God, has been a gigantic engine in America culture, society, and politics. The sermon spread the theological idea like seeds in the expanding nation. This introspection about personal status before God has mobilized piety and self-control, but has also imbued Americans with a daunting belief in self-fulfillment. As with all sermon traits, this belief in providence, election, and conversion has instilled American culture with both good and bad habits of mind.

2. The sermon has also given the American mind the belief that an Almighty God will provide comfort. "Lay down your heavy burden," says the gospel. The acceptance of free grace was central to the Reformation and a doctrine on which America was founded. Without the comfort sermon, most people would not be attracted to organized religion. It offers sense in a world that often is chaotic. It gives a restless soul peace. It speaks to different social classes as well. For the have-nots, it promises future justice and something

better. For the middle and upper classes, the comfort sermon offers assurance of social stability, and that what is owned will not be lost. For the intellectual, the comfort sermon can offer sweet reason, when so much religion can seem arbitrary or fanatical.

Although Jonathan Edwards preached an "angry God," he also preached a euphoric world beyond human imagination, a "superlative excellency" that would fill the senses of the chosen person. Centuries later, Norman Vincent Peale preached a more widely palatable "positive thinking," which said people can succeed, and that success was quite all right. In ways, many 1960s youth decided to hear their own American sermon of comfort, a message of euphoric experience, the "grace" of drugs, sex and rock and roll, obviously minus the scolding of Calvinism. The sermon, in short, has been an engine of American optimism. But as with all such values, the search for comfort can be abused and easily turned into a justification for greed, license, indifference, and the status quo. In the quest for comfort, Americans might easily tag all discomforters as traitors, demonic outsiders, and enemies. But the discomfort must come, for it is replete in the Bible itself. That is why the challenge sermon has also never been absent in America, even though it is the sermon least enjoyed by its audiences.

3. The challenge sermon says, as Abraham Lincoln did by quoting the Bible in his second inaugural address, "Woe unto the world because of of fenses; for it must needs be that offenses come, but woe to that man by whom the offense cometh." This admonishment is the enemy of princes and principalities, political bureaucracies, and established orders. It sides with the oppressed and virtuous. As a sermon, it is a form of social criticism that patriotic Americans can barely tolerate. In early American preaching, the emphasis on depravity and the "terrors" waiting for the wicked was intended to produce a positive response, and in some sectors of fundamentalist religion it still may work. After generations of hairsplitting on whether human beings had free will or were predestined, however, free will won out in American religion. Accordingly, the challenge sermon tries to scold people into better behavior, because behavior has become a matter of "choice."

The challenge sermon has attacked individual sin, from alcohol to frivolity and sexual promiscuity. It has been the battle cry of revolutionists, abolitionists, temperance leaders, and preachers against racism, poverty, and war. The challenge sermon never leaves the national conscience at peace, for there is always something to fix, always a sinful motive to be analyzed. When used, the challenge sermon can uphold either liberty or order. In the first, the dissenters claim rights the collective has stolen. In the second, the collective urges

scofflaws and ingrates to work for the benefit of the whole. Either way, the challenge sermon always is unwelcome, though there is an obvious satisfaction for those who preach its warnings. Disliked universally, the challenge sermon protects both liberty and order, so it has never disappeared.

4. All of these themes—chosenness, comfort, and challenge—gain their intensity from a final contribution of the American sermon: the American belief in good and evil. Neither the classic world of Greece and Rome nor the Hebrew Bible presented a stark world of good and evil in perpetual battle. Some believe it came with the apocalyptic writings of the exiled Hebrews, influenced by dualist Zoroastrianism, and later by the emphasis on a cosmic battle between God and the devil in the New Testament.

In any case, if any nation nurses the outlook of Manichaeism—an early Christian "heresy" named for the Persian prophet Mani's belief that Good and Evil clash eternally—it is America. This has been inbred by four hundred years of the sermon. Many have claimed that, contrary to the Manichaean impulse, the true American philosophy is pragmatism. In pragmatism there is no good and evil, just experimental trial and error to find out what brings the best result. Pragmatists might say that the true belief is the belief that works. The sermon determined, however, that in American life the choosing of good and evil sides, saviors and villains, is the most workable way to view the world.

If Manichaeism has co-opted pragmatism, it also has given Americans an aversion to complex moral arguments. In much of life, human troubles arise from conflict over two or more moral goods trying to get their way, much as political factions vie for the best advantage. Contrary to this, the sermon has urged Americans to see opposition as evil, reinforcing a belief that the protagonist is good. The tragic view of life sees mixed motives on all sides, and acknowledges that even the "loser" had a "lesser good" in mind. Manichaean rhetoric, however, places the protagonist completely on the side of the angels and the antagonist on the side of perdition. The Founding Fathers recognized a mixture of human motives and appetites, and thus endorsed a separation of powers. But in the nation's religious rhetoric, the apocalyptic images of Children of Light and Children of Darkness continue to prevail.

Manichaeism is not unique to the Christian tradition, for as modern events show, it runs through Islam and other kinds of monotheism as well. The one true God is a jealous God, and this leads to battles between darkness and light. Finally, in pragmatic terms, a simple drama of good and evil seems to work for America. It works in elections and in rallying a national spirit in

times of war. America's embrace of the rhetoric of good and evil comes from the Bible and the sermon.

The four sermonic themes that have made America are not always in concert, and this is for the good. When the nation feels it is God-like, the challenge sermon is also there. In its worst trials, comfort assuredly comes. The four habits of mind can rival each other; they can make combinations, and sometimes America can feel the strain of all four impulses at once—being chosen, comforted, challenged, and living in a world of darkness and light. The habits of mind make for the best and worst of American feelings and actions. They have changed the course of American history for good and for ill.

Since the days when the ancient Greeks and Romans looked at rhetoric, its chief aim has been to persuade people and move them to decisive actions. That is just what the sermon has done in America. It has distilled a few basic biblical themes and delivered them to every generation in specific sermons, millions of times, and the result has been a general frame of mind that is American. In colonial days, Benjamin Franklin called it a "publick religion." Today it continues as the civil piety of a religious people, and for all its nebulous simplicity, this sermonic legacy continues to shape the nation.

Notes

Introduction

1. Benjamin Franklin, "Proposals Relating to the Education of Youth in Pennsylvania," in *A Benjamin Franklin Reader,* ed. Walter Isaacson (New York: Simon & Schuster, 2003), 144; for the debate on civil religion, see Roderick P. Hart and John L. Pauley II, eds., *The Political Pulpit Revisited* (West Lafayette, IN: Purdue Univ. Press, 2005).

Chapter 1: Robert Hunt's Library

1. George A. Kennedy, *A New History of Classical Rhetoric* (Princeton: Princeton Univ. Press, 1994), 257–70.

2. Perkins, quoted in Teresa Toulouse, *The Art of Prophesying: New England Sermons and the Shaping of Belief* (Athens: Univ. of Georgia Press, 1987), 20.

3. Andrewes sermon, quoted in O. C. Edwards Jr., *A History of Preaching* (Nashville: Abingdon Press, 2004), 375.

4. Peter J. Thuesen, *In Discordance with the Scriptures: American Protestant Battles over Translating the Bible* (New York: Oxford Univ. Press, 1999), 30.

5. David Hackett Fischer, *Albion's Seed: Four British Folkways in America* (New York: Oxford Univ. Press, 1989).

6. William Laud, "The Last Words of the Archbishop of Canterbury," in *Tongues of Angels, Tongues of Men: A Book of Sermons,* eds. John F. Thornton and Katharine Washburn (New York: Doubleday, 1999), 305.

Chapter 2: The Three Convenants

1. Francis J. Bremer, *John Winthrop: America's Forgotten Founding Father* (New York: Oxford Univ. Press, 2003), 174.

2. John Winthrop, "A Modell of Christian Charity," in *American Sermons: The Pilgrims to Martin Luther King Jr.,* ed. Michael Warner (New York: Library of America, 1999), 40, 42, 41, 29.

3. John Cotton, "A Sermon," in *Sermons in American History: Selected Issues of the American Pulpit, 1630–1967,* ed. DeWitte Holland (Nashville: Abingdon Press, 1971), 31, 36, 33, 39, 41.

4. These statistics on colonial preaching are found in Harry S. Stout, *The New England Soul: Preaching and Religious Culture in Colonial New England* (New York: Oxford Univ. Press, 1986), 3–6, 13–15.

5. Roger Williams to John Cotton Jr., March 25, 1671, in *The Complete Writings of Roger Williams,* vol. 6, ed. John Russell Bartlett (New York: Russell & Russell, 1963), 356.

6. John Winthrop, *The Journal of John Winthrop, 1630–1649,* eds. Richard S. Dunn, James Savage, and Laetitia Yeandle (Cambridge: Harvard Univ. Press, Belknap Press, 1996), 158.

7. Roger Williams, *The Bloudy Tenet of Persecution for Cause of Conscience,* ed. Richard Groves (Macon, GA: Mercer Univ. Press, 2001), 4. (Originally printed in London, 1644.)

8. John Wheelwright, "A Fast-Day Sermon," in *The Antinomian Controversy, 1636–1638: A Documentary History,* ed. David Hall (Middletown, CT: Wesleyan Univ. Press, 1968), 158, 164.

9. Hutchinson, quoted in George H. Shriver, *Dictionary of Heresy Trials* (Westport, CT: Greenwood Press, 1997), 181–83, 185.

10. Quoted in *The Antinomian Controversy,* 337, 338.

11. William Hubbard, *A General History of New England from Discovery to MDCLXXX* (New York: Arno Press, 1972), 173. See also Alfred Habegger, "Preparing the Soul for Christ: The Contrasting Sermon Forms of John Cotton and Thomas Hooker," *American Literature* 3 (Nov. 1969): 342–54.

12. Thomas Hooker, "The Application of Redemption," in *The Puritans in America: A Narrative Anthology,* eds. Alan Heimert and Andrew Delbanci (Cambridge: Harvard Univ. Press, 1985), 177.

13. Phyllis Jones, "Biblical Rhetoric and the Pulpit Literature of Early New England," *Early American Literature* 3 (1976): 245–58.

Chapter 3: Jeremiah in America

1. Quoted in Perry Miller, *The New England Mind: The Seventeenth Century* (New York: Macmillan, 1939), 329; quoted in Ronald A. Bosco, ed., *The Poems of Michael Wigglesworth* (Lanham, MD: University Press of America, 1989), 95, 97, 102.

2. Quoted in Harry S. Stout, *The New England Soul: Preaching and Religious Culture in Colonial New England* (New York: Oxford Univ. Press, 1986), 72.

3. Quoted in James D. Drake, *King Philip's War: Civil War in New England, 1675–1676* (Amherst: Univ. of Massachusetts Press, 1999), 82.

4. Bulkeley, quoted in Stout, *New England Soul,* 79.

5. Increase Mather, quoted in Richard Slotkin and James K. Folsom, eds., *So Dreadful a Judgment: Puritan Responses to King Philip's War, 1676–1677* (Middletown, CT: Wesleyan Univ. Press, 1978), 90, 118, 193.

6. Quoted in Stout, *New England Soul,* 83.

7. Quoted in Stout, *New England Soul,* 84.

8. John Tillotson, "Against Evil Speaking," in *Tongues of Angels, Tongues of Men: A Book of Sermons,* eds. John F. Thornton and Katharine Washburn (New York: Doubleday, 1999), 380–81.

9. Cotton Mather, "The Wonders of the Invisible World," in *American Sermons: The Pilgrims to Martin Luther King Jr.,* ed. Michael Warner (New York: Library of America, 1999), 196.

10. Silence DoGood, quoted in Walter Isaacson, ed., *A Benjamin Franklin Reader* (New York: Simon & Schuster, 2003), 22.

11. Benjamin Franklin, "Proposals Relating to the Education of Youth in Pennsylvania," in *A Benjamin Franklin Reader,* 144.

12. Cotton Mather, "Of Style," in Perry Miller, ed., *The American Puritans: Their Prose and Poetry* (New York: Doubleday, 1956), 335.

13. Quoted in Stout, *New England Soul,* 177.

14. Stoddard, quoted in Perry Miller, *The New England Mind: From Colony to Province* (Cambridge: Harvard Univ. Press, Belknap Press, 1953), 235.

15. Jonathan Edwards, "A Faithful Narrative," in *Jonathan Edwards: The Great Awakening,* ed. C. C. Goen (New Haven: Yale Univ. Press, 1972), 151, 206.

16. Whitefield, quoted in Milton J. Coalter Jr., *Gilbert Tennent, Son of Thunder* (New York: Greenwood Press, 1986), 73.

17. See Jon Butler, *Awash in a Sea of Faith: Christianizing the American People* (Cambridge: Harvard Univ. Press, 1990), 184–85.

18. First critics, quoted in Coalter, *Gilbert Tennent,* 74; next critic and Tennent sermon, quoted in Alan Heimert and Perry Miller, eds., *The Great Awakening: Documents Illustrating the Crisis and Its Consequences* (Indianapolis: Bobbs-Merrill, 1967), 170, 18.

19. Gilbert Tennent, "The Dangers of an Unconverted Ministry," in Heimert and Miller, *The Great Awakening,* 77–80.

20. Tennent, quoted in Coalter, *Gilbert Tennent,* 106.

21. Jonathan Edwards, "A Divine and Supernatural Light," in *Jonathan Edwards: Sermons and Discourses, 1730–1733,* ed. Mark Valeri (New Haven: Yale Univ. Press, 1999), 410, 413.

22. Jonathan Edwards, "Sinners in the Hands of an Angry God," in *Jonathan Edwards: Sermons and Discourses, 1739–1742,* ed. Nathan O. Hatch (New Haven: Yale Univ. Press, 2003), 410, 411.

23. For the Chauncy-Edwards debate, see Edwin Scott Gaustad, *The Great Awakening in New England* (Gloucester, MA: Peter Smith, 1965), 80–101.

24. Jonathan Edwards, "A Treatise Concerning Religion Affections," in *Jonathan Edwards: Religious Affections,* ed. John E. Smith (New Haven: Yale Univ. Press, 1959), 120.

25. Quoted in Charles W. Akers, *Called unto Liberty: A Life of Jonathan Mayhew, 1720–1766* (Cambridge: Harvard Univ. Press, 1964), 205.

Chapter 4: Pulpits of Sedition

1. Jonathan Mayhew, "A Discourse Concerning Unlimited Submission and Non-Resistance to the Higher Powers," in *American Sermons: The Pilgrims to Martin Luther King Jr.,* ed. Michael Warner (New York: Library of America, 1999), 419, 417–18.

2. Mayhew, quoted in Charles W. Akers, *Called unto Liberty: A Life of Jonathan Mayhew, 1720–1766* (Cambridge: Harvard Univ. Press, 1964), 202–4.

3. Thomas Hutchinson, *The History of the Colony and Province of Massachusetts-Bay,* vol. 3 (Cambridge: Harvard Univ. Press, 1936), 89–90.

4. Mayhew, quoted in Akers, *Called unto Liberty,* 206.

5. John Wesley, "A Calm Address to Our American Colonies," in *Political Sermons of the American Founding Era, 1730–1805,* vol. 1, ed. Ellis Sandoz (Indianapolis: Liberty Fund, 1998), 419–20.

6. Jonathan Boucher, *Reminiscences of an American Loyalist, 1738–1789* (Port Washington, NY: Kennikat Press, 1967), 74, 113, 122.

7. Jonathan Boucher, *A View of the Causes and Consequences of the American Revolution* (New York: Russell & Russell, 1967), 523, 529–30.

8. Boucher, *A View,* 319, 515.

9. Thomas Paine, *Common Sense and Other Writings,* ed. Gordon S. Wood (New York: Modern Library, 2003), 31.

10. Baldwin, quoted in Derek H. Davis, *Religion and the Continental Congress, 1774–1789: Contributions to Original Intent* (New York: Oxford Univ. Press, 2000), 50.

11. John Witherspoon, "The Dominion of Providence over the Passions of Men," in *Political Sermons,* vol. 1, 549, 533.

12. Quoted in Davis, *Religion and the Continental Congress,* 74, 75.

13. Dwight, quoted in John M. Murrin, "Religion and Politics in America from the First Settlements to the Civil War," in *Religion and Politics: From the Colonial Period to the 1980s,* ed. Mark Noll (New York: Oxford Univ. Press, 1990), 34.

14. Bishop James Madison, "Manifestations of the Beneficence of Divine Providence Towards America," in *Political Sermons of the American Founding Era, 1730–1805,* vol. 2, ed. Ellis Sandoz (Indianapolis: Liberty Fund, 1998), 1310, 1316, 1317, 1319.

15. Quoted in Robert V. Friedenberg, *Hear O Israel: The History of American Jewish Preaching, 1654–1970* (Tuscaloosa: Univ. of Alabama Press, 1989), 10–12.

16. John Thayer, "A Discourse, Delivered at the Roman Catholic Church in Boston," in *Political Sermons,* vol. 2, 1346, 1355, 1359, 1360–61.

17. Burton, quoted in Ruth H. Bloch, "Religion and Ideological Change in the American Revolution," in *Religion and Politics,* 55.

18. Timothy Dwight, "The Duty of Americans at the Present Crisis," in *Political Sermons,* vol. 2, 1367, 1382, 1388, 1380, 1383.

Chapter 5: The Movement West

1. The following Cartwright quotes are in Peter Cartwright, *Autobiography of Peter Cartwright* (Nashville: Abingdon Press, 1984), 38, 33, 75, 308.

2. For these two Baptist episodes, see Cartwright, *Autobiography,* 58–60, 154–55.

3. Lyman Beecher, *The Autobiography of Lyman Beecher,* vol. 1, ed. Barbara M. Cross (Cambridge: Harvard Univ. Press, Belknap Press, 1961), 412.

4. David Robinson, ed., *William Ellery Channing: Selected Writings* (New York: Paulist Press, 1985), 72, 71, 76, 90.

5. Robinson, *William Ellery Channing,* 223, 242, 230, 249, 252.

6. On manliness and oral culture, see Rhys Isaac, "Preachers and Patriots: Popular Culture and Revolution in Virginia," in *The American Revolution: Explorations in the History of American Radicalism,* ed. Alfred F. Young (DeKalb: Northern Illinois Univ. Press, 1976), 127–54.

7. Quoted in D. Ray Heisey, "One Entering the Kingdom: New Birth or Nurture," in *Preaching in American History: Selected Issues of the American Pulpit, 1630–1967,* ed. DeWitte Holland (Nashville: Abingdon Press, 1969), 150.

8. Horace Bushnell, *Christian Nurture* (New Haven: Yale Univ. Press, 1953), 4.

9. Horace Bushnell, *God in Christ, Three Discourses Delivered at New Haven, Cambridge, and Andover* (New York: Scribner, 1876), 308. The sermons were given in 1848.

10. Horace Bushnell, *Women's Suffrage; the Reform Against Nature* (New York: Scribner, 1869).

11. Catherine A. Brekus, *Strangers and Pilgrims: Female Preaching in America, 1740–1845* (Chapel Hill: Univ. of North Carolina Press, 1998), 343–46.

12. Palmer, quoted in Thomas C. Oden, ed., *Phoebe Palmer: Selected Writings* (New York: Paulist Press, 1988), 279.

13. The following Mott quotes are in Margaret Hope Bacon, *Valiant Friend: The Life of Lucretia Mott* (Philadelphia: Friends General Conference, 1999), 56, 94.

14. Lucretia Mott, "Abuses and Uses of the Bible," in *American Sermons: The Pilgrims to Martin Luther King Jr.,* ed. Michael Warner (New York: Library of America, 1999), 638.

15. The following Palmer quotes are in "Tongue of Fire on the Daughters of the Lord," in *Phoebe Palmer: Selected Writings,* 33–34, 36, 42, 48, 46.

16. Cartwright, *Autobiography,* 47.

17. Palmer letter, quoted in Oden, *Phoebe Palmer,* 210.

Chapter 6: Dreams of Utopia

1. Robert Owen and Alexander Campbell, *Debate on the Evidences of Christianity; Containing an Examination of the Social System* (London: R. Groombridge, 1839), 23, 353.

2. Owen, quoted in Frank Podmore, *Robert Owen: A Biography* (New York: Augustus M. Kelley, 1968), 338.

3. *Harbinger,* quoted in Ernest Lee Tuveson, *Redeemer Nation: The Idea of America's Millennial Role* (Chicago: Univ. of Chicago Press, 1968), 81.

4. Noyes, quoted in Podmore, *Robert Owen,* 636.

5. Ward, quoted in Tuveson, *Redeemer Nation,* 54.

6. For statistics, see Richard J. Cawardine, *Evangelicals and Politics in Antebellum America* (Knoxville: Univ. of Tennessee Press, 1997), 43–44.

7. Van Buren, quoted in Cawardine, *Evangelicals and Politics,* 44.

8. John Quincy Adams, quoted in Peter Guilday, *The Life and Times of Joseph England* (New York: America Press, 1927), 50, 51.

9. England, quoted in Guilday, *Life and Times,* 52.

10. England, quoted in Ignatius Aloysius Reynolds, ed., *The Works of the Right Rev. John England, First Bishop of Charleston,* vol. 4 (Baltimore: John Murphy, 1849), 172.

11. England, quoted in Guilday, *Life and Times,* 66–67.

12. England, quoted in Guilday, *Life and Times,* 52, 53.

13. England, "Discourse Before Congress," in *Works of the Right Rev. John England,* vol. 4, 173–90.

14. Finney sermon, quoted in Charles E. Hambrick-Stowe, *Charles G. Finney and the Spirit of American Evangelism* (Grand Rapids, MI: Eerdmans, 1996), 202–3.

Notes

15. Charles G. Finney, *The Original Memoirs of Charles G. Finney,* eds. Garth M. Rosell and Richard A. G. Dupuis (Grand Rapids, MI: Zondervan, 1989), 325–26.

16. Sermon, quoted in Hambrick-Stowe, *Charles G. Finney,* 81.

17. Charles G. Finney, "Tradition of the Elders," in *Principles of Revival,* ed. Louis Gifford Parkhurst, Jr. (Minneapolis: Bethany House, 1987), 114.

18. Finney, quoted in William G. McLoughlin, "Introduction," in Charles Grandison Finney, *Lectures on Revivals of Religion,* ed. William G. McLoughlin (Cambridge: Harvard Univ. Press, Belknap Press, 1960), xlix–l.

19. The Finney quotes on perfection are in Hambrick-Stowe, *Charles G. Finney,* 180, 184, 187, 182, 185, 190.

20. Quoted in Dwight Lowell Dumon, *Antislavery: The Crusade for Freedom in America* (Ann Arbor: Univ. of Michigan Press, 1961), 184.

Chapter 7: Words of Freedom

1. David Walker, "Appeal," in *African American Religious History: A Documentary Witness,* ed. Milton C. Sernett (Durham, NC: Duke Univ. Press, 1999), 197, 200.

2. C. C. Goen, *Broken Churches, Broken Nation: Denominational Schisms and the Coming of the Civil War* (Macon, GA: Mercer Univ. Press, 1985), 54.

3. Nat Turner, "The Confessions of Nat Turner," in *I Was Born a Slave: An Anthology of Classic Slave Narratives, 1770–1849,* vol. 1, ed. Yuval Taylor (Chicago: Lawrence Hill Books, 1999), 251, 250, 247.

4. Quoted in Kenneth S. Greenberg, ed., *Nat Turner: A Slave Rebellion in History and Memory* (New York: Oxford Univ. Press, 2003), 47–48.

5. James H. Thornwell, *The Collected Writing of James Henley Thornwell,* vol. 4, eds. John B. Adger and John L. Giradeau (Richmond, VA: Presbyterian Committee of Publication, 1873), 501.

6. Albert J. Raboteau, "The Chanted Sermon," in Raboteau, *A Fire in the Bones: Reflections on African-American Religious History* (Boston: Beacon Press, 1995), 141–51.

7. Garrison, quoted in Goen, *Broken Churches,* 2.

8. Andrew, quoted in Horace M. Du Bose, *Life of Joshua Soule* (Nashville: Publishing House of the M.E. Church, South, 1911), 216.

9. The following Soule quotes are in Du Bose, *Life of Joshua Soule,* 221–23, 241, 256.

10. Convention, quoted in Du Bose, *Life of Joshua Soule,* 230.

11. Calhoun, quoted in Goen, *Broken Churches,* 110–11.

12. Capers, quoted in Goen, *Broken Churches,* 85.

13. See Raphall, in Robert V. Friedenberg, *Hear O Israel: The History of American Jewish Preaching, 1654–1970* (Tuscaloosa: Univ. of Alabama Press, 1989), 46–52.

14. James Oscar Farmer Jr., *The Metaphysical Confederacy: James Henley Thornwell and the Synthesis of Southern Values* (Macon, GA: Mercer Univ. Press, 1986).

15. 1850 Census, cited in Farmer, *Metaphysical Confederacy,* 12.

16. The following sermon quotes are in James H. Thornwell, "The Rights and Duties of Masters," in *'God Ordained This War': Sermons on the Sectional Crisis, 1830–1865,* ed. David B. Chesebrough (Columbia: Univ. of South Carolina Press, 1991), 177–80, 184, 188, 189.

17. The following Emerson quotes are in Ralph Waldo Emerson, "The Divinity School Address," in *Ralph Waldo Emerson: Representative Selections,* ed. Frederic I. Carpenter (New York: American Book Co., 1934), 72, 75, 84, 76–77, 85, 80.

18. Parker, quoted in Paul F. Boller, *American Transcendentalism, 1830–1860: An Intellectual Inquiry* (New York: Putnam, 1974), 16.

19. Theodore Parker, "A Discourse of the Transient and Permanent in Christianity," in *The American Transcendentalists: Their Prose and Poetry,* ed. Perry Miller (New York: Anchor Books, 1957), 120, 128–29.

20. Theodore Parker, "The Mexican War," in *Theodore Parker: Orator of Superior Ideas,* ed. David B. Chesebrough (Westport, CT: Greenwood Press, 1999), 86–87.

21. Quoted in Chesebrough, *Theodore Parker,* 52, 64, 63.

22. Emerson, quoted in Anne C. Rose, *Transcendentalism as a Social Movement, 1830–1850* (New Haven: Yale Univ. Press, 1981), 218.

23. B. M. Palmer, D.D., *Thanksgiving Sermon, Delivered at the First Presbyterian Church, New Orleans, Thursday, Nov. 29, 1860* (New York: George F. Nesbitt & Co., 1861), 15.

Chapter 8: The God of Battles

1. B. M. Palmer, D.D., *Thanksgiving Sermon, Delivered at the First Presbyterian Church, New Orleans, Thursday, Nov. 29, 1860* (New York: George F. Nesbitt & Co. 1861), 4, 12, 15, 17.

2. Benjamin Morgan Palmer, "National Responsibility Before God," in *'God Ordained This War': Sermons on the Sectional Crisis, 1830–1865,* ed. David B. Chesebrough (Columbia: Univ. of South Carolina Press, 1991), 214, 219, 220.

3. Elliot, quoted in James W. Silver, *Confederate Morale and Church Propaganda* (New York: Norton, 1957), 32.

4. Harry S. Stout, *Upon the Altar of the Nation: A Moral History of the American Civil War* (New York: Viking Press, 2006), 373.

5. Frederick Douglass, *Autobiographies* (New York: Library of America, 1994), 801.

6. A. L. Stone, *The War and the Patriot's Duty* (Boston: Henry Hoyt, 1861), 18; Daniel Alexander Payne, *Recollections of Seventy Years* (New York: Arno Press, 1968), 145.

7. James D. Liggett, "Our National Reverses," in *God Ordained This War,* 100, 95, 96, 97, 102.

8. James Moorhead, *American Apocalypse: Yankee Protestants and the Civil War, 1860–1869* (New Haven: Yale Univ. Press, 1978), 65–67.

9. See Stout, *Upon the Altar,* 51.

10. Bishop Daniel A. Payne, "Welcome to the Ransomed; or, Duties of the Colored Inhabitants of the District of Columbia," in *Sermons and Addresses, 1853–1891,* ed. Charles Killian (New York: Arno Press, 1972), 6.

11. Stephen Elliot, "Ezra's Dilemma," in *God Ordained This War,* 248, 254, 262, 256.

12. *The War of the Rebellion: A Compilation of the Official Records of the Union and Confederate Armies,* series 1, vol. 47, pt. 2 (Washington, DC: Government Printing Office, 1895), 37–41.

13. The following Payne quotes are in *Recollections,* 277, 17, 76, 253–54, 162, 163.

14. Bishop Daniel A. Payne, "Semi-Centennial Sermon," in *Sermons and Addresses, 1853–1891,* 84.

15. Mary Chesnut, *A Diary from Dixie,* eds. Isabella D. Martin and Myrta Lockett Avary (New York: Appleton, 1905), 326–27; *New Orleans Times* and Palmer, quoted in *God Ordained This War,* 198.

Chapter 9: Reconstructing America

1. The following sermon quotes are in Henry Ward Beecher, "Address at Fort Sumter Flag-Raising," in *Patriotic Addresses,* ed. John R. Howard (New York: Fords, Howard & Hulbert, 1887), 677, 683, 679, 685, 688, 689, 695.

2. Quoted in Debby Applegate, *The Most Famous Man in America: The Biography of Henry Ward Beecher* (New York: Doubleday, 2006), 17.

3. Beecher, "Conditions of a Restored Union," in *Patriotic Addresses,* 716, 720.

4. See this Hoge account in Charles Reagan Wilson, *Baptized in Blood: The Religion of the Lost Cause, 1865–1920* (Athens: Univ. of Georgia Press, 1980), 18–24.

5. Quoted in Wilson, *Baptized in Blood,* 39, 49, 54, 41, 42.

6. Quoted in Wilson, *Baptized in Blood,* 47, 45.

7. James Moorhead, *American Apocalypse: Yankee Protestants and the Civil War, 1860–1869* (New Haven: Yale Univ. Press, 1978), 70, 72–77.

8. *The American Jewish Pulpit: A Collection of Sermons by the Most Eminent American Rabbis* (Cincinnati: Bloch & Co., 1881).

9. John A. Broadus, *A Treatise on the Preparation and Delivery of Sermons* (Philadelphia: Smith, English & Co., 1870), 235.

10. Broadus, *A Treatise,* iv–v; Hugh Blair, *Lectures on Rhetoric and Belles Lettres,* ed. Harold F. Harding (Carbondale: Southern Illinois Univ. Press, 1965), 114.

11. Phillips Brooks, *Lectures on Preaching: The Yale Lectures on Preaching, 1877,* ed. Ralph G. Turnbull (New York: Dutton, 1907), 5, 16, 110, 254.

12. Phillips Brooks, "Help from the Hills," in David B. Chesebrough, *Phillips Brooks: Pulpit Eloquence* (Westport, CT: Greenwood Press, 2001), 152.

13. Roosevelt, quoted in Joseph E. Gould, *The Chautauqua Movement: An Episode in the Continuing American Revolution* (New York: State Univ. of New York Press, 1961), 97.

14. Russell Conwell, "Acres of Diamonds," in *American Voices: Significant Speeches in American History, 1640–1945,* eds. James Andrews and David Zarefsky (New York: Longman, 1989), 334, 337.

15. Beecher, quoted in Richard Hofstadter, *Social Darwinism in American Thought* (Boston: Beacon Press, 1992), 31.

16. Henry Ward Beecher, "Progress of Thought in the Church," *North American Review* 135 (Aug. 1882): 117; Henry Ward Beecher, "The Herbert Spencer Dinner," in *Lectures and Orations by Henry Ward Beecher,* ed. Newell Dwight Hillis (New York: Fleming H. Revell, 1913), 318, 322; quoted in Halford R. Ryan, *Henry Ward Beecher: Peripatetic Preacher* (New York: Greenwood Press, 1990), 63.

17. Henry Ward Beecher, "The Two Revelations," in Ryan, *Henry Ward Beecher,* 121–22.

Chapter 10: The White City

1. Queen, quoted in William R. Moody, *D. L. Moody* (New York: Macmillan, 1930), 213.

2. Moody, quoted in William R. Moody, *The Life of Dwight L. Moody* (New York: Fleming H. Revell, 1900), 400, 403, 413.

3. Dwight Lyman Moody, "The Fire Sermon," in *Sermon Classics by Great Preachers,* rev. ed., ed. Peter F. Gunther (Chicago: Moody Press, 1982), 7–17.

4. "Response to Addresses: Cardinal Gibbons," in *Neely's History of the Parliament of Religions and Religious Congresses at the World's Columbian Exposition,* 3d ed., ed. Walter R. Houghton (Chicago: Frank Tennyson Neely, 1893), 45, 46.

5. John Tracy Ellis, *The Life of James Cardinal Gibbons: Archbishop of Baltimore, 1834–1921,* vol. 1 (Milwaukee: Bruce, 1952), 489.

6. "Cardinal Gibbon's Message," in *Neely's History,* 185, 187, 190; "Swami Vivekananda," in *Neely's History,* 853.

7. Washington Gladden, "Religion and Wealth," in *Neely's History,* 568, 570, 571.

8. Washington Gladden, "The Prince of Life," in *The World's Great Sermons,* vol. 8, ed. Grenville Kleiser (London: Funk & Wagnals, 1909), 111.

9. Cornelius Wolfkin, *Religion: Thirteen Sermons* (New York: Harper & Bros., 1928), 9.

10. Rauschenbusch, quoted in Donovan E. Smucker, *The Origins of Walter Rauschenbusch's Social Ethics* (Montreal: McGill-Queens Univ. Press, 1994), 64–65; see also Charles Howard Hopkins, *The Rise of the Social Gospel in American Protestantism, 1865–1915* (New Haven: Yale Univ. Press, 1940), 215.

11. Walter Rauschenbusch, *A Theology for the Social Gospel* (New York: Abingdon Press, 1917), 145.

12. Josiah Strong, *Our Country: Its Possible Future and Its Present Crisis,* rev. ed., ed. Jurgen Herbst (Cambridge: Harvard Univ. Press, Belknap Press, 1963), 214, 216–17.

13. John R. Mott, "The Obligation of This Generation to Evangelize the World," in *Addresses and Papers of John R. Mott,* vol. 1 (New York: Association Press, 1947), 309, 311, 312.

14. John R. Mott, "The Leadership Demanded in This Momentous Time" (Dec. 13, 1946), in *Les Prix Nobel en 1946,* ed. Arne Holmberg (Stockholm: Nobel Foundation, 1947).

15. Quoted in Robert V. Friedenberg, *Hear O Israel: The History of American Jewish Preaching, 1654–1970* (Tuscaloosa: Univ. of Alabama Press, 1989), 92, 93.

16. Jones, quoted in Charles Reagan Wilson, *Baptized in Blood: The Religion of the Lost Cause, 1865–1920* (Athens: Univ. of Georgia Press, 1980), 128, 134, 135.

17. Proctor, quoted in Janette Thomas Greenwood, *The Gilded Age: A History in Documents* (New York: Oxford Univ. Press, 2000), 158–59.

18. The Bryan quote and speech are in Donald K. Springen, *William Jennings Bryan: Orator of Small-Town America* (New York: Greenwood Press, 1991), 71, 77.

19. William Jennings Bryan, "Imperialism" (1900), in *American Voices: Significant Speeches in American History, 1640–1945,* eds. James Andrews and David Zarefsky (New York: Longman, 1989), 402–3.

20. Wilson, *Baptized in Blood,* 173, 180.

Chapter 11: Modern Times

1. Quoted in William W. Sweet, *Methodism in American History* (Nashville: Abingdon, 1954), 371; this section relies on Ray H. Abrams, *Preachers Present Arms: The Role of the American Churches and Clergy in World War I and II* (Scottdale, PA: Herald Press, 1969), and Jess Yoder, "Preaching on Issues of War and Peace, 1915–1965," in *Preaching in American History: Select Issues in the American Pulpit, 1630–1967,* ed. DeWitte Holland (Nashville: Abingdon, 1969).

2. McKim, quoted in Charles Reagan Wilson, *Baptized in Blood: The Religion of the Lost Cause, 1865–1920* (Athens: Univ. of Georgia Press, 1980), 172.

3. Quoted in Yoder, "Preaching," 243, 245.

4. Harry Emerson Fosdick, "My Account with the Unknown Soldier," in Halford R. Ryan, *Harry Emerson Fosdick: Persuasive Preacher* (New York: Greenwood Press, 1989), 105.

5. The Anthony quote and "True Woman" speech are in *Women Public Speakers in the United States, 1800–1925,* ed. Karlyn Kohrs Campbell (Westport, CT: Greenwood Press, 1993), 21, 17.

6. The Anthony trial speech is in Karyln Kohrs Campbell, ed., *Man Cannot Speak for Her,* vol. 1 (Westport, CT: Praeger, 1989), 108, 110–11.

7. Willard, quoted in Ruth B. A. Bordin, *Frances Willard: A Biography* (Chapel Hill: Univ. of North Carolina Press, 1986), 97.

8. Frances E. Willard, "My First Home Protection Address," in Willard, *Woman and Temperance* (New York: Arno Press, 1972), 458, 454, 456, 457, 459.

9. William G. McLoughlin Jr., *Billy Sunday Was His Real Name* (Chicago: Univ. of Chicago Press, 1955), 260, 262.

10. E. B. White, *One Man's Meat* (New York: Harper & Bros., 1944), 110.

11. "The Famous 'Booze' Sermon," in William T. Ellis, *Billy Sunday: The Man and His Message* (Chicago: John C. Winston, 1936), 101, 112, 105, 115.

12. Roger A. Bruns, *Preacher: Billy Sunday and Big-Time American Evangelism* (New York: Norton, 1992), 180, 176.

13. William B. Riley, "The Great Divide, or Christ and the Present Crisis," in *God Hath Spoken: Twenty-five Addresses Delivered at the World Conference on Christian Fundamentals* (New York: Garland, 1988), 27, 28, 29, 39, 40, 42, 44, 37.

14. Harry Emerson Fosdick, "Shall the Fundamentalists Win?" in *Sermons in American History: Select Issues in the American Pulpit, 1630–1967,* ed. DeWitte Holland (Nashville: Abingdon, 1971), 346, 340, 339. See also Clarence E. Macartney, "Shall Unbelief Win?" in *Sermons in American History,* 349–64.

15. Bryan, quoted in Ferenc Morton Szasz, *The Divided Mind of Protestant America, 1880–1930* (Tuscaloosa: Univ. of Alabama Press, 1982), 109.

16. The eugenics movement quotes are in Christine Rosen, *Preaching Eugenics: Religious Leaders and the American Eugenics Movement* (New York: Oxford Univ. Press, 2004), 31, 47. For McCullough story, see 27–30.

17. The following Bryan quotes are in Donald K. Springen, *William Jennings Bryan: Orator of Small-Town America* (New York: Greenwood Press, 1991), 105–6, 108.

18. The sermon contest quotes are in Rosen, *Preaching Eugenics,* 124, 3–4, 123.

Chapter 12: Radioland

1. Quoted in Daniel P. Fuller, *Give the Winds a Mighty Voice: The Story of Charles Fuller* (Waco, TX: Word Books, 1972), 113. See also Tona J. Hangen, *Redeeming the Dial: Radio, Religion, and Popular Culture in America* (Chapel Hill: Univ. of North Carolina Press, 2002).

2. Maier, quoted in John Dunning, *On the Air: The Encyclopedia of Old-Time Radio* (New York: Oxford Univ. Press, 1998), 572.

3. Sermon, quoted in Fuller, *Give the Winds a Mighty Voice,* 102.

4. Columnist, quoted in J. Elwin Wright, *The Old Fashioned Revival Hour and the Broadcasters* (Boston: Fellowship Press, 1940), 241.

5. Charles Edward Fuller, "Seven Marvels of God's Mercy," in *Sermons of the Century: Inspiration from 100 Years of Influential Preaching,* ed. Warren W. Wiersbe (Grand Rapids, MI: Baker Books, 2000), 160, 156, 158.

6. Fred Hamlin, *S. Parkes Cadman: Pioneer Radio Minister* (New York: Harper & Bros., 1930), 131–32.

7. Banquet, quoted in Robert Moats Miller, *Harry Emerson Fosdick: Preacher, Pastor, Prophet* (New York: Oxford Univ. Press, 1985), 379.

8. Harry Emerson Fosdick, "Learning to Preach," in *Harry Emerson Fosdick's Art of Preaching: An Anthology,* ed. Lionel Crocker (Springfield, IL: Charles C. Thomas, 1971), 13.

9. Harry Emerson Fosdick, "What Is the Matter with Preaching?" in *Harry Emerson Fosdick's Art of Preaching,* 29, 36, 41, 30.

10. Harry Emerson Fosdick, *A Great Time to Be Alive: Sermons on Christianity in Wartime* (New York: Harper & Bros., 1944), 192–93.

11. Coughlin, quoted in Charles Henry Whittier, "The Reverend Charles E. Coughlin," in *American Orators of the Twentieth Century,* eds. Bernard K. Duffy and Halford R. Ryan (New York: Greenwood Press, 1987).

12. Rev. Chas. E. Coughlin, *Why Leave Our Own? Thirteen Addresses on Christianity and Americanism,* Jan. 8–April 2, 1939 (Royal Oak, MI: Shine of the Little Flower), 47. (Undated pamphlet.)

13. Chaplin, quoted in Daniel Epstein, *Sister Aimee: The Life of Aimee Semple McPherson* (New York: Harcourt Brace Jovanovich, 1993), 351.

14. McPherson, quoted in Hangen, *Redeeming the Dial,* 65.

15. Aimee Semple McPherson, *Divine Healing Sermons* (Los Angeles: Biola Press, 1921), 50.

16. Reporter, quoted in Edith L. Blumhoffer, *Aimee Semple McPherson: Everybody's Sister* (Grand Rapids, MI: Eerdmans, 1993), 303.

17. McPherson sermons, quoted and analyzed in Stephen J. Pullum, *Foul Demons, Come Out! The Rhetoric of Twentieth-Century American Faith Healing* (Westport, CT: Praeger, 1999), 11, 8, 16.

Chapter 13: The American Way of Life

1. Reinhold Niebuhr, "Differing Views on Billy Graham," *Life,* July 1, 1957, 92.

2. "Warring Church Opposed," *New York Times,* Oct. 7, 1940, 12.

3. Gerald L. Sittser, *A Cautious Patriotism: The American Churches and the Second World War* (Chapel Hill: Univ. of North Carolina Press, 1997), 114–16, 8–13, 245; for the wartime sermons, see G. Paul Butler, ed., *Best Sermons: 1944 Selection* (Chicago: Ziff Davis, 1944), 147, 145.

4. Karl Barth, *The Preaching of the Gospel,* trans. B. E. Hooke (Philadelphia: Westminster Press, 1963), 11; see Donald G. Miller's "Barthian" Beecher lecture in, Donald G. Miller, *The Way to Biblical Preaching* (Nashville: Abingdon Press, 1957), 15.

5. Harry Emerson Fosdick, *Living in These Days: An Autobiography* (New York: Harper & Row, 1956), 247; Fosdick, "The Church Must Go Beyond Modernism," in Halford R. Ryan, *Harry Emerson Fosdick: Persuasive Preacher* (New York: Greenwood Press, 1989), 113.

6. Billy Graham, *Just As I Am: The Autobiography of Billy Graham* (San Francisco: HarperSanFrancisco, 1997), 13.

7. The Graham sermon quotes are in William Martin, *With God on Our Side: The Rise of the Religious Right in America* (New York: Broadway Books, 1996), 29.

8. Oral Roberts, *If You Need Healing Do These Things,* rev. ed. (Tulsa, OK: Healing Waters, 1955), 19, 20, 30, 35.

9. Hux, quoted in Peter J. Thuesen, *In Discordance with the Scriptures: American Protestant Battles over Translating the Bible* (New York: Oxford Univ. Press, 1999), 97.

10. Sheen, quoted in Chester Morrison, "Religion Reaches," *Look,* Dec. 14, 1954, 44, 45.

11. Fulton J. Sheen, "Easter Sermon," in *Best Sermons,* ed. G. Paul Butler (New York: Macmillan, 1952), 131.

12. Sheen, quoted in Thomas C. Reeves, *America's Bishop: The Life and Times of Fulton J. Sheen* (San Francisco: Encounter Books, 2001), 227.

13. Fulton J. Sheen, "Life Is Worth Living" in *Sermons of the Century: Inspiration from 100 Years of Influential Preaching,* ed. Warren W. Wiersbe (Grand Rapids, MI: Baker Books, 2000), 196, 200, 158.

14. James C. Palmer Jr., "An Analysis of the Themes of Bishop Fulton J. Sheen's TV Talks," *Southern Speech Journal* 30 (1965): 223–30.

15. Jack Gould, "Video Departure," *New York Times,* Oct. 26, 1952, XII; Tim Brooks and Earle Marsh, *The Complete Directory to Prime Time Network and Cable TV Shows (1946–Present),* 6th ed. (New York: Ballantine Books, 1995), 595.

16. Norman Vincent Peale, *The True Joy of Positive Living* (New York: Fawcett Books, 1985), 179.

17. Quoted in Carol V. R. George, *God's Salesman: Norman Vincent Peale and the Power of Positive Thinking* (New York: Oxford Univ. Press, 1993), 63.

18. Peale's father, quoted in Charles S. Braden, *Spirits in Rebellion: The Rise and Development of New Thought* (Dallas: Southern Methodist Univ. Press, 1963), 391.

19. Allan R. Broadhurst, *He Speaks the Word of God: A Study of Sermons of Norman Vincent Peale* (Englewood Cliffs, NJ: Prentice-Hall, 1963), 91.

20. The following Peale quotes are in Norman Vincent Peale, *The Power of Positive Thinking* (New York: Prentice-Hall, 1952), 55, 37, 52, vii.

21. Wayne E. Oates, "The Cult of Reassurance," *Religion in Life* 24 (1954–1955): 72–82.

22. Norman Vincent Peale, "The Tough-Minded Optimist," in *Best Sermons,* vol. 9, ed. G. Paul Butler (Princeton, NJ: Van Nostrand, 1964), 252–53.

23. Reinhold Niebuhr, "Varieties of Religious Revival," *New Republic,* June 6, 1955, 13.

24. Quoted in Paul Scherer, "Reinhold Niebuhr—Preacher," in *Reinhold Niebuhr: His Religious, Social, and Political Thought,* vol. 2, eds. Robert W. Bretall and Charles W. Kegley (New York: Macmillan, 1956), 322.

25. Reinhold Niebuhr, "Mystery and Meaning," in Niebuhr, *Discerning the Signs of the Times* (New York: Scribner, 1946), 165.

26. Scherer, "Reinhold Niebuhr," 324.

27. Reinhold Niebuhr, "Suffering Servant and the Son of Man," in Niebuhr, *Beyond Tragedy: Essays on the Christian Interpretation of History* (New York: Scribner, 1937), 186; Niebuhr, "Ark and the Temple," in *Beyond Tragedy,* 62.

Chapter 14: From Left to Right

1. "MIA Mass Meeting at Holt Street Baptist Church," in *The Papers of Martin Luther King, Jr.,* vol. 3, ed. Stewart Burns, et al. (Berkeley and Los Angeles: Univ. of California Press, 1992), 71, 72, 73, 74.

2. Quoted in Richard Lischer, *The Preacher King: Martin Luther King, Jr. and the Word That Moved America* (New York: Oxford Univ. Press, 1995), 225.

3. Martin Luther King Jr., "I Have a Dream," in *A Testament of Hope: The Essential Writings of Martin Luther King, Jr.,* ed. James Melvin Washington (San Francisco: Harper & Row, 1986), 217–20. For King's Memphis sermon, "I See the Promised Land," see *A Testament of Hope,* 283, 284, 286.

4. Quoted in William Martin, *With God on Our Side: The Rise of the Religious Right in America* (New York: Broadway Books, 1996), 52.

5. A. James Reichley, *Religion in American Public Life* (Washington, DC: Brookings Institution, 1985), 145.

6. "Prayer Still Legal in Public Schools," *Christian Century,* July 4, 1962, 832–33.

7. Robert J. McCracken, "The Power and Future of Preaching," in *Best Sermons, Volume X, 1966–1968, Protestant Edition,* ed. G. Paul Butler (New York: Trident Press, 1968), 11.

8. Quoted in Michael B. Friedland, *Lift Up Your Voice Like a Trumpet: White Clergy and the Civil Rights and Antiwar Movements, 1954–1973* (Chapel Hill: Univ. of North Carolina Press, 1998), 230.

9. Henry H. Mitchell, *The Recovery of Preaching* (San Francisco: Harper & Row, 1977), 90, 97, 98.

10. Justo L. Gonzalez and Catherine Gunsalus Gonzalez, *Liberation Preaching: The Pulpit and the Oppressed* (Nashville: Abingdon, 1980), 95.

11. Phyllis Trible, *Texts of Terror: Literary Feminist Readings of Biblical Narratives* (Philadelphia: Fortress Press, 1984). Trible gave the Beecher Lectures in 1981–82. See also E. Lee Hancock, "Introduction," *The Book of Women's Sermons,* ed. Hancock (New York: Riverhead Books, 1999), 2, 10.

12. Quoted in Fred Craddock, *Preaching,* vol. 4, videorecording of Candler School of Theology course (Nashville: Abingdon, 1986). See also Fred Craddock, *Overhearing the Gospel* (Nashville: Abingdon, 1978).

13. The following Coffin sermons quotes are in Warren Goldstein, *William Sloane Coffin, Jr.: A Holy Impatience* (New Haven: Yale Univ. Press, 2004), 197, 199, 204–5; quoted in *New York Times,* Oct. 13, 1967.

14. William Sloane Coffin Jr., "Preaching in the Eighties," Beecher Lectures on Preaching, Fall 1980, author's tapes.

15. William Sloane Coffin, "Not to Bring Peace, but a Sword," broadcast sermon on "30 Good Minutes," Feb. 16, 1992 (http://www.30goodminutes.org/csec/sermon/coffin_3519.htm).

16. Sermon, quoted in Jim O'Grady and Murray Polner, *Disarmed and Dangerous: The Radical Lives and Times of Daniel and Philip Berrigan* (New York: Basic Books, 1997), 226; Daniel Berrigan, *To Dwell in Peace: An Autobiography* (San Francisco: Harper & Row, 1987), 251–52.

17. Hargis, quoted in Dale G. Leathers, "Billy James Hargis," in *American Orators of the Twentieth Century,* eds. Bernard K. Duffy and Halford R. Ryan (New York: Greenwood Press, 1987), 188–89.

18. Jerry Falwell, *Strength for the Journey: An Autobiography* (New York: Simon & Schuster, 1987), 342, 352; and quoted in Martin, *With God on Our Side,* 69–70.

19. Address, quoted in "Jerry Falwell," *American Orators,* 136–37.

20. Reagan, quoted in David Henry and Kurt Ritter, *Ronald Reagan: The Great Communicator* (New York: Greenwood Press, 1992), 39, 52, 184–85.

Conclusion: The "Publick Religion"

1. Joseph Fort Newton, ed., *Best Sermons 1925,* vol. 2 (New York: Harcourt, Brace, 1925), iv.

2. Karl Barth, *Church Dogmatics,* vol. 1, pt. 1, trans. G. T. Thompson (Edinburgh: T. & T. Clark, 1960), 57.

3. Joseph R. Sizoo, quoted in *Best Sermons,* ed. G. Paul Butler (New York: Macmillan, 1952), xx.

4. *Cleveland Press* sermon reviewer George Plagenz, quoted in "American Preaching: A Dying Art?" *Newsweek,* Dec. 31, 1979, 64.

5. James W. Cox, ed., *Best Sermons: 2* (San Francisco: Harper & Row, 1989), ix; "Baylor Names the Twelve Most Effective Preachers," press release, Feb. 28, 1996, Baylor University, Waco, TX.

6. Billy Graham remarks, Oklahoma City Fairgrounds, April 23, 1995, author's transcript.

7. "Religion and Politics: The Ambivalent Majority," Sept. 20, 2000, Pew Research Center for People and the Press, Washington, DC.

8. John C. Green, et al., "The American Religious Landscape and the 2004 Presidential Vote: Increased Polarization," Feb. 3, 2005, Pew Forum on Religion and Public Life, Washington, DC.

9. "Post 9–11 Attitudes: Religion More Prominent, Muslim-Americans More Accepted," Dec. 6, 2001, Pew Forum on Religion and Public Life, Washington, DC.

10. Barbara Brown Taylor, "Abraham's Brood," *Christian Century,* Sept. 11–24, 2002, 39; "Remarks by the Reverend Billy Graham at the Memorial Service for the Victims of the Terrorist Attacks of September 11th," Federal News Service, Washington, DC, Sept. 14, 2001.

11. "Survey: Americans Hearing About Iraq from the Pulpit, but Religious Faith Not Defining Opinions," March 19, 2003, Pew Forum on Religion and Public Life, Washington, DC.

12. David F. Ericson, "Presidential Inaugural Addresses and American Political Culture," *Presidential Studies Quarterly* 27 (Fall 1997): 727–44.

13. Roderick P. Hart and John L. Pauley II, eds., *The Political Pulpit Revisited* (West Lafayette, IN: Purdue Univ. Press, 2005), 64–68.

14. "Religion, Rhetoric, and the Presidency," remarks by Michael Gerson, Dec. 6, 2004, transcript by Ethics and Public Policy Center, Washington, DC, Jan. 13, 2005.

15. DeWitte T. Holland, *The Preaching Tradition: A Brief History* (Nashville: Abingdon, 1980), 113.

Bibliography of Other Sources

General

Holte, James Craig. *The Conversion Experience in America: A Sourcebook on Religious Conversion Autobiography*. New York: Greenwood Press, 1992.

Jones, Edgar DeWitt. *The Royalty of the Pulpit: A Survey and Appreciation of the Lyman Beecher Lectures on Preaching*. New York: Harper & Bros., 1951.

Stout, Harry S., and D. G. Hart, eds. *New Directions in American Religious History*. New York: Oxford Univ. Press, 1997.

Willimon, William H., and Richard Lischer, eds. *Concise Encyclopedia of Preaching*. Louisville, KY: Westminster John Knox Press, 1995.

Colonial Period

Bonomi, Patricia U. *Under the Cope of Heaven: Religion, Society, and Politics in Colonial America*. New York: Oxford Univ. Press, 1988.

Gaustad, Edwin. *Roger Williams*. New York: Oxford Univ. Press, 2005.

Gewehr, Wesley M. *The Great Awakening in Virginia, 1740–1790*. Durham, NC: Duke Univ. Press, 1930.

Gilje, Paul A. "The Crowd in American History." *American Transcendental Quarterly* 3 (2003).

Goff, Philip. "Revivals and Revolution: Historiographic Turns Since Alan Heimert's *Religion and the American Mind*." *Church History* 4 (1998).

Hall, David D. *Worlds of Wonder, Days of Judgment: Popular Religious Belief in Early New England*. Cambridge: Harvard Univ. Press, 1989.

Heimert, Alan. *Religion and the American Mind: From the Great Awakening to the Revolution*. Cambridge: Harvard Univ. Press, 1966.

Levernier, James A., and Douglas R. Wilmes, eds. *Sermons and Cannonballs: Eleven Sermons of Military Events of Historic Significance During the French and Indian Wars, 1689–1760*. Delmar, NY: Scholar's Facsimiles & Reprints, 1982.

Marsden, George M. *Jonathan Edwards: A Life*. New Haven: Yale Univ. Press, 2003.

Miller, Perry. *Errand into the Wilderness*. New York: Harper & Row, 1956.

Morgan, Edmund S. *The Puritan Dilemma: The Story of John Winthrop*. Boston: Little, Brown, 1958.

Reinhold, Meyer. *Classica Americana: The Greek and Roman Heritage in the United States*. Detroit: Wayne State Univ. Press, 1984.

Shuffelton, Frank. *Thomas Hooker, 1586–1647*. Princeton: Princeton Univ. Press, 1977.

Williams, David R., ed. *Revolutionary War Sermons*. Delmar, NY: Scholar's Facsimiles & Reprints, 1984.

Zimmer, Anne Young, and Alfred H. Kelly. "Jonathan Boucher: Constitutional Conservative." *Journal of American History* 4 (March 1972).

National Period

Carter, Paul A. *The Spiritual Crisis of the Gilded Age*. DeKalb: Northern Illinois Univ. Press, 1971.

Chesebrough, David B. *Clergy Dissent in the Old South, 1830–1865*. Carbondale: Southern Illinois Univ. Press, 1996.

Doland, Jay P. *In Search of American Catholicism.* New York: Oxford Univ. Press, 2002.

Evensen, Bruce J. *God's Man for the Gilded Age: D. L. Moody and the Rise of Modern Mass Evangelism.* New York: Oxford Univ. Press, 2003.

Hatch, Nathan O. *The Democratization of American Christianity.* New Haven: Yale Univ. Press, 1989.

Holifield, E. Brooks. *The Gentlemen Theologians: American Theology in Southern Culture, 1795–1860.* Durham, NC: Duke Univ. Press, 1978.

———. "Theology as Entertainment." *Church History* 67 (Sept. 1998): 499–520.

Merk, Frederick. *Manifest Destiny and Mission in American History: A Reinterpretation.* New York: Vintage Books, 1966.

Miller, Randall M., Harry S. Stout, and Charles Reagan Wilson, eds. *Religion and the American Civil War.* New York: Oxford Univ. Press, 1998.

Nelson, Emmanuel S., ed. *African American Authors, 1745–1945: A Bio-Bibliographical Critical Sourcebook.* Westport, CT: Greenwood Press, 2000.

Phares, Ross. *Bible in Pocket, Gun in Hand: The Story of Frontier Religion.* Lincoln: Univ. of Nebraska Press, 1964.

Pipes, William H. *Say Amen, Brother! Old-Time Negro Preaching: A Study in American Frustration.* Detroit: Wayne State Univ. Press, 1992.

Pitzer, Donald E., ed. *America's Communal Utopias.* Chapel Hill: Univ. of North Carolina Press, 1997.

Schlereth, Thomas J. *Victorian America: Transformations in Everyday Life, 1876–1915.* New York: HarperCollins, 1991.

Seager, Richard Hughes. *The World's Parliament of Religions: The East/West Encounter, Chicago, 1893.* Bloomington: Indiana Univ. Press, 1995.

Sellers, Charles. *The Market Revolution: Jacksonian America, 1815–1846.* New York: Oxford Univ. Press, 1991.

Sernett, Milton C., ed. *African American Religious History: A Documentary Witness.* Durham, NC: Duke Univ. Press, 1999.

Turner, Frederick J. *The Significance of the Frontier in American History.* Ann Arbor, MI: University Microfilms, 1966.

Waynes, Sam W., and Christopher Morris, eds. *Manifest Destiny and Empire: American Antebellum Expansionism.* College Station: Texas A&M Univ. Press, 1997.

Weinberg, Albert K. *Manifest Destiny: A Study of Nationalist Expansionism in American History.* Baltimore: Johns Hopkins Press, 1935.

Modern Period

Anker, Roy M. *Self-Help and Popular Religion in Modern American Culture: An Interpretive Guide.* Westport, CT: Greenwood Press, 1999.

Braden, Charles S. *Spirits in Rebellion: The Rise and Development of New Thought.* Dallas: Southern Methodist Univ. Press, 1963.

Ellwood, Robert S. *The Fifties Spiritual Marketplace: American Religion in a Decade of Conflict.* New Brunswick, NJ: Rutgers Univ. Press, 1997.

Harrell, David Edwin Jr. *Oral Roberts: An American Life.* Bloomington: Indiana Univ. Press, 1985.

Larson, Edward J. *Summer for the Gods: The Scopes Trial and America's Continuing Debate over Science and Religion.* New York: Basic Books, 1997.

Marcus, Sheldon. *Father Coughlin: The Tumultuous Life of the Priest of the Little Flower.* Boston: Little, Brown, 1973.

Marsden, George M. *Fundamentalism and American Culture: The Shaping of Twentieth Century Evangelicalism, 1870–1925.* New York: Oxford Univ. Press, 1980.

Ryan, Halford R. "Harry Emerson Fosdick." In *American Orators of the Twentieth Century,* 145–52. Edited by Bernard K. Duffy and Halford R. Ryan. New York: Greenwood Press, 1987.

Illustration Credits

Page 8. "Religious services at Jamestown," illustration by Felix O. C. Darley. Courtesy of the New York Public Library.

Page 12. "Pocahontas at the court of King James," by Richard Rummels, printed by Jamestown A. & V. Co., 1907. Courtesy of the Library of Congress.

Page 18. Engraving by Samuel Harris, 1806. Courtesy of the Library of Congress.

Page 26. Painted illustration, *Harper's Weekly*, Feb. 1901. Courtesy of the Library of Congress.

Page 31. Sketch by Charles H. Neihaus for lunette carving in Connecticut State House, 1893. Courtesy of the Library of Congress.

Page 36. Hand-colored wood engraving, undated. Courtesy of the Library of Congress.

Page 43. Mezzotint by Peter Pelham, 1728. Courtesy of the Library of Congress.

Page 49. Engraving by John Boyd, ca. 1811–27. Courtesy of the Library of Congress.

Page 60. Mezzotint of painting, printed by N. Hurd, Boston, 1766. Courtesy of the American Antiquarian Society.

Page 60. Title page from Mayhew's sermon. Title page reproduced by permission of The Huntington Library, San Marino, California.

Page 63. "Harmony weeps for the present situation of American affairs," illustrated by Isaac Taylor, engraver, 1775. Courtesy of the Library of Congress.

Page 65. Engraving by P. Conde, 1815, after painting by W. J. Thomson. Courtesy of the Library of Congress.

Page 69. Engraving by J. B. Longcare after painting by C. W. Peale. Courtesy of the Library of Congress.

Page 69. Title page from Witherspoon's sermon. Title page reproduced by permission of The Huntington Library, San Marino, California.

Page 82. Ambrotype, date unknown. Courtesy of the McLean County Historical Society, Bloomington, Illinois.

Page 84. "The circuit preacher," drawing by A. R. Ward, *Harper's Weekly*, Oct. 12, 1867. Courtesy of the Library of Congress.

Page 86. Lithograph by Hugh Bridport, ca. 1829. Courtesy of the Library of Congress.

Page 97. Engraving, American Portrait Print Collection, undated. Courtesy of the American Antiquarian Society.

Page 102. Undated portrait painting of Owen. Courtesy of the Library of Congress.

Page 102. Twentieth-century painting of Campbell by J. Bogle. Courtesy of the Library of Congress.

Page 112. Daguerreotype of Finney ca. 1850. Courtesy of the Oberlin College Archives.

Page 112. "Our country's hope," etching printed on satin, 1840. Courtesy of the Library of Congress.

Page 120. Wood engraving, 1830. Courtesy of the Library of Congress.

Page 123. Art copyrighted by the Estate of Bernarda Bryson Shahn/License by Vaga, New York City, New York. Bernarda Bryson Shahn, 1936, ink and watercolor. Courtesy of the Library of Congress.

Page 130. Courtesy of First Presbyterian Church, Columbia, South Carolina.

Page 135. Mezzotint of Emerson, ca. 1884. Courtesy of the Library of Congress.

Page 135. Sketch of Parker by Gaspard, 1907. Courtesy of the Library of Congress.

Page 141. Courtesy of First Presbyterian Church, Columbia, South Carolina.

Page 146. "Sherman's March to the Sea," illustration by Felix O. C. Darley, ca. 1868. Courtesy of the Library of Congress.

Page 152. From *History of the Negro Church* (Washington, DC: Associated Publishers, 1921). Courtesy of the Schomburg Center for Research in Black Culture, New York Public Library.

Page 153. Wood engraving by Sol Eytinge Jr., in *Harper's Weekly,* Aug. 10, 1872. Courtesy of the Library of Congress.

Page 158. Engraving by John A. O'Neill, 1866. Courtesy of the Library of Congress.

Page 159. Flag-raising ceremony at Fort Sumter, glass stereograph, April 14, 1865. Courtesy of the Library of Congress.

Page 163. By Keating, undated. Courtesy of the Library of Congress.

Page 169. Courtesy of the American Jewish Archives, Cincinnati, Ohio.

Page 171. Cover of Phillips Brooks Calendar for 1898. Courtesy of the Library of Congress.

Page 171. People socializing at Chautauqua, ca. 1908. Courtesy of the Library of Congress.

Page 180. Moody photo by Barron Fredericks, New York, ca. 1900. Courtesy of the Library of Congress.

Page 180. World's Fair photographs, Allgeier Co., ca. 1893. Courtesy of the Library of Congress.

Page 184. Drawing by T. de Thulstrup in *Harper's Weekly,* May 15, 1886. Courtesy of the Library of Congress.

Page 184. Photo of Gibbons by Perkins, ca. 1920. Courtesy of the Library of Congress.

Page 195. Photoprint by J. E. Purdy, Boston, ca. 1902. Courtesy of the Library of Congress.

Page 206. Photo on glass negative, undated, in George Grantham Bain Collection. Courtesy of the Library of Congress.

Page 208. Photo by Sterns Wildermuth & Sterns, ca. 1913. Courtesy of the Library of Congress.

Page 217. Gelatin silver print, July 1925. Courtesy of the Library of Congress.

Page 226. Photo of Fosdick on glass negative, in George Grantham Bain Collection, undated. Courtesy of the Library of Congress.

Page 226. Photo of church by Samuel H. Gottscho, 1931. Courtesy of the Library of Congress.

Page 231. Father Coughlin addresses a Cleveland rally, Acme Newspictures, Inc., May 10, 1936. Courtesy of the Library of Congress.

Page 233. Photo, ca. 1931. Courtesy of the Library of Congress.

Page 243. Photo by Phillip Harrington, *Look* magazine collection. Used with photographer's permission.

Page 244. Photo by Jim Hansen, *Look* magazine collection. Used by estate permission.

Page 249. *New York World-Telegram and Sun* Newspaper Photograph Collection, staff photographer Fred Palumbo. Courtesy of the Library of Congress.

Page 254. *New York World-Telegram and Sun* Newspaper Photograph Collection, staff photographer Roger Higgins. Courtesy of the Library of Congress.

Page 257. Photo by Jim Hansen, *Look* magazine collection. Used by estate permission.

Page 262. King preaching at an Atlanta church, Associated Press wire photo, *New York World-Telegram and Sun* Newspaper Photograph Collection, 1967. Courtesy of the Library of Congress.

Page 268. United Press International photo, *New York World-Telegram and Sun* Newspaper Photograph Collection, June 17, 1963. Courtesy of the Library of Congress.

Page 271. Photo by Jim Hansen. Used by estate permission.

Page 276. December 1968 photo. AP Images.

Page 280. Courtesy of Jerry Falwell Ministries.

Page 285. Painting by David Martin, 1767. Courtesy of the Library of Congress.

Page 291. Photograph from Architect of the Capitol, Jan. 20, 1981. Courtesy of the Library of Congress.

Index